AMERICA'S OLD MASTERS

Books by James Thomas Flexner

AMERICA'S OLD MASTERS

AMERICAN PAINTING
I. First Flowers of Our Wilderness
II. The Light of Distant Skies
III. That Wilder Image

THE POCKET HISTORY OF AMERICAN PAINTING
(also published as *A Short History of American Painting*)

JOHN SINGLETON COPLEY

GILBERT STUART

THE WORLD OF WINSLOW HOMER
(with the editors of Time-Life Books)

NINETEENTH CENTURY AMERICAN PAINTING

DOCTORS ON HORSEBACK:
Pioneers of American Medicine

STEAMBOATS COME TRUE
(also published as *Inventors in Action*)

THE TRAITOR AND THE SPY
(also published as *The Benedict Arnold Case*)

LORD OF THE MOHAWKS:
A Biography of Sir William Johnson
(previously published as *Mohawk Baronet*)

WILLIAM HENRY WELCH AND THE HEROIC AGE
OF AMERICAN MEDICINE
(with Simon Flexner)

GEORGE WASHINGTON
I. The Forge of Experience (1732–1775)
II. In the American Revolution (1775–1783)
III. And the New Nation (1783–1793)
IV. Anguish and Farewell (1793–1799)

WASHINGTON: THE INDISPENSABLE MAN

THE FACE OF LIBERTY

THE YOUNG HAMILTON

STATES DYCKMAN: AMERICAN LOYALIST

Library of Congress Catalogue Card Number 79-8923

America's Old Masters

James Thomas Flexner

REVISED EDITION
WITH
NEW FOREWORD

McGRAW-HILL BOOK COMPANY

New York St. Louis San Francisco Bogotá Guatemala
Hamburg Lisbon Madrid Mexico Montreal Panama
Paris San Juan São Paulo Tokyo Toronto

759.13
Fle
c. 1
Rev. ed.

Extracts from a "keynote address" which appeared in *The Shaping of Art and
Architecture in Nineteenth Century America*, copyright © 1972 by The Metropolitan
Museum of Art. Reprinted by permission of The Metropolitan Museum of Art.

Reprinted by arrangement with Doubleday & Company, Inc.
Originally published by The Viking Press, New York, in 1939.
Published by Dover Publications, New York, in 1967.
Revised hardcover edition republished by Doubleday, New York, in 1980. The
author furnished text changes and a new Foreword, Biographical Note, and
Catalogue of Illustrations. This McGraw-Hill Paperback is a reprint of the
Doubleday edition, but with color plates omitted.

First McGraw-Hill Paperback Edition, 1982.

1 2 3 4 5 6 7 8 9 0 DODO 8 7 6 5 4 3 2 1

LIBRARY OF CONGRESS CATALOGING IN PUBLICATION DATA

Flexner, James Thomas, 1908–
America's old masters.
Reprint. Originally published: Rev. ed. with
16 new color illustrations and new foreword.
Garden City, N.Y. : Doubleday, 1980.
Bibliography: p.
Includes index.
1. Painting, Colonial—United States. 2. West,
Benjamin, 1738–1820. 3. Copley, John Singleton,
1738–1815. 4. Peale, Charles Willson, 1741–1827.
5. Stuart, Gilbert, 1755–1828. 6. Painters—United
States—Biography. I. Title.
ND207.F55 1982 759.13 [B] 81-8292
ISBN 0-07-021285-6 (pbk.) AACR2

FOREWORD TO THE
NEW EDITION*

*This Foreword includes passages from the "keynote address" delivered at a symposium held in celebration of the centennial of The Metropolitan Museum of Art. The proceedings were published under the title *The Shaping of Art and Architecture in Nineteenth-Century America.*

It is difficult to credit today, now that American pictures are so greatly admired and exhaustively studied—and bring such impressive prices—what the situation was in 1939, when this book first appeared. Almost all American museums regarded the works of all but a very few of the painters as so vastly inferior to European art that it was only considered necessary to represent America by a small covey of dilapidated canvases languishing yellowly in a dark hallway. Trustees often refused to acquire for pittances pictures that their successors would be glad to buy for sums in six figures. *Icebergs*, the huge canvas by the Hudson River School painter Frederic Church, that recently brought two and a half million dollars (the third highest price ever paid at an auction for a painting by any artist of any school) would probably have been, when *America's Old Masters* was first published, completely unsalable (it was so unfashionable and so big) except as a wall covering for a restaurant or cheap movie theater. Disdain for the American tradition in art was the correct sophisticated attitude.

It was not a personal aberration that made me, although I had studied Italian painting and spent months with Bernard Berenson, publish a book on American painting without having taken a single course on the subject. Courses on the subject were not offered. The university art departments were even more scornful of the art of our nation than the museums.

There did exist, in the desert of American art studies, two oases, each of which fostered important modern works. Concerning the end of the nineteenth century, Lloyd Goodrich had published his biography of Thomas Eakins (1933) and was at work on his *Winslow*

Homer (1944). Concerning the end of the eighteenth, there had appeared in 1926 Lawrence Park's *Gilbert Stuart*, which contained the first authentic checklist to be compiled of any American painter. Twelve years later came Barbara Neville Parker and Anne Bolling Wheeler's checklist of Copley's work, which was, however, limited to his American period.

During my research on my first book, *Doctors on Horseback*, I had come to realize that the American Revolutionary era had not only fostered political creativity; our society had sprung forward on many fronts. Most of these advances were sorely in need of being charted. I turned my attention from medicine, which reflected family interests, to painting, which appealed to me more personally.

I quickly discovered that what examination there had been of American art in the Revolutionary and Federal periods had been motivated primarily by two considerations, neither of which particularly concerned me. Much of the interest had spilled over from the eagerness of pre-Depression American millionaires to hang on their walls expensive, social-position-enhancing likenesses of eighteenth-century British aristocrats. Collectors more patriotically inclined bought equivalent American portraits. Gilbert Stuart, who was viewed as almost an English painter, reigned among American artists as the hero. Although he dashed off portraits of Washington at the rate of one every two hours—he called them his hundred dollar bills —"Stuart Washingtons" were considered the blue chips of any collection.

The other interest was largely genealogical. People who owned portraits of their own ancestors wanted to know more about the ancestor and who had painted the picture. This encouraged a fruitful concern with attribution, but also an emphasis on the biographies of the sitters that, in fact, filled most of the letterpress in Park's *Stuart*.

Having faced the same situation concerning *Doctors on Horseback*, I was not dismayed to find that so much of what I wanted to

Foreword to the New Edition

know was unexplored. I was more worried by the possible presence of other explorers. Park's *Stuart* and Parker and Wheeler's *Copley*, being primarily checklists, served rather than competed with my ends. But there was afloat a disturbing rumor that an English scholar was at the point of completing a profound and extensive book on Benjamin West. Although it seemed that I might well be scooped and outclassed, West remained essential to my plan. I could only say to myself what Admiral Farragut is reputed to have said, "Damn the torpedoes. Full speed ahead!" As it turned out, the book on West never appeared, the only important work on that artist remaining John Galt's published in the 1820s. As *America's Old Masters* is being republished in 1980, there still exists no book dealing effectively with West both as a man and an artist.

More immediately impinging was the fact that a descendant of Charles Willson Peale, who kept his ancestor's papers in his own house, was writing a biography. With considerable trepidation, I got in touch with Charles Coleman Sellers. He proved to be the most generous of men: he put me up in his Connecticut home and placed the papers, which he had conveniently indexed, at my disposal. We had many discussions of our mutual concerns. The first volume of Sellers' still-definitive biography of Peale came out in the same year with *America's Old Masters,* the two works not competing but helping each other.

As the bibliography here published makes manifest, I was able to find a considerable scattering of sources relevant to my "old masters." However, there was no effective synthesis concerning any of my protagonists, and much of what had been published was so inaccurate that I was perpetually menaced by booby traps. More hampering still was the almost total lack of intelligent considerations of the artistic climate in late colonial and early national America. By far the most perceptive and comprehensive work was still William Dunlap's *History of the Rise and Progress of the Arts of Design in the United States,* published in 1834.

Foreword to the New Edition

Despite my best efforts, there were in *America's Old Masters* as it was first published crudities and errors. I have, of course, not allowed the book to move, in its succession of editions, down the years without emendation. My object has never been to bring the text up to the minute—for that minute will soon pass—but to make it sounder in its own context. Although I have not interfered with my younger self on defensible disagreements with what I currently believe, I have corrected actual misconceptions, whether due to my own naïveté or misleading sources. One of my most glaring was my acceptance of Benjamin West's claims that he had come from a semi-primitive society and thus could be considered an incarnation of the "Noble Savage." To prove the opposite, I have appended to this volume an examination of the sophisticated influences that played in Philadelphia on the youthful prodigy.

I soon suppressed the subtitle I gave to *America's Old Masters*— "First Artists of the New World"—and altered the text that reflected this fallacy. I had been fooled by lack of information into ignoring painters who had been practicing on the continent for a full century. The realization of a significant gap to be filled so grew on me that I wrote, as my second book on American painting, *First Flowers of Our Wilderness* (1947), the first—and still the only—comprehensive view of American painting from the known beginnings in the 1660s to the outbreak of the Revolution.

Except for Sellers, I had not, until *Old Masters* was published, met any of the other workers in the field. They proved to be few. As is often the case in a neglected and underpopulated specialty, they were cranky and tended to hate one another. I remember having suggested that progress could be encouraged by organizing a society of students of American art. I was warned that I would be suborning murder. Indeed, such a meeting would have been a perfect setting for a detective story, since everyone had a motive.

When I turned from the four protagonists of *America's Old Masters,* who have never been altogether forgotten, to the painters who

had been their predecessors and contemporaries, the terrain I had previously surveyed seemed tame compared to the wilderness which I now had to penetrate. There was only one solid outpost, one secure fort in which I could take refuge: *Seventeenth-Century Painting in New England* (1939), published by the Worcester Art Museum under the editorship of Louisa Dresser.

The realization, born of modern taste, that crude-seeming paintings could have esthetic quality was just beginning to seep in. Francis Taylor, subsequently director of the Metropolitan Museum, liked to say that he had rescued the portraits of John Freake and Mrs. Freake and Baby Mary, the great masterpieces of seventeenth-century American painting, on a street in Worcester, Massachusetts, as they waited among ash cans for the garbage collector. Since Taylor, one of the most amusing men alive, was never adverse to improving a story I have never decided whether this anecdote was factual or symbolic.

Research had been immensely complicated by a classic example of good intentions gone astray. Thomas B. Clarke, who had befriended Inness and Homer, decided to put knowledge of the beginnings of American painting on solid feet. He announced that we was in the market for early works, the authenticity of which was attested to by inscriptions on the pictures and by supporting documents. Key pictures for a whole squad of seventeenth- and early eighteenth-century artists quickly appeared. Only after this trove had received much scholarly attention was it discovered that in many cases, the inscriptions and histories had been applied to semi-sophisticated printings of the correct period but of European origin. The inscriptions had withstood chemical analysis because they had been put on the back with paint dissolved from the front. Mysterious operators had found in old legal records the limners' names they signed, and they had examined the genealogies of old families for some authentic member whose descendants the genealogist had failed to trace. Into these gaps the mysterious operators hooked a line of imaginary descendants. In the name of the spurious last of these, they concocted an

affidavit of authenticity stating that the picture had never been out of the family. Long after the sad facts had been ascertained, legal technicalities prevented their publication, which meant that writers too far from the centers to be reached by word of mouth continued disastrously to base conclusions on the false as well as the true Clarke collection pictures.

When sources were incomplete and scattered, when few illustrated publications existed and no real effort at synthesis had been made, my major resource was the Frick Art Reference Library. Here were several thousand unpublished photographs of early American paintings accompanied by summaries of what was known, or thought to be known, about the pictures. Since the genealogists who had done most of the research thus reported were better at reading documents than discriminating between styles, the archives of the Frick revealed prevailing confusion. To take one example: Theodore Bolton, the compiler of the first checklist of many an early painter, had a simple technique. He listed as the work of an artist every picture that he could discover had ever been attributed to that artist. I never made out whether it was unconsciousness of the fact or indifference to it that permitted him to list without comment the same picture as the work of several different painters.

Into this welter there had marched as a savior one of the most improbable figures you can imagine. William Sawitzky was a Russian ornithologist who had forgotten his birds to become fascinated with the beginnings of American art. The most self-demanding of scholars, he set a salutary example, bringing rigorous standards into a field where solidly based research was a rarity. It was a compliment to the other workers that they admired—I could say revered—the man who did what they did not and probably could not do.

I came to know Sawitzky well, and, indeed, before I knew him at all, he had acted as fairy godmother to *America's Old Masters*. The little group of occupants of the field were sharpening their knives to cut up a book with literary pretensions written by a complete out-

sider, when word came out that Stawitzky approved. With amazing speed, knives were sheathed. I learned much from Sawitzky, who died the year that *First Flowers* was published.

Sadly, the great scholar suffered from the fault of his virtue: He was too much of a perfectionist to bring to publication most of his work. His effect on his colleagues was largely by word of mouth: especially through a series of lectures he gave at the New-York Historical Society, which neither he nor his widow considered final enough to be printed. It is a tragedy that the reputation of a man who made so important a contribution must now rest on such paragraphs as these.

At about the time that Sawitzky died and *First Flowers* was published, appreciation of American painting began to take off on its phenomenal course. Pictures came up from cellars and down from attics; restorers cleaned and rebacked, dealers sniffed the sweet scent of profits. These developments accompanied and were a result of a most fruitful flowing of scholarship and criticism. Pioneering museums, particularly Brooklyn, under the leadership of John I. H. Bauer, and Detroit, under E. P. Richardson, brought increasing strength to comprehensive collections of American painting; exhibitions with informative catalogues were widely staged; monographs published. Specialized facts and individual careers were soon integrated with the greater panorama by three excellent general histories: by Oliver Larken in 1949; by Virgil Barker in 1950; by Richardson in 1956. I extended my own studies with a brief general history in 1950, and two further detailed volumes (1954 and 1962) that carried the development of American painting through Winslow Homer.

It was a different and somewhat coincidental development that brought the study of American painting into the colleges. Departments of the history of art continued to ignore American creativity or to view it with scorn, but general curricula were being widened to include a popular major called American Studies. The programs

were usually steered by the one faculty dealing with American creativity that had any standing; literature. But for the sake of completeness, some kind of course had to be given in the visual arts. The professors of art history to whom this unwelcome task was assigned commonly felt that they were being sent across the aesthetic railroad tracks into an artistic slum; and like old-fashioned social workers, they considered it their mission to uplift. Each set out to reconstruct the existing study of American art according to the methodology he had been in the habit of applying to whatever aspect of Old World art had been his actual speciality.

I know from my own experience the tensions this question can raise on the level of institutional administration. When the universities were beginning to wonder about American painting, the dean of a major faculty of the fine arts asked me whether I would be willing to give a course in American painting and to lead graduate students. I, being wedded to my typewriter, hesitated, and he went back to his faculty. They proved to be broad-minded. They were willing to overlook the fact that my education as an art historian had not been conventional; they were willing to forget that American art was not an established discipline. But they did have one proviso. They would agree only if I would promise to teach American painting exactly according to the methodology they applied to the study of European painting.

One can see their point of view. A doctorate is not awarded by a single professor but by an institution, and they practiced techniques of which they were justly proud. But I had to refuse because I believe that the study of American art presents its own problems, which must be dealt with in their own way.

The dilemma I then faced has increased as the snowball we started rolling in the 1930s has expanded to such tremendous proportions. True, most departments of the history of art have accepted American painting as a permissible subject for study. Courses are now standard in college curricula. The little band of inspired pio-

neers and cranky antiquarians who were originally my colleagues have been supplanted by a much larger cohort of academics. Much more is being published, many an empty spot is being filled with solid knowledge, but often, so it seems to me, techniques are misapplied.

We should not forget that one of the excitements felt by the Hudson River School landscapists were inspired by their realization that they had an unhackneyed realm of nature to explore and express. Thomas Cole believed that the painter of American scenery had privileges superior to any other since all nature here was new to art. How fortunate scholars of American art are to be able to share, in their own field of endeavor, the same pioneering excitement felt by the Hudson River School! Much of the painting it is their privilege to explore is new to art history. What a feast lies before them! From any position they care to take, they have only to look around them to see unexplored aethetic peaks and glades Our task thus requires more pioneering than is called for in the pursuit of established European art history. We cannot proceed along highly cultivated ground sustained by a host of able predecessors in whose footsteps we can walk. We must blaze our own trails.

When Worthington Whittredge returned from years of study in Düsseldorf and Italy, he concluded sadly that to try to paint American landscape altogether according to the techniques he had learned in Europe would result in blemishing distortion. To learn to paint American nature, he isolated himself for months in Catskill glades. Fellow scholars, we cannot study American art altogether in terms of the European! We, too, have need for Catskill glades.

Two interrelated phenomena that have been determining in American art have only partial parallels in any major European school. One is the relationship between our culture and that of the more sophisticated, but in many ways profoundly different, parent culture overseas. The other is the fact that so large a number of our best artists have been primarily self-taught.

Foreword to the New Edition

The cultural difference between European and American art is likely to begin as soon as the future painter is old enough to escape from his nursery into the outer world. The European child enters an environment that often contains man-made objects of true beauty. At the very least, it contains objects that are old, and time is an excellent repainter, softening contours, meliorating colors. And always, the European is immersed in an atmosphere of tradition, of culture viewed as a quality that accretes down the years.

The American child is urged by his environment not to take tradition seriously. The world in which he finds himself is exciting, pulsing with change and growth, but new. The chances that he will find close to his home any man-made object of real beauty are small, and time has not yet started its process of toning down. If, as the American gets older, he is to see a monument of art, he must search it out, find it usually in a spot separated from his normal environment. He steps from the street into a museum.

The European who wishes to be an artist is presented with established traditions and institutions that give him a solid base to build on or react against. But usually the American must either accept exterior artistic conventions separated from the dynamism around him, or he must proceed from hand to mouth.

It is axiomatic that to be a great artist a man must express his deepest feelings. These deepest feelings are profoundly and inevitably shaped by the environment in which he was raised. If that environment does not offer cultural maturity, how is he to achieve it? By reaching out for flowers growing in another environment, he risks ending up with a cut bouquet that quickly withers. But if he does not reach out, he risks ending up with crudeness. How and in what proportion is he to achieve a viable synthesis?

The question has been fundamental to American art—it is to some extent with us today—and down the generations individual artists and artists in groups have found a variety of answers. When I entered the field forty years ago, what criticism there was tended to admire

most those painters whose works were closest to admired European productions. This bias is gone, yet it is so much a part of the academic procedure to search out lines of influence, that students are driven to scanning European achievements—made now so much more available through photographs—hoping to be in the end like Little Jack Horner who "stuck in his thumb and pulled out a plum and said, 'What a good boy am I.'" Where resemblance can be found, it is assumed that here the American found his inspiration. If it is impossible to work out that the American could conceivably have had direct contact with the European "model," it can be presumed that he somewhere saw some picture by someone who had had such contact.

Although there was once a time when it was believed that every mechanical or scientific invention had a single inventor, it is now generally recognized in the history of science that when the necessary ingredients are available in the general environment, a number of individuals, completely isolated from each other, will make the same creative combinations.

Even in European art, I suspect, parallel invention was more rife than is generally admitted. However, in modern Europe the possibility and necessity for such invention has been, because of the presence of strong traditions and close artistic contacts, less great than in the United States. Only too often an American painter could not, however hard he searched, find aesthetic sources adequate to help him achieve his ends. So he had to improvise. If he wished to show a man throwing an object, he might easily evolve a form that had been used by a Renaisssance artist or ancient sculptor to express a man throwing an object. The body, after all, can engage in only a limited number of contortions, and when you have no pictures to look at, you are likely to look at the people around you. Gilbert Stuart pontificated that in Europe pictures grew from other pictures, while in America they grew from life.

As they develop their styles, all artists make choices among available alternatives. If artists have worked in cultural centers in an

atmosphere of strong traditions, explanations for these choices may jutsifiably be sought in cultural terms. One can proceed along a methodological road, at least seemingly solid, paved with ideas gleaned from books, with the sights and associations of studios, and with memories of past art. But in the study of American painting the road, if one tries to follow it any distance, soon shrinks to a footpath and then vanishes in a tangle of wilderness trees and second growth. It is phenomenal how many scholars of American art, as we grope around on the resulting blind thickets, fail to realize that they have lost their way.

There was no effective art school in the United States, let us remember, until the Art Students League was founded in the 1870s. The choices made by artists who began their labors before they went to Europe (if they ever did go) were commonly decided by two factors not primarily cultural: their individual personalities and the conceptions they derived from their total environment. Most significantly, the only coherent school of painting developed in the United States before the Abstract Expressionists, the Hudson River School, preached as doctrine the avoidance of cultural and artistic influences. A beginner, Asher B. Durand wrote in his "Letters on Landscape Painting" (*The Crayon*, 1855), should not worry about theory or look at the other men's pictures until he had developed a style of his own in personal contact with nature. At least until the end of the nineteenth century, almost all American painters were neither learned nor intellecutal. Learned, intellectual explanations of their attitudes or styles, unless backed by documentation specifically applicable, run a great risk of being highflown rather than accurate.

The fact that so many aspects of American art grew from the interaction of innate personality and non-artistic environment gives a greater significance to such a biographical approach as dominates *America's Old Masters*. In particular, the study of our paintings cannot accept the convention, which I suspect is a hangover from the old aesthetic theory of "art for art's sake," that it is only legitimate

to write about paintings as if they were conceived by disembodied cultural machines. The greatest handicap evident in current studies of American painting is the ignorance, often grounded in indifference, of the scholars concerning the basic realities of the societies in which the artists grew.

Perhaps it is a realization of this fact, so disturbing to simon-pure art historians, that has encouraged the emergence of an opposite—and degrading—fallacy: American painters are treated as sociological illustrators. Not only in general textbooks, where the authors are uneasy with aesthetic matters, but also, I regret to say, in monographs, in exhibitions sponsored by reputable 'museums and the accompanying catalogues, there is a tendency to view the pictures as springboards for social theorizing. Get an advocate of women's rights together with a picture of a woman, and she is off on a doctrinal diatribe. Woe to any American painter who included a black in his composition: the picture is likely to be discussed as a piece (usually lamentable) of historical evidence. And how can an ecologically minded critic look at a Hudson River School landscape without orating on the rape of American nature? Such considerations can only have an aesthetic significance if it can be demonstrated that they so impinged on the individual artist as actively to influence his work.

On a more aesthetic level, a similar drive is the insistence that we apply to past art what are called modern insights. A dead painter should not be judged in terms of his own objectives but of ours. I will confess that after all I have lived through I am still flabbergasted that some people familiar with art history can apply to aesthetic evolution the conception of progress. They should have observed that in art what follows is by no means necessarily better than what went before. They should know that the only constant is change: The position any generation occupies will be soon deserted. Yet there is no lack of presumably rational and educated human beings who feel that the movement of taste has come to a halt in their

own times and, more specifically, in themselves. If a painter of the past does not fall in with their preconceptions, the worse for him!

These seem vexed matters, and they are at the moment throwing up much spray. But perhaps if viewed rationally the solution lies obviously at hand. The need is, of course, for the present to achieve as much pleasure, inspiration, and understanding as possible from the achievements of the past. What is involved is a mediation between two points of view; both must be represented at the conference table. The present is automatically there in the form of the critic who, however much he may reach out in a desire for sympathetic understanding, is still rooted in his own times. The past is there in the integrity of the object being examined. Let the two parties by all means get together as wholeheartedly and as intimately as it is possible for them to do. The result will of necessity be contemporary because of the age in which the critic lives. But it will not be so superficial and one-sided as if the critic beats on the conference table, berating the poor artifact as not being up to the present date, as not being "relevant."

For such an old campaigner as I have become, it is gratifying to observe that what we started as a forlorn hope had turned into a cultural wave. That the faddish aspects of this wave will pass is to be foreseen and need not be dreaded. Surely much that will last has been gained. The corpus of knowledge has been and will continue to be augmented. The old Stygian ignorance is no more. And, although many of the second-rate pictures that have been dug up to be sold at high prices will undoubtedly vanish again, the true works of art will be preserved as permanently as any painting can be. Admirable pictures that newly appear are certain to be valued. Never again will the investigator penetrate (as I once did) into the subcellar of a major museum to find many works by a major artist (in this case Washington Allston) piled among steam pipes.

FOREWORD TO THE
FIRST EDITION

In Colonial America the last half of the eighteenth century was a period of great flowering. Seeds that had been planted when Columbus discovered a continent and European exiles colonized it, roots that had been growing obscurely for hundreds of years burst suddenly into blossom. The revolution and the founding of a new nation were only symptoms of a fundamental deepening of the American spirit, for in diverse fields the Colonies harvested glorious fruits. The first liberal university and the first medical school were founded on a continent whose educational institutions had wandered in a maze of theology; scientists such as Benjamin Franklin and John Morgan built reputations that were known the world over. Manufactures too began to appear in the provincial cities, and rich merchants walked with new pride down lamp-lit streets.

Naturally this flowering was largely limited to the utilitarian pursuits which had occupied preceding generations of pioneers. Cut off by sea and forest from Europe and even from neighbouring colonies, the settlers had gradually developed great skill in supplying their own requirements. Statesmen had been nurtured by the need for government and doctors by the need for medicine. Contriving their own guns and ploughs, farmers had become mechanically ingenious, while their wives became expert in handicrafts, for in the wilderness the spinning wheel was as essential as the axe.

The settlers, however, did not have the leisure to carry to any heights the non-utilitarian fine arts. Since among conscious æsthetic pursuits only architecture, which supplied roofs and walls, had a real place in America's early economy, we should expect only architecture to flourish when that economy widened into America's eighteenth-century renaissance. Indeed, literature was to wait several generations before it could boast names such as James Fenimore Cooper and Washington Irving, while music and

sculpture were almost unknown. One might assume that painting would remain in an equally backward state.

In the early eighteenth century only obscure craftsmen painted on the North American continent: glaziers who drew primitive portraits on the side, or disgruntled Europeans, too inferior to succeed at home, who crossed the ocean to dazzle the citizens of a backward land. By 1800, however, a miraculous change had taken place. Perhaps the strangest development in all Colonial America was the development of a school of great painters. Some spent parts of their lives in England and competed successfully with Reynolds and Gainsborough, Raeburn and Lawrence; the first famous painters born on our continent enjoyed a greater European acclaim than came to any other American artists for at least a century. And they were not the only competent workmen of the American school; others such as Charles Willson Peale, painting almost entirely on this side of the water, produced canvases much admired today.

This amazing story has been largely neglected by the historians of our national life. It begins with four boys, isolated from one another in provincial settlements, who somehow began to draw in an environment unconcerned with drawing. As the years went by, each sat at the feet of the craftsmen who practised art in their communities; each dreamed of the European masters whose achievements he read about but could not study, for no great paintings had found their way to America. Finally, at least two of these young men performed a miracle: they outstripped their teachers and painted greater pictures than any they had seen.

Each of the painters whose lives this book discusses struggled so successfully with his environment that he managed at long last to make the expensive journey in a sailing ship to the galleries of the Old World. Then the self-taught artist of many years' standing who was already famous in his native land saw all at once, in a wild phantasmagoria of styles and colours, the works of Raphael and Van Dyck and Rubens and a hundred more. Nor in several cases

was this all. Antique statues burst upon the consciousness of those who reached Italy; Venus and Apollo stood in naked splendour before men who had never seen a nude work of art; Laocoön writhed and Niobe wept for her children. The American painters were dazzled and exalted and bewildered. Then there was the necessity of coming to earth again, and of painting again, now they had seen great art. Could they keep the virtues they had worked out for themselves among the forest shadows or in the quiet of provincial cities; could mature painters graft onto a self-taught style the wonder and burden of centuries?

Although they were all humbly born men rising from the people, each of America's old masters reacted very differently to the revolution which dragged its trail of blood across their lives. Peale fought and Stuart ran away. Copley braved the fury of revolutionary meetings to preach conciliation. And West, who was already settled in England when the fight began, remained the intimate friend of George III despite his refusal to hide his sympathy for the American rebels. Amusingly enough, it was Stuart, the only Tory among America's first great artists, who painted what was perhaps the most famous picture associated with the revolution and went down in popular history as the idealizer of Washington.

We need not be surprised that one of America's old masters was an inventor, founded an important museum of natural history, the earliest on this continent, and exhumed the first mastodon skeleton seen since the days of cavemen. Painters did not live in ivory towers in those days; far from it. Every development in one of the most exciting periods of American history was reflected in the lives and the work of America's old masters. Their portraits and historical paintings have kept for ever visible the men and the events associated with the birth of a great nation.

Dedicated to history not art criticism, to biography not the evaluation of pictures, this book attempts to tell the story of four amazing lives. In discussing the achievements of these men, we shall try to

show how their paintings succeeded or failed in the eyes of their contemporaries and according to the standards of their own school, leaving to writers more skilled in such matters the evaluation of their work according to some universal principle of æsthetics. It is not our object to make judgments, but to resurrect from the obscurity of time the men behind the canvases that gave American art its first stature in the world.

CONTENTS

Contents

ILLUSTRATIONS

Illustrations

Illustrations

Benjamin West

(1738–1820)

"THE AMERICAN RAPHAEL"
BENJAMIN WEST

I

B ENJAMIN WEST, the first major American artist to study abroad, had been at twelve a professional painter and at twenty famous in the provinces of New York and Pennsylvania. When in 1760 he stepped from a grain ship onto the quay at Leghorn, a handsome young man with a self-confident stride, he began the long procession of American youths who still crowd the art academies of Europe. Before him lay what was perhaps the most successful career ever achieved by an American artist. He was soon to be regarded all over the world as the leading exponent of the "grand style" of painting, which Reynolds and Romney attempted so unsuccessfully that they were thrown back on what they considered the mere hackwork of portraiture; he was to be a founder of the Royal Academy in London and its president during twenty-seven of the most brilliant years of English painting.

The appearance of an American art student in Rome created an immediate sensation, for the dilettanti who haunted that ancient capital thought of Americans as a savage people living in the twilight of a primeval forest. It seemed strange that there should be artists among them, and almost unbelievable that one should penetrate to the centre of the civilized world; the rumour that West belonged to the odd sect of Quakers heightened the wonder. No sooner had West arrived than the young English æsthete Thomas Robinson, who was later to become British Foreign Secretary, swept the American off to a reception where he might exhibit him to the leading antiquarians and painters of Rome.

West reported years later in a discourse before the Royal Academy that after he had shaken many a hand and looked into many a strange dark face, Robinson led him with obvious awe into a room apart. There, surrounded with worshippers like an idol in a shrine, sat a blind and shrivelled old man. Cardinal Alessandro Albani, Robinson whispered to West, was the nephew of Pope Clement XI; he was rich; he was one of the most powerful princes of the Church; and despite his blindness his word on art was law. His opinion of the beauty of a statue, once he had run his long, episcopal fingers over its surface, was so respected that no sighted critic in Rome dared disagree; his pronouncements were final concerning even the most delicate medals and intaglios.

With hushed steps, Robinson led West to the churchman's feet. "I have the honour," the American remembered he said, "to present a young American who has a letter of introduction to Your Eminence, and who has come to Italy for the purpose of studying the fine arts." *

The Cardinal raised his blind head with a sudden gesture of interest; to him the word American connoted Indians. "Is he white or black?" the old man asked. Robinson replied truthfully that West was very fair. At this the Cardinal wrinkled his dark brow. "What, as fair as I am?" Fortunately the satellites did not have to hide their smiles, since the swarthy churchman was blind. Soon the phrase "as fair as the Cardinal" was current all over Rome.

Stretching out his famous hands, Albani asked West to approach. Conversation ceased; all present watched the bloodless fingers pass over the American's face. When the Cardinal reported that he had an admirable head, the head of an artist, West's reputation was already half made.

West, who did not know a word of Italian, must have been bewildered by most of what went on around him, but he was attracting

* I have modernized the spelling and punctuation of the letters and documents I have quoted.

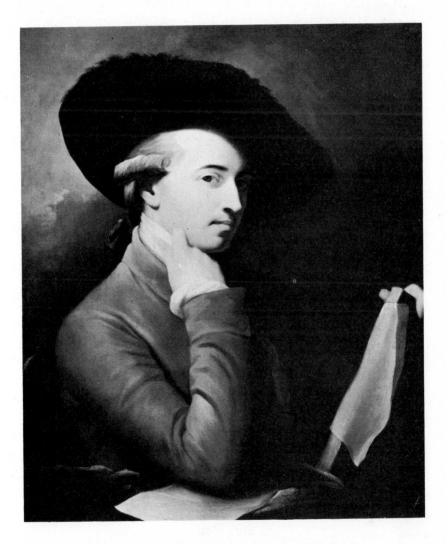

WEST: SELF-PORTRAIT AT THIRTY-THREE

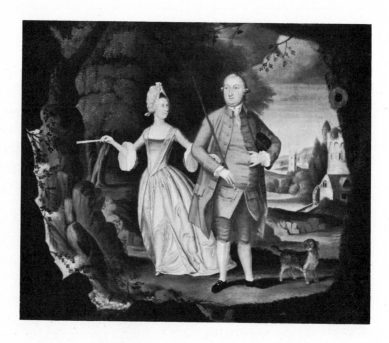

WILLIAMS: CONVERSATION PIECE

WEST: LANDSCAPE WITH COW

Naïve impressions of a gifted child

attention, and that was pleasant. Finally the talk rose to a higher pitch, the gesticulations became more emphatic, and Robinson told him that the entire company had decided to show him the Vatican Museum the next morning. The virtuosi were curious to see what effect the *Apollo Belvedere,* which they considered the greatest statue of antiquity, would have on a young man educated among Indians, a noble savage who seemed to have stepped out of the newly published pages of the early romantic writers.

The next morning thirty carriages moved in procession down the historic streets of Rome, the most magnificent carriages in the capital of Christendom, and every one was crowded with connoisseurs. In the first rode the Cardinal, with blind, inturned eyes and wrinkled mummy's face, a living symbol of the past. And beside him the blond young man from the wilderness, the muscles of youth tense under his clothes, sat flushed, excited, and a little afraid. They passed by monuments of dead emperors, by broken columns around which new grass grew. Then the Vatican rose before them, and West saw for the first time the symbol that had ruled the medieval world. The carriages stopped; the old man and the young alighted, while the crowd flocked after. They walked down high hallways, gilded and tinted during the Renaissance, until they stepped into an even older world. The shards of antiquity lay around them now: broken figures from pediments, sarcophagi of the anonymous dead. Still the old man shuffled on and the young followed.

Finally they came to a room where the stage had been set. In the centre stood the closed case which contained the *Apollo;* beside it an attendant in the livery of the Popes. The Cardinal placed West before the case while the connoisseurs crowded behind them. Every eye was on the young man when at a signal from the octogenarian the doors were thrown open. There, dazzlingly white, stood the first nude statue West had ever seen. He cried: "My God, how like a Mohawk warrior!"

When this remark was translated, it excited indignation; the savage, instead of falling on his face before the great statue, had compared it to something as savage as he. A disgruntled murmur went up from the crowd. Told the cause of their dissatisfaction, West explained to the translator what a noble race the Mohawks were, how strong, how proud, what admirable children of nature; "I have seen them often standing in that very attitude, and pursuing with an intense eye the arrow which they have just discharged from the bow." Then the virtuosi, remembering their Rousseau, declared that a better criticism of a statue had never been heard. West was increasingly fêted in the salons of Rome.

He was not surprised, for he was used to being a focus of admiration. As far back as he could remember, he had been regarded as a remarkable being; in his old age he insisted that even his birth had been miraculous, though in the Protestant manner. He told his biographer John Galt, the Scottish novelist, that divine destiny had marked him in his obscure birthplace and guided his footsteps for ever after.

The painter was the youngest among ten children of John West, a cooper who had emigrated from England as an adult and improved his status by becoming an innkeeper in America. After conducting a tavern in the river city of Chester, Pennsylvania, he had moved in 1737 to Springfield Township, a prosperous farming area some six miles north of Chester and ten west of Philadelphia. He had rented one of the finest houses in the region, a three-story stone mansion on the highroad, where he opened an inn to serve the German immigrants who were streaming from the banks of the Delaware into the back country.

John West's neighbours were Quakers, descendants of the religious rebels who had fled England with William Penn only sixty years before; many of the original settlers still preached salvation in the new stone meeting house. It was a sober hard-working community; the men laboured all week in their fields and the women

by their firesides, but on "First Day," as the Sabbath was called to avoid a word that smacked of sun-worship, not a hand touched plough or spindle; everyone hurried to meeting. Although they wore their best clothes, there was not a hint of finery; black coats and round black hats gave the men an air of perpetual mourning, while the women hid their hair and shadowed their faces under disfiguring grey bonnets. Like a flock of earth-bound ravens, the farmers streamed to worship under trees bright with summer bloom.

However, every breast, despite its sombre seeming, seethed with the unslaked fire of a passionate worship of God. The farmers escaped from the monotony of field and forest into visions of Hell and Heaven, into the flattering war waged between God and Satan for their individual souls. The visit of an itinerant evangelist who brought a new message from the battlefront was the most exciting event possible in their restricted lives; they flocked to revival meetings as their descendants might to a barn dance or a country fair.

Benjamin West told his biographer that when his mother was far advanced in her pregnancy, an English Quaker evangelist, a doughty wrestler with evil, appeared in Chester County; although the baby already moved in her womb, Mrs. West could not bear to stay at home. The preacher, she later told her son, was in fine form that autumn afternoon. He cried out against the wickedness of the Old World, from which so many of his listeners had recently emigrated. He held up to abhorrence the licentious manners and atheistical principles of the French, and in fluent words depicted England worshipping the golden calf of commerce; God would visit Europe with fire and brimstone, he promised. Then he begged his hearers to turn their eyes to America, where "the forests shall be seen fading away, cities rising along the shores, and the terrified nations of Europe flying out of the smoke of the burning to find refuge here." Mrs. West was so moved by this vision of greatness descending on her forest clearing that she was seized by labour

pains. The meeting broke up; the ladies made a circle around her and finally carried her home, where the premature pains, obviously brought on by excitement, soon subsided.

Although Benjamin was not born for another thirteen days (October 10, 1738), his father, so the story goes, was deeply impressed by his wife's seizure in the meeting house. Even reputable scientists then believed in prenatal influence, and every Quaker knew that the Lord often manifested Himself by signs to the most humble. Did it not all mean that God had selected little Benjamin for some divine mission? Eagerly John West sought out the preacher and confided his hopes. The delighted evangelist took him by the hand, "and with emphatic solemnity said that a child sent into the world under such remarkable circumstances would prove no ordinary man." Mr. West hurried home and studied the wizened infant in his cradle, watching for another sign to show what destiny awaited the lad. And when in the taproom of his inn he repeated the prophecy to the Friends there assembled, they listened with excitement and carried home to their families awed accounts of how God's Grace had descended on their forest settlement.

This story, which West told when over eighty, is thrown into great doubt by the fact that Edmund Peckover, the evangelist West named, did not reach America until several years after the painter was born. However, incidents which happened to the insignificant are with the passage of time often attributed to the famous; it may be that the reputation of the Friend who preached that day had been forgotten and that therefore West had gradually convinced himself that the preacher involved was the internationally famous Peckover. In its other details, the account is very plausible; no good romancer, making it up from whole cloth, would have allowed the birth to wait for thirteen days after the meeting. And the aura of sanctity with which such a happening would have surrounded West

helps to explain strange and well-authenticated events that followed.

Even if we do not accept the story, its inclusion in the official biography West himself edited is significant. Why did the painter, who was already as famous as he possibly could be, want the public to believe such a falsehood? Or had he come himself to believe at the end of an almost fabulous career that he had been miraculously born?

West's first years had been spent to the sound of turning wheels and of guttural German voices. When he was four or five, his father seems to have moved to another tavern in the same neighbourhood, since in 1743 he applied for a new licence, stating that he had "rented a commodious house and all other conveniences there and to belonging for a house of entertainment on the road leading from Darby to Springfield and from thence to Conestoga, which is of late much frequented by the Dutch wagons, to the number of forty or fifty a day."

Every evening the unwieldy covered vehicles rumbled into the courtyard, the men walking beside the tired horses. There would be a burst of foreign jabbering, and then the wagons would disgorge a flood of women and children from the Palatinate who stretched and groaned, for they had been perched uneasily on the chairs and chests that were all their worldly goods. Boys of Benjamin's own age who could not speak his language stared gravely at him in the courtyard; later perhaps they threw stones at him with the sudden hatred that springs up in childish breasts at the sight of strangers. Often the lad must have helped in the tap-room or carried warming pans up to the crowded chambers where the Germans lay, covering the floor as well as the beds.

Thus the years passed until when Benjamin was six destiny intervened; he was, he told Galt, left to watch over his sister's baby. The vigil proved a long one and finally, in utter boredom, he reached for

the pen and paper that lay on a near-by table and drew the infant's picture. On her return, Mrs. West was delighted. "I do declare," she cried, "he has made a likeness of Sally!" And she kissed him. "That kiss," West used to say sententiously, "made me a painter."

But more important was the fact that his father was deeply impressed, perhaps because he saw in the drawing the sign he was waiting for, or perhaps because he thought it remarkable that his son should spontaneously start to draw. There were not many pictures in the region to inspire him,* since the Quakers frowned on all "images" as tending toward "Popish idolatry" and encouraging "the lust of the eyes." Had John West been more orthodox, he might have regarded his son's leaning toward art as evidence of an indwelling devil, but the innkeeper, who was born a Quaker and lived in a Quaker community, had proved the independence of his mind by resigning from meeting over some doctrinal disagreement. However, he continually took his doubts and his family to worship, and many years later returned to the fold. We have the testimony of one neighbour that he was a very religious man.

Most amazingly, when John West exhibited to his more orthodox neighbours the drawings he now encouraged his son to execute, only a few followed the strict doctrinal line and denounced the boy's accomplishments as wicked; most of the Friends were impressed. If we accept the story of West's miraculous birth, this would explain their ready acquiescence, for they would never have dared question the manifest will of God; otherwise we can point out only that the Quakers who lived near Chester had already proved themselves one of the most radical communities in all America. As early as 1711, the sober farmers, sitting quietly in quarterly meeting, had adopted one of the first resolutions ever voted that denounced slavery, a resolution so revolutionary that it was greeted with horror by the central body of the Friends, the Philadelphia Yearly Meeting. Year after year John West's neigh-

*See Appendix.

bours sent their demands to Philadelphia, until gradually other meetings followed their example. However, it was not till forty-three years after their first resolution that John Woolman published his famous *Some Considerations on the Keeping of Negroes*, and still another four years were to pass before the Friends came out unequivocally against all forms of slavery. Benjamin West was to tell Galt that his father had started the movement by freeing a slave of his own and arguing with his neighbours. This must be an exaggeration, since John West, who was not officially a Quaker, did not reach America until three years after the Chester meeting had adopted its first resolution. However, innkeepers were men of influence in those days; his action may have materially strengthened the movement for reform.

We may be certain that the men who bounced young Benjamin on their knees were not hidebound by tradition. Indeed, in this radical community the Quaker prejudice against art probably helped the infant painter, since it prevented his elders from seeing sophisticated images to compare with his childish drawings of animals and flowers. These seemed to them miracles of skill. While West was still a small boy, his reputation travelled for miles through the countryside.

Soon little Benjamin learned to put his talent to practical use. When the shades of the schoolhouse closed around the growing boy, he proved unable to do arithmetic. Regularly he failed in his sums, and as regularly felt a switch laid onto his buttocks. However, he finally induced a classmate named Williamson to do his exercises in return for having a textbook decorated with wild animals. This illuminated primer, West's first commission, was in existence until a few years ago.

The historical fact that families of Indians continued to live in Delaware County until long after West's childhood, rearing their wigwams on the banks of creeks and walking at peace among the Quaker farmers, lends credence to a story the painter told his

biographer. One afternoon, he said, he was amusing himself after school by drawing in the forest when he heard a rustling behind him and saw a party of Indians approaching in single file. The child was not afraid; indeed, the Indians may have been old friends, since small boys have a tendency to hang around disreputable adults who can be induced to tell tall stories. In any case, the boy showed the savages his drawings. They admired stolidly, as Indians do, and then asked why he did not give that robin a red breast. On learning that the child had no colours to play with, the savages squatted down at once and told him how to mix the red and yellow earths with which they painted their faces. West ran home delighted, and when he told his mother, she added blue by giving him a piece of indigo. Thus he had the three primary colours.

But how was he to put them on paper? His thumb was too thick an instrument and his pen too thin. Told of this difficulty, a particularly erudite Friend explained that brushes could be made by fastening camel's hair in a quill. That was exciting news, but what was he to do for a camel? As he meditated glumly, his father's black cat padded into the room. Snatching up his mother's scissors, Benjamin cut off the fur at the end of the tail. This made only one brush, however, and the indefatigable painter wore that out in a few hours. Soon Mr. West was heard to wonder what had happened to Kitty to make her hair come off in large patches; she must have the mange. Galt, who never missed a moral lesson, tells how West confessed and was forgiven.

In 1744 John West, probably because his tavern was not as successful as he had hoped, moved a few miles farther north, renting an inn at Newtown Square. Here the lad painted away, while his parents and their new Quaker neighbours admired. When Benjamin was eight, a Philadelphia Friend named Pennington came to stay at the inn. Amused by the childish pictures hung up with such care, after his return to the city he sent Benjamin a box of

paints, several prepared canvases, and six engravings by "Grev-ling," perhaps Hubert-François Gravelot, who was Gainsborough's first master. Up to that moment, so West insisted to Galt, he had never seen any drawings but his own and did not know that engravings existed. In any case, Pennington's pictures and paints were certainly the most elaborate that had ever come his way. That night he kept the gift close by his bed, and woke every few hours to touch the possession, which he was afraid might be a dream.

In his old age West used often to tell how he played hooky from school, pretending to set out each morning but really taking a circuitous route to the attic. While his friends sweated over sums, he combined two of the engravings into one picture. Finally the schoolmaster sent to ask if Benjamin was ill. Mrs. West found the truant in the attic, but her anger turned to joy when she saw the picture on the canvas. She kissed the little artist with transports of affection, and was so worried for fear he would hurt his painting that she would not let him finish it. This is the canvas West showed everyone who visited his studio when he was old and famous; it revealed, he insisted with sentimental tears in his eyes, "inventive touches of art . . . which with all my subsequent knowledge and experience I have not been able to surpass." Indeed, the picture marked a period in his life, since it convinced his parents and many of his neighbours that he had certainly been chosen by God to be a painter. The boy himself was convinced, and for the remaining seventy-four years of his life he never lost the consciousness of a divine mission.

II

Mr. Pennington invited West to visit him in Philadelphia. The little boy had no sooner looked at the harbour and seen his first big boats than he demanded some paints and a canvas. While his host watched in awe, he slapped off "a picturesque view of a river, with vessels on the water and cattle pasturing on the banks." Word

of the prodigy at Pennington's sped quickly through the provincial capital; a rich merchant who had just had his portrait painted commanded the artist, William Williams, to show it to West. Thus the boy obtained his first view of a painter not himself and a painting not his own.

The transports of delight he went into before Williams's stiff canvas enchanted the painter into inviting the lad to his studio. It was the most exciting place West had ever seen, for not only did it smell of paints, not only were there canvases against the wall, but Williams himself was a character to delight any small boy's heart. He had been captured by Indians. Many years later West described him in a letter. "As he was an excellent actor in taking off character, he often, to amuse me, repeated his adventures among the Indians." He told West about "the scenery of the coasts, the birds on them, in particular the flamingo birds, which he described, when seen at a distance, as appearing like a company of soldiers in red uniforms. He spoke the language of the savages and appeared to have lived among them some years. I often asked how he came to be with them. He replied that he had gone to sea when young, but was never satisfied with that pursuit; that he had been shipwrecked and thrown into great difficulties; but Providence had preserved him through a variety of dangers." That Williams was an effective story teller we may be certain, for in his old age he wrote *The Journal of Llewellin Penrose,* a vivid tale very like *Robinson Crusoe* but based on his own experiences among the American Indians.

Williams would turn from tales of adventure to another subject just as exciting; he would talk of art. "He told me that he had imbibed his love of painting when at grammar school at Bristol, where his greatest delight was to go and see an elderly artist who painted heads in oil, as well as small landscapes." After his escape from the savages, he had used what he remembered from those childhood days to set up as a portrait painter, and in provincial

Philadelphia, which had never harboured a truly skilful painter or imported a first-rate canvas, his work exerted considerable appeal. If he did not make his living entirely from art, but ran what he described in newspaper advertisements as "an evening school for instruction of polite youth in the different branches of drawing, and to sound the hautboy, German and common flutes," that was no criticism of his reputation. As we have seen, many Quakers disapproved of images, even images of their own faces, and, indeed, up to then hardly any painters in all the British Colonies had been able for any length of time to support themselves altogether with their brushes.

Williams was an adventurous painter; he manifested histrionic leanings by painting the scenery for that heathen abomination, the old Southwark Theatre in Philadelphia. He lived "in Loxley's Court at the sign of Hogarth's head," and some of his surviving pictures reveal the influence of Hogarth's "conversation pieces." These group portraits, depicting several people painted in full length and behaving somewhat naturally, had come to England via the French courtly artists, and it was the courtliness that appealed to Williams. One canvas shows a lady and gentleman posed with stiff elegance in a grotto of foliage; the lady is pointing with her fan at a waterfall trickling in one corner. At their feet is a little dishrag of a dog. But the amazing part of the picture is the background against which the two Americans stand. We are startled to see romantic European hills, a Norman church tower, a thatched mill, and a ruined medieval castle. Although the drawing is weak and the composition crowded, the colour is pleasing and the picture has charm in its very naïveté and stiffness. It is easy to understand how West was enchanted with such elaborate pictures as this.

When Williams asked his young disciple what books he had read, Benjamin replied that he had read nothing but the Bible; the horrified artist allowed him to take back with him to his father's house Richardson's *Essays in Painting* and a translation of Dufres-

noy's poem *L'Art de la Peinture*. West studied them with frowning attention while the mighty trees of the wilderness, gleaming prismatically in every shade of green, rocked unnoticed over his head. He did not even look up to greet his friends the Indians as they padded by; he was too absorbed in mouthing strange names of foreign painters. "At the raising of Lazarus," he read in Richardson, "some may be allowed to be made to hold something before their noses, as this would be very just to denote that circumstance in the story, the time he had been dead; but this is exceedingly improper in the laying of Our Lord in the sepulchre; although he had been dead much longer than he was; however, Pardenome has done it. . . . That the blessed Mary should swoon away through excess of grief is very proper to suppose, but to throw her into such a posture as Daniel da Volterra has done in the descent from the cross is by no means justifiable." West, of course, had not the faintest idea how any of these pictures looked, but what small boy could resist such long words and such quaint considerations? A few years before, another country lad, this time across the ocean, had been so thrilled by Richardson's *Essays* that he had determined to become a painter; his name was Reynolds and he was to become West's rival in a city neither had ever seen.

One day West half reluctantly laid down the books Williams had lent him in order to go riding with a schoolmate on a single horse. Full of the newly realized dignity of his profession West refused to ride behind. "Oh, well," he remembered that his companion replied, "you take the saddle and I will get behind you." Thus they proceeded gaily until West's friend boasted he was going to be a tailor.

"Surely," the infant artist cried, "you will never follow that trade!" and he held forth on its feminine character until his companion asked in irritation what he intended to be. West sat up straighter as the Pennsylvania scenery jogged by. "A painter," he replied.

His companion was not impressed. "A painter? What sort of a trade is a painter? I never heard of such a thing."

"A painter is a companion of kings and emperors."

"Surely you are mad, for there are no such people in America."

"Aye, but there are plenty in other parts of the world. And do you really intend to be a tailor?"

"Indeed I do. There is nothing surer."

"Then," cried West, "you may ride alone! I will not ride with one willing to be a tailor."

In his old age, after kings and emperors had been his friends, West used to tell this story with great glee. He even instructed his pupil Thomas Sully how to find the spot in the road where he had jumped off the horse, full of the glory of his destiny.

In his twelfth year West sold several canvases to local gentlemen; by the time he was eighteen, he was doing a flourishing business in portraits of his neighbours, and had won so widespread a reputation that he was called to Lancaster, two days' ride from home. His portraits are what we today call "American Primitive" or "Folk Art." Piously ignorant of the female figure, he made the torsos of his women look like flaring pipes of cast iron. But the faces of the ladies can be very pretty, and his canvases always have vitality and imagination. Although his means were simple, his compositions are usually ambitious. Even the portrait of the smallest child is embellished with a column and swirling draperies, while he was so impressed with the medieval castles Williams painted that he sprinkled them in his backgrounds. These anachronisms are given charm by the mountainous romantic scenery, unlike anything in Pennsylvania, he often imagined for their settings, and by the fact that he had no idea what castles look like. One writhes into the air like a handful of windowed snakes; another resembles a serrated pie. West's landscapes, in which he was not tied down by the struggle for a likeness, show more sweep and gaiety than his portraits. Some of his quaint country scenes, with castles serving as

backgrounds for commonplace Pennsylvania cows, with cock-hatted figures fishing happily in the middle of waterfalls, show an audacity and a power that boded well for the future.

When West did a portrait of William Henry, the rich gunsmith and inventor in Lancaster, Henry asked him why he wasted his time on portraits, rather than painting truly sublime subjects such as the death of Socrates. West said that sounded like a nice subject, but who was Socrates? After Henry read him the story from Rollin's *Ancient History,* West set right to work, painting antique togas as self-confidently as he had painted medieval castles. He used the frontispiece of the history as a model, but moved the figures around to suit the needs of a much more heavily populated paint-ing. We see Socrates calmly taking the hemlock, with his mourning followers grouped on his right, and the stolid, bestial, military murderers on his left. Conceiving that the slave who had just handed Socrates the deadly bowl should be half-naked, West did not—as most beginners would have done—copy an engraving of the bare figure, but did his best to draw the semi-nude from life. Although he could not possibly have had any knowledge of Gothic painting, the resulting torso has definite resemblances to primitive Italian forms.

It would be too much to expect that this endlessly ambitious picture by a self-taught provincial lad of eighteen would turn out as a consistent æsthetic whole. Yet it has very moving passages. There is real relaxation in the figure of Socrates and real passion in the faces of some of the mourners. Most strangely, West's canvas presaged the kind of crowded neo-classical composition which he painted after meeting in Italy the most advanced European art critics, and on which his first world-wide fame was based. In western Pennsylvania, West glimpsed somehow a coming move-ment in European art.

This picture attracted the attention of the Reverend Dr. William Smith, provost of the College of Philadelphia, who offered the youthful genius free instruction in the classics if he would come

WEST: DEATH OF SOCRATES

WEST: MRS. GEORGE ROSS

to Philadelphia. Soon West found himself in the centre of that
Colonial flowering which might well be called the Quaker renais-
sance. The rest of the continent was harried by ministers who
interfered in public affairs to further their particular brands
of doctrine, but the Friends, lacking a paid ministry, believed in
tolerance; during the early part of the eighteenth century, Phila-
delphia harboured the only avowed Catholic church in the Col-
onies, and permitted a theatre although the Quakers disapproved
of plays. Through the bars thus let down a deist—to contemporary
eyes almost a heathen—marched to intellectual leadership; Ben-
jamin Franklin was able to found the first liberal university on a
continent that boasted nothing but sectarian institutions for the
education of ministers. Emphasizing social economy, English lit-
erature, and modern history, the College of Philadelphia was more
progressive than Oxford or Cambridge, the most progressive uni-
versity in the English-speaking world.

The private pupil of the provost of this college, West became
intimate with a group of artistic young men. His special friends
were Francis Hopkinson, the poet and composer who designed the
American flag; Jacob Duché, who was to be chaplain of the Con-
tinental Congress before he deserted to the British; Joseph Reed,
Washington's favourite aide, who was to be president of the Su-
preme Executive Council of Pennsylvania during the darkest years
of the revolution; and Thomas Godfrey, the watchmaker's appren-
tice whose "elegant genius for pathetic poetry" led him to become
America's first playwright. In a continent where religion and poli-
tics were the only respectable subjects of conversation, West and
his friends strolled on the banks of the Schuylkill reciting verses.
West often longed as an old man to return to a certain clump of
pines where he used to angle while Godfrey lay on the bank com-
posing elegies. The poet read out the verses as they were written,
and the fishes West pulled out of the water beat time with their
tails.

During an illness that removed him temporarily from such de-

lights, West lay in a darkened room with no other light than what filtered through the shutters; he was suddenly horrified to see the apparition of a white cow walk stolidly across the ceiling. Afraid that fever had affected his mind, he called the family with whom he was staying. At that very moment, he explained, a drove of pigs was stampeding over his head. His friends, who could see nothing with eyes unaccustomed to the darkness, sent post haste for the doctor, but before he arrived West was watching hens peck at the cobblestones of a street. Although medical art could find no symptoms of fever, the physician gave West some pills and walked off shaking his head. Finally the painter determined to get up and investigate the matter. He found that when he covered a knothole in one of the shutters with his hand, the visionary images vanished. Employing the principle thus discovered, West made a camera obscura, and only when he showed it to Williams did he learn that the instrument had already been invented. This was the story West told Galt as a very old man, but fifteen years before he had told a friend a simpler tale. He said that when he asked Williams how he managed to draw cows so accurately, Williams showed him a camera.

Discovering that West was not well enough prepared to follow the regular courses at the college, Dr. Smith devised a special course for him, in which no emphasis was placed on fundamentals, but his attention was called to the stories of antiquity that would make nice paintings. "At no time in his life," wrote a contemporary English chronicler, "had he any claim to be called an educated man. He was the first and last president of our academy who found spelling a difficulty." Even West's wife was to admit that he had been so occupied with art in his youth "that every other part of his education was neglected."

However, West's talent as a painter and his romantic story served to keep him a leader among the young men of the Quaker renaissance; he did a rushing business in portraits, getting two and a half

guineas for a head and five for a half-length. Probably the first published notice of his work was a poem entitled "Upon Seeing the Portrait of Miss —— by Mr. West" which appeared in the *American Magazine* for February 1758. The editor, who was no other than Dr. Smith, comments: "The lady who sat, the painter who guided the pencil, and the poet who so well described the whole, are all natives of this place and very young. We are glad to make known to the world that name of so extraordinary a genius as Mr. West. . . . Without the assistance of any master [he] has acquired such a delicacy and correctness of expression in his paintings, joined with such a laudable thirst for improvement, that we are persuaded . . . he will become truly eminent in his profession." The poet, who signs himself "Lovelace," describes West's canvas in verse reminiscent of Gray's *Elegy,* which had appeared only seven years before:

> "The enlivened tints in due proportion rise,
> Her polished cheeks in deep vermilion glow;
> The shining moisture swells into her eyes,
> And from such lips nectareous sweets must flow.
>
> "The easy attitude, the graceful dress,
> The *soft expression* of the *perfect whole,*
> Both Guido's judgment and his skill confess,
> Informing canvas with a living soul."

A poem by Francis Hopkinson published the same year calls West "sacred genius," and shows that he was a disciple of John Wollaston, the itinerant artist who, according to Charles Willson Peale, "had some instruction from a noted drapery painter in London." In society portraiture it was the duty of the drapery painter, after the master had finished the head, neck, and hands, to add the clothed body, that construction of jewels and satins and laces which would endow the picture with an air of wealth and gran-

deur. When Wollaston applied such transatlantic glamour to por-
traits of the provincial leaders of Colonial society, they were
delighted to see their effigies glitter as they themselves never had
in life. However, Wollaston was not very good at faces. His trick
of giving all his sitters oriental eyes slanting toward the tips of
their noses has won him the name of "the almond-eyed artist."

West was for a time so under his influence that it is difficult to
tell their pictures apart; Wollaston's characteristic slanty eyes ap-
pear in several of West's portraits, and in one case at least he copied
almost literally a composition used by his elder. However, as Wil-
liam Sawitzky, that outstanding expert on early American art,
points out, West's originality of approach separated even his most
imitative canvases from their prototypes. He painted flesh with a
soft smoothness that none of his Philadelphia contemporaries could
rival, and had a subtle sense of reflected colour; he made the lace
on a blue costume a light blue, not a dead white as Wollaston did.
Indeed, a predilection for blue is one of the distinguishing charac-
teristics of his American work.

West had always made minimal use of the stiff mannerisms and
formal poses that had been brought to Philadelphia by inferior
foreign craftsmen during the previous century and had been
eagerly imitated by the native-born painters. The portraits he exe-
cuted during his twentieth and twenty-first years are even more
spirited and original, obviously the work not of an old hack re-
peating a formalism he had inherited but of a talented young man
at the beginning of his career. His likeness of Thomas Mifflin, for
instance, shows a broadness of conception and a sincerity of feeling
that place it far in advance of the output of his contemporaries.

The brilliant young painter seemed to have been endowed by
nature with every requisite of success; he was even very handsome.
Five feet eight inches tall and athletically built, he had strong,
harmonious features and light brown hair that shone over a re-
markable pink and white complexion. He moved quickly and his

eyes sparkled with an illusive vitality. All who met him were im-
pressed by the contrast between the alertness of his look and his
sedate remarks, which seemed more suitable to a Quaker preacher
than to so radiant a young man. The quick repartee you expected
never came, nor the sudden flash of emotion. West had great con-
trol over his temper, and on the rare occasions when it was aroused,
he said nothing, working his clenched lips as if to hold in the fury.
That his thoughts were methodical rather than brilliant pleased
his neighbours, who would not have tolerated a genius of the By-
ronic stamp; moral in all his actions, never given to excess, he was
the perfect type of Quaker youth inspired by God. Undoubtedly
this was largely responsible for his amazing success in a proscribed
profession.

The ladies of Philadelphia found him very charming, but in the
eyes of their parents his romantic story did not make up for the
poverty of his family or the dubiousness of his calling. The first
object of his affection was a Miss Steele. "We were very much in
love with one another, sir," West told a friend, "and the old lady,
her mother—whose memory I honour—didn't like my intended pro-
fession." Afraid the couple would elope, Mrs. Steele kept them
apart. West painted a miniature of himself for his lady, but as soon
as he had smuggled it in to her, he fell in love with Miss Elizabeth
Shewell. But she also was forbidden to see him.

West was too interested in his painting really to mind; his im-
agination had been greatly excited by a representation of St. Ig-
natius—later he was to discover it was from the school of Murillo—
which had been captured in a prize ship during the war with Spain.
Suddenly conscious of the inadequacy of his own work, he de-
termined to go abroad where he could see more such masterpieces.
But his father, whose inns seem never to have been successful,
could give him no money, and in those days only the richest could
afford to sail for three months across the ocean.

Undaunted, West began to save. He journeyed to New York in

search of higher fees, and stayed eleven months, painting anything he could get paid for, including signs; one showing a bull's head was imported to England sixty years later by a reverent admirer. The boy was unhappy in the strange city, for he found no Francis Hopkinson to recite poetry to him, no Dr. Smith to tell him exciting fables out of antiquity. Missing the Quaker renaissance, he denounced New York's "disposition to estimate the value of things not by their utility or their beauty, but by the price they would bring in the market." One bright spot, however, was a Flemish painting of a lamplit hermit that inspired him to depict a man reading by candlelight. He had great difficulty posing a model and yet having light enough on his canvas to paint by, but finally solved the problem by making his landlord sit in a closet surrounded with candles, while he peeked through a crack in the door.

West's savings increased with agonizing slowness, yet the spirit of the times was working in his favour. He had reached young manhood during the period of Colonial self-assertion that was leading irrevocably to the revolution. The settlers, once content in their fringe of civilization to import all but their most basic needs from England, had gradually built up an economic system which showed possibilities of being self-sufficient. A growing realization of the resources of their continent, from which the French were at that moment being driven, filled them with a desire to build a culture and a civilization of their own. The eagle began to scream, but his screaming was necessarily defensive, for he was forced to boast about the future and ignore the present. Men all over the continent took inventory of their resources, eager to find an excuse for self-adulation, and the men of Philadelphia and New York did not have to look hard to discover that they boasted a youthful painter who might, if properly encouraged, prove a genius.

When John Allen, a Philadelphia merchant who was later chief justice of his State, arranged to send a cargo of grain to Leghorn, Italy, he offered West free passage. Hearing of this, a rich New

Yorker, John Kelly, gave the painter an order for fifty guineas. West rushed back to Philadelphia and proposed to Miss Shewell. She accepted but, according to a story often told by Bishop William White, her brother intervened. Insisting that West was "a pauper" and "an object of charity" who had begged alms for his trip abroad, he locked his sister in her room until West's boat had sailed. The painter's spirits fell hardly at all. Elizabeth had promised to wait, and in any case he, the son of a poor innkeeper, was setting out almost unbelievably to the centre of art, to a larger stage, where there was no telling what part his destiny would call on him to play. Perhaps as his boat slipped down the Delaware late in 1759, West remembered his childhood ambition to be a companion of kings and emperors. He would have the chance now.

III

In his later years, West loved to describe his sensations as he looked for the first time on the city of Rome. He had walked ahead by himself while his companions were resting their horses, and suddenly had found himself on a height from which he saw the sun, freshly risen, cast the calm and clear radiance of new day over a wide valley bounded by green hills. Fertile land it was, terraced, cultivated to the last acre as no land he had ever seen in America; and in the middle of the spacious view was a wilderness of ruins over which towered a huge dome that could only be St. Peter's. A broken column serving as a milestone at his feet said he was eight thousand paces from the ancient mistress of the world, while a sluggish boor clad in rough goatskins, who was driving his flock to pasture through the ruins of a near-by temple, reminded him how far the city had fallen. Standing upright in the dawn, he had meditated, as was proper for an eighteenth-century gentleman— or so he told his London friends—on fallen greatness and the mutability of worldly things.

Who knows what the Colonial youngster really thought now that he had reached the ending of his fabulous quest? What did Jason think when he hefted the golden fleece, or Perseus when Medusa's head hung limply from his hand? Ever since he had worn swaddling clothes, West had been trained to believe that all beauty and all knowledge came from across the ocean. Ever since a gunsmith in the hamlet of Lancaster, Pennsylvania, had evoked the magic name of Socrates, West had been certain that the classic cities were the æsthetic centres of the universe. Humbly he advanced, eager to gaze on the painting and sculpture he believed would for ever after be his models.

However, when West saw the pictures of the old masters for the first time, he was terribly disappointed; the complexity of their techniques puzzled him and he found their subject matter shocking. For the naïve émigré from a Protestant coast had been taught to despise the legends of saints and miracles with which the Quakers insisted that the Catholics had polluted the Gospel; he was horrified by pictures of saints skewered with arrows or martyrs roasting over slow fires. Since Virgin worship had also been denounced by his elders, he was disgusted to see Christ rarely represented except as a helpless child in the Virgin's arms. "Mr. West," his son wrote many years later, "observing the degraded state of painting in Italy and France, and its employment to inflame bigotry, darken superstition, and stimulate the baser passions of our nature, resolved to struggle for a recovery of its true dignity, of its moral and pious uses."

When West stepped dizzily out of the Vatican galleries in an effort to regain his composure, he found himself faced with a new horror. The steps of St. Peter's were crawling with beggars, half naked and filthy, sick and whining, exhibiting horrible deformities. West had rarely seen a beggar in America, for the ailing were kept off the streets and there was always new land for the destitute. He

was so horrified that, as he later remembered, his feet buckled beneath him and he almost fainted.

West's adventure with Cardinal Albani and the *Apollo Belvedere* had been bruited about the city, making him a curiosity that every rich Roman wanted to see. As soon as night fell, bands of new friends called at his lodgings and took him to houses whose grandeur was almost unbelievable to the lad from Pennsylvania. But under the noble tapestries in the huge gilded rooms moved men and women who, his Quaker conscience told him, were very wicked. Amorous intrigue bubbled like a vat of champagne all around him. Ladies smirked at him brazenly in dresses that showed charms always hidden in Philadelphia; dropping his eyes from such shining and evil whiteness, West gripped tighter the miniature of Elizabeth Shewell in his pocket. But the ladies followed him about none the less, and though he could not understand their words, their eyes and gestures spoke clearly; they were trying to lead him on, and some of them were married! Indeed, the noble savage from the wilderness provided a new sensation for the experienced Roman beauties; that he ran away only made the chase more exciting. They gathered round him in crowds and tapped his shrinking shoulders with their fans.

One evening an English painter named Gavin Hamilton took West to a famous coffee house. The instant the American stepped into the crowded room, every face turned to stare, for he was the sensation of the hour. An old man with a long beard, and a guitar slung over his shoulder, hurried up to his table. When Hamilton addressed the newcomer as "Homer," West was amazed, but it was explained to him that the stranger had won this name by being the most famous of the entertainers who made up verses in cafés. "Those who once heard his poetry," Galt wrote, "never ceased to lament that it was lost in the same moment, affirming that it was so regular and dignified as to equal the finest compositions of Tasso

and Ariosto." Hamilton suggested that Homer sing about West's pilgrimage from America to study painting. The minstrel immediately showed signs of inspiration; he bent his body from side to side until he had worked himself into perfect tune with his guitar, and then chanted of the darkness which had for many ages veiled America from the eyes of science. He described how "the seraph of knowledge" had inspired Columbus to discover the continent and now had descended again on this young man, who was specially ordained by Heaven to raise in America the golden banner of art. When Hamilton translated these words, West was deeply moved, for, so Galt tells us, this reiteration of the evangelist's prophecy seemed to him more than a coincidence. He rewarded Homer handsomely and left the café more than ever certain that he was a chosen instrument of destiny.

But despite his great mission, West was being overwhelmed by a rising tide of bewilderment; he no longer was sure about anything. How could he believe his eyes, which told him the old masters were not supremely great? How could all the connoisseurs who lectured him with such certainty, how could all the wisdom of the ages, be wrong? Sometimes even his distaste for Rome's dissolute society wavered. It was fun to be a lion; it was fun to swim in luxury even if you realized the splendour of your friends caused the shocking condition of the poor. There were moments when the ladies who angled for West with their expertly displayed charms seemed beautiful, and desirable too under their paint and patches, the like of which the Colonial had never seen. All the old standards that had carried him so far began to give way. He first became nervous, then overexcited, and finally so ill he could hide the fact no longer. The noble savage suffered a nervous breakdown.

However, he was still a celebrity. The rich men of Rome sent their favourite doctors to treat him, and when he was ordered to take a rest cure at Leghorn fine carriages accompanied him to the outskirts of town, making his retreat a triumphal progress. West

recuperated rapidly, for before his collapse he had met two men
who had shown him how to resolve the conflicts that were under-
mining his intellect. In the quiet of retirement he reflected on the
doctrines of Raphael Mengs and Johann Joachim Winckelmann,
finding comfort there.

Although now a fine gentleman, Winckelmann had come from
a simple background; his father had been a shoemaker in Stendal,
Prussia. As curator of Cardinal Albani's collection, he enjoyed
great prestige in Rome, and at the very moment of West's arrival
he was writing his *History of Ancient Art* which, by dealing with
the very problems that troubled West, did much to create the neo-
classical style that was to sweep Europe and become one of the most
widespread artistic movements of modern times.

For West's quandaries were not peculiar to himself but were
based on economic changes that were soon to cause two revolutions.
The growth of trade and the birth of manufactures had created a
new class, the bourgeoisie, who, as they fought with aristocratic
prerogative for power, reacted against the religion and the culture
of their foes. From low church chapels they denied the divine right
of the Pope along with the divine right of kings. In opposition to
the salons of the emperors, they preached the sanctity of the home
and stood up for simple virtues. It was better, they shouted, to be
good than to be fashionable; in fact, God would praise them for
casting down the immoral aristocrats.

Naturally they denounced the art of their rulers; men like Dide-
rot expressed horror of the voluptuous painting of men like
Boucher. Away, the French encyclopædist cried, with pictures that
tickled the jaded palates of royal mistresses! Away with Virgins who
were "pretty little gossips" and angels who were "satyrs and liber-
tines"! When he demanded a return to moral painting, all over
the western world a rising economic class applauded.

However, such criticisms, like West's first repugnance for the
art and manners of Rome, were largely negative; they told artists

what not to do but failed to substitute another inspiration. It remained for Winckelmann to crystallize a bourgeois style by turning painters back upon an exact study of the antique. His approach was inspired and made possible by the excavations of Pompeii and Herculaneum carried out during the twenty years before West reached Italy. Classical archæology was being born, and its findings, disseminated by engravings like those of Piranesi, filled imaginations all over Europe with accurate data on antiquity. These data, Winckelmann insisted, must form the basis of all future great art, and his voice was listened to gladly, since democrats everywhere liked to identify themselves with the heroes of republican Greece and Rome. The American orator shouting against King George in the glades of the pre-Adamite forest thought of himself as Brutus; it was Cato who whispered sedition in the Paris slums. Spartan virtue was practised with conscious pride on the banks of the Delaware and the banks of the Seine.

Insisting that painters must represent the universal not the casual, Winckelmann argued against drawing from living human bodies that had been corrupted by the rule of the aristocracy; artists should reproduce antique statues exactly, since the Greeks had been ideal men uncorrupted by evil governments. In his reaction to the voluptuous courtly painters, he said that painting should imitate the virtues of sculpture and discard what had been usually considered its own virtues. "Colouring, light, and shadow do not give such value to a painting as noble contour alone," he wrote, but rather impeded the "noble simplicity and quiet grandeur" he considered beauty. Worthy subjects, he continued, were to be found primarily in the heroic legends of antiquity which illustrated moral qualities so aptly; it was necessary to "make every picture a school of virtue."

Winckelmann's most important early disciple was Raphael Mengs, the painter to whom West referred in his letters home as "my favourite master." Mengs was only ten years older than the

American and their early histories had been amazingly alike. Also from a provincial background, Mengs had at twelve been a professional artist in his native Bohemia, and at nineteen so famous that he was appointed court painter to the King of Poland. He had arrived in Rome during his early twenties even as West had done, and had immediately won a great reputation. He was already famous when, becoming intimate with Winckelmann, he took over many of the German philosopher's ideas.

However, Mengs never went the whole way into neo-classicism; he was a precursor rather than a member of the school whose greatest ornament was to be Jacques-Louis David. Although he obediently found his inspiration in the antique, depicting figures that were more like painted statues than real men, Mengs had for so long imitated the baroque painters that he still used his brush in their manner. As Muther writes, he broke with the taste of the rococo, but not with the technique.

Mengs had reached this point in his development when West, newly arrived in Rome, was brought to his studio. The master's request that he show what he could do by drawing an antique statue worried the noble savage, who realized that he had never learned to make a line drawing. However, he was sure he could paint; he did a portrait of Thomas Robinson instead. Although he told Galt that the resulting picture was mistaken for a Mengs by the connoisseurs, who were worried only because the veteran's colouring was usually not so good, this story must be an exaggeration, for Mengs's style had little resemblance to the crude realism West had brought with him from America. A few years after he left Italy, West gave Charles Willson Peale what was probably a more accurate account; the connoisseurs, he reported, had been unable to understand how he could paint when he was unable to draw. "He is an artist," they said, "that comes we do not know from where, and paints as we do not know how." In any case, the picture showed so much promise that Mengs took the young man into his studio.

Word of West's success, carried back to America, persuaded his patrons to continue advancing him money. "From all accounts," John Allen wrote to his Italian bankers in 1761, "he is likely to turn out a very extraordinary person in the painting way, and it is a pity such genius should be cramped for want of a little cash." He told them to pay West a hundred pounds, and a year later added another hundred and fifty.

Before West's nervous breakdown intervened, Mengs had begun to teach him to appreciate the virtues of the old masters by showing him how the technical brilliance to be learned from their canvases could be used for the moral ends of the bourgeois reaction to which West's American background had already predisposed him. Indeed, West had years before painted the *Death of Socrates,* beginning in the wilderness to move in the newest direction of European art.

Banished to Leghorn by his illness, West was so eager to return to Mengs's studio that he did not give himself time to recuperate fully; after a month or so he hurried back to Rome, only to be taken ill again and sent again to Leghorn. When at last West regained his health, Mengs started him on an intensive study of the old masters; the Bohemian painter was an eclectic who believed that the perfect style could be achieved only by combining the styles of the great painters of the past; he had little use for original inspiration. Under his tutelage, West copied paintings by Rembrandt, the Caraccis, Titian, Correggio, Guido Reni, Raphael, and Mengs himself, travelling to Florence, Bologna, and Venice.

After he had completed his copies and returned to Rome, West was finally allowed to combine the techniques he had studied into compositions of his own. Keeping in mind exactly what the old masters would have done, he painted two scenes from literature: *Cimon and Iphigenia* and *Angelica and Medoro.* It is clear from the latter picture, which illustrated a sentimental passage from Ariosto, that West was for the moment much more under the influence of Mengs than of Winckelmann. A childlike shepherd sits

WEST: THOMAS MIFFLIN

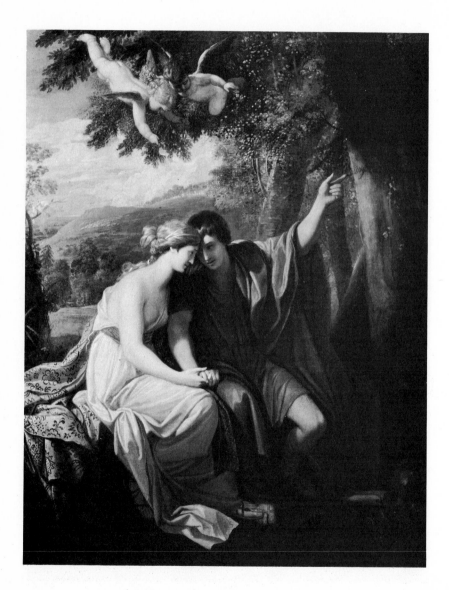

WEST: ANGELICA AND MEDORO

in an idyllic landscape surrounded with lambs and kids and under cupids dropping flowers. His head touching the head of a tender female also childlike and pure, he points at a tree in whose trunk both the lovers' names are carved. This allegory of innocent love is largely in the baroque tradition, the semi-nude young lady in particular being quite lushly painted, but the sculpturesque outlines of the figures seem to point to the purely neo-classic art West was soon to execute, when at last he fell more under the influence of Winckelmann than of Mengs.

Rounding a cupid's form, West had forgotten the forests of his homeland; dreaming of ancient legends, he despised the battle to subdue a continent. What if he had lost the originality which, although crude, had given his American paintings their freshness and power? The polite works he had combined from a dozen accepted sources created a sensation in Rome. He was called "the American Raphael."

During his third year abroad, a beautiful young girl appeared from Switzerland infused with the love of painting; soon she was sitting at West's feet in rapt admiration. According to an article in *La Belle Assemblée* for 1808, West gave Angelica Kauffmann her first lessons in "the principles of composition, the importance of outline, and likewise the proper combinations and mixtures of colours." Peale tells us that the fresh and lovely girl, with whom Reynolds was later so much in love that after she refused him he remained for ever a bachelor, was supposed to have wanted to marry West. The moral American, however, was faithful to his Philadelphia fiancée.

When after three years in Rome West found himself universally regarded as a great painter, he decided his education was complete; he prepared to return to Pennsylvania. His father, however, suggested that he make use of the recent peace between France and Britain to take a hurried trip "home" to England. On his way north, he stopped off at Parma and copied Correggio's *St. Jerome.*

Having already learned the publicity value of being a Quaker, when presented to the Grand Duke he kept his hat on, to the great delight of that monarch, who had heard that Quakers did such things. He was promptly elected a member of the Academy of Parma, as he already had been of the Academies of Florence and Bologna.

Paris did not interest him enough to keep him long; he was disgusted by men like Boucher how, he insisted, "humiliated" painting "to stimulate the lascivious passions." But England was his own homeland; there were few Americans, however extreme their patriotism, who would consider returning to the wilderness if they could make a career for themselves in the mother country. Riding on the top of the Canterbury coach down tight-hedged English post-roads, the handsome Colonial meditated on the destiny that had led him so far. Although only twenty-five, he had for ten years been considered a genius, both in savage America and in cultured Italy. A great exultation swept through him to the tune of the horses' hoofs; perhaps it was his destiny to conquer London as well. But when houses began to close around the Canterbury coach, a sudden terror plucked at his nerves. He alighted precipitately at the Shooter's Hill Tavern, a mean ordinary two miles from the centre of town. Finding his way into the stale and musty taproom, he ordered dinner. There, he was to tell his friends, he sat trembling for a long time "before I entered the metropolis to seek my fortune."

IV

The London West entered in August 1763 was on the verge of the artistic movement that was, according to Roger Fry, to contain "almost all the painting which creates the spiritual value and importance of the British school." English art had for centuries been quiescent. During the Protestant reaction that extended from

Henry VIII to Cromwell, political policy had urged the razing of the "Popish idols" which awed the peasantry by their pretended miraculous powers, and sanction for such vandalism was found in the Biblical prohibition of "graven images." A single entry in the records of a "visitor" appointed by Parliament to demolish "the superstitious pictures and ornaments of churches" read: "Clare. We break down 1000 pictures superstitious." Thus England was harried until it was as devoid of pictorial art as Ireland of snakes.

The only demand for painting that remained, the desire for portraits of members of the court, was met for the next two hundred years by the importation of foreign masters. Holbein, Van Dyck, Lely, Kneller came in rapid succession and stayed long. Since the portrait market was limited to a small, highly compact group of aristocrats, swept by the same fashions and all eager to sit for the same great names, the native-born artists were unable to obtain commissions while the famous foreigners, having more business than they could execute single-handed, organized portrait factories. Kneller, for instance, painted the heads of fourteen sitters a day, and then turned the unfinished canvases over to a squad of German specialists; one added the hands, another the drapery, another the lace.

The progression of these foreign masters was downward. Van Dyck created and practiced with great effect an elaborate, often spacious, portrait style that swept the courts of Europe, exerting a lasting influence. Lely was more limited and more sensuous, at best in darkly glowing effigies of sulphurous, high-born women, sometimes shown with one breast bare. Kneller had a knack for delineating decorative, sensitive heads. His death in 1753 had left England without a foreign artist capable of monopolizing the business, but also without a vital tradition on which the native artists could build. Hudson and Highmoor, the two leading portraitists of the next generation, extrapolated from Kneller's work empty formalism, using stock compositions and poses. Every lady had a grace-

fully elongated hand. The richer tradition of Van Dyck was almost forgotten.

However, it became the fashion for every English gentleman, when he made the grand tour of Europe, to bring back old masters; the profession of art dealer became profitable, and England was flooded with dark, musty canvases that could be ascribed to the flamboyant names of the past. As yet this wider interest in painting helped the native artists not at all, for their actual inferiority convinced the connoisseurs that no Englishman could paint, while two German-born kings encouraged the court to despise English culture.

Hogarth, the first British painter of importance, was born in 1697; his whole life was an unsuccessful struggle to paint English life sincerely and yet be admired. Since the dilettanti, their eyes glued on old masters, were certain that if one of their compatriots managed by a miracle to paint well, his work would look like an Italian masterpiece, Hogarth's exact representations of the citizens of London were regarded as vulgar, nothing more. The great artist had to support himself by making prints for the common people, which were very successful, but the gentlemen laughed at the idea of buying the oil paintings from which they were made.

Before 1760 there was no place in England where a painter might publicly show his work. When the growing body of English artists had attempted to form a society that would sponsor exhibitions, they found that the connoisseurs would not co-operate with inferior persons like painters unless they themselves were given complete control of the exhibitions; the plan was abandoned. Three years before West's arrival, however, the artists had found the courage to ignore the connoisseurs and set out on their own. The first show of the Society of Artists was a greater success than anyone had dreamed possible, and the amazing discovery was made that most Londoners were not, like the connoisseurs, indifferent to native art.

When West left the Shooter's Hill Tavern after his solitary meal and walked into London, England had almost gained the self-confidence to recognize ability among its own painters. Three years before, George II had died and had been succeeded by the first English-born king in almost fifty years, whose accession had coincided with a victory over France. Hogarth still had a year to live, and his insistence upon a return to reality had laid the foundation for a school that was already beginning to flourish. Wilson, the father of English landscape painting, was forty-nine, and Reynolds, at forty, was recognized as the leading portraitist, although he was being pressed for the honour by Gainsborough, a man of thirty-six. At twenty-nine, Romney was exhibiting regularly, building up to a reputation that was soon to come.

Thus was the stage set when the twenty-five-year-old American strolled in from the wings. He found greater opportunity for a painter than had ever existed in England, but also greater competition. The sky was the limit, but it was the high sky of late spring, a difficult sky to reach.

West started out modestly as a student. He studied drawing at the St. Martin's Lane Academy, and viewed the principal English collections. As good fortune would have it, three of his American patrons—Chief Justice Allen, Governor Hamilton, and Dr. Smith—were in London and they spread word of his triumph in Italy. He met Reynolds, Romney, and Gainsborough, and for a time frequented Dr. Johnson's club. When he showed Wilson the classical compositions he had executed in Rome, the landscape painter could not believe that so young and uneducated a Colonial had done such fine work. "If you painted those pictures," Wilson said, "remain in England. Stay here. If not, get away to America as fast as you can."

Thus West was introduced at once into the artistic world, but painters and writers do not buy pictures; if he were to stay in England, he must get commissions. He did an occasional portrait,

although portrait painting bored him, and for the rest sat idle in his studio. However, he had learned on the broad reaches of the Schuylkill to be an expert ice skater; when the weather grew cold, he left his empty studio and found his way to the basin in Kensington Gardens. Soon he was weaving at a breakneck pace among the staid English gentlemen. "West! West! Benjamin West!" a voice called. Stopping with a graceful curve, West turned to see Colonel William Howe lumbering after him. The soldier who was to command the British army during the revolution explained that when he had told his friends of the brilliant skating he had seen during a trip to America, he had been accused of lying. He begged the young man to give an exhibition, and West's rendering of "The Salute" in the best Philadelphia style was so admired that the next day the banks of the basin were crowded with sports-loving aristocracy who had come to see. They rushed to be introduced to a man who could cut such fine capers. When they discovered he was a painter as well, they went to see his pictures and came away entranced, for their classical preconceptions made them admire the pure forms West had borrowed from antique low reliefs, tempered, as they were, by nobleness learned from Raphael and lushness learned from Correggio, two painters every Briton who aspired to taste was required to admire. Fashionable London flocked to West's studio, and his servant received thirty pounds for showing his work, but the painter remained penniless, since no one offered to buy a canvas. According to the *Percy Anecdotes,* a gentleman who praised West's pictures was asked why he did not buy one. He threw up his hands. "What could I do if I had it? You surely would not have me hang up a modern English picture in my house, unless it was a portrait."

At the urging of Reynolds and Wilson, West sent the two classical compositions he had painted in Italy to the Society of Artists exhibition of 1764. Although all the leading British artists were represented, West's pictures received the most ·praise from spec-

tators and newspaper critics alike. He decided to settle in England rather than return to his primitive homeland.

When he sent to Philadelphia for his fiancée, her brother was furious; still determined that no painter should marry into his family, he locked Elizabeth Shewell into her room. But William White, who was to be the first Episcopal bishop of Pennsylvania, and Francis Hopkinson—two of the brightest young spirits of the Quaker renaissance—determined that "Ben should have his wife." They consulted the Nestor of their group, the ageing Franklin, who assisted them in bribing Elizabeth's maid to smuggle her mistress a rope ladder under her dress. An accompanying note said that they had arranged for the ship on which she was supposed to sail to weigh anchor during the afternoon and disappear from the harbour. Feeling that Elizabeth was safe until the next ship, her brother would relax his vigilance, but the boat would wait sixteen miles down the river. At eleven p.m., the lady was to drop the ladder out of her window and climb down.

When she did so, she found the three conspirators below to catch her and sweep her into a coach. Instantly they galloped off, two of the gentlemen inside to comfort Miss Shewell—we can hear the wise saws that Benjamin Franklin uttered—and one on the box to watch for pursuers. The roads were so bad that they did not reach the ship until daybreak, but still there was no sound of hoofs behind. The lady was put off in a rowboat, the oars churned up red hues of dawn, and then, while the philosopher, the poet, and the future bishop anxiously scanned the road, square sails caught the breeze.

This is the story Bishop White often told in his old age, and the letters of Francis Hopkinson contain some hints that point in the same direction. The churchman delighted in the memory of his one slightly scandalous adventure. "Ben deserved a good wife!" he would cry to his incredulous friends. "And old as I am, I am ready to do it again to serve such worthy people." Stephen Shewell,

he added, never forgave his sister, and for the rest of his life refused all communication with her.

The whole story of the elopement was, however, denied by Matthew Pratt, the young American painter who with West's own father accompanied Miss Shewell across the ocean. Pratt, the first of the many Colonials who studied in West's studio, insisted that the marriage had the approval of the bride's relatives. But his gratitude to West may have induced him to deny a truth that his master, who liked to be considered the most respectable of men, would not have wanted whispered around London. Whose word shall we take, the Bishop's or the painter's?

However romantic its beginning, West's marriage was not an affair of overwhelming emotion; the young couple took Pratt and old Mr. West along with them on their honeymoon. Cunningham, a contemporary chronicler, says of the painter: "As he was a man without passions, and somewhat cold and considerate, he made, perhaps, an indifferent figure as a lover; his wife, however, was kind and obedient, and their fireside had repose and peace." After forty years of married life, Mrs. West told Joseph Farington, the painter whose diary is the most important authority concerning West's English career, that she had never seen her husband intoxicated or in a passion. "Ah," she once exclaimed to her husband's pupil Washington Allston, "he was a good man! He never had a vice."

Mrs. West was not a beauty, for her grey-green eyes and uptilted nose were set in a soft face that lacked chin. As the years passed, she grew heavy. An omnivorous reader, she amused herself by writing verse. "When," the *Analectic Magazine* tells us, "she indulged her poetic fancy by delineating living characters, it was to cherish virtue or gently admonish, but never to wound the feelings of her friends for the sake of displaying wit." There was comfort in her look rather than excitement; she must have been more a mother than a mistress, and her account books show her to have been an

WEST: RALPH IZARD AND HIS FRIENDS

WEST: AGRIPPINA WITH THE ASHES OF GERMANICUS

efficient and meticulous housekeeper. She had only two children, both sons. Benjamin Franklin was godfather to the second.

During his first years of married life, West received enough portrait commissions to keep him going, but he regarded portraiture as mere hackwork; he wanted to paint the stories of antiquity in a manner that would teach virtue. In order to find a market for such compositions, he had to override a prejudice that had lasted for centuries, yet he soon found patrons; his moral art was taken up by the high prelates of the Church of England. Robert Hay Drummond, the Archbishop of York, commissioned him to paint *Agrippina with the Ashes of Germanicus*. After the Bishop's son had read the passage from Tacitus aloud, the painter and the prelate discussed how such a noble story of connubial love could best be placed on canvas. West rushed home, made a sketch containing almost a hundred figures, and had it back at the Bishop's before he got up the next morning.

Impressed with the sketch and the celerity, Drummond tried to organize a subscription of three thousand guineas to enable West to devote all his time to painting "history." Although the scheme had to be abandoned because the sum could not be raised, that fifteen hundred guineas were actually subscribed gives some idea of the reputation of the young painter. In 1766 Reynolds complained: "The great crowd of the year is about Mr. West's pictures: *The Continence of Scipio, Pylades and Orestes, Cimon and Iphigenia, Diana and Endymion,* and *Ladies at Play."* A contemporary rhymester described how when he arrived at the Society of Artists exhibition:

> "Sly malice plucked my sleeve and did assure
> That all above was modern, mean, and poor,
> But *West* and Genius met me at the door;
> Virgilian West, who hides his happy art
> And steals, through nature's inlets, to the heart

Pathetic, simple, pure in every part. . . .
Thou long expected, wished-for stranger, hail!
In Britain's bosom make thy loved abode
And open daily to her rapturous eye
The mystic wonders of thy Raphael's school."

In less than three years West had become a popular idol, regarded by many as the probable founder of a British school that would rival the Italian Renaissance. Nor was the new Raphael's skill as a skater allowed to be forgotten. A newspaper paragrapher wrote: "There never was a more brilliant exhibition than Hyde Park afforded on Sunday; Ministers, Lords, Commons, all on the ice. Of the Commons, Mr. West, the celebrated painter, and Dr. Hewitt were the best. They danced a minuet on their skates, to the admiration of the spectators."

Since his departure from Italy, West's classical paintings had evolved along the lines set down by Winckelmann, in the direction of greater fidelity to Græco-Roman models. It is a strange fact that the American, who had never heard of Socrates until he was eighteen and whose knowledge of the classics was superficial to say the least, now became an important innovator in the learned and antiquarian-inspired neo-classical movement. As we have seen, Mengs, despite the importunities of Winckelmann, had never succeeded in discarding the baroque elements he had learned from the late Italians; this West now largely did in his classical compositions, although he also upon occasion painted baroque pictures. According to that leading student of neo-classicism, Jean Loquin, West's canvases of this period were many years in advance of the French school that was to carry the style to its greatest height. Eleven years before Renous, West painted *Agrippina with the Ashes of Germanicus,* and six years before Lépicié, *Regulus Leaving Rome;* since the large engravings made from West's canvases were very popular on the Continent, his work may easily have in-

spired the French painters. In the same year West and the young David painted *Erasistratus Discovering the Love of Antiochus for Stratonice,* and there can be no doubt that West's canvas was the more developed and mature.

The English neo-classical painters whom West led proved their superiority to their French contemporaries, Loquin writes, "by the general conception of the works, by the disposition of the figures as on a classic low relief, by the clear and calm arrangement of the groups and cortèges, by the grave rhythm of movements and draperies, by the effort toward exact reproduction of the furniture and the costumes of the Greeks and Romans, by the evocation of forms from antique statuary, by the laconic energy of expression of which Poussin had discovered the secret." Since neo-classicism grew to be largely a French movement, it is perhaps natural that Loquin should have more admiration for West's canvases than have modern English and American critics.

One day when West was painting with quiet efficiency in his studio, his servant announced that there was a lady downstairs who would not give her name. No, she was not a beggar; she was expensively dressed. The painter went down and was greeted with a coy smile and the statement that he was a very lucky man; he was to have an audience with the King. Then the lady curtsied and withdrew; West never found out who she was.

She had been eavesdropping at court. In his desire to find patronage for West's moral painting, Archbishop Drummond had held forth to George III on the American's rendering of *Agrippina with the Ashes of Germanicus;* it was a masterpiece, he said. Trying to approach the monarch on his most sensitive side, the royal love for the royal children, Drummond explained that he had ordered the painting in order to interest his own sons in furthering the fine arts. Did not His Majesty agree that collecting was a noble activity for the children of the great, since support of a great artist brought honour to the patron down all the ages through which the

artist's work was admired? The King was moved by his archbishop's words; he agreed to send for the painter and the picture.

At the appointed time, the Colonial who had boasted he would be the companion of kings and emperors sat trembling in the anteroom of the Queen's palace, his picture across his knee. The door opened and the King appeared. He was a young man of West's age, and his face contained a similar illusory sprightliness backed by a similar basic gravity. He stared earnestly at West's picture and then asked if it was in a good light. On being told that it was not, he led West through several state chambers and picked a better place with his own royal eye. He called for servants, who came running, but himself helped move the picture. He stared for a long time, then turned and went out. West stood there chagrined, but in a moment the King was back, leading the Queen. The ugly and stiff German girl listened gravely while her royal husband told West's story, how he had come from the wilderness of their Colonies, how he had created a sensation at Rome, and particularly how he had made the sketch for this elaborate painting in one night. Then they both stared at the canvas.

Finally the monarch said that he understood the subject had seldom been treated properly. Agreeing, West expressed his amazement that Poussin had never painted it, for he would have done it justice. George thought for a minute. "There is another noble subject which corresponds to this one," West remembers the King said at last, "and I believe it also has never been well painted; I mean the departure of Regulus from Rome. Don't you think it would make a fine picture?" West replied it was a magnificent subject. "Then," cried His Majesty with great animation and joviality, "you shall paint it for me!" After a servant had brought him a text, he remarked to the Queen, with evident pleasure at his condescension, that Archbishop Drummond had ordered his son to read the story of Agrippina to West, "but *I* will read to him myself the subject of my picture." After they had listened to the

passage which described Regulus's courage and patriotism in sur-
rendering himself to the cruel Carthaginians, West and the King
discussed how the moral fable should be represented, and their
ideas agreed very well. Soon their eyes were shining with the ex-
citement of a venture they both were sure would produce immortal
art.

Thus began the friendship that was to be one of the closest in
history between a monarch and a painter, a friendship based on
paradoxes typical of an age of extreme transition. Although edu-
cated in the Stuart doctrine of the divine right of kings, and the
last English monarch to attempt to rule through royal prerogative,
George was personally less like the aristocrats of his reign than the
bourgeoisie. The gay and elegant nobility looked with disapproval
on a king who left empty the stately show palaces of his predecessors
to live in a country home that might have belonged to a well-to-do
shopkeeper. They were shocked at the lack of vice and fashion in
the leader of society; they shuddered to think that his idea of a gay
evening was to walk on the terrace and play piquet. The slow-
witted but crafty monarch who followed with blundering stub-
bornness the command of his domineering mother, "George, be
king"; the tyrant who forced the American Colonies into rebellion,
was a sentimentalist who doted on his fifteen children and was as
fond of moralizing as a Quaker elder. Thus he was deeply moved
by the neo-classical art that was born of a revolt against the very
aristocratic powers he was trying to perpetuate. Not for him were
the highly coloured portraits of beautiful women done for his
pleasure-loving nobles by Reynolds and Gainsborough, whom he
rarely patronized; in common with his more simple subjects,
George preferred the visual sermonizing of the young American.

Never before in modern history had England boasted an artist
who was in advance of continental styles; here, George believed,
was a man worthy of a monarch's friendship. Kings, of all men in
the world, are most deprived of personal affection; perhaps that is

why so many have fought violently, even surrendered their crowns, to keep a woman's love. Unable to oppose his mother, George had been forced to give up the two women he had wanted; they were not royal. He had learned that friendship and love require equality, but that few are the equals of a king. When George came into a room, everyone stood at attention; if he expressed an opinion, it was a breach to contradict him; his children resented his presence, for it was a signal that all games must stop while the adults stood rigid. Queen Charlotte would not even let her sons sit down when she was there. Surrounded like Brünhilde with a ring of fire, a monarch must languish in loneliness till a hero come, strong enough to break through the ring. Of course, the fire could some-times be quenched by a royal word, but kings, like Victorian vir-gins, are trained to resist hysterically the very surrender they de-sire. Had an ordinary man ventured to be familiar, George would have banished him from court. A man must appear whom a king could without shame admit to equality. Such a man, as George had learned, could not be a statesman, lest he anger the nation or rob the monarch of power. But supposing he should be an artist, a great genius who ruled in a world of imagination where temporal power was forgotten?

George III had succeeded in establishing his dictatorship over Parliament, but ever since he had been forced to sacrifice his favour-ite minister it had been a lonely and arduous battle. What a relief, after wrangling with politicians and bribing country members, to hurry to the studio he soon gave West in the palace, where the painter stood working ever sedately on moral and immortal pic-tures. "The King," Leigh Hunt tells us, "would converse half a day at a time with him while he was painting." The two men dis-cussed ways of furthering art in the kingdom, or else they leaned together over a sheet of paper and planned some picture that was to survive till the end of time. West had little difficulty in bringing George around to his æsthetic opinions; the King, he confided to

Farington, "was ready in business and attentive to communication, but he wanted direction in deciding." Nor did West regard himself as the monarch's inferior; he too was a king, but in a world of art. Northcote reports that West used to say: "When my pictures come into the exhibition, every other painter takes his place as if a sovereign had come in."

Sometimes West was worried to notice that Queen Charlotte frowned jealously on his friendship with her husband, but he could usually win her smile again by the present of a picture. And in the meantime, royal commissions followed one another more quickly than he could execute them; his future as a historical painter seemed assured.

West's friendship with the King had grown up so quickly that before he had completed his first commission, *Regulus Leaving Rome,* his influence was recognized at court. Soon his colleagues needed this influence. In 1768, the less distinguished members of the Incorporated Society of Artists used their superior numbers to throw the leading painters off the board of directors. Then the better-known artists decided to form a new organization with membership limited to forty and if possible with the active support of the Crown. West was placed on the committee of four which laid the matter before the King and secured his support for the Royal Academy, that organization which was to be so influential in the cultural history of England. In order to keep George from backing its rivals, the Society of Artists had elected as its president John Joshua Kirby, the man who had taught the King perspective and had for long been the most influential painter at court. After a talk with George, during which the monarch said nothing of a rival organization, Kirby assured his society it had nothing to fear.

West told Galt that when he took his finished canvas of *Regulus* to the palace, Kirby came in. The old favourite was horrified to see the royal couple staring in awe at the painting of a rival. "Your Majesty never mentioned anything of this to me!" he cried, and

then, on learning that the frame had not been made by the King's carver and gilder, added triumphantly: "That person is not Your Majesty's workman. It ought to have been made by him."

"Kirby," said the King, "whenever you are able to paint me a picture like this, your friend shall make the frame."

Instantly the courtier began to fawn on his rival; it was a wonderful picture; he hoped that Mr. West planned to exhibit so wonderful a picture. When the King said he would be glad to have *Regulus* shown, Kirby brightened. "Then, Mr. West, you will send it to my exhibition?"

"No," said George with quiet cruelty. "No. It must go to *my* exhibition, the Royal Academy."

Thus informed that his own influence and the influence of his society were over, Kirby, like a well-trained courtier, bowed and withdrew. West asked the King if he liked the way he had turned Regulus's drapery.

V

The young man from the wilderness stood in his London studio painting the heroes of Greece and Rome. Sometimes he was troubled by the artificiality of his subjects, for the classical shibboleth had not been burned so deeply into his mind as into the minds of educated Englishmen; indeed, he was ignorant of everything in antiquity except the stories and settings he painted. Although an innovator in depicting ancient history, he had early attempted to escape from subjects so unnatural to him into painting the legends on which his childhood imaginings were fed, the legends of the Bible, but he had run into religious prejudice. When he had induced Reynolds and other leading British artists to join him in offering free canvases to decorate St. Paul's Cathedral, the Bishop of Terrick had cried: "I will not suffer the doors to be opened to introduce Popery!"

West then turned to modern history, but here he found reality
was banned. Inflexible tradition all over the western world dictated
that heroes looked heroic only if represented in ancient costumes.
Anyone who has visited St. Paul's must remember the statues of
English admirals and generals, for under every stern Anglo-Saxon
face is a naked marble breast framed in a toga; sandals divide the
toes that paced the quarter-deck. However, our mirth at such
artificiality is nothing compared to the combined mirth and horror
of West's contemporaries at the idea of "boots and breeches pic-
tures." The costumes of the eighteenth century were considered too
ordinary, too unæsthetic for any pictures more serious than por-
traits, and portraits were often "heightened" with antique draper-
ies; Reynolds painted Mrs. Siddons as the tragic muse.

In 1771 West finally revolted against the convention he had
himself helped to strengthen, and determined to return to the
realism he had practised when, as an untutored lad, he had evolved
his own technique from copying nature. He determined to depict
truthfully the most important historic event that had impinged on
his childhood, the conquest of Canada; he would paint the death of
General Wolfe at the moment when his army took Quebec. This
was a conventional subject that had been done many times before,
but when word leaked out that he intended to show the soldiers in
the red uniforms they wore, his friends were sure his reputation
would be destroyed by such madness. The King begged him to de-
sist, while Archbishop Drummond and Reynolds hurried to his
studio and pleaded that Wolfe and his officers be wrapped in togas.

"The event to be commemorated," West replied, "took place
on the thirteenth of September 1759, in a region of the world un-
known to the Greeks and Romans, and at a period of time when
no such nations, nor heroes in their costumes, any longer existed.
. . . The same truth that guides the pen of the historian should
govern the pencil of the painter. . . . I want to mark the date, the
place, and the parties engaged in the event." He promised, how-

ever, that if they disapproved of the picture when it was finished, "I will consign it to the closet, whatever may be my own opinion."

Realizing that in attempting so radical a picture he risked his reputation, West worked more slowly and carefully than was his wont, and he produced one of his masterpieces. Reynolds and Drummond were impressed despite themselves. "Mr. West has conquered!" cried the British artist. "I foresee that this picture will not only become one of the most popular, but will occasion a revolution in art." Yet he was not really convinced. In his tenth discourse, he attacked the use of modern dress in statues, and insisted that no painter of "high art" should attempt literal representation of contemporary history. In 1783 he wrote to Lord Hardwicke that the use of modern dress was "mean and vulgar."

Shown during 1772, *The Death of Wolfe* attracted larger crowds than had any other painting in all British history; the King, delighted with the success of his favourite, asked West to copy the picture for him. Yet there were some dissenting voices. In his search for realism, West had made Wolfe a very sick man, a pale and pitiful figure looking pleadingly upward as if he did not enjoy dying. The comment of the elder Pitt was described as follows: "Upon retiring, he pronounced it well executed upon the whole, but thought there was too much dejection not only in the dying hero's face, but in all the faces of the surrounding officers, who, he said, as Englishmen should forget all traces of private misfortunes when they had so grandly conquered for their country."

Garrick went to the gallery very early one morning, hoping to get there before the crowd, but the room was already packed. When he heard a young lady object to the expression of Wolfe's face and noticed that the young lady was very beautiful, he became inspired and announced he would show how Wolfe should have been represented. Supported by two willing gentlemen, he lay in the attitude of the dying general, and first assumed the tragic look West had painted. Then he changed his expression to the sublime

WEST: THE DEATH OF WOLFE

WEST: THE BATHING PLACE AT RAMSGATE

Engraved by William Birch

joy a hero should feel after an enemy bullet has pierced his bowels. Garrick's feat was much applauded.

The engraving that was made from West's picture was received with enthusiasm all over the world; it is reputed to have had a larger sale than any similar engraving in modern times. Indeed, West had shown the way by which artists could tap the vast market for news pictures that a hundred and fifty years later, after the discovery of photography, was to support innumerable newspapers and magazines. Again the unlettered Colonial anticipated by many years an important branch of French painting. His continental contemporaries Gérard and Girodet still believed that they could raise military pictures to the grand style only by the use of antique trappings. Although Gros was to approach his realism, not for the years that intervened before Horace Vernet's representations of Napoleonic campaigns did the creators of great battle pictures paint as realistically as West.

West immediately executed another subject that had possessed great meaning for his childhood, *William Penn's Treaty with the Indians,* and again he produced one of his major works. He had been sicklied o'er with so thin a veneer of European culture that when he painted classical subjects or medieval battles it was merely an intellectual exercise; these things, which he had never known until he was an adult, were not part of his fundamental being. In representing them he relied on a facile imagination rather than feeling, on technical tricks he had collected in the galleries of Europe rather than the technique he had laboriously worked out for himself in the wilderness. But when he represented things that existed deep in his own nature, he painted in a restrained, realistic, and emotional style. It is not a coincidence that his two important American canvases are among his few masterpieces. He might have been a much greater painter than he was, had he continued to mine his own past, but shortly after the completion of *William Penn* the quarrel between England and the Colonies became so

intense that the King's favourite thought it no longer wise to paint American subjects.

The revolution immediately placed his friendship with George III on a difficult basis. Regarding himself as a king in the realm of art and thus almost the equal of his patron, West only partly hid his sympathy for the rebels. This outraged the Queen, who frowned now when he came to the palace, but George did not seem to notice; indeed, he took advantage of the painter's friendship with the enemy leaders to discuss their personal characteristics by the hour. The King, West told Morse, was sitting to him for his portrait when a messenger brought in a dispatch box that announced the Declaration of Independence. Morse was all eagerness to know what George had said. "He made a reply characteristic of the goodness of his heart," West volunteered suavely. "He said: 'Well, if they can be happier under the government they have chosen than under mine, I shall be happy.' " Perhaps no one will ever know what really took place on that difficult occasion.

The American loyalist exiles in London were furious that a rank traitor should be at the King's right hand, and indeed, when we consider George's usually unbending nature, it seems a strange phenomenon. The following incident, which is found in several contemporary documents, suggests an explanation. Lord Cathcart, whose wife was an American refugee, asked West in the presence of the King if he had heard the news of the British victory at Camden. The peer supposed, he cried in so loud a voice that the sovereign would certainly hear, that the victory would not give West as much pleasure as it gave His Majesty's loyal subjects in general! Silence filled the room as all the courtiers listened for West's reply. When the painter said, also loudly, that the calamities of his country never gave him pleasure, everyone waited for George to toss him from the court. But the King walked quietly over and put his hand on the American's shoulder. "Right, right, West. I honour you for it." Then he turned on Lord Cathcart and told him to remember

that a man who did not love his native land could never be a faithful subject of another "or a true friend."

Or a true friend—there lies the key to the mystery. A king, standing upright among his bowing courtiers, can trust and love a man who tells the truth even when it seems to his own disadvantage.

By 1781, the King's blundering policies had become so unpopular that he was attacked in a resolution of the City of London. He felt that he was doing his best for England and the Protestant Church, and could not understand why the whole world turned against him. In despair, he sent for his American friend. He was determined, he said, to quit ungrateful England for ever and go back to his ancestral Hanover. There was a pleading note in his voice when he asked West to go with him.

A short time later, West told Farington, he went to the palace to congratulate the King on his birthday. Instead of finding a press of people as usual, he found the King alone with the Queen, "and evidently affected by the neglect." George stood at the window for a long time, looking out over St. James's Park, where many people pushed against the rails. Then he turned to his friend. "Those people," he said, "are looking to this building as the mansion of worldly superiority and happiness; little do they know what belongs to royalty."

The defeat at Yorktown annihilated George's control of Parliament, and destroyed for ever the dictatorship of the British Crown. A few days later, West went to the Queen's palace to transact some business with her. When it was done, she asked if he was engaged, and invited him to her closet. There he found the King in deep depression. George asked West how America would act toward England if declared independent; the painter replied that the ill-will would soon subside and America would prefer England to all other European nations. Then George wondered whether Washington would proclaim himself king. When West answered that on the contrary he would return to private life, the King shook his

head and said that if he did so he would be the greatest man in the world.

Jubilant at the victory, West returned to his project of painting American history. Within a month after the signing of the peace he wrote to Charles Willson Peale, one of his pupils who was in Philadelphia, that he intended to compose "a set of pictures containing the great events which have effected the revolution of America. For the better enabling me to do this, I desire you to send whatever you thought would give me the most exact knowledge of the costume of the American armies, and [also] portraits in small, either painting or drawing, for the conspicuous characters necessary to be introduced into such a work." However, West discovered that it was one thing to talk frankly to the King, and another publicly to represent the King's defeats. He was forced to turn the scheme over to another of his pupils, John Trumbull.

West was not really depressed at abandoning American history, for he had already broken away from neo-classicism into what he considered greener pastures. During the thirteen years between his arrival in England and 1776, he had exhibited thirty-four classical canvases; during the next thirteen, he was to exhibit only three, for the King had assisted him to overcome the Church of England's objections to religious paintings. After arguing with the bishops, George had commissioned him to decorate a chapel at Windsor with thirty-five huge murals showing the progress of "revealed religion." Once the gates were thus let down, the facile painter poured out a flood of Biblical pictures; he was to exhibit almost a hundred at the Royal Academy.

During his childhood, the Bible had been West's primer and its tales had fathered his imaginings. The Prophet Jeremiah was more terrifying on the Indian trails than any Manitou; and Ruth, not Pocahontas, wept in the forests of his Jehovah-haunted coast. Painting the moral stories that had always appealed to his profoundly

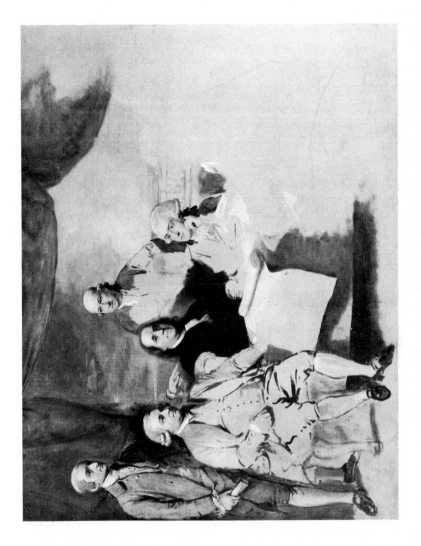

WEST: THE AMERICAN PEACE COMMISSIONERS

John Jay, John Adams, Benjamin Franklin, Temple Franklin, Henry Laurens

WEST: THE BATTLE OF LA HOGUE

moral nature, West seemed bound to strike a rich vein in his being that would produce masterpieces.

But, alas, it required a more powerful imagination than he possessed to depict the supernatural. Saints, prophets, and the Saviour exist only in vision, and West, the realist who could paint convincingly what he saw with his own eyes, was lost in the world of dream. Sensing this, he tried to find models; he enlarged a macaw's wing into the wing of an archangel, and searched London's ghetto for nobly bearded Jews to pose as prophets. To help himself over chasms his imagination could not bridge, he also had recourse to the old masters. He would remember how Rembrandt solved a difficulty and try to solve it the same way, or if he could not visualize a flight of angels, he would interpolate into his canvas some angels that Raphael had painted. The result was often a mélange of forms and styles that seemed not so much a single painting as an anthology.

Despite everything he could do, West lacked the inner fire to reveal the glory of God. Bombast took the place of power, sentimentality of worship. Today we can look with pleasure at only a few square yards out of his acres of religious canvases.

West had not given up representing English history, and it is significant that of all his battle pictures the best is generally considered *The Battle of La Hogue,* in which he painted what he had seen with his own eyes. The King commanded an admiral to take West to Spithead and for the artist's delectation order out the mighty British fleet. The painter sketched assiduously as the columns of frigates manœuvred into battle array and fired blank charges. He saw smoke billow terribly against the sky, and was able to reproduce powerfully on canvas an effect it would have been past his power to imagine.

Some critics have blamed the emptiness of so many of West's canvases on the lack of suffering in his own life; never until his

old age did he know frustration, defeat, or loneliness. Can a man, they ask, paint scars who never felt a wound? It is indeed possible that lack of experience made the emotional scenes he loved to paint break down into a thicket of bombastic gestures; they are more rhetorical than deeply felt. And undoubtedly the exaggerated praise that had greeted his work from the time he was a child encouraged him to do too much too fast. He dashed off barndoor-sized canvases of every conceivable type with a rapidity that would have tripped up a greater genius than he. It would take a wall ten feet high and three-quarters of a mile long to show all his work. He spread himself too thin.

But West's contemporaries found no emptiness in his emotional scenes, no lack of force in his Saviours. An explanation for this puzzling phenomenon may be found in Reynolds's *Discourses*. Those famous essays, which were revised by Johnson, Burke, and Malone, show us that what we consider West's faults were virtues by the best standards of the day. Do we find his work too cold and intellectual? The painter of the grand style, according to Reynolds, "like the philosopher, will consider nature in the abstract, and represent in every one of his figures the character of the species. . . . It is not the eye, it is the mind which the painter of genius desires to address." Since a historical painter must discover "that central form from which every deviation is deformity," West was correct in making all his noble old men or tender virgins look alike, for "there is only one common form" for each major division of humanity. Indeed, a portrait painter descends from the sublime when he paints "a particular man and therefore a defective model."

Is West's brushwork uninteresting, are his colours cold? "To give a general air of grandeur at first view," Reynolds writes, "all artful play of little lights, or attention to a variety of tints is to be avoided. A quietness and simplicity must reign over the whole work, to which a breadth of uniform and simple colour will very much contribute. . . . It is an inferior style that marks the variety of stuffs.

With him [the painter of the grand style] the clothing is neither woollen, nor linen, nor silk, satin, or velvet; it is drapery; it is nothing more." Reynolds permitted himself the bravura work which lightens his canvases only because portrait painting was one of the "lower exercises of the art. . . . Such of us as move in these humbler walks of the profession are not ignorant that, as the natural dignity of the subjects is less, the more all the little ornamental helps are necessary to its embellishment."

Is West's poorer work too derivative; does he borrow too many elements from too many old masters? "Our art," Reynolds writes, "being intrinsically imitative, rejects this idea of inspiration more perhaps than any other. . . . The artist who can unite in himself the excellencies of various great masters will approach nearer to perfection than any one of his masters."

Thus Reynolds describes the grand style in which he himself tried unsuccessfully to paint and whose object, he tells us, is to improve mankind by expressing noble ideas. We may be certain that he did not consciously make his theorizing describe West's work, for he was not on the best terms with the American. The Literary Club, although West had gone there as a young man, resented his intimacy with the King. They felt that the royal patronage should have come to Reynolds, who was bitter at being confined to portraits.

Indeed, West would have been out of place in Dr. Johnson's cultured group. Working unremittingly on canvases that were generally conceded great, he never bothered to make up the deficiencies of his education; maybe he was unconscious that they existed. The two social movements that are ordinarily considered as dominating eighteenth-century London passed West by, for he was neither learned nor fashionable. The gay and witty peers smiled sarcastically to see him go from his gallery to Windsor and back again "with the staid look of one of the brethren going to and from chapel." But the King was pleased.

West's hours were so regular that to describe one day of his life is to describe years. He rose early; planned pictures before breakfast; saw his pupils; painted steadily from ten to four; washed, dressed, and received visitors; then, having dined, commenced his studies anew. At all times, however, he was willing to break through his routine to assist a young painter.

West was perhaps most important to the history of art as a teacher. Since almost every distinguished American artist of the next generation studied in his studio, he was incontrovertibly the father of American painting. Copley, Stuart, Charles Willson Peale, Rembrandt Peale, Pratt, Trumbull, Allston, Morse, Malbone, Leslie, Earle, Dunlap, Sully—West trained them all and many more besides. English painting too owed him a great debt. Contemporary art chroniclers tell us that every important British painter of the generation after Reynolds received instruction from West.

There was no institution in England to teach painting, for the Royal Academy classes taught only to draw. In order to make up this deficiency, West spent hours every morning instructing whatever students came to him, nor, as Leslie tells us, did he ever turn anyone away because of disreputable clothes or lack of social station. The fact that he painted more by reason than by emotion made West a good teacher, for it enabled him to explain the exact purpose of every brush-stroke. In talking to his students, he insisted on the importance of observing nature, an importance he himself sometimes forgot. He would tell the young that he was fortunate to have been educated in the wilderness. "My having no other assistance but what I drew from nature (the early part of my life being quite obscured from art), this grounded me in the knowledge of nature, while had I come to Europe sooner in life, I should have known nothing but the receipts of the masters." So interested was he in having youngsters paint from life that he once had the body of a hanged man rushed from the gallows and nailed to a

cross, so that a plaster cast might be made to show the students at the Academy what a crucifixion really looked like.

Common sense was at the bottom of his teaching. Morse, the American art student who was to invent the telegraph, once brought him a drawing he had made of an antique cast. West handed it back, saying: "Very well. Go on and finish it." Morse replied that it was finished. "Oh, no. Look here and here." The young man worked on it another week and brought it back. "Very well," said West. "Go on and finish it." "Is it not finished?" Morse asked. "No, you have not marked the articulation of the finger joints, or this muscle or that." After three more days a bedraggled Morse returned with the sketch. "Very clever. Go on and finish it." "I cannot finish it," Morse replied. At last West allowed himself to smile. "Now you have learned your lesson and I have tried you long enough. It is not half-finished beginnings, but one thorough drawing that makes the artist; learn to finish one picture, and you are a painter."

One of West's greatest gifts as a teacher was his ability to appreciate unconventional genius; he was one of the few artists who praised the work of William Blake during the lifetime of that great mystic; he was among the first to admire Turner. The powerful academician did not try to force his pupils into any mould, but helped them to develop in the directions they themselves wished to go. West, Stuart tells us, was never dogmatic. "Try it," he would say when he made a suggestion, "and if it is not good you can alter it."

As a young man, Constable had great difficulty getting his canvases into the Royal Academy shows. On one occasion when the unknown student was mourning over a rejected picture, he felt a hand on his shoulder and, looking up, saw the King's painter smiling down at him. "Don't be disheartened, young man," West said. "We shall hear from you again. You must have loved nature

very much before you painted this." Then West squatted down
and criticized the landscape. "Whatever object you are painting,
keep in mind its prevailing character rather than its accidental
appearance. . . . In your skies, for instance, aim at brightness,
although there are states of the atmosphere in which the sky itself
is not bright. . . . Remember that light and shadow never stand
still." Constable always insisted that this was the best lesson he
ever received.

Any talented aspirant who lacked the funds to finish his educa-
tion as a painter could rely on a loan from the American, or even
an invitation to stay with him as a permanent guest. In 1805, the
King's painter withdrew three of his canvases from the Royal
Academy exhibition to make room for some young artists who had
been crowded out, nor did he waver in his good deed when the
other veterans, whom he had urged to do likewise, refused to make
the sacrifice. And, most amazing of all, the usually self-righteous
painter did not stand on his dignity with the young; if a student
had ability, he might create a continual uproar in his master's
studio, as Stuart did with impunity, and even make fun of the way
the great man painted. Never was a successful artist kinder to the
young.

West's generosity was probably created by his greatest fault;
egotism made him a saint. There is no end to the anecdotes show-
ing his exalted opinion of his own work. "He spoke of it in the
highest terms of praise and admiration," Fanny Burney tells us.
"Another man would have been totally ridiculous who held such
language about his performances, but there is in Mr. West a some-
thing of simplicity in manner that makes his self-commendation
seem more the result of an unaffected mind than a vain and proud
one. It may sometimes excite a smile, but can never, I think, offend
or disgust." West's boasting had none of the aggressiveness of one
who feels himself undervalued; he regarded it simply as a state-
ment of universally accepted truth.

Certain of his greatness, he had no need for jealousy. He believed that, since the object of art was to further virtue, beautiful pictures could be painted only by a man who was himself virtuous; he would have been unfaithful to his dream of himself as a supreme genius if he had stooped to petty deeds. And, of course, his saintliness, which so endeared him to the King, the clergy, and the bourgeoisie, did as much as the quality of his paintings to raise him to that secure pinnacle that made his saintliness possible.

West believed himself so great a painter that it was his duty to found great schools of art both in England and in America; therefore he did everything in his power to assist the young. In his later years he convinced himself that his ambitions were about to be realized. He wrote to Trumbull during 1806 that he was certain that New York and Philadelphia "would in a few years, under the blessings of peace, take the lead in mental accomplishments in the civilized world, and would be the next great school of art that should arrive. At heart, these two cities would be the Athens and the Corinth of the western world." On the other hand, he told the Royal Academy that "it is not flattery to the present era in Britain to say that in no age of the world have the arts been carried in any country to such a summit as they now hold among us, in so short a period of time as half a century." With adequate patronage, English painting would soon outshine that of Italy.

West continually strove to build up patronage, not only for himself, but also for his colleagues. He kept the King interested in the Royal Academy; he argued with peers that the support of art was a sure way to immortality; he pointed out to the rising class of manufacturers that artistic taste "is able to convert the most common and simple materials into rare and valuable articles of commerce." It was inevitable that when Reynolds died in 1792, West was elected to succeed him as president of the Royal Academy by an almost unanimous vote. In his opening address, he promised to maintain the credit of the institution. "Therefore, gentlemen, not on ac-

count of any personal merits on my part, but to do honour to the office to which you have so kindly elected me, I shall presume in the future to wear my hat in this assembly." And he did so too.

At the time of his election, West refused a knighthood. "The chief value of titles," he told the Duke of Gloucester, who came to him representing the King, "are that they serve to preserve in families a respect for those principles by which those distinctions were originally obtained. But simple knighthood, to a man who is at least as well known as he could ever hope to be from that honour, is not a legitimate object of ambition. To myself, then, Your Royal Highness must perceive, the title could add no dignity, and, as it would perish with myself, it could add none to my family." West's son tells us that the King later promised to make West a peer as soon as his series of pictures on *Revealed Religion* for the Windsor Chapel was completed.

During West's first year in the presidency, Boswell, who was the Academy's secretary of foreign correspondence, surprised the annual dinner in April by publicly expressing doubt that West had the ability to succeed his beloved Reynolds. The speech was so coldly received in court that Boswell wrote a bootlicking song for the informal meeting on Queen Charlotte's birthday:

> "This is the day,
> 　The Queen's birthday,
> 　The very day, sir, when
> 　We'll drink and sing
> 　God save the King
> 　And eke our own rare Ben.
>
> "Someone I ween
> 　May tell the Queen
> 　That I have wrote again
> 　On *her* birthday

To while away
The time of our rare Ben. . . .

"Then be it so,
For well I know
Her Majesty will then
Applaud the thing
And tell the King
How I respect rare Ben. . . ."

Thus were West's enemies forced to backwater, while he sat serene in the presidency of the Royal Academy. But already the most menacing storm-clouds he had ever met were gathering on the horizon.

VI

In the autumn of 1788, West had painted a landscape of Windsor Castle for the Queen and at her request put in a lion to please little Prince Adolphus. When he showed the canvas to George, the King's eyes were rolling in great excitement. With a flood of words, the monarch insisted that the lion looked more like a dog and, grasping a pencil, he slashed several heavy strokes through the offending animal. Then he rushed for a piece of paper, almost tripping in his haste, and slapped down some tangled lines. There, he said, that would show West what a lion looked like! The artist, who had always been treated by the King with the respect due genius, was deeply offended. He complained to the Queen, who, according to the contemporary press, admitted to him that she was very worried about the King's sanity. In a few weeks, George had gone mad.

The King, although he appeared in public again after several months, never completely recovered. As there had been talk of a regency, Queen Charlotte was afraid to leave him alone with anyone lest he behave wildly. West found himself frowned on in court;

he told Farington that the Queen deeply resented his having been so much with the King "when he showed symptoms of disorder."

Soon a new terror came to haunt the already frightened royal family; a king and queen were executed in France. Horror of the revolution across the Channel swept England's ruling classes into a reaction that was to kill all progressive legislation for almost forty years and make mild liberals seem in the terrified eyes of the aristocracy reeking with blood from the guillotines. Since artists are usually interested in social progress, the Royal Academy fell "under the stigma of having many democrats in it." The conservative wing, made up largely of members who were jealous of West, whispered in the high halls of Windsor that the King's favourite was a Jacobin. Queen Charlotte and the princesses, who remembered West's views during the American revolution, were easily convinced, and even the unstable monarch was shaken. Now that madness hung over him, now that more than ever he needed friends, he felt that his beloved friend was deserting him. "Who," he cried to Alderman Boydell, "would have thought that he could have been one of them!"

In November 1793, Farington wrote in his diary: "Remarks are made at Windsor that the president [West] does not go there as usual. He says it is to prevent that envy that arose from seeing him there so often and so noticed." But no one believed the excuse. Courtiers observed with sly smiles that James Wyatt, who was royal architect and West's bitter rival for favour, was for ever closeted with the Queen. Every time the harassed monarch spoke in a moment of irritation against his American friend, the royal words were scratched down in innumerable diaries. The conservative wing of the Academy was delighted that after one of West's presidential discourses the King referred to his ill-bred tendency to say "hackademy." "I suppose," remarked George with a tortured smile, "you heard a great deal of hack, hack, hack."

Since the King was subject to recurring mental attacks, there was

no foreseeing what mood he would be found in; at sixty, West was thrown back from the position of a friend to that of a cautious courtier. If only he had not confided fifteen thousand pounds, all his savings, to the monarch in more propitious days! He complained to Farington that the King changed the subject whenever money was mentioned. Not only did West fail to recapture his savings, but the frequent commissions from the Crown which he had grown to count upon during long years ceased altogether; his income shrank to the annual pension of a thousand pounds that was paid to him automatically; yet it cost him sixteen hundred pounds a year to keep up his elaborate establishment. He dismissed three of his six servants, but still sank deeper into debt.

However unpleasant things became at court, West was trapped there until he could get his money. He told Farington that if only he could obtain payment, he would "quit England for America." He would settle in Philadelphia, and his pupil Trumbull would settle in New York; they would build up a rivalry between the two cities that would lift American art high. All his life West and his wife had periodically hankered for their homeland. Once an American relative was sitting at tea when a flunkey brought in a plate covered with a napkin. "You must not laugh, Cousin Tommy," Mrs. West said, "at my attempt to raise some Indian corn in a hothouse. I have only succeeded in growing the cobs, but I have them boiled so as to get the perfume." As a young man, West had written to Dr. Jonathan Morris that his travels in Europe only made him perceive more acutely the blessings of America, and now, thirty years later, he wrote to the same friend that Pennsylvania produced free minds "capable of receiving the dictates of reason without the bigotry and superstition [with] which the artful systemizing policy of the old countries has clouded and bound the mind."

Although now more than ever West needed to walk carefully so as to avoid further offence to the royal family, in 1800 he sent to

America a design for a monument to George Washington which he offered "as a small token of my respect." His emissary in this matter was the American ambassador, Rufus King, who wrote him enthusiastic praise of the simplicity and grandeur of the plan. The ambassador promised to send it immediately to the President, Thomas Jefferson. West's design, however, was never approved, and thus the world was cheated of one of the strangest situations possible in the history of art: the court painter of a monarch raising a monument to that monarch's successful foe.

As up to the publication of this book West's offer has been buried in obscurity, we may be certain that it was not responsible for the blow which fell on the painter in 1801, when Wyatt, his rival, notified him that the commission he had worked on for twenty years, the commission to decorate the chapel at Windsor with religious pictures, had been cancelled, and his pension with it. After a month of anguished hesitation, West wrote the King a letter that was not the plea of a courtier but rather full of pride. His paintings, he said, were such "that the most scrupulous among the religious sects of this country about admitting pictures into churches must acknowledge them as truths or the Scriptures fabulous. Those subjects are replete with dignity, character, and expression as demanded the historian, the commentator, and the accomplished painter to bring them into view. . . . Your Majesty's known zeal for promoting religion and the elegant arts had enrolled your virtues with all the civilized world; and your gracious protection of my pencil had given it a celebrity throughout Europe and spread a knowledge of the great work on revealed religion which my pencil was engaged on under Your Majesty's patronage; it is that work which all Christendom looks on with complacency for its completion. . . . If, gracious Sire, this suspension is meant to be permanent, myself and the fine arts have to lament."

West's letter was not answered, but when the court returned to Windsor, he fought his way through to the King. George was

WEST: SKETCH FOR THE ASCENSION OF CHRIST

WEST: DEATH ON A PALE HORSE

His romanticism led the world

puzzled; he said he had never heard of the countermanding order or received the letter. "Go on with your work, West; go on with your pictures. I will take care of you." West encouraged Galt to say that this was the last time he ever saw his royal friend; perhaps the subsequent interviews were so painful he preferred to pretend they had never been.

After the peace of Amiens had put a temporary stop to the Napoleonic war, West like most of the other painters in London travelled to Paris to see the works of art Napoleon had stolen from all over Europe. The French artists greeted his advent with enthusiasm, gave him dinners and made eulogistic speeches, for he was recognized as a pioneer in the style they all practised. Neo-classicism had captured France. In the Salon of 1802, all the important canvases were calm and cold and modelled on Græco-Roman low reliefs—all the important canvases except one. West's *Death on a Pale Horse* was not restrained; its movement was explosive in the manner of Rubens, its colours bright and various, its composition infused with an almost hysterical fire. The disciples of neo-classicism must have been horrified to see that the prophet they had followed was now preaching an exactly opposite doctrine.

For West had left the stern æsthetic principles of the eighteenth century far behind him. When he had arrived in London, Dr. Johnson had been dictating English taste from the sounding board of his club; but now Johnson was dead, and the new voices of Wordsworth and Coleridge, Blake and Turner, glorified not the classic mean but extreme emotion. Advancing with his times, West had stepped into the romantic movement, painting many canvases full of violence and ardour.

And again he was a leader in the evolution of art. The French painters who looked with disapproval at the wild pictures of the ageing man could not know that future painters still in their cradles or not even born would grow up to paint in the heretical manner of *Death on a Pale Horse*. Fiske Kimball, the director of the

Pennsylvania Museum of Art, asserts that West's canvas foreshadowed the paintings that were to appear in France a quarter of a century later with the neo-Christianity of Chateaubriand; there were elements in West's work that pointed to Delacroix. For the time being, however, the French artists were puzzled and annoyed. But Napoleon was pleased; he specially asked to be introduced to West and praised the picture highly.

Most of the British artists scuttled back home horrified by what they saw in the capital of the revolution, but not West. He was delighted with the political manifestations of the movement he had supported in Italy as an artistic reaction to the licentiousness of Boucher. He told Farington that the people seemed in a better state than under the monarchy; before, there had been pomp and many religious processions while the masses starved. Now everyone seemed to belong to the middle class.

And how could he help comparing the great conqueror Napoleon, who admired his work, with the half-mad King at home, who would not pay lawful debts? Napoleon, West insisted, was a real connoisseur who had collected art objects from everywhere to help the young painters of his nation. West told Leigh Hunt he was with the emperor when it was mentioned that the French had captured the *Venus de' Medici*. Bonaparte's eyes lit up. "She's coming!" he cried, as if he spoke of a living person. The president of the Royal Academy was so impressed with the state support for art he saw in France that he started agitating at once for a national English museum of painting. Over a period of years he argued with a succession of Prime Ministers: Fox, Pitt, Perceval. The scheme failed, perhaps because it smacked too much of republicanism, but from its ashes rose the British Institution, in whose founding West played a major part. Antedating the National Gallery by many years, the British Institution formed the first important public collection of pictures in all England.

On his return to London, West did not hide his heretical ad-

miration for the Jacobins. His public remark that Napoleon had the best-turned leg in Europe was quickly carried to Windsor by eager schemers, who were delighted to see the King, the Queen, and the princesses all drawn rigid by the sound of such evil words.

Wyatt's cabal in the Academy chose the propitious moment to launch a personal attack on West's skill and his integrity. When West's adherents countered by suspending their opponents from the council, the King insisted that the enemies of his former favourite be reinstated, but he could not quite make himself accept the resignation from the presidency which West immediately offered. "No, no," he said. "All parties concur in wishing you to remain in it, nor can any other be proposed so proper. You have my friendship and shall continue to have it, and make yourself easy." Yet West knew that behind his back the distracted monarch was telling his enemies that he had never been much of a painter. Soon West heard that rumours were being spread at court that he had put up Tom Paine in his house; he insisted that on the contrary he had seen the notorious revolutionary only three or four times during his stay in England. When an adherent of West's told the princesses that any man who walked down West's gallery would have to acknowledge him a great artist, one of the royal virgins replied that in that case he certainly kept his best works at home.

The King's mind suffered a severe relapse, and all through the summer of 1804 he was hidden from his court. When he reappeared in the autumn, West was so uncertain of how the King would receive him that he did not ask for an interview. Instead, he placed himself conspicuously in the chapel at Windsor so the King could see him and send for him if he wished. After he had caught the monarch's eye, he hurried back to his house, but no message came. Finally he summoned up the resolution to appear on the terrace of the palace while the King took his evening walk. George looked through him, although the Queen and princesses nodded to him coldly. West must have noticed that his old friend looked

thin and ill; perhaps a little pity mingled with the rage and anxiety that made him tell Farington on his return to London that he regretted he had not gone back to America while he was yet young enough.

Alarming rumours circulated daily about the King's condition; West heard, for instance, that he was so excited he rode his favourite horse almost to death. When, in the middle of these perplexities, West was notified that he had been elected with Napoleon's approval to the French Institute, he could not contain himself; he poured out to all who would listen praise of the dictator all England hated, nor could Lawrence's warning, that the prejudice against him at court was "inexpressively strong on account of his democratic spirit and lavish admiration of Bonaparte," make him hold his tongue.

Wyatt's cabal, taking every possible advantage of his indiscretions, prepared to unseat him as president of the Academy; West's adherents were in despair. John Inigo Richards, the secretary of the Academy, wrote to him: "I do not know whether I am capable of writing to be understood; I am so unwell, so perplexed, foiled, and deranged in our proceedings on your business." Before the crucial election of 1804, word went round that the King would under no circumstances receive West, even in his capacity as president; without the royal sanction, of course, no one could preside over the Royal Academy. When Farington repeated the rumour to him, West replied "that he had fortitude for this possibility, and that he had acted faithfully to the King both as subject and servant, and that he defied any man to impeach his moral character." He set right out for Windsor. With the terrified Richards quaking at his heels, he left word at the castle that he wished to see the King. The night was sleepless, but the next morning, while he and Richards were at breakfast, a footman appeared to say the King would receive them at four. Although George remained distant during the interview, he treated them with courtesy and said nothing to indi-

cate that he was plotting West's downfall. When it was all over, Richards cried: "Give me your hand, Mr. West! This has been a most grateful visit. When I went in to the King, so alarmed was I for what might follow that a straw might have turned me over. But I was full of admiration at your coolness."

West returned to town jubilant, but was warned by Farington not to be too sanguine, for the King had again denounced his faction as democrats, encouraging the opposition in their determination to elect Wyatt in his place. Indeed, George, in his half-mad and terrified loneliness, seems to have been deeply hurt by the treason of his old friend, although he had not yet found the heart to destroy him.

At the annual meeting on December 10, Henry Tresham—"that reptile," as West called him—announced that he had much to say about the president, and did not West wish to leave the chair? It was agreed he should stay to defend himself. Tresham then stated that West no longer had the King's confidence, giving Yenn, the treasurer, as his informant. When Lawrence sprang to his feet and asked if Yenn had the King's authority to say what he was going to say, Yenn replied ambiguously that although he had no authority to use the King's name, he had been given a discretionary power to repeat what had been said to him. After a long and acrimonious discussion, the vote was taken; West got twenty votes, Wyatt seven.

The victory was West's, but the opposition maintained that it was hollow, for they had it from the most reliable rumour that the King would certainly never receive him again. Followed again by the trembling Richards, West travelled to Windsor and asked to see George. The next morning at breakfast, however, no footman came with an invitation; the hours dragged by until West could not resist going again to the castle. He was told that his name had been given to the King, and that if the King wished to see him he would be sent for. West returned to his house and watched Richards bite his nails. At one o'clock there was a rap at the door; a flunkey

announced that George was going in to dinner alone and would receive them. When they were ushered into his presence, the King was standing before the fire, looking so haggard and anguished that West's heart bled for his old friend, but there was nothing in the monarch's formal manner to encourage familiarity. He said the weather was cold, and that he had been out that morning, and that he was glad to be back in a warm room. He showed the two artists some changes that their enemy Wyatt, as court architect, was making in the palace, and listened coldly to their formal approval. "Now you can find your way out as well as you can."

West started to go, but the pain in his old friend's face suddenly overcame his diffidence. Turning, he said something to the King in a low voice. At the words, which no one overheard, George's stern look wavered and then broke into an expression of unutterable loneliness. He took West alone into another apartment, "where His Majesty spoke on a subject quite different from what he had before touched upon, during which, at times, tears ran down his cheeks." West was with him for three hours.

A few months later West wrote to Trumbull that all England was so engaged in fighting and money-making that no one cared for the fine arts but the King. "His Majesty has by a single act placed under my feet all those vipers who have been endeavouring for some years past to sting and drive me out of the chair of the Royal Academy." He described how on his return from Windsor he had called a meeting and given a short account of George's gracious reception of him "both as president and Mr. West. . . . I must say I never saw an opposition so crushed." * However, West would not let his adherents pass a motion of censure against his foes.

But the King, whose mind was whirling ever more rapidly now, soon returned to his suspicion of the American "democrat." Again the harsh words he spoke behind West's back encouraged the op-

* From William T. Whitley's *Art in England, 1800–1820*, by permission of the Macmillan Co.

position in the Academy, and West, refusing to be daunted by a mere worldly monarch, became even louder in his praises of the French revolution. The English court, deep in war, trembling at the spectre of an invasion from across the Channel, could not stand such heresy; the connoisseurs turned on their former darling. A bishop exclaimed at Windsor: "Oh, do look at those wretched things by West!" while Queen Charlotte paled at the mere mention of West's name, and the princesses spoke of him with disgust.

On November 29, 1805, West told Farington he was sick of the whole intrigue; he would resign as president. On December 1 he added that he would not continue in the presidency for a thousand pounds a year. He did not trouble to tell the King personally of his decision; he sent a letter. Although he probably could have been re-elected, he continued to refuse to run, and on December 10 watched Wyatt's election to succeed him. Farington commented that West's appearance had changed very much in a year; he had become very thin and bony.

West set to work grimly to show the Academy what it had lost by repudiating a great painter and electing an architect; he painted *The Death of Nelson*. A year or so before, according to a story he told George Ticknor, West had sat beside the admiral at a public dinner. After regretting that in his youth he had never imbibed a taste for art, Nelson said: "But there is one picture whose power I do feel. I never pass a paint shop where your *Death of Wolfe* is in the window without being stopped by it." He asked West why he had not painted other similar subjects.

"Because, my lord, there are no more subjects."

"Damn it!" cried Nelson. "I didn't think of that."

"But, my lord, I fear that your intrepidity may yet furnish me such another scene, and if it should I shall certainly avail myself of it."

"Will you?" cried Nelson, pouring out champagne and clinking his glass violently against West's. "Will you, Mr. West? Then I

hope I shall die in the next battle." The next battle was Trafalgar.

West did not send his *Death of Nelson* to the Academy exhibition, but showed it as a rival attraction in his own studio; the subject was so popular and the artist's reputation still so great with the masses, who did not know of his political heresy, that thirty thousand people came to see the painting.

Although West pretended that "what he had experienced in the Academy, and the abhorrence in which he held many members of it, rendered it hateful to him," he was delighted to see Wyatt's administration lead to nothing but intrigue and dissatisfaction. The architect did not have the calm, dispassionate temper of the American-born painter; instead of smoothing over disagreements between members, he aggravated them, and soon the Academy meetings degenerated into acrimonious battles that made even West's former opponents miss the more quiet years of his presidency.

Watching from the sidelines, West hinted that he would run again if the King's approval could be elicited. "For a little time past," he told Farington, "the King appeared to be rather hurried in his manner, dresses himself three or four times a day, and on the whole is in such a state as those about him, when they observe it, do not like to address him on any subject but what is absolutely necessary, but wait till he is more calm." West was worried about his commission for the royal chapel, since Wyatt was converting that part of the castle into cloisters, and hoped his re-election would bring a specific order to continue the pictures. However, he refused to degrade himself by any courtier-like fawning. When the campaign was at its height, his best friends, Farington and Lawrence, joined in expressing incredulous amazement that, despite his need for royal support, West continued publicly to praise Napoleon. They agreed that West did not have "an English mind," but was kept in England only by his royal pension and the fact that his sons were married there.

Since there was no other artist in the Academy on whom its innumerable prima donnas could agree, in December 1806 West was re-elected with only one contrary vote. All the members were so glad to return to his equitable rule that there was no more dissension, and he remained president for the fourteen years until his death.

West continued painting with unabated rapidity on huge religious canvases. When he was seventy-two, he completed in twenty days a picture of *Christ Requiring the Pure of Mind to Come to Him as Little Children,* in which all the innumerable figures were life-sized. Lawrence, Farington, and Westall agreed it was one of his best pictures. "I thought West looked very old," Farington wrote, "and much reduced in his person and countenance, and his spirits seemed to be low, as if exhausted, but he only complained of having finished his task, and the stimulus which had lately operated upon him being taken away. He felt somewhat painfully."

Less than a year later the blow that he had been dreading came. The King went completely mad, the Prince of Wales was appointed regent, and instantly West's pension and all his royal commissions were cancelled. Courtiers, who had always resented the dominance of an American democrat, spread stories that he had taken advantage of the insane monarch; the newspapers reiterated that West had plundered the King of 34,187 pounds. They did not explain that he had earned this sum during forty-three years of hard labour.

At seventy-three, West was deprived of the means of support he had relied on during most of his life. His wife told Farington that he had never invested a penny, and that his easy temper had allowed his sons to be brought up so improvidently that they would contribute nothing to his support. She herself was ill of a "paralytic complaint"; they did not have the money to take her to Bath, as the doctors ordered.

"If you expect either honour or profit by spending your days and nights in endless labour that you may excel in the department of

historical painting, you will be miserably deceived as I have been," West told the pupils at the Royal Academy. "Who purchases historical specimens of art now? Our very churches and cathedrals are closed to our voluntary contributions. . . . Formerly it was otherwise. . . . What lady will permit a painting in a drawing room? Festoons and fringes of silk drapery flaunting a meticulous glare of colouring; lustres, and girandoles, and pier glasses; French paper and Chinese paper and coloured borders and gilt borders and all the frippery of French upholsterers and their English imitators drive out the labours of Reynolds, Mortimer, and Wilson with as little remorse as Guido, Claude, and Rembrandt.

"But hold! . . . Amid the glare of glass and gilding we do find a niche in every room appropriated to a huge frame surrounding the insipid features of some family portrait. . . . It is upon these mawkish and wearisome monotonies that our first artists are now employed. . . . You must live. You cannot live by historical painting. Do you sigh for riches? Turn the whole bent of your mind, expend all your anxious laborious hours in becoming a fashionable painter of vacant faces."

Now, after more than a half-century of prosperity and fame, West faced destitution. It seemed in the cards that destiny's darling would die of a stroke as so many disappointed old men do, or at least drag out his remaining years in denunciation of a world that had passed him by. But great reservoirs of strength still lay in the shrunken body of the septuagenarian from the Schuylkill.

VII

West calculated that during the previous thirty years he had averaged less than two hundred pounds annually from selling pictures to the public; the Crown had always been his support. But now that royal favour had left him, he was not daunted; he turned to the public with a new will.

WEST: IRIS COMMUNICATING JOVE'S COMMAND TO PRIAM

WEST: CHRIST REJECTED

When the Pennsylvania Hospital in Philadelphia asked him for a contribution toward a new building, West promised them a picture instead, and began on *Christ Healing the Sick,* a huge canvas containing scores of life-sized figures. Before it was completed, it had received such celebrity that the British Institution bought it for three thousand guineas, the largest sum ever paid in England for a contemporary picture. It was so popular with the public that the Institution made back all but five hundred guineas in gate receipts. A replica sent to Philadelphia brought in twenty-five thousand dollars, enough money to enlarge the hospital for thirty more patients. And when prints of the picture were made, they netted West twenty-two hundred guineas. The painter suddenly found himself richer and more famous than he had ever been.

The reverberation of West's triumph penetrated even into the walled chamber of the King's madness; during an unusually lucid moment, George III sent his old friend a word of praise. "It afforded me inexpressible joy to receive His Majesty's congratulations on the successful issue of that picture . . ." West replied on May 25, 1811. "Had the great work of my life on revealed religion of His Majesty's chapel not been checked some years past, that work would by this time be in the same class in art with the one now exhibiting. . . . It would have been worthy of His Majesty's protection as a Christian and a patriot king, and all Christendom would have received it with attention and piety." But the towers of madness had risen round the monarch again; West's letter was not answered.

None the less, the painter started on *Christ Rejected,* an even bigger and more ambitious picture than *Christ Healing the Sick.* "I expressed my surprise," Farington writes, "at his resolution in undertaking so large a canvas at his time of life, seventy-four years old. He smiled and made light of it." Soon he had refused eight thousand guineas for the picture. When it was exhibited in Pall Mall, the thoroughfare was blocked by eager crowds. A newspaper

critic wrote: "The work is indubitably the greatest performance of modern times, and irrevocably fixes the painter on the highest pinnacle of the temple of fame. Long may he flourish in his green old age, setting a high example to the British school of perseverance, correctness, elegance, and piety." *

Although Lord Byron attacked "the dotard West, Europe's worst daub, poor England's best," praise for the old man's pictures was so nearly unanimous that it is almost inexplicable today. The canvases were largely painted by West's assistants; they are windy, vacant, and relaxed; dull in colour; insipid in characterization; showing nothing but the genius for composing a complicated picture which West never lost. Undoubtedly the age of the artist, his courage and piety, impressed the public. Lawrence later told the Royal Academy: "The display of such astonishing ability in age, combined with the sacred importance of his subjects, gave him a celebrity at the close of his life far greater than he had ever before enjoyed, and he became . . . the one popular painter of his country."

However, the celebrated canvases of his old age have done West's reputation much damage in the long run; they are the platform from which he is denounced by many outraged critics. Now that historical painting is out of fashion and moralizing elicits wrath, writers love to say that West was a canting humbug who gained celebrity by hypnotizing a demented king. The fury of some of these purifiers of the arts is interesting psychologically; one wonders why, if they are convinced West is so insignificant, they expend so much hatred in lambasting him. A milder school of critics casts out all West's historical paintings, but admires his portraits. Certainly there is much less in his portraits to offend modern taste, if one can overlook a naked cupid or two, and many of them have a brilliance that is startling when we remember that West despised

* From William T. Whitley's *Art in England, 1800–1820*, by permission of the Macmillan Co.

portrait painting and avoided it whenever he could. Despite his egotism, he urged young men who wanted to study portraiture to work with Reynolds or Stuart. "I seldom paint portraits," he told Archibald Robertson, "and when I do, I neither please myself or my employers." Perhaps the fact that West did not take his portraits seriously is responsible for their greater simplicity which appeals to modern eyes.

Surrounded with adulation, West saw no sign that his reputation as a historical painter would ever decay. Leigh Hunt describes for us "the mild and quiet artist at work, happy, for he thought himself immortal." In his picture rooms "everybody trod about in stillness, as though it were a kind of holy ground. . . . The talk was very quiet, the neighbourhood quiet, the servants quiet; I thought the very squirrel in the cage would make a greater noise anywhere else. James, the porter, a fine tall fellow who figured in his master's pictures as an apostle, was as quiet as he was strong; standing for his picture had become a sort of religion with him. Even the butler, with his little twinkling eyes full of pleasant conceit, vented his notions of himself in half-tones and whispers. . . . My mother and I used to go down the gallery as if we were treading on wool." It was fashionable for sensitive young ladies, when brought into the presence of the immortal artist and his moral pictures, to be so moved they burst into tears.

While West was basking in this apotheosis, his younger rival, Wyatt, was killed in a coaching accident, leaving, according to Farington, one of his female servants large with child. How could West fail to see shown again, as he so often showed in his pictures, the different rewards for virtue and vice?

Not that his lot was altogether sunny. As the result of a series of strokes his beloved wife had been reduced by 1815 to complete imbecility; she could neither talk nor move, though she suffered no pain. West merely became more absorbed in his work and busied himself with enlarging his sketch of *Death on a Pale Horse* into

a tremendous picture. The seventy-seven-year-old painter allowed himself only five hours a day away from his easel for sleep, and when his son remonstrated with him for eating nothing between breakfast and dinner, he looked up from his canvas long enough to reply that if he took anything in the intervening time he could not paint, as it made him "heady and incapable of application." So convinced was he that he was painting better than ever before, that, despite the remonstrances of Lawrence and Farington, he insisted on touching up the canvases of his prime.

But the old man's brain wandered while his hand, like a well-trained servant, almost automatically laid in the colours. The woods of Pennsylvania spread out before his mind's eye, more green and lush than they had ever been, and he saw his own childhood self wandering with Indians through the glades of romance. When he told Galt the story of his life, he did not, as we have seen, limit himself to facts; his aged mind threw up images so bright it was impossible to tell what was truth and what was fancy. How could any fancy be stranger than the truth of his career?

On December 6, 1817, his wife died. Soon West himself was confined to bed, suffering from decay rather than a specific malady. He had himself placed on a sofa in his studio and there, surrounded by his own works and his important collection of old masters, he spent quiet days studying two volumes of Fra Bartolommeo's drawings. When he became too weak to hold them, they were laid on a settee beside him. Sometimes he called for his pencil, and worked on the composition of the next canvas he was going to paint, the biggest, the most beautiful of all: *Christ Looking at Peter after the Apostle's Denial*. One day his son did not bring him the newspaper, and when West asked for it said it was mislaid. West understood at once what had happened. "I am sure the King is dead," he whispered, "and I have lost the best friend I ever had in my life." All the bitterness was forgotten.

Mercifully, for his pictures were again beginning not to sell, the

old man grew weaker, and shortly before one a.m. on March 11, 1820, his heart stopped beating. His body was enthroned in state in the great room of the Royal Academy, and it was regarded as almost miraculous that his right hand even in death kept the position of holding a brush. An eager worshipper took a cast of it, and for years the cast was regarded as one of the holy relics of art.

After a flurry during which the churchmen refused to receive his body because there was no evidence that he had ever been baptized, West was buried with great pomp in St. Paul's, next to Sir Joshua Reynolds. His death was regarded as a national calamity; peers, bishops, statesmen, and commoners jostled one another to get into the church. The undertaker's bill was almost a thousand pounds.

When the American's body had found its resting place with the bodies of Britain's great, West's old servant Robert walked sadly back to the studio and looked over the empty benches where so many eager students had sat. In his mind's eye he saw Constable there and Stuart, Peale, and Lawrence. "Ah, sir," he cried, "where will they go now?"

John Singleton Copley

(1738–1815)

THE LOW ROAD AND THE HIGH
JOHN SINGLETON COPLEY

I

THE picture stood against the wall of Sir Joshua Reynolds's studio, striking a strange note in that centre of elegance. The great English painter scowled at it in amazement, for, as he later explained, he had never seen a canvas that gave him quite the same feeling. There was a stiffness about this portrait of a young boy, a dryness of outline and a coldness of colour, that seemed to stem from the imitators of Sir Peter Lely, the school that Sir Joshua had himself overthrown, but the practitioners of that school never painted so realistically, with such powerful sincerity. And what was one to think of the strange animal that was represented standing on the table over which the boy leaned? It was some kind of rodent and was eating a nut. The queer, tiny thing nibbled away quite as naturally as if there really were miniature squirrels in the world that had white membranes running from their bodies to their legs like the membranes of a bat. Indeed, the animal was so meticulously drawn one had to believe it really existed.

Sir Joshua turned to Lord Buchan, who had brought the picture into his studio, and asked the painter's name. Shrugging, the connoisseur replied that he could not remember; it was a name he had never heard before. The canvas had been left with him by an American sea captain he had met somewhere, so he assumed it was by an American. Indeed, he was sure of only one thing: the painter, whoever he was, wished to have the picture exhibited at the Society of Artists.

Sir Joshua could hardly believe that so fine a picture could have

been done by an unknown Colonial. "It exceeds any portrait Mr. West ever drew!" he exclaimed. But he naturally called in that patron saint of all American painters.

West took one look at the squirrel that had so confused Reynolds, laughed, and said he knew that type of animal well; flying squirrels had been part of his boyhood in Pennsylvania. Then he turned the picture on its back and stared at the frame on which the canvas was stretched. "That's American pine wood," he said. The picture was certainly by an American, but by what American? None of the Colonials in England painted in that style or so well. Ecstatically West praised the "delicious colour worthy of Titian," and although Sir Joshua, who thought the colouring cold, winced at this, he agreed that the picture was excellent, more than good enough to exhibit at the Society of Artists. However, there was a rule against showing anonymous pictures; the name of the painter must be discovered and that at once.

West rushed out and questioned Joseph Wright, a young compatriot who had, in West's words, "just made his appearance in the art in a surprising degree of merit." But Wright denied that he had painted the picture. From then on West and Reynolds scratched their heads in vain; they could think of nobody. Finally Reynolds was forced to send the canvas, although its painter was still unidentified, to the exhibition with his own pictures. He argued that the portrait was so outstanding it should be hung despite the rule against anonymous pictures, and the conservative academicians, after poring one by one over the strange canvas, agreed that an exception would have to be made for so remarkable a work of art.

However, before the exhibition opened, Lord Buchan hurried to Sir Joshua's studio, followed by a large, seafaring American. Captain Bruce seemed out of place in the elegant chamber where hung many portraits of stylish ladies, but it was he who had brought the painting to Lord Buchan. It was done, he said, by a young Bostonian named Copley, John Singleton Copley. Sir

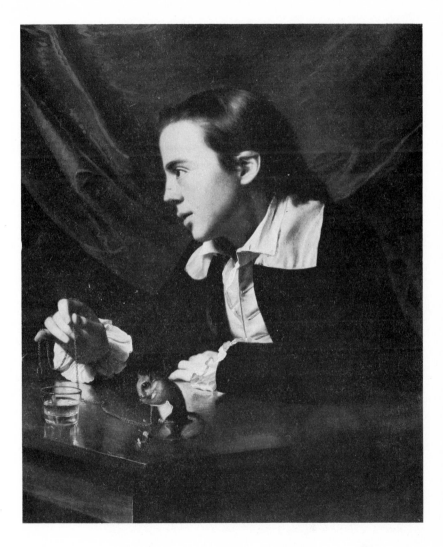

COPLEY: BOY WITH SQUIRREL

A Portrait of Henry Pelham

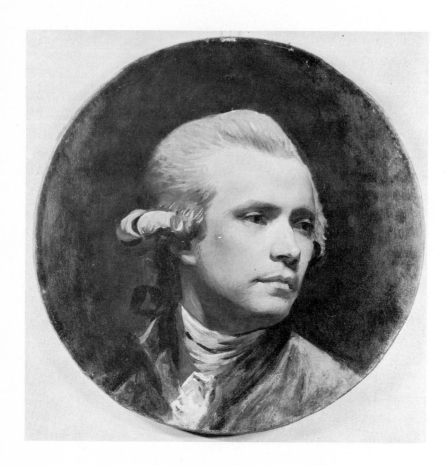

COPLEY: SELF-PORTRAIT AT THIRTY-EIGHT

Joshua looked at Bruce with increasing amazement as the sea captain told him that Copley, although twenty-eight years old, had never been out of the provincial city of Boston, and had never in his life seen a picture worthy to be called a painting. Bruce was to write home to Copley that Reynolds had said: "Considering the disadvantages you had laboured under, it is a very wonderful performance. . . . He did not know one painter at home, who had all the advantages that Europe could give them, that could equal it, and that if you are capable of producing such a piece by the mere efforts of your own genius, with the advantages of example and instruction which you could have in Europe, you would be a valuable acquisition to the art and one of the first painters in the world." In fact, Reynolds was so excited that he forgot to write down the name of the painter. Thus it came about that the first picture of John Singleton Copley to be publicly exhibited anywhere in the world was mislabelled; the artist's name was given as "William Copley."

The romantic story of the masterpiece that had emerged unheralded from the wilderness soon spread through the compact art world of London. Connoisseurs flocked to see the picture of a provincial child leaning intently over a table where stood a strange animal. Soon the name of Copley was on every cultivated tongue. On the strength of this one picture, the unknown and misnamed painter was given the highest honour the English art world could offer: he was elected a member of the Society of Artists. People wondered how such a genius could have sprung up spontaneously under the shadow of America's primeval trees.

The best evidence that exists, which however is by no means conclusive, indicates that John Singleton Copley was born in or near Boston on July 3, 1738, a few months before Benjamin West. According to family tradition, his parents, who were of English stock, had arrived from Ireland at about that time, and his father had sailed on to the West Indies, where he died shortly after the boy

was born. Copley's early years are shrouded in mystery, for the inhabitants of Boston, with whom the searching of genealogical records is almost a mania, have been unable to find any mention of his birth or baptism.

A newspaper advertisement, however, shows that before Copley was ten his mother was living over a tobacco shop she operated on Long Wharf. Boston was at that time the largest city of British America and the most important commercial centre. Since the old harbour, most of which is now filled in with land, was very shallow, the end of the main street had been extended some two thousand feet out into the bay to form a pier so broad that houses could be built on one side. In one of these Copley spent his early childhood. Looking from the back windows, he saw water lapping the foundation of his dwelling, and from the front windows he had a view that seemed calculated to make any boy's heart swell with the romance of travel and far places. Separated from his house by only a fifteen-foot walk lay moored the square-rigged boats that brought Boston its prosperity; sometimes twenty or more were tied to the long quay. The day and the night as well were loud with the creaking of blocks, as square sails blossomed from high spars.

Daily the boats came to and fro; daily the future painter watched ships emerge tiny from between the outlying islands and grow momentarily larger until the wild cormorant of the ocean lay bobbing at rest by his front door. He watched the sailors stand in a dizzy line on the rigging as they lashed down the furled sails, and then his mother's tobacco shop would be full of the sound of voices. Standing behind the counter, answering with alacrity demands for tobacco "cut, pigtail, or spun," the boy served mariners who had returned from the seven seas. These gaudy men with gold rings in their ears had been to Africa, where they had exchanged sperm candles and rum for slaves; they had carried their human merchandise to the West Indies, where men were exchanged for molasses; and already there was a rumbling in the street as the hogs-

heads of molasses were being rolled toward distilleries where they would be changed into more rum with which to obtain a new harvest of black slaves. Sometimes, perhaps, the crinkly-skinned sailors brought queer idols into Mrs. Copley's tobacco shop, and the youngster stared in amazement at the brown grotesques that would in another hundred and fifty years inspire a school of painters as different from the work he was to do as it was possible to be. How stories must have leapt from mouth to mouth while the blue smoke drifted toward the ceiling! Silent bays on the fringes of jungle, black potentates under canopies accompanied everywhere by a whisper of drums; and then a sudden change to the Spanish mansions of the West Indies, white in a glaring sun, where resplendent dons scraped and bowed, and where from behind barred windows came a tinkle of castanets—castanets that were drowned out by the tomtom beat of slaves returning at evening from the fields. And between these scenes that floated like islands on the narrators' memories there were months of sailing to describe. Seas calm or riotous; strange, half-human albatrosses that followed tall masts; and sometimes blue lights gleaming from each of the ship's pinnacles, the corposants that boded—who knows?—disaster or prosperity, and made even blaspheming boatswains pray.

Every day brought new excitements as the endless war with Spain unrolled. Pirate ships set out from Long Wharf with the blessings of the Commonwealth, half-hidden guns peeping black from portholes. The sailors who crowded into Mrs. Copley's shop for a last hunk of tobacco before the adventure began had cutlasses in their belts, and their voices were thin with anticipation. Watching pirate sails vanish down the horizon, an imaginative lad could coin endless visions of blood and glory. Then months later there would be a running of feet on Long Wharf and a staring from the tip as the privateer came home towing a prize. In 1748, when Copley was ten, the frigate *Bethel* out of Boston, armed with only fourteen guns and carrying only thirty-eight men, brought following docilely

in its wake a Spanish treasure ship of twenty-four guns. More than a hundred prisoners lay bound beneath its decks. The breathless rumour went round that in the Spaniard's hold was a hundred thousand pounds in ducats and doubloons.

We should expect an adventurous boy brought up in such an atmosphere to run off to sea at an early age, ship as a cabin boy, and return at last resplendent with strange oaths and cutlass wounds. Or if he became a painter we should expect his canvases to be instinct with the dash of adventure: battles would be glorified, generals and privateers. But we may search Copley's work in vain for such pictures as these; rarely has a great artist been so unreceptive to the possibilities of romance. Neither interested nor impressed by men of physical action, Copley idealized sensitive intellectual faces, portraying them so lovingly that they formed the subject matter of his finest portraits. And when in the manner of his time he turned to scenes of war, his canvases revealed no taste for carnage. In the best of his battle pictures, *The Death of Major Pierson*, the eye is caught and held by a weeping group in the foreground; the wife and child of the dying hero wail, louder than the guns and the shouts of victory, their anguish at man's inhumanity to man.

Copley's few paintings of the sea are tinged with horror. In his *The Repulse of the Floating Batteries at Gibraltar*, he shows the ocean full of the writhing forms of dying men; half-naked, mangled bodies struggle in every contortion of pain with the enveloping flood. Only one other of his important canvases deals primarily with the ocean, and that is a brilliantly painted representation of nightmare. In the foreground, a naked and defenceless swimmer sprawls in a contortion of anguish; he is being attacked by a shark. Behind him several men in a small boat huddle together in helpless terror, or vainly gesture to bring assistance when assistance is past hope. And the water in which the victim flounders is a sickly yellow-green, a stringy and repulsive element in which naked men are attacked by monsters.

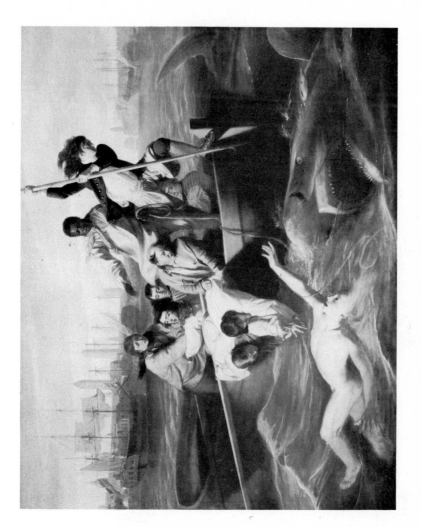

COPLEY: WATSON AND THE SHARK

BLACKBURN:
MARY SYLVESTER
Painted 1754

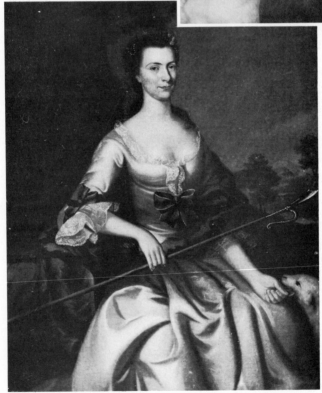

COPLEY:
ANN TYNG
Painted 1756

Whenever in the many letters that have come down to us Copley refers to ships or the sea, he does so with displeasure. If he had to travel from Boston to New York and Philadelphia, he travelled by land, although the roads were so bad that water offered a much quicker and more comfortable route. As we shall see, Copley hesitated for years before he made the trip across the ocean so necessary to a Colonial painter, and he could never force himself to return.

Eighteenth-century seafaring was not altogether romantic; there was another side that might impress a lad more sensitive than adventuresome. Watching from his mother's window, Copley saw rebellious sailors hanging from yardarms; he heard the cut of cat-o'-nine-tails on naked backs. Impressed seamen who had been knocked down in the streets of London and carried off in stinking holds without a word to their families; battered, wincing derelicts limped into Mrs. Copley's shop, and their hands trembled when they picked up the tobacco the boy dealt out to them. In 1747, Commodore Charles Knowles tried this British custom in Boston. Annoyed by desertions, he landed a press gang that kidnapped apprentices as they strolled down Long Wharf. Then the Boston populace rose and rioted for three long days, while the Royal Governor fled to Castle William and the naval commander threatened to bombard the town. With anxious eyes, the nine-year-old Copley watched sails rise on the British frigate as it manœuvred into position. But the commodore did not shoot, and in the end was forced to release the men he had stolen.

The slave trade, too, had its horrors. The West Indian planters, most of whose black imports died anyway during the first five years on the steaming and unhealthy plantations, would buy only prime human stock. Negroes who had sickened but not died during the long voyage from Africa, children born on the voyage or accepted in the jungle as a compromise to close a deal, these found no buyers. The traders were forced to ship such defective merchandise on to Boston and sell it for what it would bring as domestic servants. How often Copley must have seen black children of his own age un-

loaded with the barrels of molasses, driven in terrified groups down Long Wharf to the markets where they were sold. How often he must have seen emaciated Negroes, once the pride of the jungle, hustled unmercifully off boats where there was no room for them any more, and allowed to die, for they were too infirm to have any value.

Flanking Mrs. Copley's shop on Long Wharf were grog shops which made the night hideous with the sound of drunken singing and drunken fights. We need not be surprised that Copley reacted violently against his childhood environment. Induced by his own children to talk of those unhappy days, he told them that he had escaped from brutal reality into the recesses of his own mind; he became a quiet and studious lad. When the tough waterfront boys, seeing his pale face at the window, dared him to come out and hooted him as a sissy, he fled to an empty room, where he comforted himself by drawing pictures on the walls. Family tradition tells us that at seven or eight he sketched in charcoal a group of martial figures engaged in some unnamed adventure. The Bible also was a source of inspiration to the well-brought-up lad, who showed his literal-mindedness by painting the sea Moses crossed a glowing red. Or did he think of all oceans as tinged with blood?

Copley's letters show that he had been well educated. Probably he went to the school conducted by Peter Pelham, for during 1748 his mother married that estimable widower. A month later the following advertisement appeared in the Boston *Gazette:* "Mrs. Mary Pelham (formerly the widow Copley, on the Long Wharf, tobacconist) is removed to Lindel's Row, against the Quakers' Meeting House, near the upper end of King Street, Boston, where she continues to sell the best Virginia tobacco, cut, pigtail, and spun, of all sorts, by wholesale and retail at the cheapest prices."

Thus Copley escaped from the waterfront. However, his mother's marriage had an even more important consequence; Peter Pelham was the first well-trained mezzotint-scraper to appear in the Colonies. He had already earned an English reputation before coming

to America about 1725, and on his arrival he immediately secured all the business there was for engravings after portraits of leading citizens. Yet all the business there was did not suffice to keep him in food and lodgings; he was forced to open a school where, according to an advertisement published the year of Copley's birth, "young gentlemen and ladies may be taught dancing, writing, reading, painting, and needlework." His dancing assemblies were immediately criticized by the pious burghers of Boston. "What could give encouragement to so licentious and expensive a diversion in a town famous for its decency and good order? . . ." an indignant citizen asked in the Boston *Gazette*. "When we look back upon the transactions of our forefathers and read the wonderful story of their godly zeal, their pious resolution, and their public virtues, how should we blush and lament our present corruption of manners and decay of religious and civil discipline. . . . In vain will our ministers preach charity, moderation, and humility to an audience whose thoughts are engaged in scenes of splendour and magnificence, and whose time and money are consumed in dress and dancing."

Blue laws hampered the artistic-minded of Boston at every turn. During Copley's thirteenth year, the town had the excitement of its first theatrical performance. When two English actors announced that they would present *An Orphan, or Unhappy Marriage* at the British Coffee House and persuaded some rash Bostonians to take the minor rôles, the citizens were so shocked at the idea of a play that everyone wanted to see it. A huge crowd gathered outside the coffee house, on King Street near Copley's home, and finding that there was not room to admit them all, they rioted. Immediately, with the entire approval of the mob that had been so eager to get in, the government passed an "Act to Prevent Stage Plays and Other Theatrical Entertainments" on the grounds that they "occasioned unnecessary expenses, discouraged industry," and increased "immorality, impiety, and contempt for religion." This law was reenacted as late as 1784.

Perhaps because of religious opposition, all Pelham's innumerable activities did not bring in enough money to enable his new wife to give up her tobacco shop; the house to which Copley moved was continually alive with the voices of customers and the droning of pupils. However, it contained a marvellous room into which the boy could flee. Here was the scarred table on which Pelham made his prints, here were all the sharp and intricate tools of art. His step-father took delight in teaching the eager youngster how to engrave. Pelham occasionally did oil paintings too, and he allowed the boy to dabble in bright pigments, to spread paint with soft, imported brushes. Or, first making sure Copley's hands were clean, Pelham would bring down from a shelf the prints of English paintings that he tried to sell the parsimonious Colonial connoisseurs; Copley fingered in excitement black and white representations of portraits by Highmore and Hudson, and wondered whether a mere American could ever do as well. Indeed, chance had thrown the lad into one of the few households in the Colonies where art was the predominant interest.

Painting had had a long history in British America—the earliest surviving canvases date from the 1660's—but it had almost always been created on an artisan level. A typical "limner" was at an early age apprenticed to a trade: clockmaking, or saddling, or, if he were very lucky, house and sign-painting. After he had reached his majority and set out for himself, he followed a pattern natural for craftsmen in a society where the smallness of population and the virtual isolation of communities made specialization, as a general rule, economically unfeasible. Ingenious artisans were encouraged by their neighbours to try their hands at a wide range of activities. If a workman had a gift for design and could produce the necessary colours, he would take up painting as one more string to his bow, and, if he were successful enough in this exciting occupation, art would gradually overshadow in his practice his other crafts.

On the sign-painting level, there was a steady demand for every

kind of picture: painted hats to identify haberdasheries; images of heroes on horseback to hang in front of taverns; murals that would decorate humble walls at less cost than imported papers. But on the level of easel-painting, in Colonial America only portraiture was in considerable demand. A desire to immortalize on canvas such wild scenery as the new continent offered appeared only later, with the romantic movement. Decorative paintings of a quality suited to gentlemen's houses could be and were imported. But a written description of human features however eloquently composed did not elicit from a London studio a recognizable portrait. Likenesses had to be painted on American soil, in the presence of the sitter, and such pictures came to be considered by prosperous Americans as a kind of necessity.

Individualism was the watchword of Colonial America. Even the Puritans, who were so strongly opposed to pictures in churches that religious paintings were rarely attempted in Colonial times, felt their own personal importance as creators of the New Jerusalem. And more worldly Americans, who had taken advantage of the opportunities offered by the New World to raise themselves by their own bootstraps, were fascinated by the romance of their careers. Everyone felt that dynasties were descending from them, and they could not bear the thought that their followers would never see their features. Another source of business for portrait painters was created by the prevalent geographic separation of families: settlers sent their "effigies" to relations in other Colonies or back home across the water.

Throughout the Colonial period there was a continuing demand for portraits. From the numbers that survive, we may conclude that they were produced by the thousands. But not, of course, by a few fecund practitioners. When most painters practised other trades as well, the number of active artists ran to the hundreds. Concerning the art traditions of Europe, they had only the inklings they could imbibe from reading books, examining occasional engravings, and standing rapt before some inferior im-

ported canvas which fate or vigorous exploration brought into their ken. They were forced, willy-nilly, to work out individually and in cooperation most of their own techniques. As a general rule, their portraits were crude, simply conceived and simply painted, but the best of the pictures have the freshness of unspoiled vision.

When Fate entered the shop of a naturally gifted Colonial artisan and placed a paint brush in the hand that had just put down a saw or saddler's tool, she inspired an agile mind to struggle on its own with the eternal problems of art. Unable to remember how Raphael had lighted a hand, how Lely had folded drapery, the artist had to work these things out for himself. If he achieved a solution, it was profoundly felt, deeply his own.

Up until recently, it is true, Americans have blushed with embarrassment at the roughness of our early portraits, and often commissioned restorers to repaint an ancestor into more acceptable shape. But all that has changed since the rise of modernism first in Europe and then in America has opened the eyes of connoisseurs to the virtues of naïve art. No longer demanding an altogether illusionistic image, we are responsive to the emotions communicated by shapes distorted for emphasis, by colours selected as much for the ends of pure design as for the exact reproduction of nature. Canvases once relegated to attics with loathing now hang in museums as "American Primitives" or "American Folk Art." Yet it would take a zealot of major proportions to claim that more than a very few of these naïve and charming works are comparable in quality with examples of more highly evolved American art.

Occasionally, the early American painters were joined by artists from abroad. These imports were usually very simple craftsmen whose names were unknown to the great practitioners of the European courts; they brought with them provincial styles almost as crude as the work of their American contemporaries. The great exception to this rule was John Smibert, the artist who was to play so important a rôle in Copley's development.

A Scot by birth, Smibert began his career humbly enough as an apprentice to an Edinburgh house-painter and plasterer, but as soon as he was released from his indentures he journeyed to London, where he struggled to overcome his lack of social position and his lack of training, to become a portrait painter. Finally, fortune presented him with a three years' trip to Italy. Being able to boast of foreign study, he became on his return a successful portraitist; not one of the most fashionable, perhaps, but yet a man of reputation. The connoisseurs were amazed when he gave up his hard-earned position to join the radical philosopher, Dean Berkeley, in a mad scheme to found in Bermuda a college for the education of the Indians. During 1728, ten years before Copley was born, Smibert accompanied Berkeley's crew of idealists to Newport. There they waited for promised funds that never came.

When Bishop Berkeley's scheme collapsed, Smibert settled in Boston, where he made a rich marriage and established a virtual monopoly of the portrait business. A friend and business associate of Pelham, he probably gave Copley some instruction. We know the boy saw hanging in his studio the copies he had made of European masterpieces, including the one of Van Dyck's *Cardinal Bentivoglio* that was by itself to constitute the first American art school. Copley, Allston, and Trumbull, three of America's leading painters, all found in this one picture their first hints of a richer portrait style.

We can visualize Copley, not yet in his teens, bent with aching attention over the copies that brought him a pale reflection of great art. Twenty years later, when he was himself a famous artist, he was to see the originals and write home that Smibert's copies were inaccurate, miscoloured, and badly drawn. But as a boy he was deeply impressed. There in the studio of a disgruntled English painter of medium ability, the muses first whispered in the ears of the Colonial genius who had never seen a well-painted picture.

However, Copley's period of instruction under Pelham and Smibert was short, for they both died in 1751. Pelham's estate was so

small that his widow did not trouble to file an inventory; and there was another mouth in the family to feed, for Copley had a half-brother, Henry Pelham. Again poverty faced the boy who had suffered the horrors of Long Wharf. At thirteen he was forced to try to make money at the trade for which he was being trained. He set up as a painter and engraver.

II

Benjamin West's career has shown us that it was possible to achieve fame in the Colonies as an infant-prodigy painter, but Copley's temperament was the opposite of West's. While the Pennsylvania lad was slashing away in happy disregard of his ignorance, painting castles and togas and Colonial faces with the naïve self-confidence of childhood, in Boston Copley was bending over his canvases in an agony of bewildered indecision. Every feature he painted was questioned, rubbed out a dozen times, and then allowed to remain at last only because the picture had to be finished. If the boy whose childhood had been a round of terror possessed any self-confidence, it was the grim determination of the frightened who fight lest they perish.

An example of Copley's early industry is supplied by a group of large anatomical drawings which he executed when he was eighteen. They are based on plates in *Anatomy Improv'd and Illustrated* (1691) by Bernardino Genga and Giovanni Maria Lancisi, and at first glance they seem exact copies. However, a little attention will reveal that extremely subtly and probably subconsciously, by tiny changes in the shading originally intended just to make the muscles stand out, Copley transmuted scientific abstractions into visions that seem to walk the real world, monsters that might illustrate some story of the supernatural. He was too able an artist ever to copy exactly.

COPLEY: ANATOMICAL DRAWING

COPLEY: BROTHERS AND SISTERS OF CHRISTOPHER GORE

However, it was natural to his character to seek instruction wherever he could find it. Since he never relied on original inspiration unless forced to by lack of models, he certainly consulted all the artists and studied all the paintings that came his way. During his childhood, there was the example of Pelham and Smibert, and also that of Robert Feke, the mariner from Oyster Bay who is generally conceded to have been the best American-born painter before Copley and West, and who practised in Boston during 1748–49. Although the boy was only eleven when Feke went away, he may easily have studied during his teens some of the admirable canvases that the primitive master left behind him.

After Smibert, Pelham, and Feke had died or left, two greatly inferior artists, Joseph Badger and John Greenwood, practised in Boston; they were the rivals, perhaps the inspirers, of Copley's first professional efforts, which were made when he was about fifteen. Badger, the son of a poor tailor, had been trained as a house-painter and glazier; that he moved in very simple circles is shown by the fact that his wife was illiterate. He imitated Smibert and, as Lawrence Park points out in his article on Badger, copied stock poses from English prints. Filling in the gaps from his own imagination, he painted canvases which, despite their muddy colour and clumsy drawing, have a naïve sincerity that gives them a certain archaic charm. They were considered such wonders of art that for ten years he was the most admired painter in New England.

Second to Badger was Greenwood, who had learned to paint as an apprentice to a maker of charts and coats of arms. His style was more nervous and sensitive, but he had the disadvantage of coming from a relatively sophisticated background; he recognized his lack of training and thus never attained the childlike self-sufficiency that makes some of Badger's canvases delightful though ridiculous worlds of their own.

Whoever were his Colonial masters, Copley forgot them instantly when in 1754 or 1755 Joseph Blackburn turned up in Boston. Blackburn is like a figure in legend; he came from nowhere and

disappeared into the void, but during his seven or eight years in America he executed some of the most urbane portraits the Colonies had ever seen. In particular, he had a gift for graceful poses, quite unlike the stiff mannerisms of the local artists. Although he must have been trained in England (for his work suggests that of Hudson, Reynolds's master), not a single canvas of his has ever been found there. Perhaps he had been the drapery painter for a more famous artist; his American portraits show an almost feminine affection for laces and satins, and considerable skill in depicting still-life objects, while the faces do not reveal an equivalent glow.

Although Copley, who was doing portraits on his own, could never have been Blackburn's apprentice, he enthusiastically imitated the newcomer's virtues, not hesitating to borrow entire conceptions if they pleased him. When Blackburn painted a Colonial belle as a shepherdess with a crook in her hand and a lamb by her side, Copley did the same for one of his own sitters. By such means he quickly assimilated the grace of his elder's style, and then he was the better painter, for he was developing to a superlative degree the quality Blackburn lacked: the ability to depict character in faces. By the time he was nineteen, Copley's fame had travelled so far that he was invited to Nova Scotia. "There are several people who would be glad to employ you," wrote Thomas Ainslie of Halifax. "I believe so because I have heard it mentioned." Copley, however, did not go; perhaps the idea of travel terrified him.

The boy who had huddled behind locked doors on Long Wharf had become a self-contained young man who worked at his trade with passionate intensity and rarely went out in the world. The popular historical novelist who depicted him as turning up at a drunken brawl at Harvard and taking the blame when the college authorities intervened could hardly have distorted his character further from what the evidence shows. By nature afraid of his fellowmen, painfully conscious that he practised a socially inferior profession, Copley carried sober respectability to the extreme. The worst aber-

ration that is recorded against him is that a Selectman once caught him strolling on the Sabbath. Gravely he explained that he worked so hard during the week, he had to take exercise on Sunday for his health.

When Copley had with methodical industry learned all that he could from Blackburn, he was the best painter in the Colonies, but he was conscious that his work was still crude. There was that matter of eyes, for instance; no one in America could paint an eye that did not look like a slit cut into a mask. Copley toiled by the hour over this detail of his paintings, doing a sitter's eye over and over, trying a hundred different expedients, until sometimes he got himself so entangled that in the delivered picture the eye was a complicated blur. If only he could find good models to imitate! He was to tell his children that he had been entirely self-taught and had never seen a decent picture while a young man. He was to write Benjamin West: "In this country, as you rightly observe, there is no example of art except what is to [be] met with in a few prints indifferently executed, from which it is not possible to learn much. . . . I think myself particularly unlucky in living in a place into which there has not been one portrait brought that is worthy to be called a picture within my memory, which leaves me at a great loss to guess the style that you, Mr. Reynolds, and other artists practise."

Seeking, perhaps, for a quicker medium than oil paint in which to try experiments, Copley determined to do pastels, although he had in all probability seen only a few indifferent ones by Blackburn, and certainly was not sure what kind of crayons to use. The books he read told him that the best living pastellist was Jean-Etienne Liotard, who lived in Geneva and was famous for sentimental pieces such as his *Chocolate Girl*, now in the Dresden Gallery. In 1762, he wrote to Liotard, asking him to send "one set of crayons of the very best kind, such as you can recommend [for] liveliness, colour, and justness of tints. . . . You may perhaps be surprised that so remote a corner of the globe as New England should

have any demand for the necessary utensils for practising the fine arts, but I assure you, sir, however feeble our efforts may be, it is not for want of inclination that they are not better, but the want of opportunity to improve ourselves. However, America, which has been the seat of war and desolation, I would fain hope will one day become the school of fine arts, and Monsieur Liotard['s] drawings with justice be set as patterns for our imitation." It was a nice compliment, but Copley was too truthful to keep from adding: "Not that I have ever had the advantage of beholding any one of these rare pieces from your hand, but [have] formed a judgment on the true taste of several of my friends who has seen [th]em." When the crayons arrived, Copley taught himself to use them, and became the first important American draughtsman in pastel.

At first Copley had eked out his income by doing miniatures, but already he had abandoned these as bringing too low a price, for his increasing fame had brought him sitters of higher social position until his studio was filled with the most prosperous citizens of Boston. The depression that had followed the French and Indian war was over, and the bright sun of prosperity seemed to have shrivelled up the popular party of men like Samuel Adams, who a few years before had almost started an insurrection in the name of a land bank and cheap money. The many-headed were silent; not the smallest cloud in the sky indicated that in fifteen years the country would be torn by revolution. In refusing another invitation to Halifax, Copley wrote during 1765: "I have a large room full of pictures unfinished which would engage me these twelve months if I did not begin any others. . . . I assure you I have been as fully employed these several years past as I could expect or wish to be, as more would be a means to retard the design I have always had in view, that of improving in that charming art which is my delight, and gaining a reputation, rather than a fortune without that."

Copley, however, was not indifferent to the sums he earned, for he had known poverty too well in his youth not to recognize its

power of bringing unhappiness, and he knew that in the material-istic Colonies he could command respect only if he became rich. The low opinion in which Americans held art filled him with anger. "Was it not," he wrote, "for preserving the resemblance of particu-lar persons, painting would not be known in the place. The people generally regard it no more than any other useful trade, as they sometimes term it, like that of a carpenter, tailor, or shrew-maker [shoe-maker?], not as one of the most noble arts in the world. Which is not a little mortifying to me. While the arts are so disregarded, I can hope for nothing either to encourage or assist me in my studies but what I receive from a thousand leagues' distance, and be my improvements what they will, I shall not be benefited by them in this country, neither in point of fortune nor fame."

It is a lonely task to perfect your art in a country that already considers your art fine enough, but Copley persevered. Too good a business man to paint for his own instruction pictures that he did not sell, he took advantage of his sitters' artistic ignorance by ex-perimenting on them; he knew they would accept the unsuccessful canvases as gladly as the successful ones, so long as the face was like, "that being the main part of excellence of a portrait in the opinion of our New England connoisseurs." When he admired a print after a portrait by Allan Ramsay, he copied the composition exactly, and although he required three attempts to make a replica that pleased him, he did not throw away the failures; into each he interpolated the head of one of his sitters. Several other of his portraits are adaptations of British prints.

Actually, the engravings that brought him into some contact with European art muddled rather than improved his style. Brit-ish portrait painters loved to display the richness and nobility of their sitters; poses were elegant, gowns expensive, backgrounds cluttered with the accessories of wealth. Unself-confident like most Colonials, Copley imitated the graces that flattered the British upper class, and tried to make his delighted sitters look as much like

lords and ladies as he could. In copying one print after Reynolds, he even included a replica of the little dog Reynolds's sitter held in her arms; he put the same number of pearls in his sitter's hair. These accessories may have been natural to Reynolds and the lady he painted, but they were an affectation for Copley and his patroness. Even in pictures he did not entirely imitate from prints, he often cluttered his canvases with imported detail.

In his Colonial embarrassment, he hated to paint the women of Boston in the clothes they really wore; he was to complain to West that in order to dress his women in the latest styles, he would have to import the gowns himself from England. But when, *faute de mieux,* he painted provincial costumes, he painted them with meticulous fidelity, for beneath his Colonial feeling of inferiority, beneath the self-doubt that was natural to his character, he was at heart a passionate realist who gloried in depicting things as they are. It is a remarkable tribute to the verisimilitude of Copley's brush that even his adaptations of European prints carry with them an accent of truth. And when, in the heat of creation, he forgot he was painting crude persons in a crude technique, his portraits reveal great strength and sincerity of personal vision, as his portrait of Epes Sargent shows.

Since engravings cannot reproduce the brushwork used in the paintings after which they were made, Copley was forced to work out his own style by the laborious process of trial and error. He learned few tricks from others; every detail of his technique was driven deep into his consciousness by successive acts of creation. The figures he painted, though clumsy and occasionally faulty in drawing, had a solidity not to be found in the work of many of his more brilliant English contemporaries; they looked as if they had been hewn with an ax from the hard wood of American forests. What if the silk of his sitters' gowns lacked the soft sheen of silk but seemed rather a hard, solid substance carved by the woodcutter

into folds that would remain immovable for centuries? This too added to the strength and inevitability of the impression.

Able to secure few hints on colouring from abroad, for colour printing had not been invented and the copies of European pictures he saw were usually very inaccurate, Copley was forced to work out his own palette. Many of his paintings are experiments in tones; some miserable failures, some brilliant successes whose originality and skill take your breath away. Finally he developed a personal palette; cool metallic colours; greens and tans and russets and greys laid on smoothly over large surfaces. There is none of the tinkling of little lights, none of the brilliant contrasts, none of the bravura work of the British school. His colour, evolved by the same anguish from the same mind as his brushwork, his drawing, and his characterization, blended with them to give an impression of great power.

Copley, who had trusted his own intellect only because he could find no models to copy, was not conscious of his skill; always he felt that, if he could see the work of the old masters he had read about, his own work would be proved worthless. Even moderns like West and Reynolds, he believed, must paint twice as well as he. When he heard that some of West's pictures had been imported to Philadelphia, he considered journeying to see them, but despite his passionate desire for self-improvement, he did not go. Was this due to the fear of travelling that hampered him all his life, or to the fear that he would find his own art vastly inferior?

Copley's timidity hampered him in every aspect of his life; he was so afraid of his fellowmen that he never had a friend. His intimates were always in his family circle, which was now made up of his ailing mother and his much younger half-brother Henry Pelham. For the rest, there was the long succession of sitters who streamed into his studio, but with them he had only formal intercourse. The seeker for perfection struggled so hard with his medium that he never talked while he painted, and had he talked, who

would have understood him? His mind was engrossed in an art everyone considered a menial trade. No one in the whole city, Copley· felt, was capable of appreciating what he was trying to do, and he was overcome by a sense of loneliness when his good pictures were not distinguished from his bad, when the pompous Colonial connoisseurs commented only on the likeness. Perhaps he could have escaped his isolation by surrounding himself with young men who wanted to paint, eager young craftsmen whom he could have fired with his own aspirations and ideals. A few such called on him, but were not encouraged; in his entire life he never had a pupil except his half-brother. He may have dreamed of a woman who would love and understand him, but he certainly was very shy with the ladies. When one of his kinsmen married, the contrast with his own loneliness depressed him deeply; only a desire to reach perfection in his art, he wrote, has "given me the resolution to live a bachelor to the age of twenty-eight. However, I don't despair but I shall be married, as I find miracles don't cease."

Certainly his loneliness, his desire for intelligent intercourse, helped to overcome his fears so far that in 1766 he sent a picture to London for submission to the Society of Artists. However, as soon as he had entrusted his *Boy with Squirrel* to Captain Bruce, he regretted having done so. He wrote to Bruce that he half hoped the sea voyage had so changed the colours that the picture could not be exhibited, and "I may not have the mortification of hearing of its being condemned. I confess I am under some apprehension of its not being so much esteemed as I could wish. I don't say this to induce you to be backward in letting me know how far it is judged to deserve censure, for I can truly say, if I know my own heart, I am less anxious to enjoy than deserve applause."

Captain Bruce was slow in notifying Copley how the picture was received, but the painter heard from other sources that "none but the works of the first masters were ranked with it. . . . This is an encouragement to me, I confess, and adds new vigour to the pen-

cil." Jubilantly, he wrote West to say that he was delighted to have the approval of one "from whom America receives the same lustre that Italy does from her Titiano and divine Raphael." Of course he had never seen a picture by any of the three artists he compared, but how, in his excitement, could he resist citing the great names he had seen in books? He begged West to correspond with him.

Finally a boat brought Copley two letters. The one from Captain Bruce, having repeated Reynolds's praises, added that the English master had criticized the hardness and overminuteness of the drawing, the coldness of the colours. The other letter was from West himself; it too was full of encouragement, though West wrote that the connoisseurs generally had thought the picture too "liny . . . which indeed, as far as I was capable of judging, was somewhat the case, for I very well know that from endeavouring at great correctness in one's outline, it is apt to produce a poverty in the look of one's works. . . . For in nature everything is round . . . which makes it impossible that nature, when seen in a light and shade, can ever appear liny." Both West and Reynolds urged Copley to come to Europe before his style had hardened into its provincial mould. "You have got to that length in the art," West wrote, "that nothing is wanted to perfect you now but a sight of what has been done by the great masters, and if you would make a visit to Europe for this purpose for three or four years, you would find yourself then in possession of what will be highly valuable. . . . You may depend on my friendship in any way that's in my power to serve."

At last in communication with someone he felt would understand, Copley poured out in letters to West complaints about lack of taste in America and the scarcity of good pictures to study. Then he begged his new friend to explain various points that had puzzled him in books on painting. "I shall be exceeding glad," he wrote, "to know in general what the present state of painting in Italy is; whether the living masters are excellent as the dead have been. It is not possible my curiosity can be satisfied in this by any-

body but yourself, not having any correspondence with any whose judgment is sufficient to satisfy me."

Taking to heart all the criticisms West and Reynolds had sent him, Copley determined to obviate them all in the full length of a little girl that he painted for the next London exhibition. Since Reynolds had called his colours cold, he used bright tints he did not feel, and in an attempt to keep the figure from standing out in a manner that could be called "liny," he made the background very conspicuous, confusing the picture with a red-figured turkey rug, a scarlet curtain, a yellow chair, a spaniel, and a green and yellow parrot. Although his portrait of Mary Warner was, as most modern critics agree, one of the least sincere he had ever done, he sent it off with a sense of self-satisfaction.

West wrote him that on the whole it had been less well received than the *Boy with Squirrel*. "Your picture is in possession of drawing to a correctness that is very surprising, and of colouring very brilliant, though this brilliancy is somewhat misapplied, as for instance the gown too bright for the flesh." Each part of the canvas, he added, was of equal strength in tint and finish, without due subordination to the principal parts. "These are criticisms I should not make was not your pictures very nigh upon a footing with the first artists who now paints." Again he urged Copley to come to Europe, promising to put him up in his own London house and to give introductions to all the principal Italian connoisseurs. Letters from Captain Bruce notified him of his election to the Society of Artists, and also importuned him to come abroad before it was too late.

The advisability of crossing the ocean now stared Copley in the face. He had long mourned the lack of opportunities for self-improvement in America, and now, since his new picture had been considered inferior to the *Boy with Squirrel*, he was forced to recognize that he could not profit from criticism by letter. In addition, he was most favourably situated for a European trip: he was a mem-

COPLEY: MARY WARNER (?)

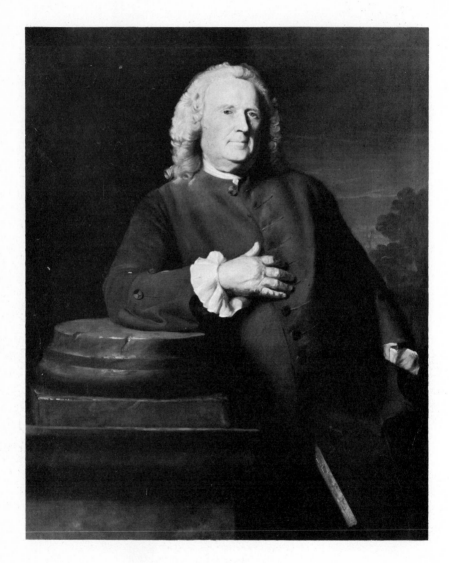

COPLEY: EPES SARGENT

ber of the London Society of Artists; the King's painter invited him to stay; he would meet all the most famous Italian connoisseurs.

Yet Copley did not jump at the chance; in his imagination, the roads of Europe swarmed with bandits eager to cut his throat. Many years later, he was to write from abroad: "It [is] curious to observe that in all the places that I have [been] in, men seem to be the same set of being, rather disposed to oblige and be civil than otherwise. . . . Robberies are very rarely known to be perpetrated. . . . I do not find those dangers and difficulties . . . so great as people do that sit at home and paint out frightful stories to themselves in their imaginations. . . . I find all the difficulty is in setting about such business." But in the 1760's, he had not yet learned this lesson.

Financial terror joined with physical fear to make Copley put behind him his desire to excel in his art for the joy of excelling. Supposing he did study in Europe, he asked in an unaddressed letter that was probably to Captain Bruce, "what shall I do at the end of that time (for prudence bids us to consider the future as well as the present)? Why, I must either return to America and bury all my improvements among people entirely destitute of all just ideas of the arts, and without any addition of reputation to what I have already gained . . . or I should set down in London in a way perhaps less advantageous than what I am in at present, and I cannot think of purchasing fame at so dear a rate."

In another letter to Bruce, Copley harps on the same theme: "I would gladly exchange my situation for the serene climate of Italy, or even that of England, but what would be the advantage of seeking improvement at such an outlay of time and money? I am now in as good business as the poverty of this place will admit. I make as much money as if I were a Raphael or a Correggio, and three hundred guineas a year, my present income, is equal to nine hundred a year in London. With regard to reputation, you are sensible that fame cannot be durable where pictures are confined to sitting rooms,

and regarded only for the resemblance they bear to their originals. Were I sure of doing as well in Europe as here, I would not hesitate a moment in my choice, but I might in the experiment waste a thousand pounds and two years of my time, and have to return baffled to America. Then I should have to take my mother with me, who is ailing. She does not, however, seem averse to cross the salt water once more, but my failure would oblige her to recross the sea again. My ambition whispers me to run this risk, and I think the time draws nigh that must determine my future fortune."

Copley wrote West that he was sending him two pictures that would show what improvements he had recently made. The subject of one would be in England; he asked West to compare the sitter to his likeness and decide whether Copley could expect to make his living as a portrait painter in London. "I must beg, however, that you will not suffer your benevolent wishes for my welfare to induce you to think more favourably of my works than they deserve." He had concluded that it would not be worth his while to go abroad unless he would not have to return to America.

When West's reply came, it showed that the court painter was puzzled by Copley's materialistic attitude. The old masters, he wrote, "to a man of powers . . . are a source of knowledge ever to be prized and sought after. I would therefore, Mr. Copley, advise your making this visit while young and before you determine to settle. I don't apprehend it needs be more than one year, as you won't go in pursuit of that which you are not advanced in, but as a satisfaction to yourself hereafter in knowing to what length the art has been carried. By this you will find yourself in possession of powers you will then feel, that cannot be communicated by words." West added that in the candid opinion of the connoisseurs "you have nothing to hazard in coming to this place," but advised Copley not to make up his mind whether he would stay in England until he had finished his studies.

Copley did not answer this letter or send any more pictures to

be exhibited in London. A new interest had joined with the discouragement of West's equivocal answer to turn his eyes back to his Colonial homeland. The new interest was love.

III

Colonial Boston was a British dependency and, like Great Britain, ruled by a few hereditary families, who were, however, merchants, not landowners. These families held by royal appointment all the higher offices in the state and looked down on Sam Adams's elective supporters as rabble; through their English connexions and the complications of the English mercantile laws they held a virtual monopoly of the trade that was the life-blood of the Colony. As a poor boy on Long Wharf, Copley had watched the great merchants strut to their warehouses, dressed in imported clothes, radiating the self-confidence of those who are born to command. And if one of them deigned to walk into Mrs. Copley's tobacco shop, how his mother curtsied behind the counter, how the little boy stared with grave-eyed wonder at such magnificence!

But the opportunities offered ability in the rapidly expanding Colony were too various to allow any oligarchy to rule unchallenged; new merchants arose to meet the ever-enlarging demand for goods, and when they found the path to prosperity closed by the monopoly the old families held under the English law, they violated the law, becoming smugglers and rebels. Rich men like John Hancock joined with Sam Adams's rabble to form a revolutionary party. Copley, the poor practitioner of a socially inferior profession, seems to have sided with these at first; his letters show that during the Stamp Act riots his sympathy was with the mob that sacked the houses of the rich.

As time passed, however, the pauper-born limner was taken up by the great. In his eagerness for self-improvement, he had modelled his manners on those of his more elegant sitters till no one could

tell he had not been born into the Colonial aristocracy. When he had been younger, we gather from his early self-portraits, his square face had been too fat, the hair growing down too low over his forehead, but now, although he had not thinned down into the handsome man he was to become in middle age, the shapelessness of his face was giving way to a look of stubborn power, a bulldog look which successful merchants must have found more impressive than graceful beauty. Although his brown-grey eyes gleamed with intelligence, they did not flit from object to object with mercurial rapidity; they fixed in a long, intense stare. Probably he spoke slowly and with deliberation, the words heavy with thought.

It was plain that Copley was sober and hard-working, and the number of his commissions indicated that he was making a good income. When he called at fine houses to arrange for portraits, his sitters got in the habit of asking him to stop in the drawing room, and soon it seemed natural for him to call when he had no portrait to paint. Sitting with his legs comfortably stretched under an imported table, a cup of the best China tea in his hand, he found himself chatting as an equal with gentlemen who had stared through him when he was his mother's errand boy. In such surroundings, he forgot his ambition to study in Europe; Benjamin West's advice faded from his mind while he heard wealthy men talk of cargo and the King's Council.

Naturally Copley was impressed by the delicate and accomplished women he now met, so different from the hoydens of the waterfront. One in particular appealed to him. Susannah Clarke, the daughter of a rich Tory merchant, had a gentle smile that made him feel at home in the elegance of her drawing room. She was handsome, but not with the cold, flashing beauty of the great belles; under soft blue-grey eyes her chin receded gently toward a soft white neck. However, she was nobody's fool and this impressed the painter too; her over-large nose jutted out strong with deeply etched nostrils; her brow was high under the upsweep of her fashionably piled

hair; and the words she spoke in a harmonious voice were clever. Copley must have known it was foolhardy for the son of a tobacconist to fall in love with the daughter of Richard Clarke, but surely his eyes did not deceive him, surely her lips smiled when he came into the room, surely she listened with interest to his passionate talk of art, to his hungry aspirations. When at last he found the courage to propose, she accepted. Probably her father was not enthusiastic about the match, but Copley was able to show that he was a hard workman in a profitable line of business which netted him three hundred guineas a year. On November 16, 1769, he married into one of the leading Tory families of Boston.

Faced with the responsibility of providing an elegant home for his elegant bride, Copley put behind him all thought of going to Europe. Perhaps he was ashamed of this, for when he wanted information about a special kind of oil paint, he wrote not to West, but to an indifferent practitioner who had emigrated from Boston to the Barbados.

His rich marriage helped his business. Soon he had invested some three thousand dollars in a twenty-acre farm with three houses on it, which took in most of what is now Beacon Hill, but was then, according to a contemporary account, "exactly like country, with trees, bushes, shrubs, and flowers." It was a magnificent site, suitable to a prosperous gentleman. His next-door neighbour was John Hancock, one of the richest men in Boston, whose mansion was a show place of the city. Copley's front windows looked out on the Common, and his back windows over the water to the hills of Brookline beyond. Many hundreds of acres that are now Back Bay had not been filled in; where the best families now live, their ancestral codfish swam.

A year after his marriage, Copley had a daughter; he seemed tied to Boston and Colonial respectability for ever, but under his feet a rumble of earthquake grew daily louder. In order to stop mob intimidation of the Royal Commissioners of Customs, the British

government had sent four regiments of regulars to Boston, where their presence stirred mounting bad feeling. Sam Adams published atrocity stories accusing them of beating babies and raping young girls; anyone might share the grief of the venerable patriarch who "the other morning discovered a soldier in bed with his favourite granddaughter." The patriots haled the soldiers into court on every pretext, while the soldiers hustled their tormentors around, pricking them with bayonets. On March 5, 1770, some small boys snowballed a sentry on King Street. When he frightened them away with his bayonet, an angry mob gathered; the sentry called the main guard. Its arrival drew hoots from the crowd, and then a shower of missiles. Losing their heads, the troops fired, killing five civilians. The famous Boston Massacre had taken place.

Conscious that an engraving of the massacre would have a large sale, Copley's pupil and half-brother, Henry Pelham, designed one immediately and sent a proof to Paul Revere, the silversmith who made the frames for Copley's pictures. When Revere published his own print of the tragedy, the one that is reproduced in millions of school books and is probably the best-known print ever made in America, Pelham wrote him the following letter:

"Sir,

"When I heard that you was cutting a plate of the late murder, I thought it impossible, as I knew you was not capable of doing it unless you copied it from mine, and as I thought I had entrusted it in the hands of a person who had more regard to the dictates of honour and justice than to take the undue advantage you have done of the confidence and trust I reposed in you. But I find I was mistaken, and after being at the great trouble and expense of making a design, paying for paper, printing, etc., I find myself in the most ungenerous manner deprived not only of any proposed advantage, but even of the expense I have been at, as truly as if you had plundered me on the highway. If you are insensible at the dis-

honour you have brought on yourself by this act, the world will not be so. However, I leave you to reflect upon and consider one of the most dishonourable actions you could well be guilty of.

"H. Pelham.

"P.S. I send by the bearer the prints I borrowed of you. My mother desired you would send the hinges and part of the press that you had from her."

Revere's engraving of the Boston Massacre overshadowed Pelham's, of which only two examples have come down to the present.

The shooting of unarmed citizens had so enraged the Boston patriots that militia companies sprang up by spontaneous generation, and a citizens' army was soon drilling on the Common under Copley's windows. Every evening just as twilight put a stop to the painter's labours, the air was riven with the shrill whistle of fifes and the menacing pound of drums. Round and round, back and forth, the apprentices and dock-hands manœuvred clumsily, fowling pieces on their shoulders. The tramp of many feet shook the floor of Copley's living room, and the peaceable artist's heart shrank within him. "I avoid engaging in politics," he wrote to his wife some years later, "as I wish to preserve an undisturbed mind and a tranquillity inconsistent with political disputes." He was not stirred by martial tunes; he hated the idea of slaughter. Looking from the window of his fine mansion at the young men drilling below, he felt again the fear and horror he had known as a small boy when he looked from the window of his mother's shop at the rowdies gouging out each other's eyes on Long Wharf.

It was during these troubled times that he received a letter from John Greenwood, his former rival, who had given up painting and become a successful picture dealer in London. Greenwood said that city was the artistic centre of the world, and that "West goes on painting like a Raphael"; he then commissioned Copley to do a portrait of his aged mother and send it across the ocean to him.

He suggested that Copley allow him to exhibit it at the Royal Academy.

Thus prodded, Copley's thoughts returned to Europe. After he had completed the picture, he wrote again to West. "I am afraid you will think I have been negligent in suffering two years to pass without exhibiting something, or writing to you to let you know how the art goes on this side of the Atlantic." Having, as usual, complained of the lack of opportunity in America "to prosecute any work of fancy for want of materials," he blamed his marriage and his sick mother for keeping him in so unpropitious a place. "Yet be assured, notwithstanding I have entered into engagements that have retarded my travelling, they shall not finally prevent it."

Actually Copley was painting better than he ever had in his life, as his double portrait of Governor and Mrs. Thomas Mifflin shows. The world should be grateful for the concatenation of circumstances that had kept him in America and had cut the leading strings which had tied him to the foreign-trained artists whose advice by letter had undermined the integrity of his vision. Languishing in what he considered exile, Copley was forced to give up for a time his ambition to be a great painter. A Boston business man eager to provide for his family, he worked at his art as if it were a craft. The untutored Colonials wanted likenesses; very well, he would give them likenesses. They had no interest in the imaginative flights that the books said made artists immortal; he put imagination behind him and, at heart a realist, painted immortal pictures. By what he considered ill-fortune, Copley achieved greatness.

However, he did not realize this. When he told West that Greenwood intended to exhibit the portrait of his mother, Copley expressed dread that the picture would not be well received. The lady was so old that he feared her portrait would make a bad impression; he would like, he wrote, to show as contrast "a subject in the bloom of youth." However, he could not do so unless he used a

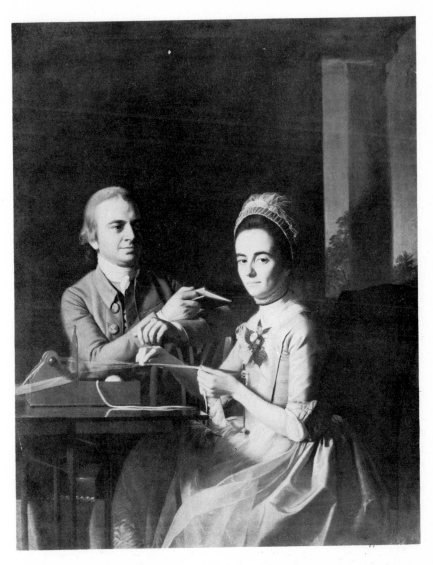

COPLEY: GOVERNOR AND MRS. THOMAS MIFFLIN

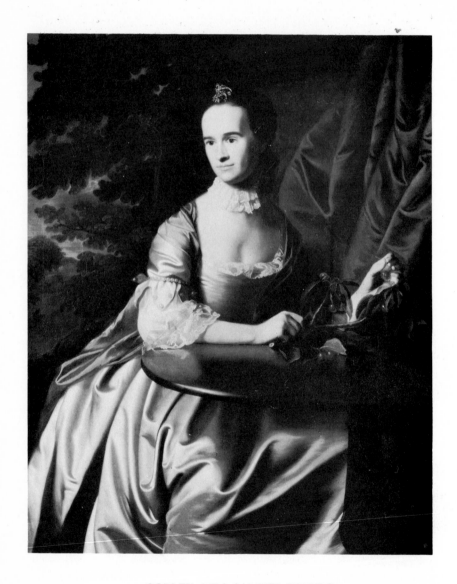

COPLEY: MRS. SAMUEL WALDO

picture already in England in the possession of John Wilkes, the famous radical. Would people, he asked, assume therefore that he agreed with Wilkes's politics? "Political contest being neither pleasing to an artist nor advantageous to the art itself, I would not have it at the exhibition on any account whatever if there is the least reason to suppose it would give offence to any person of either party." West did not exhibit the picture.

While waiting for his friend's reply, Copley made his first long journey; he rode to New York. "The city," he wrote in the words of a true New Englander, "has more grand buildings than Boston, the streets much cleaner and some much broader, but it is not Boston in my opinion yet." He stayed six months, painting about seven hundred pounds' worth of portraits. The most substantial people flocked to his studio, and even those who had been abroad, he boasted, said his were the best pictures they had ever seen. Copley rose at six, breakfasted at eight, painted until three, when he dined, and at six rode out. "I hardly get time to eat my victuals. . . . It takes up much time to finish all the parts of a picture when it is to be well finished, and the gentry of this place distinguish very well, so I must slight nothing." He missed the assistance of Henry Pelham, who usually helped him by laying in backgrounds.

But Copley was making money and that kept him cheerful; he realized the value of money as only a man who has known poverty can. "You may depend on it," he wrote to his half-brother, "I shall not send my letter in a cover, because the postage will be double if I should." Concerning a lawsuit which Pelham was handling for him, he warned: "Don't be too liberal to the lawyers; they will not do the work one bit the better."

Copley took ten days off to make the pilgrimage he had so long delayed to the works of art in Philadelphia. A copy of Titian's *Venus*, he wrote, "is fine in colouring, I think, beyond any picture I have seen," but, remembering the lesson West had given him, he

added: "I must observe, had I performed that picture, I should have been apprehensive the figures in the background were too strong." He was impressed by a *Holy Family* attributed to Correggio. "The flesh is very plump, soft, and animated, and is possessed of a pleasing richness beyond what I have seen. In short, there is such a flowery luxuriance in that picture as I have seen in no other." On his return to Boston, Copley stopped at New Brunswick, New Jersey, where he saw several portraits attributed to Van Dyck.

While he was in New York, West had notified him that his likeness of Greenwood's mother had been well received, and had again urged him to study abroad before it was too late. "I am still of the same opinion that it will every way answer your expectations, and I hope to see you in London in the course of the year."

At last Copley found the courage to write West that he would come; he would take a fishing vessel to Leghorn, study the old masters in Italy, and then proceed to London. West's reply was enthusiastic, but Copley dallied for more than a year until late in 1773 before he could make himself take the decisive step of engaging passage. That the voyage of America's leading painter to Europe was regarded all over the Colonies as a matter of patriotic importance is shown by the letters of introduction to European notables that were sent him by fellow-countrymen he had never met, including John Morgan, Philadelphia's famous physician art-lover.

After years of delay, the Colonial master was poised for flight to Italy, but he did not take off. Probably it was a political issue that kept him at home; his determination to be non-partisan had, ironically enough, suddenly thrown him into the thick of the fight for freedom. Copley was forced to play an important part in the negotiations that led up to the Boston Tea Party and thus precipitated the American revolution.

IV

Copley's father-in-law, Richard Clarke, was an agent for the East India Company and one of the consignees of the tea whose destruction was to be a turning point in American history. As soon as their names were published, the agents became the object of patriotic fury. "On the morning of the second instant," Clarke's firm wrote to their London correspondent, "about one o'clock we were roused out of our sleep by a violent knocking at the door of our house, and on looking out of the window we saw (for the moon shone very bright) two men in the courtyard." They presented a letter demanding that Clarke and his sons appear at noon the next day at the Liberty Tree "to make a public resignation of your commission. . . . Fail not, at your peril!"

All the bells in the meeting houses started ringing at eleven o'clock the next morning and continued till twelve; the town crier hurried through the streets summoning the people to the Liberty Tree. In the meantime, the consignees, supported by their male relatives, were huddled in terrified conference in Clarke's warehouse; it is quite possible that Copley was among them. They decided to stay where they were "and to endeavour with the assistance of a few friends to oppose the designs of the mob if they should come to offer us any insult or injury."

At noon the bells stopped ringing; the merchants knew the meeting was assembled, and waited to see how the popular fury would manifest itself. Finally there was a sound of distant shouting that grew louder until suddenly a mob of several hundred men poured into King Street; they gathered in front of the warehouse, and waved a forest of cudgels at the barred windows. After some negotiations, the merchants admitted a committee of nine to the counting room. As spokesman, William Molineaux demanded a promise that the tea be sent back immediately and no duty paid; despite the

roar of menacing voices below, the merchants refused. Then the mob stormed the warehouse. By taking the doors off the hinges, they broke into the lower floor, but "some twenty gentlemen" were able to defend the narrow stair to the counting room. Finally the patriot leaders, who had probably intended only to frighten the merchants, pulled the mob off. Shouting and singing, the brawny apprentices and dock-workers disappeared down King Street.

That was only the beginning. When night fell, the Clarke family received another threatening message. A letter of Henry Pelham's thus described the state of Boston: "The various discordant noises with which my ears are continually assailed in the day, passing of carts and a constant throng of people, the shouting of an undisciplined rabble, the ringing of bells, the sounding of horns in the night when it might be expected that an universal silence should reign, and all nature, weary with the toils of day, should be composed to rest, but instead of that nothing but a confused medley of the rattling of carriages, the noises of pope-drums, and the infernal yell of those who are fighting for the possessions of the devil."

On the morning of November 17, 1773, Richard Clarke's family assembled at his house to welcome a brother who had just returned from Europe; Copley was probably present, for it was an important family jubilation. "All at once," a letter to Clarke's London correspondents reveals, "the inmates of the dwelling were startled by a violent beating at the door, accompanied with shouts and the blowing of horns, creating considerable alarm. The ladies were hastily bestowed to places of safety, while the gentlemen secured the avenues from the lower story as well as they were able. The yard and the vicinity were soon filled with people." If Copley was there, he saw the nightmare that had haunted his childhood come true at last; the waterfront mob, the drunken stevedores, the sadistic bullies, had gathered to overwhelm him.

"One of the inmates [of the house]," the letter continues, "warned them from an upper story to disperse, but, getting no

other reply than a shower of stones, he discharged a pistol. Then came a shower of missiles that broke in the lower windows and damaged some of the furniture." A bloody battle seemed at hand, but at that instant some Whig leaders came galloping into the courtyard. They gathered the mob together, harangued them for a moment, and then led them down the street. Foiled of their prey, the rioters shouted over their shoulders threats for the future.

Here was a situation which every nerve in the body of the pacifist painter wished to flee. Having no interest in politics, wishing only to pursue his calling in peace, he had remained non-partisan, friendly with Hancock and Adams though a son-in-law of Clarke. But his long record of taking no sides made him the perfect person to represent the merchants in their negotiations with the patriots. When all the consignees of the tea found it expedient to flee to Castle William, the fortress in the bay guarded by British troops, Copley became their agent in Boston.

He was glad to do so, for he was moved by more than family piety; opposed to violence to the very core of his being, he was horrified by the violent path down which American politics was slipping; he knew that at the end of that path lay civil war. Since it is customary for American patriotic historians who wish to glorify the revolution to classify as Tories all those who were not in favour of extreme measures, Copley is often referred to as "the Tory painter." Many writers have explained that his economic interest lay that way, since almost all his sitters were Tories; actually his sitters were divided about equally between the two sides. He had friends on both sides. Since his own background was Whig and his wife's was Tory, he saw there was right on both sides. He realized that the English commercial laws were oppressive, but he felt their repeal could be secured by peaceful means. More clearsighted than most, he saw the fallacy in the belief of many peace-loving Colonials that violence can be turned on and off like a tap; that Parliament could be frightened into relaxing its laws and harmony be re-established.

With the insight of a quiet man who hated all brutality, he perceived that force breeds force. He saw both parties entrenching themselves into stubborn positions that could not be abandoned. He knew that if angry measures were taken to destroy the tea, compromise would no longer be possible, and knowing this, he performed what was for a man of his temperament an act of heroism: he threw himself into the fray and tried to beat down the swords of the antagonists.

Tightening his shrinking nerves to the point of action, he called on Adams, Hancock, and Dr. Warren; he argued that a violent solution of the problem of the tea would bring with it a train of calamities whose end could not be foreseen. Did he know that these men understood what he understood, that they really wanted a war of independence despite the suaveness with which they phrased their desire for ultimate compromise? Probably not. In 1775, after the hostilities had started in earnest, Copley wrote to his wife: "How warmly I expostulated with some of the violent Sons of Liberty against their proceedings they must remember, and with how little judgment, in their opinion, did I then seem to speak."

When talking to the leaders failed, the timid painter forced himself to appear before town meetings. The day after the tea arrived, the patriots assembled in Old South Church to determine on action; Copley argued eloquently for moderation. Yet the meeting voted that the tea must be returned without any duty being paid, although this would have ruined the merchants whose ships, according to the English law, would have been subject to confiscation. Copley then secured an adjournment to give him time to consult with the consignees. These gentlemen, safe behind the battlements of Castle William, were no more eager for compromise than the patriots; they sent Copley back with a flat refusal to make any concessions. His heart heavy, he carried their letter across the channel; he wandered up and down the waterfront in hesitation, past the dark corners that had terrified his childhood but that now he rarely

saw. Perhaps that evening he was not conscious where his feet had strayed, for he knew that the lives of thousands of men lay wrapped up in the paper in his pocket. It was Pandora's box; once opened in a full town meeting of Boston patriots, it would loose he shrank to think what calamities of civil war.

For a long time he paced with the slow steps of deliberation, but suddenly his footfalls were rapid in the stillness. He hurried to the slip and took a boat back to Castle William. "Mr. Copley," the Clarkes wrote their London correspondents, "on his return to town, fearing the most dreadful consequences, thought best not to deliver our letter to the Selectmen, but returned to us at night, representing this." He managed to persuade the partners to promise that they would store the tea until they received instructions from London.

After Copley had presented this compromise proposal to the meeting the next morning, the patriot orators expressed great indignation and flayed the consignees, while the crowd cheered and shouted threats. Copley seemed to be the only silent man in the meeting. Finally he pressed his white lips together, and rose to ask for the floor. A sudden stillness fell while all turned to see what the devil's advocate would suggest. If he could prevail on the Clarkes to appear, he asked, could he be assured that they would be "treated with civility while in the meeting . . . and their persons be safe till their return to the place from whence they should come?" The matter was put to a vote, and the Clarkes' safety assured unanimously. Copley then moved that he be given two hours. The motion was passed and the meeting temporarily adjourned.

Copley set out for Castle William with a slightly lighter heart; himself a disciple of peace, he was convinced that if only the adversaries could meet and talk together, they would see that both sides were made up of human beings; they would come to a compromise. It was blowing hard when he stepped into the boat that was to bear him to the castle, but the man who feared the sea was too full of the importance of his mission to be afraid. Perhaps if he

could muster his arguments well enough, he could prevent civil war. The consignees, however, were less idealistic than he; they preferred to remain behind the fortifications of the castle.

Copley argued for so long that he was very late in returning to the meeting. As he walked dejectedly down the empty street to Old South Church, he could hear the emotional soaring of an orator's voice, followed, as the voice rose in a crescendo, by a roar from the crowd. He knew that his having kept the patriots waiting had not improved their tempers. The timid painter, we may be sure, hesitated for a moment at the door before he took a deep breath and went in.

The orator in the pulpit stopped in the middle of a sentence; there was a mighty rustling as almost a thousand men turned in their seats. Copley's measured steps took him to the front of the hall, but his voice was dry and thin on the first few words he spoke. He said, according to the minutes of the meeting, "that he had been obliged to go to the castle. He hoped that if he had exceeded the time allowed him, they would consider the difficulty of the passage by water at this season as an apology." A dead silence greeted these words; everyone was wondering why Copley had returned alone.

That night Copley described in a letter to his brother-in-law how he had argued, with all the eloquence he could muster, that the consignees had refused to appear, not for fear of being attacked, but because they felt that their presence would only further enrage the meeting if they did not do what the meeting wanted. Their opposition to the patriots' demands, he insisted, was not due to "obstinacy and unfriendliness to the community, but rather to the necessity to discharge a trust, a failure in which would ruin their reputations as merchants, and their friends who had put large sums of money in the enterprise. . . . I further observed you had shown no disposition to bring the tea into the town, nor would you; but only must be excused from being the active instruments in sending it back." He had assured the patriots that this promise

would enable them to achieve their ends by peaceful means, since if the tea remained unloaded the captains of the boats would eventually have to take it back on their own initiative.

"In short," Copley continued, "I have done every possible thing, and although there was a unanimous vote passed declaring this unsatisfactory, yet it cooled the resentment and they dissolved without doing or saying anything that showed an ill-temper to you." Fifteen days later, however, the patriots dressed themselves as Mohawks and threw the tea into the bay, lighting, despite Copley's best efforts, the fuse that was to detonate the American revolution.

The only result of Copley's intervention was to make him an object of suspicion to the more rabid patriots; as Henry Pelham complained in his letters, anyone not in favour of violence was branded an enemy of liberty. During April 1774 the painter entertained Colonel George Watson, a British mandamus commissioner. He wrote to his brother-in-law that at about midnight, some hours after Watson had left, "a number of persons came to the house, knocked at the front door, and awoke Sukey [his wife] and myself. I immediately opened the window and asked them what they wanted. They asked if Mr. Watson was in the house. I told them he was not. They made some scruples of believing me, and asked if I would give them my word and honour that he was not in the house. I replied: 'Yes.' They said he had been here, and desired to know where he was. I told them . . . he was gone, and I supposed out of town. . . . They then desired to know how I came to entertain such a rogue and villain."

Copley tried to placate the growing mob by telling them that Watson had been to see Hancock earlier in the day; in any case, he had left. The rioters seemed satisfied and went off up the street, but they were soon back, milling under his window and giving the "Indian yell." Copley leaned out and said he thought he had convinced them Watson was not there. "They said they could take no man's word," the painter's letter continues. "They believed he was

here, and if he was they would know it, and my blood would be on my own head if I had deceived them, or if I entertained him or any such villain for the future." After much more talk between the timid artist at the window and the brawny men below, a chaise with the curtains down came galloping up. Its mysterious occupant called over the leaders, conferred with them for a minute or two, and then the chaise moved off with the crowd following behind in a tight, grumbling mass. The street became as quiet as it had been in those now almost unbelievable years before Americans had grown to hate each other.

Copley was deeply shaken. "What a spirit!" he wrote. "What if Mr. Watson had stayed, as I had pressed him to, to spend the night! I must either have given up a friend to the insult of a mob, or had my house pulled down or perhaps my family murdered."

V

It is a strange fact that some three weeks after the mob had threatened his house and family, Copley set out for his long-delayed trip to Europe, leaving behind in faction-torn Boston his invalid mother, his half-brother, his wife and four small children. He had put off his transatlantic studies for years, waiting for a propitious time; why did he pick this time that of all seems the most unpropitious? Perhaps he felt that it was a matter of now or never. He foresaw civil strife, but his letters home make it clear that he did not expect major trouble to come as soon as it did. Perhaps he hoped to rush through his studies in Italy, and be in a position to support his wife and children in England by the time the revolution started. However modern writers may fulminate in the name of patriotism to a nation then non-existent, it did not seem treason to Copley to flee a civil war he thought unnecessary by going to the capital of the nation of which he had always been a subject.

Copley must have sailed with a heavy heart. Not only was he

leaving his family at a difficult time, but he was embarking to face terrors from which he had shrunk for years: an ocean voyage, life among strangers, the roads of Europe, which he believed crawled with bandits waiting to cut his throat. So dark were his anticipations that the reality he found seemed almost unbelievably rosy; his letters from England are cheerful in the extreme. He was amazed by the genteelness of the public coaches and the inns. The retiring painter, who had never gone out of his way to be friendly to strangers, was deeply impressed by the courtesy with which he was received in London. "There is a great deal of manly politeness in the English," he wrote. West invited him to come to dinner every evening when he was not otherwise engaged, introduced him to Reynolds, and took him to the Royal Academy, where the Bostonian, used to the prudery at home, was surprised to find that "the students had a naked model from which they were drawing." Starved so long for good artistic talk, he plunged into endless discussions with his English colleagues; the thirty-six-year-old Colonial, who had already painted immortal pictures, asked questions that a modern art student would hardly deign to answer. He had always wondered, for instance, how you executed an imaginative picture containing several figures. "I find the practice of painting or rather the means by which composition is attained easier than I thought it had been," he wrote to Henry Pelham. "The sketches are made from the life, and not only from figures singly, but often by groups. This, you remember, we have often talked of, and by this a great difficulty is removed that lay on my mind."

For all the courtesy with which he was received, Copley felt timid and strange. He was glad to stay with other Colonials at the New England Coffee House, and one of the most ecstatic passages in his letters describes a dinner at the home of the Royal Governor of Massachusetts, who had shortly before found Boston too hot to hold him. "There were twelve of us together, all Bostonians, and we had choice salt fish for dinner."

When Copley left for the Continent after six weeks in London, he was delighted to go with George Carter, an English painter who he hoped would protect him in the terrifying mazes of Europe. "Mr. Carter," he wrote to his mother, "[is] well versed in travelling, has the languages, both Italian and French. This makes very convenient and agreeable. He is a very polite and sensible man who has seen much of the world. It is most probable one house will hold us both at Rome, and the same coach bring us back to England."

However, Copley leaned too heavily on his new friend, for he did not find France to his liking. Although the scenery was picturesque, "the victuals were so badly dressed that even Frenchmen complained of it. . . . You must know those French wines are not so strong as our cider." The continual complaining of his companion irritated Carter. "Sir," he said to Copley, "we are now more than eight hundred miles from home, through all which way you have not had a single care that I could alleviate. I have taken as much pains as to the mode of conveying you as if you had been my wife, and I cannot help telling you that she, though a delicate little woman, accommodated her feelings to her situation with more temper than you have done."

Carter's diary is full of such irritated references to Copley. "This companion of mine is rather a singular character. He seems happy at taking things at the wrong end, and laboured near a half-hour today to prove that a huckaback towel was softer than a Barcelona silk handkerchief. . . . My agreeable companion suspects he has got a cold upon his lungs. He is now sitting by a fire, the heat of which makes me very faint, a silk handkerchief about his head and a white pocket one about his neck, applying fresh fuel and complaining that the wood of this country don't give half the heat that the wood of America does; and has just finished a long-winded discourse upon the merits of an American wood fire to one of our coal. He has never asked me yet, and we have been up an hour, how I do or how I passed the night; 'tis an engaging creature."

Carter continually teased Copley because he knew no language but English, and the two men quarrelled like children about the merits of their respective countries. Sarcastically, Carter describes Copley holding forth on the future of America, insisting that in less than a hundred years it would have an independent government, and that "the woods will be cleared, and lying in the same latitude, they shall have the same air as in the South of France. Art would then be encouraged there and great artists arrive."

Here is Copley's travelling costume as Carter described it: "He had on one of those white French bonnets which, turned on one side, admit of being pulled over the ears; under this was a yellow and red silk handkerchief, with a large Catherine-wheel flambeaued upon it, such as may be seen upon the necks of those delicate ladies who cry Malton oysters—this flowed half-way down his back. He wore a red-brown or rather cinnamon greatcoat with a friar's cape, and worsted binding of a yellowish white; it hung near his heels, out of which peeped his boots. Under his arm he carried the sword which he bought in Paris [for protection against bandits, we may be sure], and a hickory stick with an ivory head. Joined to this dress, he was very thin, pale, a little pock-marked, prominent eye-brows, small eyes which after fatigue seemed a day's march in his head."

Copley soon lost his high opinion of his companion. "He was," the Colonial wrote, "a sort of snail which crawled over a man in his sleep, and left its slime and no more."

From Genoa, the last major stop before he reached Rome, Copley poured out his loneliness and ambition to his wife. "I am happy to be so near the end of my journey. Though not fatigued, I am impatient to get to work, and to try if my hand and my head cannot do something like what others have done, by which they have astonished the world and immortalized themselves, and for which they will be admired as long as this earth shall continue." But he was afraid that his art would separate him from his family. "As

soon as possible, you shall know what my prospects are in England, and then you will be able to determine whether it is best for you to go there or for me to return to America. It is unpleasant to leave our dear connexions; but if in three or four years [in England] I can make as much as will render the rest of our life easy, and leave something to our family if I should be called away, I believe you would think it best [for me] to spend that time there. Should this be done, be assured I am ready to promise you that I will go back and enjoy that domestic happiness which our little farm is so capable of affording."

But the thought of spending three or four years away from home overwhelmed him with emotion. "Although the connexion of man and wife as man and wife may have an end, yet that of love, which is pure and heavenly, may be perfected. Not that my love is not as perfect as it can be in the present state, but we may be capable of loving more by being more conformed to the infinite source of love. I am very anxious lest you suffer by my absence."

In Rome Copley rushed to the galleries, stared for hours at the paintings of the old masters, and then tried immediately to put his new technical discoveries down on canvas. All his life he had believed that greatness existed only in Europe and the past. Faced at last with the pictures about whose glories he had read, he had no more interest in the technique he had laboriously worked out for himself during long years of isolation; the style that was to make him immortal seemed now worthless. He preferred to imitate the Caraccis and Raphael. And he adhered to this determination, although like West before him he did not find the old masters as wonderful as he had dreamed they would be; he wrote to Pelham that the difference between Titian and Raphael and the common run of painters was not so great as he had been led to suppose by the fame they enjoyed.

The first picture he painted in Italy, a double portrait of Mr. and Mrs. Ralph Izard, is symbolic of his state of mind. The two figures

are painted much in his old style, but he widened the canvas to include the following objects in the background: an antique Greek vase, a classic column, a richly embroidered curtain, some heavily carved furniture in the latest Italian mode, the statue of Orestes and Electra he had seen in the National Museum, and the Colosseum done in chocolate colour. He wanted to get in everything at once.

Pleased with the result, he painted *The Ascension,* the first complicated composition he had ever attempted. After months of toil, he turned out a pleasant enough imitation of Raphael. "Mr. [Gavin] Hamilton," he wrote to Pelham, "is lavish in its praises, and he says he never saw a finer composition in his life, and that he knows no one who can equal it." Copley determined then and there to set up as a historical as well as a portrait painter. He confided to Pelham that Hamilton, who had shared with West the leadership of the English neo-classical school, had told him he was better equipped than West, since he could do portraits as well as history.

Copley was now enamoured by the vision of a successful English career. When his wife wrote to him that Boston, occupied by five British regiments, had become highly unpleasant, he replied: "I find you will not regret leaving Boston; I am sorry it has become so disagreeable. I think this will determine me to stay in England. . . . But to give you the trouble of crossing the sea with the children makes me very anxious."

Soon he had more cause for anxiety; late in September 1774 he read in a London paper that British battleships were bombarding Boston. Although the report was contradicted in the same paper, he was very worried, nor could he set his mind at rest till he received a letter from his wife a month later.

He now arranged to get London papers by every post—once or twice a week—and when they arrived he picked them up "with trepidation." He wrote to Pelham: "Could anything be more for-

tunate than the time of my leaving Boston? Poor America. I hope for the best but I fear the worst. Yet certain I am she will finally emerge from her present calamity and become a mighty empire. And it is a pleasing reflection that I shall stand amongst the first of the artists that shall have led the country to the knowledge and cultivation of the fine arts, happy in the pleasing reflection that they will one day shine with a lustre not inferior to what they have done in Greece and Rome." In the same letter, he expressed his determination to settle in London. Had he left Boston before he did, he was to explain, "it would have done more violence to myself and dear wife to have fixed in England. But now there is no choice left."

In June 1775 he left for Parma to copy Correggio's *St. Jerome.* No sooner had he arrived than he received a letter from Greenwood saying that civil war had started in America, and that some two hundred people had been killed already. Frantically, Copley tried to find some English papers, but none was to be had. All he could learn was rumour, and that became increasingly alarming. "I have seen a letter from Rome," he wrote to his mother, "by which [I] find mention is made of a skirmish having been at Lexington, and that numbers were killed on both sides. I am exceedingly uneasy, not knowing to what you may be exposed in the country that is now become the seat of war. This is the evil I greatly dreaded while I was in America. Sure I am the breach cannot now be healed, and that [the] country will be torn in pieces, first by the quarrel with Great Britain until it is a distinct government, and then with civil discord till time has settled it into some permanent form of government. What that will be no man can tell. Whether it will be free or despotic is beyond the reach of human wisdom to decide."

When a letter came from Pelham, it was not reassuring. "Alas! My dear brother, where shall I find words sufficiently expressive of the distractions and distresses of this once flourishing and happy people. . . . My hand trembles when I inform you that sword

of civil war is now unsheathed." Pelham, whose sympathies were Tory, then described the battle of Lexington quite differently from the descriptions we find in American textbooks. The British "regulars made a retreat that does honour to the bravest and most disciplined troops that ever Europe bred. The fatigues and conduct of this little army is not to be paralleled in history. They marched that day not less than fifty miles, were constantly under arms—part of them at least—from ten o'clock at night till an hour after sunset the next evening, the whole of the time without any refreshment, attacked by an enemy they could not see, for they skulked behind trees, stone walls, etc., and surrounded by not less than ten thousand men, who most vigorously assaulted them with fresh men. In short, considering the circumstances it was almost a miracle they were not entirely destroyed. When the battle ended, they had not near a charge a man."

Since then Boston, which had remained in the possession of the British, had been besieged and blockaded by the patriots. "It is inconceivable the distress and ruin this unnatural dispute has caused this town and its inhabitants. Almost every shop and store is shut. No business of any kind going on. You will here wish to know how it is with me. I can only say that I am with the multitudes rendered very unhappy; the little I have collected entirely lost. The clothes upon my back and a few dollars in my pocket are now the only property which I have the least command of. What is due me, I can't get, and I have now a hundred guineas' worth of business begun which will never afford me a hundred farthings."

This news was bad enough, but Copley was terrified lest he hear worse. "It may be," he wrote to his Tory half-brother, "for my fears suggest many terrible things, that you are called to arm yourself. But if you should be, it is my injunction that you do not comply with such a requisition, if this does not come too late, which I pray God it may not. . . . I have this exceedingly at heart and trust you will implicitly oblige me in this way. I conjure you to do as I

desire! For God's sake, don't think this a trifling thing! My reasons are very important. You must follow my directions, and be neuter at all events."

Copley wrote letter after letter to his wife, urging her to leave Boston with the children at once. "I should fly to you, but the distance is too great. . . . I find there is a great deal of work in the picture I am copying. My anxiety almost renders me incapable of proceeding with it, but it must be done." Communication was so interrupted that he did not learn his wife had sailed until he received word of her safe arrival in London. "My thoughts are constantly on you and our children," he wrote her. "You tell me you brought *three,* but do not say which you left behind. I suppose it was the youngest, he being too delicate to bring." Copley had guessed right; it was the youngest, who was soon to die in beleaguered Boston.

When Copley heard that Henry Pelham had stayed behind because their aged mother was afraid to make the arduous trip across the ocean, he wrote him long and eloquent letters pointing out the danger of remaining. The English, he insisted, would "pursue determined methods" because they "so resent the outrage offered to them in the destruction of the tea." If only the patriot leaders had taken his advice! But now it was too late for anyone to retract. Although the Americans would win after many years, "oceans of blood will be shed . . . the different towns will have at different times to encounter all the miseries of war, sword, famine, perhaps pestilence." The only thing to do was to flee while there was yet time.

Pelham's letters confirmed his melancholy prophecies. "Mrs. Copley desired we would write a word when we met with fresh meat. You will form some idea of our present disagreeable situation when I tell you that last Monday I eat at General Howe's table at Charlestown Camp the only bit of fresh meat I have tasted for very near four months past. And then not with a good conscience, con-

sidering the many persons who in sickness are wanting that and most of the conveniency of life."

Two months later he summed up the state of mind of the thousands of peaceful folk whose emotions rarely find their way into history books. "Civil war with all its horrors now blasts every tender connexion, every social tie upon which the happiness of mankind so materially depends. We are now unhappily afloat in one common ruin, and have only left us the mortifying remembrances of those halcyon days of ease and peace which we now in vain wish to re-enjoy."

"We still continue in the same state . . ." he wrote from Boston during January 1776. "Both sides strengthening their works, and preventing the other from receiving supplies. Pork and peas, and little enough of that, still continues to be our diet; a baked rice pudding without butter, milk, or eggs; or a little salt fish without butter, we think luxurious living. Lamenting our most disagreeable situation is the only theme of our discourse. Contriving ways and means to get a pound of butter, a quart of peas, to eat; or three or four rotten boards, the ruins of some old barn, to burn, our only business; and the recollection of having some friends at a distance from this scene of anarchy and confusion almost our only happiness. . . .

"I don't think if I had liberty I could find the way to Cambridge, though I am so well acquainted with the road. Not a hillock six feet high but what is entrenched, not a pass where a man could go but what is defended by cannon. Fences pulled down, houses removed, woods grubbed up, fields cut into trenches and moulded into ramparts, are but a part of the changes the country has gone through."

Doggedly Copley finished his copy of the Correggio and, although his heart must have burned to join his exiled wife in London, he continued the journey that was to prepare him to make his living in that sophisticated city. He went to Mantua, Venice, Innsbruck,

Augsburg, Stuttgart, Mannheim, Coblentz, Cologne, Düsseldorf, Utrecht, Amsterdam, Leiden, Rotterdam, Antwerp, Brussels, Ghent, Bruges, Lille, and then hurried through Paris to London, arriving late in 1775.

It was a great joy to embrace his wife and children, but the re-united family could find no high spirits with which to face the future in the strange and difficult city to which they had fled. Most of their relations and friends, all the world they had ever known, were menaced and racked by civil war. "As to England," Mrs. Copley wrote to Henry Pelham, "you must not expect from me any account of it at present, for my thoughts are so intent upon America that at times I can scarcely realize myself to be out of it. I have not had the least inclination to visit any of the public places of entertainment . . . for I think we are so made for each other that we cannot be happy when we have reason to think our friends are exposed to distress. . . . Every account increases my distress. I pray heaven to prepare me for all events!"

VI

The strain gradually lessened, for by the time Washington oc-cupied Boston all of Copley's close relatives had found refuge in British possessions; yet the environment in which he moved was hardly cheering. Like many an American after him, the painter found that the English who had received him so politely when he was a stranger were not eager to make him a friend. Although not a Tory, he was forced to rely on the society of the Tory refugees. He attended the weekly dinners of the Loyalist Club, where talk ran drearily on war and poverty; the émigrés, whose American property had been confiscated, complained of empty purses with all the ardour of the new poor. Copley was able to join in the chorus, for his savings were tied up in Boston real estate and his painting brought in little money. Although he was elected an asso-

COPLEY: THE COPLEY FAMILY

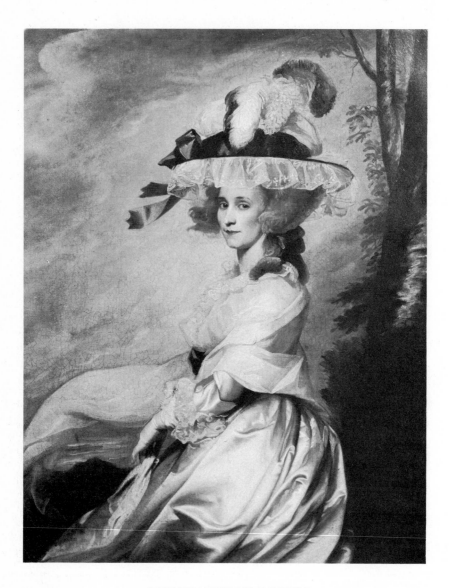

COPLEY: ABIGAIL ROGERS

ciate of the Royal Academy over twenty other candidates; although Benjamin West used all his vast influence to get him commissions, he made so little that his impoverished father-in-law had to help in his support.

Copley soon found himself in a mood where even slight mishaps seemed overwhelming. To cut short his Roman stay, he had bought casts of the most important antique statues to study in London. They were so badly packed, however, that they arrived in fragments, a misfortune which, his son tells us, "he never ceased to regret during the whole course of his after life."

Copley mourned the casts that were to smooth out the roughness of his Colonial technique with increasing intensity, for his lack of immediate success in England further convinced him that he must abandon the crudely honest approach he had worked out for himself in isolation and learn to paint like the fashionable British artists. With all the painstaking consciousness of his nature, the middle-aged master imitated their style, and he was so successful that his work underwent an almost complete change. The portrait of Mrs. Rogers he did in 1784 is painted in a new palette of very bright colours. Gone are the firm, metallic draperies set in folds that have the permanence of rock, gone the stilted bourgeois backgrounds; the picture is a swirl of sunset skies and plumy, fashionable clothes. But what of the face? In the mass of gleaming colour and brilliant brushwork, the face has become insignificant. Though it is pretty and brightly drawn, there is hardly anything left of the insight into character, the stern, intellectual beauty, that were once the glory of Copley's work. Undoubtedly this picture, like most of the pictures of his first English period, is more brilliantly painted than anything he did in America, but it is curiously unconvincing. The brush strokes, the colours, the composition are all correct, but they seem to be without meaning. They seem to be an anthology of suave tricks which the artist did not feel in his heart.

However, Copley, the Colonial who had never believed in his own virtues, was delighted with his new style, for it brought him business; soon his studio was filled with portrait sitters. And when, imitating West, he carried his glittering technique into historical painting, he had a great success.

The death of the elder Pitt, the Earl of Chatham, who suffered a stroke while addressing the House of Lords, furnished a dramatic scene that interested every Englishman. Both West and Copley started pictures of it. "Mr. West," Walpole wrote, "made a small sketch of the death of Lord Chatham, much better expressed and disposed than Copley's. It has none but the principal persons present; Copley's almost the whole of the peerage, of whom seldom so many are there at once, and in Copley's most are mere spectators. But the great merit of West's is the principal figure, which has his crutch and gouty stockings, which express his feelings and account for his death. West would not finish it not to interfere with his friend Copley."

Copley worked on *The Death of Chatham* for two years; he included the portraits of more than fifty noblemen, most of them painted from life. Dressed in state robes of ermine and scarlet, they are grouped around the Prime Minister, who has just fallen over backwards into the arms of his son. The canvas holds together amazingly well considering the number of faces included, but it was impossible to carry a unified emotion through such a hoard of likenesses; the picture seems formal rather than emotional. Yet it is startling in the glow of its colour, in its movement, and in the concise sharpness of the myriad portraits. It is polished and finished from ermine to feather, from glossy boot and shoe to glistening buckle and star. The technical brilliance displayed is almost unbelievable when we remember that Copley had been painting in the style only a few years. Critics who do not like West's work regard Copley's *The Death of Chatham* as the greatest historical painting ever done in England.

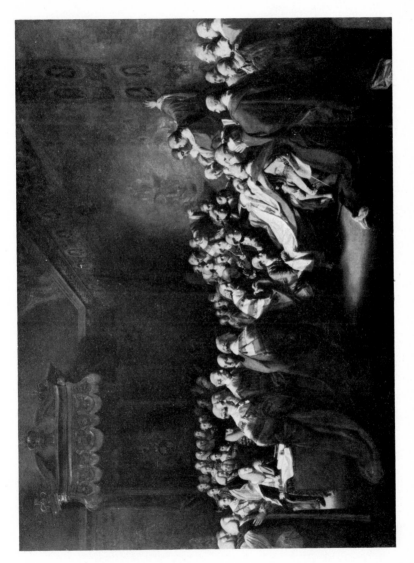

COPLEY: THE DEATH OF CHATHAM

COPLEY: STUDY FOR THE DEATH OF MAJOR PIERSON

In 1781, the members of the Royal Academy looked forward to the crowds which so fine a rendering of so popular a subject would bring to their exhibition, but Copley, who had already refused fifteen hundred guineas for the picture and had sold subscriptions for twenty-five hundred large engravings, decided it would be profitable to show *The Death of Chatham* by itself and charge admission. Choosing the "season," when the city was fullest, he scheduled his private exhibition at the same time as the academy's exhibition. His fellow-artists were so infuriated that they forced his landlord to evict him from the show room he had rented. When he found another, Sir William Chambers, the famous architect, wrote him their sentiments: "No one wishes Mr. Copley greater success, or is more sensible of his merit, than his humble servant, who, if he may be allowed to give his opinion, thinks no place so proper as the Royal Exhibition to promote either the sale of prints or the raffle for the picture, which he understands are Mr. Copley's motives. Or, if that be objected to, he thinks no place so proper as Mr. Copley's own house, where the idea of a raree-show will not be quite so striking as in any other place, and where his own presence will not fail to be of service to his views."

More than twenty thousand people paid to see Copley's picture, while the receipts of the Royal Academy exhibition, which contained seven Gainsboroughs and fifteen Reynoldses, fell a third, or more than a thousand pounds, from the previous year. Copley's private show, as the *Morning Post* estimated, made him about five thousand pounds, but it also made him many enemies. It was bruited about that the prints of *The Death of Chatham* had been distributed fraudulently, the early impressions not having gone to the early subscribers, and all the expert witness Copley could bring forth did not entirely silence the rumour.

The merchants who had worshipped Chatham flocked to Copley to have their portraits done; he was soon in the full tide of prosperity. He achieved the greatest ambition of a Colonial by becom-

ing a successful painter in the mother city, yet he was not happy.
Never a man who made human contacts easily, he found the Eng-
lish stiff and hard to get on with; their manners seemed to him
overbearing. Used to being the leading painter of a continent, he
felt undervalued in an environment where others had greater repu-
tations than he. He became particularly jealous of the man who
had made his English career possible; although he frequented
West's studio and seemed as friendly as ever, the keen eye of Hopp-
ner observed that whenever West made a suggestion at a meeting
of the Royal Academy, Copley opposed it.

As Copley grew increasingly homesick for Boston, the unending
denunciations he heard of the American rebels drove him so far
from his non-partisanship in politics that he began to believe the
revolution he had once opposed a glorious thing; the former peace-
maker became a rabid patriot. When in 1782 he painted the Ameri-
can merchant Elkanah Watson, he resolved to place in the back-
ground "a ship bearing to America the acknowledgments of our
independence." Such a ship should fly the stars and stripes, but
the cautious painter was afraid to depict that revolutionary flag
lest he offend his other sitters. For a long time the picture stood
against the wall unfinished. On December 5, however, he accom-
panied Watson to the House of Lords to hear the King acknowl-
edge American independence. Sitting there with as non-committal
an expression as he could muster, he saw West also in the audience,
also holding a vacant look. But when the meeting was over and the
King had pronounced, though hesitantly, the fatal words, Copley
in great excitement invited Watson to return to his studio. "There,"
his sitter wrote in his diary, "with a bold hand, a master's touch,
and I believe an American heart, he attached to the ship the stars
and stripes. This, I imagine, was the first American flag hoisted in
England."

Copley's historical paintings continued to bring him money and
renown. When the Corporation of London commissioned him to

paint *The Repulse of the Floating Batteries at Gibraltar,* he laid out a vast canvas, twenty-five feet by twenty, on which he worked laboriously for six years. A visitor to his studio reported that he was literally fighting the battle in his studio, for he had models of the rock, the fortifications, the attacking ships, the guns, and even of the men. These he soberly grouped into the composition he desired. He stood on a platform, and fixed his canvas to rollers so that he could manipulate any part of it within reach of his brush. During 1787, the Corporation of London sent him to Germany, where he painted the portraits of four Hanoverians who had taken part in the defence.

When the picture was finally completed in 1791, he could find no gallery large enough to contain it; he set up a tent in the Green Park. But the crowds who flocked to see the structure angered the fashionable residents of Arlington Street, particularly the Duke of Bolton, and Copley was forced to move to another site. Here, however, his huge pavilion obstructed the view of some householders. Copley was forced to move again. He was in despair, until the King came to his rescue, inviting him to put the tent near Buckingham Palace. *"My* wife," he is reported to have said, "won't complain." The royal family attended the opening, and some sixty thousand people followed their example. Again Copley offered competition with a Royal Academy show, and took away so much business that it was a failure.

Fame and prosperity did not keep the artist from becoming increasingly homesick, and when his two youngest children, who had been born in England, died within two weeks of each other during an epidemic of "putrid sore throat," probably diphtheria, his wife received a shock from which she never recovered. From that time on she, like her husband, walked about their elegant house with a perpetually melancholy face. Wild and meaningless apprehensions scudded through the minds of the nervous pair. Although money was rolling in, the spectre of poverty haunted them continually;

Copley felt so alien to his English environment that he was sure it would rise up and overwhelm him in the end. Eager to capitalize on the American savings he had invested in his eleven acres of Beacon Hill, he placed them on the market and in 1795 was delighted to receive an offer of three thousand guineas, about five times what he had paid. Only after he had accepted the offer and a thousand-dollar deposit did he learn that the new State House was to be built on Beacon Hill, and that what he had regarded as farm land would soon become a flourishing part of the city.

Indignantly insisting that he had been defrauded, he sent his young barrister son, John Singleton, Jr., to America to see if he could break the contract. Now that his last tie to America seemed about to be taken from him, Copley felt a wild urge to return to his homeland, to the land where he would again be the most famous of painters, to the land whose social liberty he had grown so passionately to desire. Although his wife dreaded leaving the mild British climate and the greater comfort of their London home, Copley instructed his son to look into the possibility of their returning to America. He gave the boy a letter of introduction to his old opponent, Samuel Adams. The then governor of Massachusetts, whose radicalism made him anathema to the moneyed classes of Boston, must have read with amazement the sentiments of the man who had tried to stop the revolution, for the painter complimented him on having "borne so distinguished a part in promoting the happiness and the true dignity of his country."

After the younger Copley had arrived in Boston, he wrote to his sisters: "Shall I whisper a word in your ear? The *better* people are all aristocrats. My father is too rank a Jacobin to live among them." And twenty years before Copley had been regarded by many as a Tory!

Although the boy was to make a great career in England in the law, he was unable to reclaim the farm, and its loss seemed so

overwhelming to Copley that he gave up all hope of returning to America. Innumerable witnesses state that the transaction in which he got only five times his original investment remained like an open wound in his mind, embittering the rest of his life. Sixteen years later Farington wrote in his diary that Copley complained that the property he had sold for a few thousand pounds was now worth a hundred thousand. "Upon this he ruminates, and with other reflections founded on disappointments, passes these latter days unhappily."

Indeed, from the time of the loss of his farm Copley's star descended rapidly. In 1798, the war with France joined with the Irish rebellion to suck England into an economic depression that deepened all through the Napoleonic period. Only the most fashionable painters were able to make a living, and even their incomes were greatly reduced. Out of pity, the Prime Minister excluded artists from the war tax. Copley was not one of the most fashionable painters; after a lifetime of dreading such an eventuality, he found himself on the brink of poverty.

And now, when more than ever Copley needed his skill, a strange blight came over his ability to paint. Each succeeding picture turned out less happily. Still trying to duplicate West's triumphant career, he turned to religious subjects—*Hagar and Ishmael, Abraham's Sacrifice, Saul Reproved by Samuel*—but they were not greatly admired. His new historical paintings did not succeed like the old; he was refused permission to show his *Duncan's Victory at Campertown* in the Green Park as he had shown *Gibraltar;* he had to set up his tent in a nobleman's private garden, and hardly anyone paid to see the picture.

Difficulties with engravers threw him increasingly into debt. Sharp, whom he had commissioned to make a print of *Gibraltar*, dawdled for years without even starting the plate; the subscribers demanded their money back. And when Copley commissioned a

small print of *The Death of Chatham* for sale to the masses, the delivered plate was so bad he dared not publish it. He refused to pay the engraver, and the engraver sued. Bartolozzi, who had made the large print of the same subject, appeared for his colleague. "Do you see, sir," Copley's attorney asked Bartolozzi, "in your own [print] the youngest son of Lord Chatham in a naval uniform bending forward with a tear in his eye and a countenance displaying the agony of an affectionate son on beholding a dying father; and do you see in the other an assassin, with a scar upon his cheek, exulting over the body of an old man whom he has murdered? . . . In one, the Archbishop of York appears in his true colours as a dignified and venerable prelate; in the other, his place is usurped by the drunken parson in Hogarth's *Harlot's Progress*. In one, the Earl of Chatham is supported by his son-in-law, Lord Stanhope, a figure tall, slender, and elegant; does not the other offer to view a short, sturdy porter of a bagnio, lugging home an old lecher who has got mortal drunk?" Bartolozzi denied all this, and was followed on the stand by "an immense number of engravers" who praised the contested print. Copley's attorney then called many painters—West, Beechey, Opie, Cosway, Hoppner—who insisted Copley could not publish the print without hurting his reputation. In his charge to the jury, the judge professed total ignorance of art, and the jury ruled that Copley must pay for the engraving. Thus the artist lost nearly a thousand pounds.

Since he needed to execute some great work to revive his waning fortunes, he enthusiastically agreed to paint one of the largest conversation pieces in history; it was to show a country squire, Sir Edward Knatchbull, with his second wife and ten children. When the squire said that he missed the portrait of his first wife, Copley, in his eagerness to do something startling, suggested hanging her from the sky as one of a group of angels. Convinced that the longer he worked on a picture the better it would be, and at best one of the slowest of painters, he mulled over every figure for months on

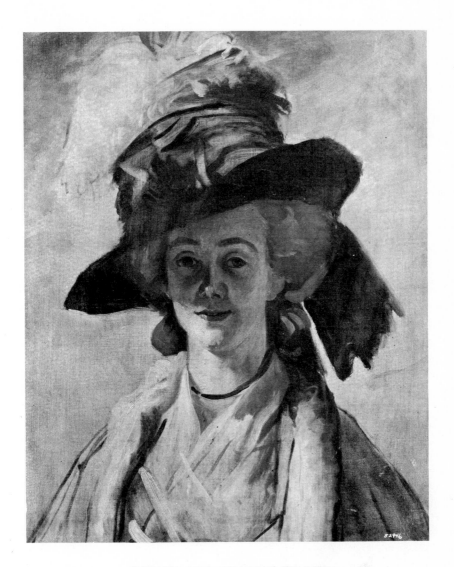

COPLEY: MRS. CHARLES STARTIN

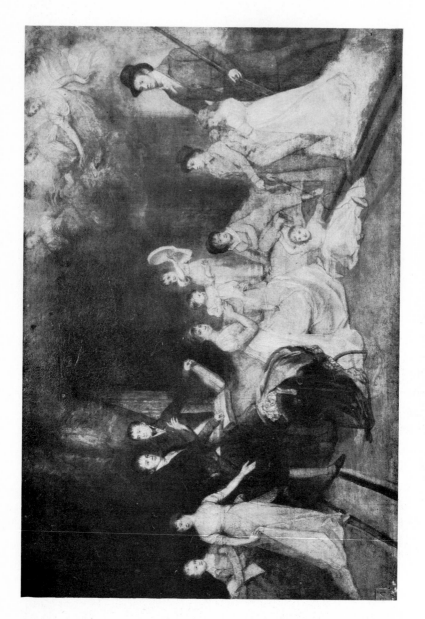

COPLEY: SKETCH FOR THE KNATCHBULL FAMILY

end, until Knatchbull's youngest child, seeing him around the house so much more often than her father, made a natural mistake and called him "daddy."

After two years, the dogged painter began to near the end, but at that moment Knatchbull's second wife died. The squire married again and insisted that his third wife be put in the picture in place of the second, while the second, now also an angel, be suspended in the clouds beside the first. Copley was so eager to please that he laboriously rearranged the composition, but just as the picture again neared completion, Knatchbull appeared to say that his new wife was pregnant; a likeness of the baby, as soon as it came, must be inserted. The bewildered painter, who had put so much effort into the canvas, did not dare disagree; again much of the picture was repainted.

Working with all the relentless determination of his nature, Copley hardly allowed himself time to eat and sleep; he could not even spare a moment to write to his elder daughter, congratulating her on the birth of his first grandchild. "Sir Edward Knatchbull's picture has confined us to London," the younger daughter complained during the heat of midsummer. Life was dull while the painter slaved away interminably and no one came to call; the painter lacked time for friends. "There have been balls, masquerades, and fêtes without end in honour of the peace, but I have had nothing more to do with them than reading the accounts in the papers."

Copley completed the picture after three years of toil, and sent it to the Royal Academy exhibition of 1803. On the night of the vernissage he dressed himself in his best clothes and hurried to the gallery, anxious to savour praise and popularity once more. Sure enough, there was a crowd before his picture. Walking more firmly than he had for years, he manœuvred into position to see their faces, but then his own face grew pale. The people before him were not staring in reverence; they were smiling. Suddenly some-

one laughed, and at once everyone shouted with mirth; they found the two dead wives suspended from the sky irresistibly funny. When Copley tried to slink away, he felt a hand on his shoulder and saw Knatchbull himself, his face red with fury. People were mocking him, he cried; how had Copley dared show the picture without his permission? It must be removed from the show at once. Utterly discouraged, Copley nodded sadly, and the next day the hanging committee were cursing as they tried to fill with smaller pictures the space where the vast canvas had been.

But Copley's troubles with the *Knatchbull Family* were not done. The third wife now demanded that the first two be painted out; sadly the painter extended the background across the faces and figures of the angels he had so carefully delineated. The irritated baronet then refused to pay for the figures that no longer showed, insisting that Copley's charge of eighteen hundred guineas for the picture was wildly exorbitant.

When the matter was brought before a legal arbiter, Knatchbull argued that if Copley had painted the picture with decent celerity, all the changes would have been unnecessary; the third wife, the new child, would never have existed at all. He added that he had been opposed to Copley's depicting his two former wives as angels; he had wanted them shown merely as portraits hung on the wall behind him. Each side called expert witnesses. After eleven painters and engravers, including Beechey and Fuseli, had sworn that they considered Copley's charge reasonable, the arbiter decided for Copley, ignoring the testimony of the principal witness for Knatchbull: Benjamin West.

A bitter story lay behind West's appearance against his former protégé. When the president had secured through his friends an important commission Copley had hoped to secure through his own, Copley's dislike for his benefactor rose to a ruling passion. He became a leader in the cabal that drove West from the presidency of the Royal Academy, but the victory, as we have seen, was

shortlived; in the end it only made Copley more than ever un-
popular with the connoisseurs and his fellow-artists.

Sitting dismally in his empty studio, he cast round for some
expedient that would bring back the prosperity he had lost. He
experimented with pigments, trying to find the secret of the
bright colours Titian had used. In 1802, his son wrote: "My fa-
ther has discovered the Venetian, the true Venetian, more precious
than the philosopher's stone . . . which the artists of three gen-
erations have in vain been endeavouring to explore. . . . Hence-
forth, then, you may fairly expect that my father's pictures will
transcend the productions of even Titian himself." But Copley's
canvases continued to grow progressively worse. All the virtues
that had made him a great artist vanished; the drawing became
weak, flabby, and pointless, the colouring watery, the compositions
empty in the extreme.

The pressure of his English environment had been against the
direction of Copley's genius. At heart a realist, he had painted
powerfully in Boston, where the simple folk liked to see reproduc-
tions of things they knew, but London was a sophisticated city, and
sophistication is a struggle against reality, an attempt to polish, to
veneer, to hide the naked crudities of life. In its higher mani-
festations it demands the use of imagination to build for man a
more beautiful world; in its lower it runs to corsets and silks and
grimaces. Since Copley was not endowed by nature to be an im-
aginative painter—never did the flights of his mind carry him into
the mystic empyrean—the lower reaches of sophistication alone
were open to him. He hid the body of truth under bright colour,
brilliant brushwork, and a startling borrowed technique.

However, the habits of a lifetime are not easily thrown over.
During his early English period, much of the solidity he had taught
himself in Boston remained. The bodies under the more subtly
painted silk of his portraits were firm, and he was still fascinated,
despite himself, by the crudely accurate depiction of some intel-

lectual face. In his historical paintings, the realism his mind decried still issued from the sinews of his painting hand; over and above the bombast of its central group, *The Death of Chatham* was a collection of shrewd portraits. And when his imagination tottered on its insufficient wings, habit still carried him back to concrete models; as we have seen, he laid siege to Gibraltar in his studio. But little by little the habits he built up during his Colonial career relaxed. The body and form drained from his paintings; when he discarded realism, sincerity went with it, and then there was nothing left, for his imagination lacked the strength to soar.

Thus we may explain much of the weakness of Copley's later paintings, but there is another important consideration which must needs escape those critics who separate an artist's life from his work; the deterioration of his art was accompanied by a deterioration in his personality. Although Copley had always been timid and unsocial, in Boston he had been universally respected, and he had risen to what was heroism for his character in his attempts to stop the revolution. Yet his later years in London show him as mean, cantankerous, envious, quarrelsome, vindictive. Minor contretemps, as we have seen, served to embitter him for years. It is probable that his nerves and health had gone back on him, that he suffered from premature senility. Although he lived to be seventy-seven, at sixty he had all the characteristics of a broken and disgruntled old man.

The stinginess that had always been part of his character became a ruling passion. The Academy female model, Farington tells us, usually got a shilling an hour. "She is very modest in her deportment, notwithstanding her habit of exposure, and was lately married to a shoemaker. She spoke of Copley's behaviour to her, who would make her sit a longer time than she could well bear to, and would scarcely pay her half-price. She had resolved not to go to him any more."

He became so crusty that it was news if he was polite to one of

his fellow-artists. "Copley," Farington wrote in 1807, "found me in the room alone and accosted me civilly, the first time in several years. He appeared to me to have suffered much in his faculties; his mind seemed to be incapable of comprehending what was going forward." Three years later, Farington noticed on his face a look of imbecility.

In 1811 Morse wrote home: "I visited Mr. Copley a few days since. He is very old and infirm. I think his age is upward of seventy, nearly the age of Mr. West. His powers of mind have almost entirely left him; his late paintings are miserable. It is really a lamentable thing that a man should outlive his faculties."

For almost twenty years Copley struggled through the twilight of old age. Always lacking money, he painted continually in an unceasing effort to produce a great picture, to secure an important commission. Occasionally he had a nervous collapse, but as soon as he was well again he picked up his brushes and returned to his studio. However, all his efforts were in vain, for the tide had set irrevocably against him. When he asked the King to sit again, His Majesty snubbed him before the whole court. "Sit to you for a portrait! What, do you want to make a show of me?" He spent four years on an equestrian portrait of the Prince Regent that no one would purchase. When the British Institution paid three thousand guineas for West's *Christ Healing the Sick*, he set to work immediately to work on a vast *Resurrection*, but the British Institution showed no inclination to buy it. "It makes me melancholy," wrote Mrs. Copley, "when I see his rooms so full of pictures that are highly spoken of, and I think with how much perplexity they were produced."

Copley's son had already started on the brilliant career that was to make him Lord Chancellor of England and finally Lord Lyndhurst, but for the moment his income was small, and he could contribute little to the family support. The painter was continually forced to borrow from his American son-in-law; the little letters

in which he asked for one more loan are stiff with mortified pride. But even the loans that were never refused did not serve to keep up his large establishment on George Street. After the failure of Copley's *Resurrection,* James Heath, the engraver, told Farington that Copley would have to sell everything he owned, including his house, which was already heavily mortgaged. He pointed out that Copley had become very unpopular as an artist. At about this time, Mrs. Copley wrote to her daughter: "We are, indeed, revolving what changes we can make, and whether to quit George Street. The difficulty of leaving our present situation is that it would in a great measure oblige your father to give up the pursuit of the arts; and I fear that if he should retire from them in the latter part of his life, he would feel the want of the gratification which the pursuit has accorded him."

The house was saved by a friend who took a second mortgage on it, but though his studio remained to Copley, it was no longer the refuge from the world it had been. As the painter sat before his canvas in an alien city and heard the greater rumble of the London traffic outside his window, he sometimes realized that the mistake of his life had been to leave America, to seek perfection by imitating the old masters. He scowled at the paintings of his English years that hung unsold in tiers around him, and turned to look instead at some of his American portraits which he had bought back in a vain attempt to evoke the past. He told his wife that these canvases, which he had once scorned as crude, were better than any of the highly polished works of his transatlantic career.

If only he could paint like that now! But no; he realized it was hopeless. "He sometimes says," his wife reported, "that he is too old to paint." Yet he had to paint, for in his ambitious youth he had never allowed himself time to learn to play. Work alone could distract his mind from his poverty and his frustrated career. What if the picture that grew beneath his hand was vapid and inane? It calmed his nerves to move the hand. In 1815 his wife wrote: "Your

father grows feeble in his limbs; he goes very little out of the house, for walking fatigues him; but his health is good and he still pursues his profession with pleasure, and he would be uncomfortable could he not use his brush."

The tragedy had acted itself out long before the curtain fell. Still the doddering actor held the centre of the stage, repeating over and over in dull parody the motions that had been the glory of his prime. He continued to paint and complain, to grow weaker and more senile, but he suffered no serious illness until his seventy-eighth year, when he was struck down during dinner by a stroke. Although it paralysed his left side, he rallied and was able to totter around a little; even a second stroke did not kill him. His daughter wrote to her sister: "He may continue in his present state a great while, but it is so distressing that without any prospect of recovery it is not to be wished."

The old man sat stuck up in a chair like an inanimate doll, but his eyes still turned in their sockets. When he felt strong enough to talk, he told his family that he would not recover. "He was perfectly resigned and willing to die, and expressed his firm trust in God, through the merits of the Redeemer." At last God took pity. Two hours after a third stroke that left him "perfectly sensible though unable to speak so as to be understood," the long-wished-for release came. On the ninth of September 1815, John Singleton Copley, whom many consider the greatest painter America has ever produced, escaped at last from the long twilight of his exile.

Charles Willson Peale

(1741-1827)

THE INGENIOUS MR. PEALE
CHARLES WILLSON PEALE

I

CHARLES WILLSON PEALE was the last and the greatest of the
Colonial craftsmen painters who, like Feke and Badger, prac-
tised art together with several other trades. An extreme example
of the ingenuity developed in pioneer civilizations by the fact that
every homestead had to manufacture its own needs, he could mend
anything, construct anything, do a thousand useful tricks; he made
a fine watch and painted a fine portrait. However, so transcendent
was his genius, so versatile his mind, that he seems to fall less into
the humble tradition of his predecessors than into the select com-
pany of men like Franklin and Jefferson. He also took a prom-
inent part in the revolution, and his interests were as various as
theirs; like them he left an enduring mark on almost every field
he touched. He was the Yankee Jack of all trades turned eighteenth-
century gentleman, a craftsman so able that he became a universal
genius. Yet he never lost the humble directness of the American
craft approach. Two years spent in England only threw him more
passionately back onto his American roots; always he remained the
ingenious settler of an isolated clearing who, for lack of a more
conventional instrument, uses his native wits to solve the problems
with which he is faced. Like the pioneer who struggles with a hos-
tile forest, he found no time for abstract reasoning; he even de-
veloped the crotchety peculiarities typical of strong minds expand-
ing in loneliness. Yet Peale lived most of his life in Philadelphia,
America's greatest city, and numbered among his friends such
accomplished cosmopolitans as Washington, Franklin, Jefferson;

while Lafayette and Baron von Humboldt frequented his studio. His life is a connecting link between America's past and America's future.

The Colonial saga of the Peale family began, as did so many other proud Southern family sagas, with felony in England. The painter's father, Charles Peale, came from a line of country parsons in Rutlandshire, but on him a more glorious destiny seemed to shine; he was the acknowledged heir of a rich uncle, Charles Wilson. Basking in golden prospects, he spent a gay term at Cambridge and then, turning his back on the ministry, which was the career selected for him by his father, he set up as a dandy in London. His son was to hear that he had kept a mistress. But however much money he might inherit, for the moment his purse was empty; he secured an appointment in the post office. Although his salary was small, graft was the established rule, and soon his delighted eyes watched candlelights flash on his mistress's jewels and on the fine wines that graced his table. However, as ill luck would have it, an honest man got into the government. The post office was investigated and Peale convicted of embezzling the huge sum of nineteen hundred pounds. He was sentenced to death. But the politically powerful cousin of one of his superiors had the sentence commuted to transportation. Charles Peale was exiled to Maryland.

The felon seemed a dazzlingly fine gentleman to his provincial neighbours. Able to boast that he had been to Cambridge, he was in such great demand as a schoolmaster that he was called to preside in rapid succession over three leading Maryland academies. "Young gentlemen," he advertised in the *Maryland Gazette*, "are boarded and taught the Greek and Latin tongues, writing, arithmetic, merchant's accounts, surveying, navigation, the use of globes from the largest and most accurate pair in America, also many other parts of mathematics, by Charles Peale." His distinguished bearing and obvious erudition made him the pride of each of the towns in

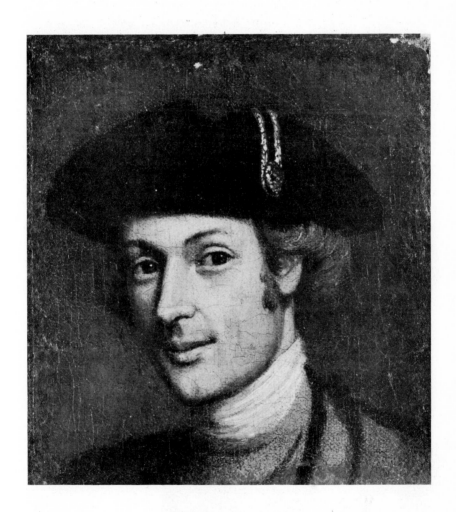

PEALE: SELF-PORTRAIT

JOHN HESSELIUS:
ANNE TILGHMAN AND
HER SON WILLIAM

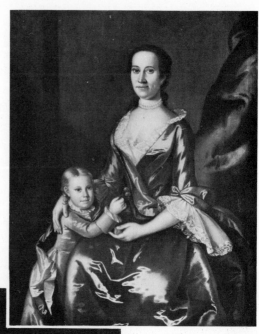

PEALE: MRS. JAMES
ARBUCKLE AND
SON EDWARD

which he lived, and he was often called to officiate in the pulpit when the minister was absent.

However, the former dandy was not impressed. He still expected his uncle's fortune, and in addition seemed, despite his recent narrow escape from the gallows, to regard a political appointment in the New World as his due; he demanded in letters home that his former colleagues use their influence to procure for him the important and well-paid office of County Sheriff. We can only draw the conclusion that during his trial he had shielded his superiors, several of whom were later convicted of fraud, and that they had promised to take care of him.

In Annapolis, where he was teaching school, Peale met Margaret Triggs Matthews, a pretty widow. They had a gay time together that made the Englishman almost forget his exile, but their carefree relationship was suddenly clouded by a grave-faced announcement from the lady. Peale married her and tried to hush the breath of scandal by leaving Annapolis; he accepted the headmastership of a school in Queen Annes County, Maryland. On April 15, 1741, six months after his parents' wedding, a boy was born and named Charles Willson Peale after the rich uncle.

A year later the schoolmaster moved again, settling in near-by Chestertown, where he wielded his birch at the Kent County School. Here the future painter spent his childhood in an atmosphere of expectancy. Boats from London to Maryland were not frequent, and as each one became due the elder Peale forgot his pupils, stared absently at the largest and most accurate globes in America; surely this time word would come that he had inherited a fortune or was being pushed for some county office. Always on the brink of affluence, he squandered the few pounds he actually had in his pocket, for, as his son wrote, he had been "used to good company." Although the boy sometimes went hungry and cold, he was proud of his father's fine clothes and reckless manner, which were, he insisted, a proof of "spirit."

The schoolmaster died when Charles Willson Peale was eight, and left no inheritance to his wife and four tiny children except a will-o'-the-wisp that was to addle his eldest son's brains as it had addled his own; the future painter was not told of his father's disgrace in London—perhaps even his mother never knew—and was wrongly assured that his granduncle's estate, which had been glorified into a vast country manor, was entailed, making him legally the heir.

Mrs. Peale moved back across Chesapeake Bay to Annapolis, where she gained a meagre living by sewing dresses, and sent her son Charles to a charity school too lowly to teach Latin; he learned only a smattering of arithmetic and writing. Showing an early propensity for drawing, he made "patterns for the ladies to work after," and eventually copied two prints in oil colours by the ingenious expedient of putting them under the glass on which he painted. Emboldened by the praise he received, he attempted an original composition of Adam and Eve, but found this almost too difficult. When an uncle died, his aged grandmother insisted that he must preserve a portrait of the corpse. The boy was forced to tiptoe into the still room where the body lay, faintly yellow in the clasp of death. He sat down, lifted his pencil in a shaking hand, and stared into the dead face. The shut lids, blue as skimmed milk, stared back. Screaming, Peale abandoned his first attempt at portraiture.

At thirteen, the boy was withdrawn from school and apprenticed to Nathan Waters, a saddler, who soon found him so able that he paid him small sums for special tasks. Peale did not save his earnings or contribute them to the family support; he bought first a watch and then a horse. "To possess such property," he moralized when an old man, "appears to be the too prevailing passion of American youth, for with such they are drawn into other expenses and too often into extravagances, whereas could they be advised to dispose of their first earnings, however small they may be, to some increasing fund, much benefit would ensue." Peale's watch

soon broke. Since he had to pay five shillings to have it mended, when it broke once more he resolved to mend it himself; however, the instrument, which came apart with most satisfactory ease, would not fit together again. Peale promptly taught himself watch-making, for he was never willing to admit there was anything he could not do.

In his eighteenth year he fell in love with a girl of fifteen. "Miss Rachel [Brewer]," he wrote in his autobiography,* "belonged to the class of small women of fair complexion, although her hair was a dark brown colour which hung in curling ringlets over her beautiful white neck. Her face was a perfect oval; she had sprightly dark eyes; her nose straight with some few angles such as painters are fond to imitate; her mouth small and most pleasingly formed. In short, she would be called handsome amongst the most beautiful of an assembly of her sex." Although the lady was lovely, the brash young man, who felt he could make as fine saddle-trees as anyone on the Continent, was convinced that he was honouring her with his attentions. When he proposed one evening in the garden, he expected instantaneous and abject acceptance. Miss Brewer, however, sat in a flushed and embarrassed silence. To his amazement, Peale found himself pleading with her. Even when he stretched a point by calling himself unworthy, the pretty girl merely lowered her eyes and remained silent. Finally he decided he had had enough of such coyness; he whipped out his watch and he told her he would "wait one hour for her determination." Delighted to see her grow pale, he leaned back nonchalantly on the garden bench.

Miss Rachel, however, remained silent while the watch ticked a half-hour away. Then Peale began to grow nervous. He strode up and down before her, pointing out what a bright young man he was, what an excellent catch; was he not the heir to a vast British

* Peale wrote his autobiography in the third person. For purposes of clarity and conciseness, the extracts in this sketch have been translated into the first person. In all other respects the text is Peale's.

estate? But the lady said nothing, and at last the hour was spent. "I went immediately to the house and thanked her mother for the kind entertainment I had received, and said I hoped Miss Rachel would get a better husband than I could make. That I now must take my leave of the family for ever." But he left his riding whip behind.

When he called for it the next day, he expected Miss Rachel to apologize, but she did not even come down to see him. Furious, he sprang on his horse and galloped to the house of another young lady whom he knew but slightly. "Finding the lady at home, I asked to speak in private to her, and began to declare my intentions of seeking a lady that might make me a wife. I asked her if she had any engagements on her hands. The lady was confused, and seemed at a loss to know how to answer such a question, but she faintly intimated that she had. I replied that I was sorry for it, but I would give her no further trouble, and very politely took my leave of her. This courtship did not take more than one hour from the beginning to the end of it, and," Peale could not resist adding, "it has been said that this lady was afterwards unhappily married."

Peale mooned about his master's shop, and sometimes hit his thumb with his hammer. Finally he met Miss Rachel on the street. "I lamented the cause of absence from her mother's house." The pretty girl tossed her head and replied that his precipitate manner had not deserved an answer, and that if he took her silence as a refusal, that was his fault. Returned eagerness gleamed in Peale's eyes, but before he agreed to call that night, he made a bargain with her; he made her promise that she would give him her answer. As he sat again with his charmer in the familiar garden from which he had been banished, Peale's manner was almost humble. Smiling inwardly perhaps, but with an outwardly grave face that did not offend her proud lover, Miss Rachel agreed to become his wife.

As a reward for special diligence, Peale was released from his apprenticeship when he was twenty, a few months before his inden-

ture ran out. "Perhaps," he wrote, "it is not possible for those who have never been in such a situation to fully feel the sweet, the delightful sensations attending a release from a bondage of seven years and eight months, a release from labour from sunrise to sunset, and from the beginning of candlelight to nine o'clock during half of each year; under control of a master and confined to the same walls and the same dull repetition of the same dull labours. . . . How great is the joy, how supreme the delight of freedom! It is like water to the thirsty, like food to the hungry, or like rest to the wearied traveller."

Jubilantly, Peale borrowed an extravagant sum from his master to set up independently as a saddler, and married Rachel Brewer. In his newfound magnificence, he boasted all day long about the great British estate he was to inherit, until someone, irritated beyond endurance, wrote him a letter purporting to come from a British army officer. He must hurry across the ocean instantly, the letter warned, lest he be defrauded of a vast inheritance that was his due. Peale lacked the fare to England, but in great excitement made out affidavits to prove his identity and legitimacy, which he sent to a lawyer in London. Since he would soon be rich, he scorned economy. No other artisan and his wife in all Annapolis were so proud and gay.

The instant Peale became twenty-one, his former master demanded payment of the large sums which the young man had regarded as an indefinite loan. At once in financial difficulties, Peale did not work harder at the saddling that had long bored him; with amazing versatility and ingenuity, he branched out into other trades, although often he had to make his own instruments and teach himself how to use them. He began with upholstery. Since buying the necessary supplies merely increased his debts, he took a chaisemaker into partnership, but that gentleman promptly absconded with their common funds. After having himself made a carriage with the materials left behind, Peale added watch- and

clockmaking to his specialties. From that it was only a step to silversmithing, and he boasts: "I once cast a set of stirrups in brass."

Peale was willing to turn his hand to anything that would make him money, so long as it was something new. When he went to Norfolk, Virginia, to buy some leather, he met, he wrote in his autobiography, "a brother of Mr. Joshua Frazier's who had some fondness for painting and had painted several landscapes and one portrait with which he had decorated his rooms. They were miserably done; had they been better, perhaps they would not have led me to the idea of attempting anything in that way."

Remembering how he had traced prints when he was a child, Peale decided he could do better than Frazier. On his return to Annapolis, he obtained canvases, paints, and brushes from a coachmaker and painted a landscape which, he remembers, "was much praised by my companions." Scowling into a mirror, he then executed a portrait of himself with a clock he had just taken to pieces before him. Although his friends were impressed by this work too, he eventually mislaid it. His son Rembrandt insists that thirty-seven years later he saw some colours gleaming through the dirt of a canvas that was used to tie up a pound or two of whiting. "I washed it off," he wrote, "and my father recognized his first attempt, well drawn and well coloured."

After Peale had executed a group picture of all his family, he was "applied to by a Captain Maybury to draw his and his lady's portraits, and with some entreaty I at last undertook, and for which I was to receive ten pounds, and this gave the first idea to me that I possibly might do better by painting than with my other trades, and I accordingly began the sign-painting business."

Peale had no idea how artists prepared and put on colours, and he had never seen a palette or an easel; he worked out these details for himself, just as he had designed his own watchmaking and silversmithing tools. Remarkable as this story may seem to us today, it had been enacted many times before on the rough continent of

North America, and it was to be enacted many times again during the westward movement that was for more than a hundred years continually to create new frontiers. Peale did not regard painting as more difficult or more ambitious than his other trades. People paid him for saddles, so he made saddles, and if people were willing to pay him for portraits, he would make portraits too. Had someone imported a new kind of saddle from Europe, he would have studied it with interest; in the same spirit, he studied a portrait of Cecilius Calvert attributed to Van Dyck which hung in the courthouse. It never occurred to him that it was ridiculous to try, without any special training, to do as well.

One day a particularly learned acquaintance mentioned another kind of paint that was easier to put on than heavy oils secured from the coachmaker; he explained about water colours. Fascinated, Peale made a special trip to Philadelphia to obtain some, but when he walked into the city's only paint shop, he found he had no idea what to demand. "I knew only the names of such colours as are most commonly known." Having induced the shopkeeper to give him a price list of the pigments most generally used, he found his way to a bookstore, whose stock contained a single volume on painting: *The Handmaid of the Arts,* published anonymously by Robert Dossie. He bought it and spent four days reading it at his lodgings in rapt amazement that there was so much more to the craft of painting than he had imagined.

Told of a professional painter named Steele, Peale in his anxiety for knowledge called on him at once, and was shown to a room where, he remembered, "the floor was covered with drawings, prints, colours, and paintings on scraps of canvas in every direction." The pictures all seemed to the saddler distorted and miscoloured, especially a self-portrait in which the face was tinted purple-red. The artist too seemed strange, with his wild eyes and quick gestures. Yet Peale, who was beginning to realize how little he knew about art, was interested by all he saw and by the queer jum-

ble of words Steele poured out in a cascade. "I intended to keep up my acquaintance with him."

However, when he called again to show the list of colours he had received at the paint shop, his new friend behaved in so odd and violent a manner that despite his need for instruction Peale felt a panicky desire to flee. But he could find no escape from the strong hand that clutched his shoulder, from the wild eyes that burned into his own, until he was relieved by a knock at the door. Steele, he remembered, "opened it cautiously, when a person touched him and said: 'You are to go with me.' "

"At whose suit is this?" Steele asked. On learning that it was at the suit of his washerwoman, he bowed, put on his coat, and apologized graciously "for being obliged to go out." Thus ended Peale's first association with a professional artist. Many years later, he wrote his son concerning Steele: "He was of a respectable and wealthy family on the eastern shore of Maryland; had a fondness for painting; I believe went to Italy and spent his fortune; and it was said was somewhat deranged in his mind. Some pieces I have seen of his pencil seemed to confirm my opinion that such was his misfortune." Nothing more is known of this colourful early American painter, who may have preceded West to Italy, than the few mentions of him in Peale's papers. Perhaps some day a scholar will identify one of his purple-faced portraits.

Having discovered that painting was so complicated a craft he might have difficulty working out all its refinements for himself, Peale offered John Hesselius, a successful artist who lived near Annapolis, "one of my best saddles with its complete furniture" to let him watch while he painted a portrait. Hesselius accepted the saddle; allowed Peale to see him paint two portraits; and then, having completed one side of a face, let Peale paint in the other side. Following exactly the line of the nose, the curve of the cheek his master had drawn, the saddler felt he was learning the secrets of great

art. How was he to know that John Hesselius would have been considered a very inferior workman in any true centre of art?

The son of Gustave Hesselius, an adequately trained Swedish painter who had settled in America in 1712, John had failed to follow in his father's footsteps but had imitated the more fashionable work of John Wollaston, the former drapery painter who had been West's first master in Philadelphia. Hesselius repeated in a more wooden manner Wollaston's poses. He caught the English artist's difficulty in painting eyes which gave all his faces an oriental look, and added to this blemish one of his own: he endowed almost all his sitters with such puffy cheeks that a study of his pictures makes one wonder if mumps were not endemic in the Colonies. Some of his pictures, however, have charm of colour. For the time being, Peale religiously copied John Hesselius's mannerisms.

Peale was still practising painting only as a sideline with his many other crafts when in 1764 he became involved in the radical political movement that was to culminate in the revolution; he took a prominent part in the campaign of a commoner against that fine gentleman, Judge Stuart. When the Court Party was defeated for the first time in the history of Annapolis, its rich supporters were so outraged that they used their financial position to ruin their opponents. Four writs were served on Peale for sums he owed. "Although I had never spent any of my time in taverns or any other kind of extravagances, and had always been closely engaged in some sorts of labour, yet I found myself nearly nine hundred pounds in debt, which was entirely caused by . . . engaging in too many pursuits at one time, and making one false step at first setting out in business: going into debt to Mr. Walters [the master saddler]."

Since he had no possibility of paying and debtors' prison yawned, Peale fled with his wife to his sister's house at Tuckahoe Bridge, where he engaged happily in painting portraits. One afternoon, however, a neighbour rushed in to say that the sheriff was already

coming up the road "to secure me in horrid jail. And I had only one minute's notice to stop the sheriff, who was entering the door to take me, so narrow was my escape. I then found it absolutely necessary to tear myself from my fond wife and friends." With part of the money he had received for the portraits, he bought a mare "and set out for Virginia under dreadful apprehensions of being overtaken or stopped by the way. A lonesome, disconsolate journey it was. The leaving a beloved wife, big with child, to subsist by the bounty of my friends was truly affecting."

However, Peale was in his later years to regard his debts and his flight from imprisonment as a great blessing. Had it not been for them, "I might have been contented to drudge in an unnoticed manner through life." As it was, he was separated from the tools of all his crafts except that of painter. He was forced to become a professional artist.

II

Peale visited his sister's family in Accomac County, Virginia. When his brother-in-law, who owned a coastal schooner, secured a cargo of grain to sell in New England and invited Peale to come along, he was delighted, but soon he wrote in his diary: "The wind blows hard, which makes our vessel leak a little. I suffer silently." After almost running on Block Island, "a place then famous for making fine cheese," the boat reached Boston on July 26, 1765.

As he walked the streets, Peale happened on a colour shop "which had some figures with ornamental signs upon it. . . . Becoming a little acquainted with the owner of the shop, he told me that a relation of his had been a painter, and said he would give me a feast. Leading me upstairs, he introduced me into a painter's room, an appropriate apartment lined with green cloth or baize, where there were a number of pictures unfinished. He [the painter] had begun a picture—several heads painted—of the ancient philosophers, and

some groups of figures." Peale stared about him thunderstruck, for he had never guessed that the world contained such marvellous canvases. He stammered for a moment before he succeeded in asking the colour dealer what had been the name of his brilliant uncle. Smiling, the man replied: Smibert, John Smibert.

Peale mourned that Smibert was dead and wondered whether any painters still lived who could equal him. When the dealer told him about a man who resided down the street, a man named Copley, Peale determined to call, but he was forced instead to accompany the schooner, which meant food and lodgings to Newburyport. After he had painted the boat as she lay in that harbour, the delighted captain lent him sixteen dollars, enabling him to stay behind when the schooner sailed on. "Having nothing to do, I painted a small portrait of myself." This picture was much admired and procured him several commissions. Peale consorted with the patriot leaders, and during the Stamp Act agitation "assisted," he tells us, "in making emblematic designs showing with what unanimity of detestation the people viewed that odious act of Parliament."

Since he was eager to meet the Mr. Copley the paint dealer had praised, as soon as he had made enough money he took passage back to Boston. "I went and introduced myself to him as a person just beginning to paint portraits. He received me very politely. I found in his room a considerable number of portraits, many of them highly finished. He lent me a head done by and representing candlelight, which I copied. . . . The sight of Mr. Copley's picture room was a great feast to me."

Perhaps because Copley told him it was easier to get started as a professional painter that way, Peale worked on miniatures, beginning with a portrait of himself. He slaved away happily until one morning he found that he was again entirely without funds. After he had failed in his attempt to rent himself out as a journeyman saddler, destitution stared him in the face, but just as he began to

despair, someone commissioned him to do his portrait and paid the princely sum of twelve dollars. "I now determined to leave Boston while I had the means." However, he met a friend who gave him free passage to Virginia, enabling him to spend his money on paints.

Back with his sister's family in Accomac County, he set up as a professional portrait painter and received five or six commissions. He presented a copy in full colour of a print after Reynolds to Charles Carroll of Carrollton, an old acquaintance, who was so impressed that he arranged with most of Peale's creditors to allow the exile to return to Annapolis, where he rejoined his wife and saw for the first time the baby that had been born in his absence. However, his difficulties eventually cropped up again, "and I was in expectation of immediately going to jail." At last he quieted his creditors by assigning to them an estate his wife expected to inherit.

The new Colonial self-consciousness that had made the rich men of New York and Philadelphia send West to Europe six years before existed in Maryland too. Impressed by Peale's work, Governor Sharpe and ten members of the Council subscribed eighty-three pounds to send him to London in the hope that he would bring honour to their province, and help to give it the pre-eminence in culture which they were all sure it would soon have in trade. A merchant gladly furnished free passage and Chief Justice Allen of Pennsylvania, who had financed West's trip to Italy, gave Peale a letter to that artist.

Leaving behind his wife and a tiny child, Peale sailed in December 1766. "Although I was sick on every turn of rough water during the whole voyage, yet my active mind would be employed in all intervals of a more moderate sea. I made myself a violin, for I had some fondness for music, yet I never practised on any instrument with diligence sufficient to make myself proficient to entertain others. . . . As we approached London, the quantity of shipping was such as their masts appeared to me like a forest in America."

The moment he landed, Peale hurried to West's studio, and

West, when told that an American student waited to see him, rushed downstairs with his brush still in his hand to greet his fellow-countryman. Then he ushered Peale right back to the painting room and set him to work posing for a hand. Although Peale, who was still dizzy from seasickness, almost fainted, he always remembered with gratitude the kindness of his reception, and the way West, instantly taking the responsibility for his welfare, found him lodgings near by and helped him in every way he could.

Those were exciting days in West's studio. The master was thirty, only three years older than his pupil, and during Peale's stay he had his first interview with the King. After His Majesty had commissioned *Regulus Leaving Rome,* Peale posed for the figure of Regulus. He remembered that "the propriety of appearing to belong to the higher orders of society" induced West to buy a small sword before he took his sketch of the picture back to the palace. We can see him rehearsing his newfound elegance before his wife and pupil, walking back and forth, as he tried to step naturally and at the same time keep the weapon from getting caught between his legs. When his audience assured him he had become so skilful no one would guess he had never worn a sword before, he put the sketch under his arm and set out. Peale and Mrs. West must have awaited his return anxiously, since on this interview depended all future royal patronage. West was gone an ominously long time; was he languishing in an anteroom, forgotten by an indifferent monarch? At last they saw the painter returning down the street, his small sword dangling jauntily, his whole demeanour denoting success. He burst into the room and told how the Queen had received him at once; she had knelt down to look closely at the sketch. Then George came in. After one quick glance, he cried: "Ah, West, I see you have chosen the Doric order of buildings, and that is my favourite order of architecture." From then on, everything was easy.

Peale was greatly impressed by his master. "I have been to see Reynolds's work," he said in a letter home, "and think Mr. West

by far exceeds them." However, the provincial was not happy; he found London too large and suffered during his entire stay from homesickness. The crowded streets that contained no familiar faces, the unending rows of houses, only would have been bearable, he wrote, if his wife had been with him. "The novelty of sights were soon satisfied when not aided by the converse with a dear friend. . . . As a proof that I could not have [had] any considerable relish for public entertainment, I went only to seven plays in the whole time of my stay in that city; I visited Windsor once, was in Hampton Court twice, on one party to Richmond. I partook of the amusements of the several gardens in the vicinity of London. With very few exceptions these were the whole of my wanderings from close study."

Eager to return home as soon as possible, Peale struggled to gulp down all European art in a few mouthfuls. However, being Peale, "I was not content to learn to paint in one way, but engaged in the whole circle of arts, except painting on enamel." He studied oil and miniature painting, modeling in plaster, and mezzotint scraping.

Peale had hoped while in London to collect the large estate that had always figured in his imaginings, but inquiries revealed hints of his father's disgrace and the certainty that Charles Wilson's property would never come to him. Deprived of this expectation, Peale soon ran out of funds. West instantly offered to put him up in his studio, but the young man, already overwhelmed by his master's kindnesses, preferred to borrow a little more from home and to set up as a professional miniature painter. Through the influence of a jeweller on Ludgate Hill, he secured many commissions. News of the death of his only child, however, threw him into deeper depression; "the loss . . . can only be felt by those who have suffered the like in lonely absence." More than ever eager to get home, he begrudged the time he spent making money from miniatures; to discourage prospective sitters, he raised his price from two to three

guineas, and when this did not suffice to ruin his business, raised it again to four.

Peale had not lost his brashness. Wishing to meet Benjamin Franklin, who was then in London, and having no letter of introduction, he simply called and gave his name. The servant was so impressed by his confident air that he told Peale to go upstairs to the laboratory, where he would find the philosopher at his experiments. Perhaps awe made him tiptoe in the sacred house; in any case, he surprised Franklin, as he tells us, with "a young lady on his knee." According to a tradition that has come down through his descendants, the couple were too busily engaged to notice his presence. Peale stepped back into the shadow of the door, whipped out the account book he always carried with him, and executed a hurried sketch of the scene. Whether the drawing was made then or after he reached home, it may still be seen on the slightly rubbed pages of the ledger; Franklin is very recognizable, and the lady he holds in close embrace seems fashionable and pretty.

After he had completed his drawing, the story continues, Peale put the ledger back in his pocket, tiptoed a little way down the hall, and stamped noisily back; when he entered the room, the couple were separated. In any case, as Peale tells us, Franklin received him graciously and, on hearing that he was an American painter, took him into the laboratory, where he "showed me his experiments which he was then making."

Peale exhibited three miniatures and two oil portraits at the Royal Academy shows of 1768 and 1769. His major English work, however, was a large neo-classical allegory showing William Pitt dressed in a toga standing before the altar of liberty with the Magna Charta in one hand, pointing with the other to a statue of British freedom stamping on the rights of the State of New York. The picture was so crowded with various symbols—busts, figures, scrolls, buildings—that Peale had to write a long essay to explain what it all meant. *Pitt as a Roman Senator* is a ridiculous combination of

the high-flown neo-classical idiom and the crudely direct approach of American craftsmen. You can feel Peale's realistic soul shrinking from the self-appointed task of wrapping a member of Parliament in a toga and placing a classic altar, complete with votive flame, in front of the buildings at Whitehall.

This allegory of Pitt, so comic to modern eyes, is really a tragic allegory of Peale's English studies. It was his misfortune to work in West's studio during that master's most artificial period. By virtue of three Italian years and great technical virtuosity, West had managed to develop a suave neo-classical style, but the former saddler, who had never seen the Mediterranean or learned to read Greek or Latin, was merely bewildered by the theorizing of Winckelmann and Mengs that West repeated as Gospel. Despite earnest efforts to behave like a modest Colonial and accept what his betters told him, Peale was unable to abandon the literal-mindedness which was both part of his own nature and typical of the environment from which he came. He did his best, as his picture of Pitt reveals, but his best was woefully inadequate. Undoubtedly this explains much of his unhappiness in London, much of his tendency to flee from the oil painting he went abroad to study into so many other arts, as well as the amazing fact that he learned very little during the two years that might have opened up to him the richness of European technique. Both the brilliance and the polite fictions of the British school passed him by, leaving him a Colonial limner with his roots deep in the realism of the native American tradition.

Reacting furiously against his entire English environment, Peale became more than ever an American patriot. He resolved, after Parliament had annulled the charter of the State of New York, never again to pull off his hat when his master's patron, the King, went by; he swore to bend all his energies to making America independent. Convinced that the Colonies should develop their own manufactures, he refused to take any English clothes back to Amer-

PEALE: GENERAL JOHN CADWALADER, WIFE, AND CHILD

PEALE: THE PEALE FAMILY

Seated left to right: brother St. George; brother James; unidentified baby; the artist's wife Rachel; unidentified baby; sister Elizabeth Peale Polk; the artist's mother. Standing left to right: the artist; sister Margaret; the artist's old nurse, Peggy Durgan

ica with him, although he was forced to buy painting materials since none were made in the Colonies.

In the spring of 1769, Peale sailed for Annapolis after two unhappy years. He dived enthusiastically into domesticity, inviting his mother and two brothers to live with him and his wife. "This now happy family . . ." he writes, "lived in the utmost harmony together, so pleasing to me that I began the portraits of the whole in one piece, emblematical of family concord." In the background he placed examples of his own work: a classical composition representing the three Graces, and several portrait busts. This naïvely gay picture is one of the masterpieces of early American art.

Peale had been irritated by the æsthetic talk he had heard in England. "It has been said and generally is an adopted opinion," he wrote, "that genius for the fine arts is a particular gift and not an acquirement; that poets, painters, are born such." In order to disprove this ridiculous theory, he taught his two brothers to paint with such success that James Peale became one of the most admired of the early American miniaturists.

Working in competition with his teacher John Hesselius, with John Durand, and with two of West's pupils, Matthew Pratt and Henry Bembridge, Peale soon earned a reputation that outstripped them all. "Since my return to America," he wrote to a friend, "the encouragement and patronage I have met with exceed my most sanguine hopes, not only in Maryland, which is my native place, but also in Philadelphia I have considerable business, for which I was very greatly rewarded and my vanity much flattered by the general approbation which my performances hath hitherto met with. The people here have a growing taste for the arts, and are becoming more and more fond of encouraging their progress among them."

Peale was being patronized with reason, for he had become one of the most charming portrait painters of the early American tradition. Of course, the characterizations that Copley was evolving in

Boston from the resistant tangles of his New England temperament boasted a power and insight that Peale could not rival, yet there was a gaiety in Peale's work, an air of gentle high spirits, that was out of Copley's range. Much of the smoothness of Peale's canvases undoubtedly reflected his years in England—as John Hill Morgan, that authority on early American art, points out, he took over the convention of painting his sitters in the open air beside a fountain or classic urn—yet his portraits seem as a whole more typical of the long line of American face painters than of the British school. The charm of his work was the charm of fresh vision. His colours, light greens and oranges and pinks, blended together with the warm innocence of spring flowers; he took a naïve delight in painting laces and the soft sheen of silks. And the poses of his figures, although more graceful than those typical of his American predecessors, have an underlying archaic stiffness that gives them their particular flavour.

Peale's likenesses lack the suavity of the polite English tradition, for he was not afraid to exaggerate the ugliest feature in a face if he thought it the most typical. His portraits vary greatly in excellence; although many of the poorer pictures that have been ascribed to him are the work of inferior artists, the fact remains that he was one of the most uneven of painters. Despite his apprenticeship in West's studio, he usually had great difficulty painting eyes, which he made too small; and often he traced the contours of a nose with a heavy black line that joined with the eyebrows to make the round-bottomed longhand V that stands out like a signature on so many of his early full faces. Yet occasionally these flaws are lacking even in the paintings of this period; the crudeness of his drawing, the shallowness of his characterization, disappear in a burst of creative excitement. Sometimes, it seems, he understood the personality of his sitter, while at other times he was baffled; he lacked the quick insight of a Stuart, who caught the personality of almost everyone chance brought into his studio. Peale had little interest in

the characters of women—if they were pretty, he made them into appealing dolls, while otherwise he was at sea—and his portraits of men were, as he himself wrote, most likely to be successful with intellectual sitters, since it was the mind he wanted to portray. On the whole, the better he knew his sitter, the better was the likeness he made; thus portraits of his friends and members of his own family are usually among his best works. They show that even at this early period he could be an artist of charm and skill.

Peale continued to receive advice from his English friends, although he never sent any pictures across the ocean to be exhibited in London. West, worried about the progress of his art in a nation without standards of taste to make him do his best, wrote that he hoped the lack of competition in Maryland "will not let you lose that great desire for improvement you carried from here." Franklin's admonition was highly characteristic: "If I were to advise you, it should be by great industry and frugality to secure a competence as early in life as may be, for as your profession requires good eyes, [it] cannot well be followed with spectacles, and therefore will not probably afford subsistence as long as some other employment." He urged Peale not to be depressed by any lack of encouragement he might receive. "The arts have always travelled westward, and there is no doubt of their flourishing hereafter on our side of the Atlantic as the number of wealthy inhabitants shall increase."

Peale, however, was in the high tide of business, although he sometimes had difficulty securing his fees, as is shown by the following advertisements that appeared during 1774 in the *Maryland Gazette:*

September 8: "If a certain E. V. does not immediately pay for his family picture his name shall be published at full length in the next paper. Charles Peale."

September 15: "Mr. Elie Vallette, Pay Me For Painting Your Family Picture. Charles Peale."

September 22: "Mr. Charles Willson Peale, *alias* Charles Peale—

Yes, You Shall Be Paid But Not Before You Have Learnt To Be Less Insolent."

In 1772, Peale was called to Mount Vernon to paint the first portrait ever made of a gentleman farmer and militia colonel named George Washington. The future hero was not pleased at having to sit. "Inclination having yielded to importunity," he wrote a friend, "I am now contrary to all expectation under the hands of Mr. Peale, but in so grave, so sullen a mood, and now and then under the influence of Morpheus when some critical strokes are making, that I fancy the skill of his gentleman's pencil will be put to it in describing to the world what manner of man I am."

Washington, indeed, hid his character so completely that the portrait, although one of the best known of Peale's works, is one of the most uninspired. The face is simplified to a few forms, in the manner of a true primitive, but the forms accentuated seem trivial, not essential, indications of character. It is a tribute to the strength of Washington's personality that Peale the man was pleased by the reticence that defeated Peale the painter. "I am well acquainted with General Washington," he wrote a few years later, "who is a man of very few words, but when he speaks it is to the purpose. What I have often admired in him is he always avoided saying anything of the actions in which he was engaged in the last war. He is uncommonly modest, very industrious and prudent."

Washington's physical power also impressed the painter. "One afternoon," he remembered, "several young gentlemen and myself, visitors to Mount Vernon, were engaged in pitching the bar, one of the athletic sports common in those times, when suddenly the Colonel appeared among us. He requested to be shown the pegs that marked the bounds of our efforts; then, smiling and without putting off his coat, held out his hands for the missile. No sooner did the heavy iron bar feel the grasp of his mighty hand than it lost the power of gravitation and whizzed through the air striking the ground far, very far, beyond our utmost limits. We were indeed

amazed as we stood around all stripped to the buff, with shirt sleeves rolled up, and having thought ourselves very clever fellows, while the Colonel on retiring pleasantly observed, 'When you beat my pitch, young gentlemen, I'll try again.' "

Peale's three-quarter length shows Washington, then forty, in the uniform of a Virginia militia colonel which he had worn eighteen years before during the French and Indian war. Probably Washington chose to stand in this out-of-date costume because it represented the high point of his career until then, and because it had been made by a good London tailor. His favourite nephew, Custis, writes concerning Peale's portrait: "This splendid and most interesting picture formed the principal ornament of the parlour of Mount Vernon for twenty-seven years." A miniature of Martha Washington, which Peale executed at the same time, was set in a gold frame as a pendant, and it is said that the hero wore it round his neck till the last days of his life.

During June 1776, after a season spent in Baltimore and another in Charlestown, Peale settled in the metropolis of Philadelphia. John Adams visited his studio there. "Peale is from Maryland," he wrote to his wife, "a tender, soft, affectionate creature. . . . He is ingenious. He has vanity, loves finery, wears a sword, gold lace, speaks French, is capable of friendship and strong family attachments and natural affections. . . .

"He showed me one moving picture: his wife, all bathed in tears, with a child about six months old laid out upon her lap. This picture struck me prodigiously. He has a variety of portraits, very well done but not so well as Copley's portraits." Encouraged by Adams's enthusiasm, Peale brought out his treasures, which proved to be some books on art, some miniatures, and some sketches of country seats where he had stayed, including Mount Vernon. "Also a variety of rough drawings made by great masters in Italy which he keeps as models. He showed me several imitations of heads which he had made in clay as large as the life with his own hands only.

Among the rest, one of his own head and face, which is a great like-
ness."

Adams was impressed, although he regarded art as a toy rather
than a profession that could absorb a grown man. "I wish," he con-
tinued, "I had leisure and tranquillity to amuse myself with those
elegant and ingenious arts of painting, sculpture, statuary, archi-
tecture, and music. But I have not. A taste in all of them is an agree-
able accomplishment."

Peale found much business in Philadelphia and seemed destined
for a triumphant career in the greatest Colonial city. Patriotism,
however, intervened. Long active among the Sons of Liberty, Peale
wrote in his diary for August 9, 1776: "Entered as a common sol-
dier in Captain Peters's company of militia. Went on guard that
night."

III

Before he had been in the militia two months, Peale's fellow-
soldiers elected him second lieutenant, although, as he remarked,
he was "but a stranger among them"; a few weeks later they pro-
moted him to first lieutenant. Eager to help in every way he could,
he joined David Rittenhouse, the astronomer, in experimenting
with telescopic rifle sights at the proving grounds in Norrington.
They fired from dawn till dusk without stopping, nearly putting
their eyes out and becoming at last so dizzy that they could hardly
find their way back to Philadelphia.

Some of the blackest days of the revolution had arrived. Wash-
ington's disorganized army was in full flight across New Jersey,
and it seemed that only a miracle could save Philadelphia. Panic-
stricken, the Continental Congress fled to Baltimore and, as Peale
wrote, "every family of Whiggish principle that could move did so";
all Philadelphia seemed on wheels. Peale's own family fled to
Abington.

PEALE: RACHEL WEEPING

(RACHEL BREWER PEALE AND DEAD CHILD)

PEALE: WASHINGTON AT THE BATTLE OF PRINCETON

When the militia prepared to make a last stand before their city, many of the men who had enlisted in more propitious times refused to do anything but stay with their families. Peale determined to get his company out intact. "I then took paper, pen, and ink, and went personally to every man whom I could find out who had ever mustered in the company I belonged to. I promised the men to get everything they should want, and told their wives that they should be supplied with necessaries while their husbands were doing their duty in the field. On one paper I set down the number of the family to supply their wants, and on another paper the wants of the soldier to make him comfortable in the field (it being the month of December), and on another paper actually enlisted them, which increased their number to eighty-one men. And with this very respectable company pushed off with all possible dispatch to join the army."

Energetic and effective as he proved himself, Peale was not happy in his rôle of military hero. He hated to desert his family in a moment of danger, and he believed that he himself lacked the physique to survive as a soldier. He was, he tells us, "a thin, spare, pale-faced man, in appearance totally unfit to endure the fatigues of long marches and lying on the cold, wet ground covered with snow." In addition, he hated brutality in any form; the idea of shooting at his fellow-beings made him shudder.

The militia joined Washington at Trenton just in time to take part in a disorganized retreat across the Delaware. "General Washington's whole army," Peale wrote, "followed that night, and made a grand but dreadful appearance. All the shores were lighted up with large fires, and boats continually passing and repassing full of men, horses, artillery, and camp equipage." The sick and half-naked veterans of the long retreat streamed by Peale's well-fed troops in a tragic procession that haunted the painter all his life; thirty-three years later he wrote in a letter to Thomas Jefferson: "I thought it the most hellish scene I have ever beheld."

Suddenly a man staggered out of the line and over to Peale. "He had lost all his clothes. He was in an old, dirty blanket jacket, his beard long, and his face so full of sores he could not clean it, which disfigured him in such a manner that he was not known by me at first sight." Only when the sufferer spoke did Peale recognize his brother James.

Since Washington destroyed all the boats that would have enabled the British to follow across the Delaware, the Americans remained for a while in peaceful encampment on the far bank. Peale earned a little money executing miniatures of his fellow-officers, and occupied himself in obtaining food for his soldiers; his soft heart could not bear to have anyone hungry.

He wrote in his diary concerning Christmas day: "We were ordered to join the brigade. Many of the men were unwilling to turn out, as it was a day they wished to enjoy themselves." However, Peale managed to drive most of his command to the banks of the Delaware, where the Pennsylvania militia were to take part in the famous crossing. "When the first and third were nearly landed," Peale's diary continues, "the wind began to blow, and the ice gathered so thick at a considerable distance from the shore that there was no possibility of landing, and they were ordered back with all the troops that had landed." Only Washington's own division reached the New Jersey shore, but they took Trenton and about a thousand Hessian prisoners.

Two days later Peale's company made the crossing and occupied Bordentown. "Taking a walk, I found a storehouse with *King's Stores* written on it, and provisions delivering out. I got a quarter of beef and some pork. I then heard of some flour. Went and got a barrel." But just as his troops were set out for a delightful feast, "we were ordered immediately to march. Having no wagon belonging to the company, we could not take our flour." It nearly broke Peale's heart.

His troops took part in the battle of Princeton and captured

some prisoners, but when they heard the enemy firing in their rear they retreated with the rest of the army to Somerset Courthouse. "The men, who before this time would not put up with indifferent quarters, were so amazingly fatigued that they were happy in having some old straw in a smoky loft where the Hessians had lain." All the soldiers stretched out in dead exhaustion except the painter, who clucked over them as anxiously as a brood hen. The poor fellows seemed so miserable; he decided a good meal would cheer them up. Although his own feet ached whenever they touched the ground, he set out in search of food and eventually managed to buy with his own money some beef, pork, and potatoes. He hurried back to his smoky loft and soon had a fine stew bubbling over the fire. When it was cooked to a turn, he shouted that dinner was ready. None of his privates moved. He shouted louder. Finally a few heads rose from the straw and voices grumbled at being disturbed; the men were too tired to eat. Peale mourned over his pot for a long time before he too lay down.

Ordered to march early the next day, Peale's troops soon complained of being hungry; their lieutenant spread a feast for them in a field. "General Washington passing, seeing the men in a small distance from the road, sallied out to know why they were there. And I stepped up to him and told the General that I was giving my men something to refresh them."

Peale's military journal never deviates long from the subject of food; the painter seems to have found comfort amid the horrors of war in being kind to his men. So assiduous was he in securing whatever stores there were that the commissary department, missing vast quantities of provender, descended upon him and took back a wagon-load of flour. It was a sad moment, but Peale soon found another type of kindness with which to cheer himself. When his men's shoes wore out, he secured some hides and, turning the fur side inside, made them all moccasins with his own hands.

Shortly after he had been elected a captain, Peale's militia enlist-

ment ran out; this was late in January 1777. Since Philadelphia had been saved by the victories at Trenton and Princeton, he returned there and planned to go on with his painting, but "curiosity," as he tells us, led him to a meeting which had been called to discuss measures against the Tories still in the city and said to be plotting treason. They were so rich and powerful, however, that no one wanted to take the lead in offending them; patriot after patriot refused the chair. When Peale denounced such cravenness in a burst of eloquent indignation, he was promptly put in the chair himself. This started him in politics, "to which I was a stranger. It was that I consider as the most disagreeable part of my life, except that where I had apprehensions of a jail."

He presided over more meetings. "Having now unfortunately become popular," he was made one of three commissioners "to secure sundry suspicious characters, or to take their paroles they would not in any manner be aiding or assisting the British." Peale was forced to arrest or intimidate men whose politics did not agree with the majority's, and he hated the task. He had most difficulty with a Quaker preacher, who refused to promise anything, since his creed did not recognize war, and who would not go peacefully to the camp prepared for those who refused to denounce the British. Peale pleaded with him to come willingly, offered to hire a coach so that he might ride to the camp in style; only as a last resort did he call "the military." When the troops arrived, he paraded them for a long time on the other side of the street, hoping to intimidate the preacher into accepting a coach. But no; the self-appointed martyr insisted on being carried off bodily. Peale remembered this as "a trial of my fortitude"; he insisted in his autobiography that he never willingly added to the troubles of the afflicted.

The British landed from the Chesapeake during August 1777, brushed Washington aside at Brandywine, and marched irresistibly on Philadelphia. Again in the militia, Peale could not bear to join

his troops at Fort Billingsport on the Delaware until he had found his family a safe haven. He engaged them rooms thirty miles up the Schuylkill, but when he galloped back to tell of his success, he found his residence dark and bolted from within. He knocked with increasing terror until a neighbour stuck his head from a window to say that they had already fled into New Jersey; John Hancock, the president of the Congress, had sent them special word by messenger that "the enemy were crossing the Schuylkill and would shortly be in the city."

Then Peale, whom the British would have loved to capture, tried to make his own escape, but in the general disorder he could find no boatman to ferry him across the Delaware. He spent the night sitting up with other refugees in a tavern that might at any moment be invested by the British. Only after he had made the crossing the next morning did he learn that the enemy were not as close as rumour had reported; they did not march into Philadelphia for another seven days.

With some difficulty, Peale located his family and took them to the house he had engaged near Germantown, but he still did not join his command, for the refugees lacked ammunition with which to protect themselves if "the British horse should become troublesome." Peale volunteered to find Washington and ask for powder. During a day and two nights he rode through an unfamiliar part of Pennsylvania in continual fear of falling into the hands of the British. In every hamlet he asked for news of the redcoats. Often the roads were not safe, and he pushed through the forest or paused in terror while suspicious-looking riders moved on the horizon. Finally he found Washington at Pennypacker's Mills. After he had loaded down his horse with as large a bag of powder as the animal could carry, he threaded his way back again, rejoining his family on the third of October. He spent the night stolidly casting bullets and trying not to notice his host, who danced about in constant

terror lest the arsenal under his roof explode. When dawn whitened the windows, Peale was at last ready for bed, but the mounting light brought with it a distant sound of muskets.

Springing on his tired horse, Peale carried the powder and bullets to the local militia colonel. Then he set out hell-for-leather toward the firing. Soon the sky darkened and a drizzling rain began to fall; he was enveloped in a fog so deep that he could hardly see the road before him. He galloped as in a dream through complete silence and emptiness toward the hellish sounds of battle. Finally a shadow approached through the mist; it was a Continental soldier without gun or knapsack whose breath came out in an aching scream from long running and whose face was a powder-blackened mask of terror. Drawing his sword, Peale ordered the deserter to turn back. But in an instant the mist was alive with shapes; Peale's horse floundered shoulder-deep in a sea of fleeing men. The painter tried to bar the road; he waved his sword and shouted, but the men jostled his horse with unseeing eyes and streamed ever onward in the mist. At last some officers appeared, "intelligent persons" who told Peale that if he valued his skin he should flee too. "I was then obliged to retreat with the retreating troops." Washington had lost the battle of Germantown and with it all hope of recapturing Philadelphia.

Hearing terrified stories of the slaughter that had taken place, Peale was sick with anxiety for his brother James and his brother-in-law, both of whom had been with the army. He spent the day looking for them through the mist, scanning the faces of the troops who were again forming into a semblance of order. "Whenever I saw the wounded, I pushed forward, full of apprehensions." It was not till the next morning that he found them both unscathed.

Peale managed despite the confusion to hire two wagons in which he took his family from that dangerous region to Newtown in Bucks County. Then at long last he joined his militia company, or perhaps it would be more accurate to say that they joined him, for the

British had saved Peale a long and dangerous ride by capturing the fort at Billingsport where he should have been, and forcing his troops to flee to Washington's camp where he was. Delighted to see their kindly captain again, the soldiers, each in turn, borrowed from him small sums of money.

At the head of his troops once more, Peale took part in some skirmishing and had the experience of being chased by the British light horse. While he was on picket duty in an old mill, his painting hand was so badly frozen that he lost the use of the fingers. However, he was not discouraged. "I might, as others have done, have acquired the habit of painting with the other hand." In two months his hand got so well again he was able to return to his art.

The commander-in-chief commissioned a miniature of himself which he wished to send home to Martha Washington. It was painted near Shippack Creek, where the general's headquarters in a farmhouse were so small that when Peale sat at a little table under a low window there was no room for another chair; Washington perched on a side of the bed. Although evidence exists to contradict the story, Peale and his son Rembrandt always insisted that during a sitting Colonel Tilghman rushed in with a dispatch. Washington glanced at it, cried: "Burgoyne is taken!" and laid the paper aside. He expressed no further emotion concerning the first great triumph of American arms, but continued the sitting "with a calm and satisfied air."

After his new term of enlistment had expired, Peale rejoined his wife. "I am now obliged to make use of my mechanical powers to relieve the necessities of my family." He made them shoes. "At that time the situation of the Whigs in Bucks County was such that they were in continued danger of being taken by surprise in the dead time of night and made prisoners. And I had frequently taken my gun and dog and gone into the woods and covered myself with a blanket amongst the leaves under an old tree or in the corner of a fence, in such places as I thought most secure by their remote situa-

tion from the probable route of the enemy in their nightly excursions. At other times, I would take my horse and ride some miles further up the country into the most obscure retreats and get lodgings by some fireside, with all my clothes on and my saddle for my pillow. At other times a number of the militia would collect together at some strong and convenient house for defence, and keep up sentries during the night. Such were generally my practices throughout most of that winter, except at such times as I spent with the army, where I always thought myself most secure, and where I also found it convenient to do some business in the miniature painting."

The army was then encamped at Valley Forge. During this winter of cold, sickness, and starvation, Peale executed miniatures of some forty officers, which they sent back to the families whom they might never again see, and there is evidence to show that a full length of the commander-in-chief which he painted on blue and white bedticking was done at Valley Forge. As a veteran is supposed to have remarked, Peale "fit and painted and painted and fit."

After the British had evacuated Philadelphia, Peale was among the first Whigs back in the city; he had been appointed by the Council of Safety one of the agents to seize the property of "such citizens as had joined the British interest." Again his soft heart bled at the task duty demanded of him. When Mrs. Galloway, a rich Tory, refused to leave her house, "I went to General [Benedict] Arnold and borrowed his carriage; and when the carriage came to the door, I took Mrs. Galloway by the hand and conducted her to the chariot." Peale wanted to "make things as easy as possible with those whose misfortune it was to come within our notice."

He was, however, heartily in accord with the radicals who were determined to keep the spoils of the revolution from falling into the hands of the rich; he became president of the Constitutional Society. This organization, founded "to counteract the machinations of our internal enemies," championed the existing Pennsyl-

vania charter, which was hated by the socially powerful, since it placed all the power in the hands of a unicameral legislature elected by popular suffrage. Even such usually violent Whigs as Dr. Benjamin Rush attacked it as establishing "mob government." Being on the extreme left wing, Peale was frowned on by most Philadelphians prosperous enough to pay for portraits; his business shrank to practically nothing.

In order to serve the poorer people who approved his politics, Peale took to painting miniatures at a reduction. They were almost invariably small, oval slices of ivory which he cut and prepared himself. As that modern critic Fielding Mantle points out, they had taste and charm; the colours pleasing, the clear flesh tones running off into olive shadows. The heads show simplicity of modelling and are generally excellent likenesses.

For the rest, his business was patriotic. He made two engravings of Washington, but a lack of tools and plates, which would have had to be imported from abroad, kept him from carrying out an ambitious project of scraping "a set of heads of the principal characters who have distinguished themselves during this contest." In January 1779 the Supreme Executive Council of Pennsylvania commissioned him to execute a full length of Washington; the press regarded the finished picture as "a striking likeness." It hung in the council chamber until September, when, according to *The Freeman's Journal*, "on Sunday, the ninth instant, *at night,* a fit time for the Sons of Lucifer to perpetrate the deeds of darkness, one or more volunteers in the service of Hell broke into the State House in Philadelphia and totally defaced the picture of His Excellency General Washington. . . . Every generous bosom must swell with indignation at such atrocious proceedings. It is a matter of grief and sorrowful reflection that any of the human race can be so abandoned. . . . A being who carries such malice in his heart must be miserable beyond exception."

Despite the activity of the anti-Tory commissioners, Philadelphia

society continued to be dominated by the wives and daughters of the rich who had stayed in the city during the British occupation and had danced with the sons of lords. Even a year before Peggy Shippen lured America's greatest military genius, General Arnold, into treason, these beautiful sirens were suspected of correspondence with the enemy. In August 1779 the Governor of New Jersey wrote to his daughter: "I know there are a number of flirts in Philadelphia equally famed for their want of modesty as want of patriotism, who will triumph in our over complaisance. . . . I hope none of my connexions will imitate them either in the dress of their heads or in the still more Tory feelings of their hearts."

While the sky-rocketing of the inflated Continental dollar impoverished the soldiers who had risked their lives for freedom, these beauties swept through the streets in British splendour, dangling from the elbows of dandies who had never smelt gunpowder. A wave of fury overwhelmed the common people, who heard that even Robert Morris, the banker of the revolution, was making a fortune through speculation. Determined to drive all such traitors from the city by force of arms, the militia assembled at the Burns Tavern and sent a messenger to invite that intrepid soldier, Charles Willson Peale, to be one of their leaders. Peale hurried to the meeting in great anxiety; he begged them to disband and use their votes at the next election to achieve their ends peacefully. When the angry men he faced waved their muskets and refused to listen, Peale hurried home again and loaded his own pistols, for, as he wrote, "no man could know where the affair would end." He feared civil war within the city.

The militia marched, arrested several suspected Tories, and were storming the house of James Wilson, a leader of the conservative faction, when Governor Reed galloped up at the head of a battalion of light horse; since the members of the cavalry had to supply their own mounts, they were sons of the prosperous. After a brief skirmish in which several died, the militia leaders were ar-

rested. The battle was not over, however, for the militia of Germantown mobilized the next morning and marched on the city, determined to help their Philadelphia comrades release the prisoners. A disastrous conflict behind the patriot lines had almost started when Peale intervened, proving himself a more successful peacemaker than Copley had been. After a long argument, he persuaded the Governor to release the insurgents on bail, and then he was able to convince their supporters, who knew he was on their side, to wait for the election.

When it came, the ballots of the poor swept down all opposition and created a radical assembly, one of whose leaders was Charles Willson Peale. The painter became chairman or member of thirty legislative committees. After his party had passed a statute freeing all children of slaves born within the State, he demonstrated his sincerity by going even further; he released his adult slaves one by one as soon as they became able to shift for themselves.

Peale added to his popularity by arranging public spectacles. In order to cheer the multitudes who had been depressed by Benedict Arnold's treason, he constructed a float which showed Arnold with two faces reaching out for a large purse Beelzebub held before him. By placing transparent paintings in the windows of his house and lighting them brightly from behind, Peale helped Philadelphia greet Washington after the victory at Yorktown. The middle window, the *Pennsylvania Packet* tells us, contained "portraits of His Excellency General Washington and Count Rochambeau with rays of glory and interlaced civil crowns over their heads, framed with palm and laurel branches, and the words in transparent letters, *Shine, Valiant Chiefs;* the whole encircled with stars and flowers-de-luce. . . . During the whole evening, the people were flocking from all parts of town to obtain a sight of the beautiful expressions of Mr. Peale's respect and gratitude to the Conquering Hero."

The artist was launched on a triumphant popular career that might have made him one of the important leaders of the new na-

tion, but his nerves had begun to give way. The man who hated violence had for two years taken part in war, and now he found himself at the head of a violent faction. When he nodded to agreeable patricians whose portraits he had painted, they turned their backs; he was even physically attacked in the streets by the partisans of the wealthy. The plaudits of the ragged half-starved commoners he championed could not make up for the hatred he saw in many a once friendly aristocratic face, for Peale loved all humanity irrespective of class. And the new painting room he had built himself, the first in Philadelphia with a skylight, was empty of sitters. Although he knew he had merely followed the call of duty, he was unhappy at having exchanged the arts of peace for the passions of controversy. At the end of his term in the legislature, he refused to run again. He retired from politics for ever.

But the sudden relaxation of tension did not bring him happiness; instead it allowed him to slide into the nervous breakdown that had been threatening him for some time. On January 15, 1783, he wrote to Thomas Brewer: "Something more than two years past I have been in a kind of lethargy, though at times I have some intervals (but of very short duration) in which I can recollect some past transactions." He tells that once when he was sitting with his family around him, he fell to wondering how many children he had. " 'Four,' I answered as if it were by instinct. 'Four.' " But in order to make certain, he counted those around him, and when he found there were only three, a cold sweat sprang out all over his body; surely he was mad! It took him a long time to figure out that his son Raphaelle was absent. "This account of myself perhaps will seem strange to you, yet it is as true as the Holy Writ."

IV

At last, however, Cornwallis surrendered and the war was over. The return of peace was balm to Peale's tortured nerves. "It was

to me like waking from a dreadful dream. I could scarcely believe my senses that it was not a dream and dangers past; my joy was great to know that I could lay me down to rest without fear of alarm before morning."

Commissioned by the State to construct a triumphal arch, Peale forgot his troubles in joyous activity, making three spans, the centre one twenty feet high and those on the sides each fifteen. He topped them with "statues of the cardinal virtues, larger than human figures," and covered them with transparent paintings to be lighted from behind; the figure of *Peace in the Clouds* alone called for eleven hundred candles.

On the night of the celebration, just as Peale was fixing the last lamp in the uppermost part of the structure, a rocket exploded by a drunken reveller set the arch on fire. Seeing the flames approach a battery of seven hundred rockets attached to the spans below him, Peale seized a rope and, as he stated, "let myself down on the back part of the frame, which was covered with topsails to keep the wind from blowing out the lamps. I had only descended a few feet when a bundle of rockets took fire and was burning all round me, and some, I believed, had got under my loose coat." Peale had no choice but to let go and drop the twenty feet to the ground. "In my descent, I fell across the edge of a board of the building, which broke one or two of my ribs, and from thence to the ground, with several blazing rockets carried with me that went off in different directions. My clothes being on fire, I went into a house and extinguished the fire." Several persons in the crowd were hurt, and one man killed by a rocket.

Although Peale had been badly burnt, the accident did not throw him back into a nervous relapse; it was human cruelty, not physical pain, that weakened his spirit. He built another arch, and was annoyed only when the State refused to pay him for it.

In order to make up the resulting deficit, Peale bent his energies to securing portrait commissions. He attracted public attention by

enlarging to life-size the small pictures of revolutionary heroes he had painted between battles, and by collecting them together into the first public picture gallery in America. His portraits of this period show that war, with its horror and unhappiness that tried the human spirit, had turned his attention from elegance of costume and posture to the fundamental facts of character. Now he was primarily interested in the faces of his sitters. It is an amazing fact that during the years of desolation, when he was entirely separated from all art except his own, his style had greatly matured. Gone were most of his former difficulties in depicting features; although his work was still uneven, he no longer outlined the nose and eyebrows with a disfiguring black V. In his best portraits, he generalized the shape of the head like a primitive woodcarver into a few typical planes that stand out strikingly in space and give an impression of great and inevitable power. Charles Henry Hart in his article on the life portraits of Benjamin Franklin states that Peale's is the best likeness of the philosopher ever made.

However, Peale's picture gallery failed to bring him the commissions he desired, for money was scarce and his political enemies had not forgiven him. As always when one venture failed, Peale promptly launched into another; he determined to "excite the admiration of the curious public" by showing moving pictures. Although he borrowed the idea from accounts of spectacles put on in London by Philippe-Jacques de Loutherbourg, Garrick's stage designer, he had to work out for himself how the effects were achieved. "My labour in this new undertaking was unremitting for eighteen months, and the powers of my mind were exerted to so great a degree as to make me totally neglectful of all other objects." During 1785 he opened the show in his studio.

The spectators were thrilled by the representation of six scenes, one of which Peale describes as follows: "A historical picture of the memorable engagement of Captain John Paul Jones when he took the *Serapis,* commanded by Captain. Robert Pearson. The *Bon*

PEALE: FRANKLIN AT SEVENTY-NINE

PEALE: WILLIAM SMITH AND GRANDSON

Homme Richard and the *Serapis* was represented at the extreme and opposite ends of the picture in full sail with a fine breeze as represented by the waves in pleasing motion, a fleet in the distance going into Scarborough. The two ships, approaching each other, begin to fire, the flash and distant reports imitated. They are now close engaged and the sails are torn in holes. The sea gradually becomes calm, and midnight coming on. The moon rises; the fight continues, and the *Serapis* is on fire and afterwards extinguished—her main mast falls—and then strikes her colours. The firing ceases; afterwards the day breaks and the sea becomes agitated. The American colours are hoisted on board the *Serapis*. The *Bon Homme Richard,* being gradually shattered, begins to sink from the sight of the spectators in a slow manner until she gets so low as to pitch her head down and quickly passes out of sight. And then the *Serapis,* brassing [bracing] about her yards, pursues her course, which ends the scene."

Although Peale left no account of how he achieved these effects more than a hundred years before the invention of modern motion pictures, we may assume that his methods were very like Loutherbourg's. The Englishman's stage, only six feet wide by eight feet deep, was filled with waves that had been carved in wood, coloured, and highly varnished to reflect light; they diminished in size and dimmed in colour as they receded from the spectator, giving an effect of perspective. Each was separately attached to a mechanical device that moved them irregularly, and here and there tiny pipes emitted jets of spray. The backdrop, which represented sky, was transparent, so that lightning, gun-flashes, and the rising moon might be imitated from behind, while long sheets of canvas were painted with cloud effects and swung by a hidden windlass across it. Further light effects were achieved by moving strips of coloured silk across lamps placed mainly in the borders; a piece of gauze dropped between the scene and the spectator reproduced a mist. The ships, of course, were solid three-dimensional pieces of scenery

manipulated like puppets, while sound effects were made backstage by much the same means as now used on the radio.

Although Peale's moving pictures delighted the spectators—the Reverend Jeremiah Belknap wrote they were "worth going four hundred miles to see"—money remained so scarce that they were unprofitable; Peale returned his principal attention to portrait painting. In November 1788 he wrote to West: "I now find it necessary to travel to get business sufficient in the portrait line to maintain my family, which is not small. I mention these things to show you that the state of the arts in America is not very favourable at present, although I am so fortunate as to please all that employ me." While on his painting trips, he saw many pictures he had formerly done in which the colours had faded to unpleasant yellowish tones because he had ignorantly used improper pigments. He now threw all the ingeniousness of his nature into experimenting with different kinds of paints. By 1790 business conditions had improved to such a point that the number of his portrait commissions enabled him to give up the less remunerative painting of miniatures; he raised his prices in order to throw all the business to his brother James.

When the Constitution was ratified, Peale was in Annapolis. He immediately painted "at my own expense" a huge transparency that was the granddaddy of all bad American murals. It revealed a female figure representing the genius of America, dressed in deep blue ornamented with stars, and wearing a band on her forehead that read *Perseverance*. With her right hand she pointed to agriculture, arts, commerce, and science; while with her left she placed behind her anarchy ("shown by the scourging of the weak and helpless"), also a monster with many heads depicting envy, hatred, and jealousy. Over all scudded a figure of fame with two trumpets. This picture was so great a success that Peale was invited to bring it to Baltimore; its descendants may be seen in almost every public building and "world's fair" in the land.

When Washington came to Philadelphia after his election as President, "the ingenious Mr. Peale," as the contemporary press tells us, built a pontoon bridge across the Schuylkill ornamented with "a laurel shrubbery which seemed to challenge even nature itself for simplicity, ease, and elegance." As the general reached the centre of the bridge, one of Peale's children, camouflaged with shrubbery, set in action a machine Peale had invented which dropped a laurel wreath on his head. Miraculously, the aim was so good that the wreath, after teetering for a moment, remained implanted over the ears of the startled President.

During the 1790's, Peale's wife died as a result of her eleventh pregnancy. The painter was heart-broken, but he could not resist trying out several theories he had long harboured concerning burials. He would not let any church bells be tolled for fear of disturbing sick persons, and his family were forbidden to wear mourning, since he disapproved of the custom which he believed brought too much expense on poor families. Often he had frightened himself by reading tales of premature burial; he refused to have his wife buried until three or four days after her death.

At that time remarriage was a necessity for widowers with small children, since no expert nurse-maids could be hired; when Peale went on a painting trip through Maryland, it was partly, he admitted to the charming Widow Goldsborough, "to seek a companion." After she had countered that there were certainly plenty of attractive ladies in Philadelphia, her wooer fixed her with an amorous glance and replied: "It is not an easy matter to obtain a correct knowledge of a lady in so large a community; but on the other hand, in a thin settled country it is less difficult to obtain a correct knowledge of a lady and her connexions." The Widow Goldsborough complimented him on his good sense, but, much to his mortification, did not seem to consider him adequately correct socially or adequately passionate.

Peale moved on to another community and promptly became

ensnared again. "Miss Susannah Caldwell," he wrote, "was in the prime of youth, perhaps twenty years old, and had a fair complexion, sandy or yellow hair, and blue eyes." His adventure with this minx made him comment that portrait painting is a dangerous profession. "Desirous to make a pleasing picture, I desired this young lady to look at me as if she wished to captivate. The idea was put into practice, and the effect had nearly being effected into reality. The picture had the winning look, and the painter's art had almost made me fall in love with the original, and in all probability had the lady wished it, she might have made me break a rule which I had proposed to govern myself, which was that I would not marry a lady of fewer years than thirty-six."

The lady did not wish it; Peale returned to Philadelphia crestfallen, but soon he heard Miss Elizabeth de Peyster sing. "So sweet a voice," he remarked, "bespeaks an harmonious mind." He tells us that the "appearance of Miss de Peyster was that of a sedate countenance, of rather a fat than lean figure, not very talkative but rather of a serious, motherly appearance." Peale was interested, yet "the rebuffs that I had so lately met with rather intimidated me to try again so uncertain a farefare." However, he found the courage to remark to the charmer that "it was a difficult task for a man with several children to get a new mother for them." He remembered that "Miss de Peyster thought it not so difficult, for her father had children and he succeeded to get her mother." Thus encouraged, Peale worked cautiously up to a proposal, although she was "younger by ten years of the number which I had proposed to myself." She accepted, and they were married a little more than a year after the death of Peale's first wife. The new "Mrs. Peale's deportment was such as made her immediately to become a favourite with my children." Soon she was bearing children of her own.

Peale had seventeen sons and daughters, of whom eleven lived to maturity. For generations, writers have made jokes about their names. Instead of using a family Bible, Peale inscribed births and

deaths in M. Pilkington's *Gentleman's and Connoisseurs' Diction-ary of Painters,* and he seems to have chosen names from its pages. Among his children were Raphaelle, Angelica Kauffmann, Rembrandt, Titian Ramsay (he gave two boys this name, the first having died), Rubens, Sophonisba Angusciola, Rosalba, and Van Dyck. Then the type of names he used changed suddenly. The boy born in 1794 was called Linnæus, and the next boy, Benjamin Franklin. Peale's predominant interest had shifted to science.

It had all begun when Dr. John Morgan had asked him to make drawings of some prehistoric bones dug up in Ohio and believed to belong to a mammoth. Fascinated by these vast relics, Peale put them on exhibition in his portrait gallery. Then a friend who enjoyed encouraging his crotchets gave him a preserved paddle-fish. A few days later a ship that had been rammed by a swordfish arrived at Philadelphia; told that the sword was still wedged in its bottom, Peale ran to the wharf, his coat-tails flying, and was soon to be seen tugging at the sword. On July 18, 1786, he advertised in the *Pennsylvania Packet* that "Mr. Peale, ever desirous to please and entertain the public, will make a part of his house a repository of natural curiosities." The angora cat Franklin had brought from Paris, to the amazement of the yokels who had only seen alley-cats, died at this opportune moment, and Franklin gave Peale the corpse. The delighted painter tried to stuff the cat, but, he wrote, "for the want of knowledge of a proper mode to preserve animals, it was lost." Peale hurried out and bought books on taxidermy.

Thus was born the first important museum on the North American continent. The more Peale studied natural history, the more he was fascinated by the multitude of God's wonders, for he had never outlived the naïve approach of a child who does not take obvious things for granted. To ordinary adults, fishes were merely edible creatures which they had always known lived in water; Peale wrote: "In every little stream may be seen numbers of happy little beings that sport through their watery element in sportive

mazes, seeming sometimes to contemplate each other's beauty, and in an instant to dart like lightning to another quarter. . . . Then on the bottom less active beings in coats of shell armour to defend them, of infinite variety of form, ornamented with pearls and other colours." He could not rest till he knew all about fishes, not only their names and their anatomy, but the relation of one species to another. Birds too fascinated him, and minerals and plants and animals both living and extinct. Soon the artist sat up all night reading heavy tomes by Linnæus and by the great naturalists who were his contemporaries: Geoffroy Saint-Hilaire, Cuvier, Lamarck, Maximilian Prince of Wied, John Latham. The time was not far off when he would be corresponding with most of these almost as an equal.

On October 15, 1786 he wrote Dr. David Ramsay that what had started out as a hobby had become an obsession. "I find that I am getting into a much greater field than I expected or intended. I find it very amusing."

After Peale had learned how to stuff, he filled his house with birds and animals of every description. He looked about him with pride, but suddenly a blight struck his specimens; the finest wolves, the brightest orioles, crumbled into dust. Despairingly Peale investigated and discovered that he was suffering from a plague of dermestids and moths. Something must be done; he doused the remaining specimens with turpentine, but when it dried he discovered he had ruined their fur or plumage. Then the painter's studio was turned into an alchemist's laboratory; Peale warmed retorts over blue flames, mixed strange chemicals his friends had given him, in search of a preservative. After two years of labour he discovered that he could protect his animals by dusting them with alum and arsenic. The continuous inhalation of poison affected his health, but he did not stop; he was glad to be a martyr to so fascinating a science.

He believed that if everyone shared his excitement the world

would be a better place. "Was our ministers of the Gospel more frequently to illustrate the goodness of the Almighty in the provisions He has made for the happiness of all His creatures, that excellent code of Christianity would produce more votaries of charity, love, and forbearance with each other." He collected his specimens into a public museum and, in order to lure as many laymen as possible into the study of natural history, used his painter's and sculptor's art to make the first habitat groups of which there is any record. He wrote: "It is not the practice, it is said, in Europe to paint skies and landscapes in their cases, or birds and other animals, and it may have a neat and clean appearance to line them only with white paper, but on the other hand it is not only pleasing to see a sketch of a landscape; in some instances, the habits of the animals may also be given by showing the nest, hollow, cave, or the particular view of the country from whence they came." After his death this method of showing specimens was forgotten, only to be revived in recent years as an important part of museum practice.

Manasseh Cutler, an agent for the Ohio Company, gives us a description of Peale's studio in 1787. Under the portraits of revolutionary heroes which had been the only attraction a year before, there was now an artificial landscape made up of a mound of turf, trees, a thicket, and a pond. Holes in the mound showed various rare earths, and beside it was a pile of curious stones. Around the pond stretched a beach "on which was exhibited an assortment of shells of different kinds, turtles, frogs, toads, lizzards, watersnakes, etc." Stuffed fishes swam in the pond and stuffed waterfowl sailed its waters. The boughs of the trees were loaded with stuffed birds, while stuffed snakes hissed from the thicket at some fierce though glassy-eyed wild animals: a bear, a deer, a leopard, and a wildcat. "Mr. Peale's animals," Cutler commented, "reminded me of Noah's ark . . . but I hardly conceived that even Noah could have boasted of a better collection."

Peale was having a wonderful time with his new hobby. If visitors asked to see him, they were told he would join them in a moment. On entering the gallery, however, they saw standing in a distant corner and intently sketching one of the specimens a wax figure the boyish painter had made of himself. As they tiptoed away so as not to disturb his effigy, Peale, who had been watching through a hole in the door, confronted them from the opposite direction. Their surprise never failed to delight him.

However, his mind had the curious quality of being both child-ish and extremely mature. He identified his exhibits according to the writings of Buffon and classified them according to the system of Linnæus. Determined to establish a national scientific institu-tion, he organized "men of distinction" into a board of visitors that he hoped would help him get government aid. Jefferson accepted the presidency of this board, and among its members were Hamil-ton, Madison, Thomas Mifflin, Robert Morris, David Rittenhouse, and Dr. Caspar Wistar. In a petition to the Pennsylvania Legisla-ture, Peale stated that his object was to preserve "the native pro-ductions and curiosities of this country especially," and to en-courage "that important study in a new and prolific soil." On another occasion he wrote: "As this is an age of discovery, every experiment that brings to light the properties of any natural sub-stances helps to expand the mind and make men better, more vir-tuous and liberal; and, what is of infinite importance in our coun-try, creates a fondness for finding the treasure contained in the bowels of the earth that might otherwise be lost."

Museums of a kind were not a novelty in America, but Peale's ideals were far beyond those of his contemporaries. Since theatrical entertainments were frowned on as immoral, people amused them-selves by attending the displays of curiosities that flourished in almost every city. The Columbian Museum in Boston, for instance, advertised during 1797 a collection of "concert clocks" which marked the hours by such devices as a mechanical "canary bird

PEALE: DAVID RITTENHOUSE

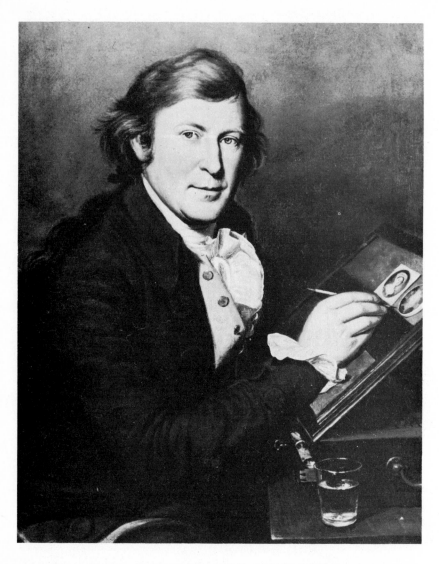

PEALE: THE ARTIST'S BROTHER JAMES

which sings a variety of beautiful songs, minuets, marches, etc., as natural as life"; and a tableau of "King Herod beheading John the Baptist, and his daughter holding a charger to receive the head." There was a natural wonder or two, but the *pièce de résistance* was "fifty elegant waxwork figures." One group showed "the late King of France taking an affectionate leave of his family, just before he suffered under the guillotine. The Queen appears in a rage of distraction, the King's sisters deeply affected. The young Princess is fainting and the Dauphin is embracing his unhappy father. The Queen's maid of honour also appears in great distress. A guard of soldiers are waiting to conduct him to the place of execution. This is an affecting scene, which appears natural as life, and is the most interesting group of WAX FIGURES that was ever exhibited in the United States."

Such museums made money while Peale's scientific institution lost it, yet he stuck to his ideal, although the Pennsylvania Legislature could not be induced to assist him, and his board of "men of distinction" met so rarely that Peale soon gave up all hope of help from that quarter. Peale's Museum, as it was called, was entirely supported by meagre gate receipts and such money as the artist could make from executing portraits.

In order to pay for his hobby, he returned to his art with new energy and made painting tours all through the South. He took his gun along, and in his spare moments shot birds for his collection, which he had to stuff at once, wherever he might be, so they would not spoil. If there were no birds to shoot, he found other occupations, for he could not bear a moment of idleness. "My active mind," he wrote concerning a trip to Maryland, "kept my hands constantly employed, and at my leisure moments here I made a fan to keep off flies and to fan the air for the refreshment of sitters at their meals, and my watch did not please me." So he made it over. "This sort of work gave me amusement, yet it was always misspent time." He tried experiments in horse training. When his balky

mount refused to go ahead, Peale, who was too tender-hearted to use a whip, took out a book and read till the horse became bored standing still; then Peale urged him on. "This mode of treatment completely broke him of such tricks."

But he was happiest when learning more of nature's wonders. During a trip to Baltimore, the Reverend Dr. Kirtz, "a German minister who had made a pretty collection of beetles," interested him in insects. The artist wrote that before this he had "only looked for objects large and striking to the sight, but now I declare that I find an equal pleasure in seeking for an acquaintance with those little animals whose life is spent perhaps on a single leaf, or at most a single bush. It is diverting to watch a flower as you approach a bush, and see the little being watch your approach, turning round a twig or part of a flower to avoid your sight, and in an instant draw up its legs and roll off, sometimes falling from leaf to leaf to get a passage to the ground. . . . The pleasure of the pursuit is great, for although we do not always find the insect we go in search of, yet our labours are often repaid by the obtaining of new subjects, those perhaps before quite unknown and undescribed."

One day, Peale tells us, he set out to make an important call near Baltimore, "but in the first meadow I found myself disposed to examine the bushes attentively, and there I found so much amusement that several hours passed away before I could think of leaving those bewitching animals; and looking at my watch I found it dinner time."

Peale became so fond of the creatures he studied that he could hardly bear to kill specimens for his collection. Tears gathered in his eyes when he heard birds singing in a wood where no hunters were allowed. "This made me reflect on the waste I had made of the feathered tribe in order to furnish my museum. However, I frequently spared those I believed I did not want to preserve and mount."

When he was off shooting seabirds, terrible tidings reached him from Philadelphia. The city was in the grip of the worst epidemic in American history; yellow fever marked its victims in every house. But more destructive than the disease, almost, was the terror it brought. All doors were locked while persons who showed the slightest symptoms of illness were unmercifully driven out into the streets, or deserted in their contaminated houses to scream and die in loneliness. Husbands who had abandoned their wives, mothers without their children, fled from the city into the surrounding countryside.

Peale packed up the birds he had shot and posted towards Philadelphia. When the agonized refugees coming the other way told him that to enter the city was certain death, he replied: "I have four children and two servants for whose safety I am justly alarmed, for I know that if half the bad news that I hear is true, I know that the museum cannot be productive of sufficient income to support them, and that if any of them should be taken sick, I have just reason to suppose that they will want assistance." Finding him obdurate in his madness, one of the refugees gave him an itinerary to his house through streets where fewer people had died.

The city Peale entered was absolutely quiet, absolutely motionless except for the rumble of carts that bore rudely coffined bodies to the communal pits that served as graves. He approached his house with mounting terror, but after prolonged knocking had gained him admittance, he found everyone well. Calmly he settled down to arranging minerals and mounting the seabirds he had shot; by eating the meat, he kept from having to go out of the house to market. "To purify the air, the rooms were sprinkled with vinegar, and I now and then exploded some gunpowder."

When his wife came down with yellow fever, Peale treated her himself in a manner far superior to the prevailing methods of Dr. Benjamin Rush, who distrusted the healing powers of nature and advocated purging and bleeding, sometimes, he reported, removing

four-fifths of the blood in the body. Peale, however, foreshadowed modern practice by disapproving such heroic measures. "Remove the cause of complaint," he wrote, "and use the best means, such as nourishing food, good air, and moderate exercise with a composed mind; as nature is ever labouring to restore the derangement of her system, sooner or later our cure will be performed." Under his care, his wife recovered.

In 1803 Peale published *An Epistle to a Friend on the Means of Preserving Health* which shows that the artist's medical ideas were very modern. Placing his reliance on hygiene not drugging, he dwelt on the importance of posture, of exercise, of moderation in eating and drinking. Clothes, he insisted in that age of corsets, should not constrain the body anywhere. His ideas on diet were based on experiments he had tried on himself; he lived several months, for instance, on nothing but "animal food." Despite errors, like his conclusion that meat is more digestible than vegetables, he discovered many of the principles of modern dietetics, stressing the importance of cooking by steam and the fact that for weak stomachs many small meals a day are better than a few large ones. In his desire for universal cleanliness, Peale invented and patented a steam bath which used only a bucket or so of boiling liquid and was thus practical in a civilization that lacked running hot water. He used soothing flaxseed enemas to purge his patients instead of prescribing, as did Rush and his disciples, huge doses of calomel and jalap.

Perhaps most startling of all was Peale's belief in the newest principle of medical practice, preventive medicine. Insisting that it was to the advantage of the State to keep men well rather than to take care of them when they were ill, he urged Philadelphia to avoid future yellow-fever epidemics by setting up free health centres that would work out and publicize methods of hygiene, and that would treat sufferers in the early stages of disease; the expense

of doctors, he argued, kept citizens from calling them until it was too late.

Undoubtedly Peale was driven into such activities as medical speculation by a growing sense of inferiority concerning his painting. As we have seen, he had never emerged from the unsophisticated tradition of his Colonial predecessors, but during the revolutionary period all American painters had worked in this vein, and he had been outstanding among them. The return of prosperity brought to this country, however, such expert European-trained artists as Gilbert Stuart, who settled in Philadelphia during 1794. Although Peale painted Washington from life more often than any other artist—fourteen times in all, his son Rembrandt tells us —his portraits of the hero seemed crude in comparison with Stuart's first portrait. Faced for the first time since he had left England twenty-five years before with really sophisticated art, Peale realized that his own pictures "appeared liny, and although I laboured to finish them with truth, yet they wanted soundness." Insisting, perhaps defensively, that "in the art of painting portraits more depends on a steady resolution to copy the proportions, the tints, the exact contours of the object portrayed than in works of imagination, efforts of invention," Peale determined to make it easier to copy nature by keeping the canvas on which he painted at the same distance from him as the sitter. This necessitated the invention of brushes some six feet long which he held out at arm's length. Although he admitted the colours were laid on roughly, he was at first delighted with the results. "All the portraits," he wrote, "are by everyone acknowledged to be superior to any I painted before." But he could not keep up the illusion for long. Lamenting the thousand interests that had kept him from sticking to his art when a young man, Peale announced his retirement from portrait painting. Some writers have said that he was motivated by a self-sacrificing desire to throw his business to his two painter sons,

Rembrandt and Raphaelle, but that is at best only a partial explanation. Peale was discouraged.

However, it was not in his temperament to remain discouraged for long. In 1801 he undertook what was perhaps the most exciting adventure of his adventurous life.

<center>V</center>

Unnumbered centuries before the dawn of history manlike apes fled to the treetops at the approach of monsters fifty times larger than they. Glaciers came and receded, millenniums elapsed, until at last man appeared, prospered, and increased while the mastodons vanished from the face of the earth. They were forgotten except, perhaps, for troubled race memories of an age of giants. Yet underneath the ground their remains waited for a resurrection at the hands of science. The Gabriel whose trumpet was to lift their bones to the light again and fit each one to each was a crotchety painter, Charles Willson Peale.

True, there had been hints before his time. In 1712 Cotton Mather was shown a huge tooth and thigh bone that had been dug up in New York State; he argued that this proved the existence of the giants mentioned in the Bible, and, mistaking the bog in which the fossils were found for the decayed remains of this son of Anak, insisted that he had been seventy-five feet tall. Fervently he thanked the Lord who had vouchsafed him this sign of the truth of His word.

When men crossed the mountains into the Ohio valley they entered a vast mastodon grazing ground whose outcroppings of fossils addled the brains of savants like Dr. William Goforth. Their speculations, however, were not quite so wild as Cotton Mather's had been, for mammoths had been discovered in Siberia; sometimes the bones were ascribed to a mammoth, sometimes to a tremendous carnivorous monster whose rib-cage shut up like an accordion when

he wished to hide or prepare for a jump: the deadly megalonyx. Always, Rembrandt Peale tells us, the fossils "were collected with such eagerness and forwarded to Europe so hastily that it shortly became impossible to distinguish one set of bones from another." The field became a morass of speculation in which any man's guess was as good as the next man's.

But ever since his first sight of prehistoric bones had inspired him to found a great museum, Charles Willson Peale had sworn to exhume a complete skeleton. In the spring of 1801 he heard that, almost two years before, a farmer near Newburgh, New York, had been digging in a marl pit when his spade struck something hard; he had expected to exhume a log of wood, but to his amazement turned up a thigh bone eighteen inches in circumference at the smallest part. The story travelled quickly, the local physicians became interested, and soon a hundred men had gathered to dig further. A great discovery seemed about to be made, "but unfortunately," Rembrandt tells us, "the habits of the men requiring the use of spirits, it was afforded them in too great profusion, and they quickly became so impatient and unruly that they nearly ruined the skeleton." Trying to pull the bones out of the clay with chains attached to oxen, they shattered them, and the broken parts sank down into the marl. Then "so great a quantity of water, from copious springs, bursting from the bottom, rose upon the men that it required several score of hands to ladle it out with all the milk-pails, buckets, and bowls they could collect in the neighbourhood." On the fourth day the flood rose so high that they were stopped.

As soon as Peale received his belated intelligence of this exploration, he galloped with Rembrandt from Philadelphia to the farm near Newburgh, where he found the bones "heaped on the floor of his [the farmer's] garret or granary, where they were occasionally visited by the curious." He offered two hundred dollars for them, and another hundred for the right to dig further. When the rustic

demurred, saying he hoped to make a fortune by sending his son on a tour with the fossils, Peale appealed to his paternal instinct by pointing out that the life of a showman was "a kind of life very prejudicial to the morals of those who attempted to get maintenance by those means." Seeing that the son in question was fascinated by the gun he carried, Peale offered to throw it in with the money; his offer was accepted.

Then the sixty-year-old painter hurried out to the marl-pit where the fossils had been found. "Behold, it was a spacious hole now filled with water. The pleasure which I felt at seeing the place where I supposed my great treasure lay," he wrote, "almost tempted me to strip off my clothes and dive to the bottom to feel for bones."

Peale now rushed back to Philadelphia and borrowed five hundred dollars from the American Philosophical Society, in which he held the position of curator. Replying to a request for help, Jefferson, who had just been inaugurated President, wrote that he had ordered the Secretary of the Navy to lend Peale a pump, and General Irvine to lend him a couple of tents. "It has been a great mortification to me to find myself in such a state as to be unable to come forward and assist you in resources for this enterprise; but the outfit of my office has been so amazingly heavy as to place me under greater pecuniary restraints for a while than I ever experienced."

Soon back in the marl-pit, Peale hired twenty-five workmen and designed a wheel to carry off the water. Twenty feet in diameter, it pulled an endless chain of buckets out of the hole, and was propelled by having people walk in it, a cheap means of locomotion, for the spectators were usually delighted to do this, "and thus I got that labour without cost." Many bones were found. However, the water was so cold that it numbed the workmen, while the banks caved in and the soft marl oozed up through the clay; Peale's elaborate apparatus and many assistants were brought to a halt

PEALE: THE EXHUMING OF THE MASTODON

The artist stands holding a scroll, behind him many members of his family

PEALE: THE STAIRCASE GROUP

PORTRAITS OF RAPHAELLE AND TITIAN RAMSAY PEALE

when he still lacked the tail bones, the toe bones, and the all-important lower jaw.

Determined to find these missing parts, Peale moved his equipment to another morass, where his excavations turned up a basketful of fossils but no lower jaw. "Almost in despair at our failure in the last place, where so much was expected, it was," Rembrandt Peale remembered, "with very little spirit we mounted our horses on another inquiry." They went to the farm of a Peter Millspaw, who had once discovered some fossils behind his dwelling. "From his log hut he accompanied us to the morass. It was impossible to resist the solemnity of the approach to this venerable spot, which was surrounded by a fence of safety to the cattle without. Here we fastened our horses and followed our guide to the centre of the morass, or rather marshy forest, where every step was taken on rotten timber and the spreading roots of tall trees, the luxuriant growth of a few years, half of which tottered over our heads. Breathless silence had here taken her reign amid unhealthy fogs, and nothing was heard but the fearful crash of some mouldering branch or towering beech. It was almost dead level, and the holes dug for the purpose of manure, out of which a few bones had been taken six or seven years before, were full of water and connecting with others containing a vast quantity, so that to empty one was to empty them all." However, the Peales set up their apparatus. After days of labour, they exhumed only some rib and leg bones so rotten they crumbled to pieces when lifted.

In one last effort before giving up their quest, the Peales pierced the surrounding mud with long, pointed rods in search of hard marl. Finding some, they dug listlessly, and at once turned up a lower jaw in excellent preservation. In a day or so, they had a second almost complete skeleton.

Jubilantly, Peale carried the fossils back to Philadelphia. Too good a scientist to mix bones found in different places, he recon-

structed the two most complete skeletons, filling in the missing parts of each with plaster casts taken from the other. This resurrection, he remembered, was "a long and arduous work," for no one knew what the completed animal would look like, "yet the novelty of the subject, the producing the form, and as it would seem a second creation, was delightful, and every day's work brought its pleasure." He was amused to find that it was an advantage to know no anatomy. "Moses Williams fitted pieces together by trying not the most probable but the most improbable positions as the lookers-on believed, yet he did more good in that way than anyone employed in the work."

Little by little the structure of bones grew from the floor of Peale's studio until human eyes saw, for the first time in uncounted years, the monsters who had terrified our prehistoric ancestors. The Peales, those puny creatures whose race had survived when such behemoths perished, triumphed over their captive skeletons; Rembrandt gave a dinner party inside one of them, finding room for a table seating thirteen people and a piano. Many quaint toasts were drunk: "The American people—may they be as pre-eminent among the nations of the earth as the canopy we sit beneath surpasses the fabric of the mouse." And later: "The ladies of Philadelphia—ere their naked beauties prove as horrible as bare bones, may Virtue behold them clothed in the garments of Modesty." A radical sprang up to propose "the bony-parts of Europe," and the toast was drunk with enthusiasm.

How accurate was Peale's reconstruction it is impossible to say, since the skeletons were long ago dismembered. We do know that the painter made mistakes, such as his assumption, justifiable according to the knowledge of his time, that mastodons (or mammoths as he called them, although he recognized differences) were carnivorous. However, there can be no doubt that his work was of major significance. His mastodons, the first reconstructed anywhere in the world, filled an important scientific gap; they inspired the

great European palæontologist Cuvier, who was soon to dig up a specimen of his own; and they excited the imaginations of the American people as few discoveries ever had, awakening in this country one of the first waves of popular interest in non-utilitarian science. Peale was the father of American vertebrate palæontology.

He kept one of the monsters in his museum, and sent the other to England with his son Rembrandt, who eventually founded a museum for it in Baltimore. The museum still exists, although the skeleton, after belonging to the showman P. T. Barnum, found its way to the American Museum of Natural History in New York, whence it has travelled to the Darmstadt Museum in Germany.

Continually Peale struggled to have his museum made a State or a national institution. In 1802, he wrote to Jefferson, asking Congress to take it over. "No person on earth," the President replied, "can entertain a higher idea than I do of the value of your collection nor give you more credit for the unwearied perseverance and skill with which you have prosecuted it." But he doubted whether Congress considered itself "authorized by the Constitution to apply the public money to any but the purposes specially enumerated in the Constitution." If an amendment were passed giving Congress power to aid science, "I am persuaded the purchase of your museum would be the first object on which it would be exercised. . . . I have for a considerable time," Jefferson continued, "been meditating a plan of a general university for the State of Virginia on the most extensive and liberal scale that our circumstances would call for and our faculties meet; were this established, I should have made your museum an object of its establishment." Jefferson advised Peale to petition the Legislature of his own State.

The Pennsylvania Legislature would do no more than give Peale the second floor of Independence Hall at a nominal rent; in 1802 he moved his museum there from the building of the American Philosophical Society, where it had been since 1794. He set up in

his new rooms some two hundred stuffed animals, a thousand birds, four thousand insects, as well as a collection of minerals, snakes, and fishes. All were displayed under a double tier of portraits of famous Americans, more than a hundred pictures painted exclusively by Peale and his sons. The museum remained in Independence Hall till after its founder's death and never obtained any substantial governmental support, although Peale's hopes were continually being raised. "Having proposed to Congress the subject of a national university," Jefferson wrote to him in 1806, "should they come into it, it will be no small part of the gratification I shall receive from it that the means will be furnished to make your museum a national establishment." Congress did not come into it.

Jefferson, however, found other ways of assisting the friend whom he so much admired that for several years he placed the upbringing of his favourite grandson, Thomas Jefferson Randolph, in his hands. When the Lewis and Clark expedition returned from its epoch-making exploration of the West, the President sent Peale's Museum the zoological specimens they had brought back with them, including "many animals not known before as belonging to this country." Jefferson admitted a great partiality for a live prairie dog, the first seen in civilization. "He is a most harmless and tame creature," the President explained in a letter expressing anxiety lest the animal begin to hibernate before reaching Philadelphia and thus cheat Peale out of the pleasure of playing with him.

Peale promptly added to his collection a wax figure of Lewis smoking his peace pipe; "my object in this work is to give a lesson to the Indians who may visit my museum, and also to show my sentiments respecting wars." He remembered that during Washington's administration two mutually hostile groups of Indian chiefs, warriors who had met only on the field of battle, had looked up from his exhibits to find themselves face to face. "They regarded themselves with considerable emotion, which in some degree subsided when by their interpreters they were informed that

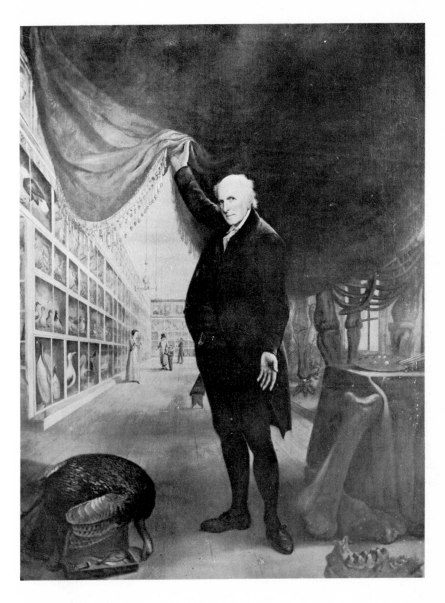

PEALE: THE ARTIST IN HIS MUSEUM

PEALE: SELLERS HALL

each party . . . had come merely to view the museum." Surrounded with so many specimens of strange animals, they decided "that as men they were of the same species and ought for ever to bury the hatchet of war." At the request of the Secretary of War, Peale lent the Indians a museum room in which to hold a peace conference. After they had heard a speech by Washington they signed a non-aggression pact that included the following tribes: Creeks, Cherokees, Choctaws, Chickasaws, Southern Shawnees, Wyandots, Delawares, Miamis, Chippewas, Kickapoos, and several more nations of the Northwest. Peale felt that the uplifting influence of his museum had been proved.

For he regarded his institution as an educational one; he collected to show to the people and anticipated modern museum practice by many new devices to interest the popular mind. Not only did he invent the habitat group, but he discovered the methods for the preservation of birds and beasts employed by modern institutions. He did not simply stuff as had his predecessors, but used his ability as a sculptor to model the bodies on which the pelts were placed. An important innovator, he placed tiny insects under permanent microscopes, hung scientific explanations beside his exhibits, and became the first American lecturer on natural history to illustrate his talks with specimens. From an educational point of view, the institution he built up single-handed ranked with the best in the world. Frederic A. Lucas, then director of the American Museum of Natural History, wrote in 1927: "Had Peale lived a hundred years later, he would have been a leader in museum methods."

Although Peale did not himself publish scientific descriptions of the specimens he discovered, his collections were of scientific importance, for they were described by C. L. Bonaparte, Richard Harlan, George Ord, and Audubon's rival, Alexander Wilson. Seventy-one out of eighty-five species described by Wilson under new names came from Peale's Museum. Nor were the exhibits

limited to American specimens; by exchanging with European institutions, Peale obtained a fine collection of purely European fauna. His museum, like a loadstone, drew all American naturalists to Philadelphia.

While he was creating a great institution in honour of natural history, the love of his middle age, Peale was concerned because the United States contained no institution to promote the love of his youth; for lack of any public gallery where art might be exhibited, painters and sculptors had still to lure possible patrons to their studios or else remain unknown. Twice, once in 1791 and once in 1795, Peale tried to organize the artists of Philadelphia into an academy. The first attempt collapsed almost immediately owing to internal disagreements; the next, called the Columbianum, began auspiciously. The published constitution shows that Peale had planned his institution on a large scale. In addition to an annual exhibition of contemporary paintings, a gallery of old masters, a hall of casts, and an art library, there was to be a school staffed by professors of perspective, architecture, anatomy, painting, sculpture, engraving, and the chemistry of paints. The constitution provided that the Columbianum was to be managed by the artists themselves, not by the rich dilettanti who were, for financial reasons, invited to become members.

From the first the prudery of Philadelphia intervened. As a basis for the hall of casts, Peale borrowed the replica of *Venus de' Medici* which the English painter Robert Edge Pine had brought to America. However, he was not allowed to show it publicly, for the woman was nude. The Cyprian queen was locked up in a case and brought out only for the elect. When Peale moved at a meeting of the academy that the students be allowed to "draw from the living figure," the rich young men who had been admitted in the hope they would become patrons of art were so shocked that they marched out in a body and sent Peale the following letter: "We, whose names are hereunto subscribed, highly disapproving of the

inconsistent and indecent motion brought forward and negatived at the last meeting of the association of artists of Philadelphia, take the liberty of informing them that we consider ourselves as no longer members of that association, and do accordingly personally and openly give our resignation."

Peale, however, persevered. He set a date for the first life class, and then scoured the city in search of someone who would pose in the nude. After many rebuffs, he managed to persuade an impoverished baker. The class met, the baker went behind a screen to disrobe, but five, ten, fifteen minutes passed and he did not reappear; he was trembling there half undressed in an agony of bashfulness. When he came out again at last, he was completely clothed; he denounced the school as an institution of the devil and stamped out of the door. Peale took one look at the disappointed faces of the boys who wanted to learn, and then went behind the screen himself. The ageing painter became Philadelphia's first public nude model.

Stories of Peale's immodesty and the shamelessness of the Columbianum were circulated through the city, doing both the artist and the academy great damage. Indeed, Philadelphia was to stick to its prudery for another century; in 1886 Thomas Eakins, one of the greatest artists America has ever produced, was driven from his classes at the Pennsylvania Academy and hounded into a pathological mental state because he wanted his pupils to learn what the human body looked like.

Although under a cloud, the Columbianum opened in 1795 America's first public exhibitions both of modern paintings and of old masters. Finances, however, went from bad to worse, and soon its members broke into two factions, the foreign-born artists led by the Italian sculptor Ceracchi against the native-born led by Peale. After a sharp internecine struggle, the Columbianum died.

Peale was for a time discouraged, but in 1802 some New York business men, egged on by the painter John Trumbull, formed the

New York Academy of Fine Arts and imported some casts. Mindful of his former difficulties with warring factions of artists, Peale adopted this method of organization three years later; he created the Pennsylvania Academy of Fine Arts by rounding up seventy-five connoisseurs, more than half of them lawyers, and carefully placing only two artists on the board, himself and the figurehead carver William Rush. Carefully he allowed the financiers to amuse themselves by erecting a neo-Greek building and by holding exhibitions of old masters before he slipped in the work of Philadelphia's young aspirants, and finally that horror of horrors, nude models. His tact was rewarded; the Pennsylvania Academy, which received its charter in 1806, two years before its New York rival, still exists, a permanent monument to Peale's perseverance and public spirit.

While Peale was organizing the Pennsylvania Academy, he was still so conscious of his inferiority to younger, better-trained artists that he did not solicit commissions as a professional portraitist, although he could not resist occasionally practising the craft he loved by painting his relations and friends. These works show that the ageing painter was eagerly imitating the virtues of the youngsters he admired; ever since the revolution his portraits had been developing in the direction of greater smoothness, and at about the turn of the century he may be said to have left the American face-painting tradition largely behind him. His son Rembrandt, whom he had sent to England with the mastodon, had studied in West's studio, and when he returned adept at the suave tricks he had learned there, Peale sat humbly at his feet; the old man was not too proud to learn from his children.

Anxious to get the young man started as a portrait painter, Peale took him to the new capital at Washington, where he collaborated with him on several portraits, including one of Gilbert Stuart. "When Mr. Stuart's son see it," Peale wrote, "he said it was the

best likeness of his father that had ever been painted." Stuart's own account of the picture, however, was less enthusiastic. He laughed at it, saying it made him appear an "awkward clown."

"I must tell you that Rembrandt has rekindled my desire of devoting as much time as I can possibly spare from the museum to the pencil, which until late I had almost laid aside," Peale wrote to West in 1807. "I thought it was too late to attempt anything worth notice, but the desire to possess a portrait of Baron Humboldt, whom I was intimate with when here, and having none of my family that could paint it for me, I told the Baron I had not painted for six years and probably should make a daub of it, yet it should be a likeness, and to my surprise it was a painting better than any I had painted for the museum before. This encouraged me to try again and again."

He determined to attempt a representation of the finding of the mastodon. Although he began a large canvas containing eighteen portraits, mostly of members of his family, "since I still doubted my abilities to make a tolerable picture," he improvised an easel out of some old laths; it would be a waste of money to buy a good one. "However," he continued to West, "as I advanced in the work it seemed to engross my whole attention, and I really took pleasure in painting from morning till night and even to use lamplight. I then ordered the cabinetmaker to make me a commodious mahogany easel, etc., so instead of burning my pencils and totally quitting the art as I thought very probably would be the case, I found it much less difficult than I imagined, and have ever since regretted that I had not taken a larger canvas and devoted more time to giving a higher finish to the piece. I often say that the aged ought not to be discouraged from undertaking works of improvement."

Peale was feeling young and enthusiastic again. A few years before, he had acquired a new partner, Elizabeth de Peyster having died, as his first wife had done, of a surfeit of childbearing. Perhaps

it was a relief. A portrait he executed of his second spouse is a revealing document, for it is one of the most disagreeable pictures he ever painted. It shows her as heavy and unattractive, with a large fleshy nose and large fleshy lips protruding over a fatly rounded chin. Her body is square and clumsy, the spine a little hunched. Although her hair is most fancily curled and powdered, the face beneath it is disagreeable, vaguely porcine.

This picture lends credence to the tradition which has come down in Peale's family that Elizabeth de Peyster had nagged her husband because of his tradesman-like enthusiasms, which were continually making him deviate from the dignified pattern of eighteenth-century gentlemen. It is said that the genial disorder of his temperament disgusted her, and certainly he commented on her neatness in his autobiography with awe bordering on horror; "she could," he wrote, "even in the darkest night lay her hands on whatever she wished to take out" of the clothes-press. We know that she resented having to sell tickets or preside at meetings of the museum, insisting that only shopkeepers' wives made themselves conspicuous by helping with their husbands' affairs. Subsequent events indicate that she trained her children to disapprove of their father's unconventional ways.

Peale's new wife, Hannah Moore, was meeker and more obliging. Although almost as old as her husband, she had not been married before, but had devoted her life first to taking care of her mother, who was for five years "confined to her bed so helpless that she could not take a pinch of snuff but received it from her daughter's fingers," and, after her mother died, to her aged father, who was so feeble he could not walk out of the house except on Hannah's arm. Peale was delighted because she was "a cheerful, discreet, and good-tempered woman, not giddy or frisky in her movements." The third Mrs. Peale wrote to her step-children: "This is my bridal day and you never beheld a more serene sky. Not a cloud is to be seen in any quarter. All is calm as the mind of

PEALE: ELIZABETH DE PEYSTER PEALE

PEALE: HANNAH MOORE PEALE

your dear father, knowing he is going to possess a most endearing companion, who will prove to be a loving mother to you all, and to give us that aid we stand in so much need of to cherish the seeds of virtue which nature has planted in the breasts of the younger branch."

With an amiable new wife to back him up, Peale bustled around Philadelphia like a young man, hurrying from his museum to his art academy to his studio, where he painted or pottered with his inventions. In the course of his life he made many, including a patented fireplace and a new kind of wooden bridge. He collaborated with Jefferson in perfecting the polygraph, a machine for multiple writing in which one pen moved several others on automatic arms; during two years of Jefferson's second term, they exchanged some fifty letters on this subject alone. The President, who had frightened the Barbary pirates with the navy, wished to impress them as well with American ingenuity in the arts of peace; he asked Peale to make three polygraphs, "one for the Bey, one for the Secretary of State, and one for the Ambassador here, but they must be entirely mounted in silver; that is to say, everything which is brass in your ordinary one must be silver." Jefferson himself kept Peale's machines by him all his life, and mourned that they had not been invented thirty years sooner so that he could have preserved copies of his correspondence during the revolution. In 1809 he wrote: "I could not therefore live without the polygraph."

Peale's passion for self-improvement increased with old age. When Rembrandt, who had been studying in Paris, brought back during his father's seventieth year a new technique acquired from the disciples of David, the old man insisted on learning to paint all over again. Soon he was turning out canvases whose hot, highly glazed colours give so different an effect from his other pictures that it is almost impossible to believe they were painted by the same man. It is a remarkable testimony to the old gentleman's

vitality that some critics regard these pictures as his best. After years of studying the more suave canvases of his juniors, Peale, it is true, had lost most of the awkwardness of his style, but it seems to this writer that he had also lost the sharpness of his personal vision. Excellent examples of the more sophisticated painting being done in America at that time, they are not outstanding examples; they lack the individual approach which made his early pictures fascinating. Yet when we consider that they were painted by a septuagenarian in a new style learned from his son, they must be regarded as one of the most amazing phenomena of American art.

VI

In 1813 Jefferson, now retired from the Presidency, heard that Peale had taken up a new hobby. "It is long, my dear sir, since we have exchanged a letter," he wrote. "Our former correspondence always had some little matter of business interspersed, but this being at an end, I shall still be anxious to hear from you sometimes and to know that you are well and happy. I know, indeed, that your system is that of contentment under any situation. I have heard that you have retired from the city to a farm, and that you give your whole time to that. Does not the museum suffer? And is the farm as interesting?"

But Jefferson could not really believe that farming could be uninteresting. "I have often thought," the great statesman continued, "that if heaven had given me choice of my position and calling, it should have been on a rich spot of earth, well watered, and near a good market for the productions of the garden. No occupation is so delightful to me as the culture of the earth, and no culture comparable to that of the garden. Such a variety of subjects, some one always coming to perfection, the failure of one thing repaired by the success of another, and instead of one harvest a continued one through the year. Under a total want of demand, ex-

cept for our family table, I am still devoted to the garden, and though an old man I am still but a young gardener."

In order to give his naturalist son Rubens more prominence by placing him in charge of the museum, and because he believed the arsenic he used to preserve specimens was at last disastrously undermining his health, Peale had retired from Philadelphia in 1810 and bought a large farm near Germantown. "That garden now became my hobby-horse," but though he bought the best stock and implements, it failed to make money; Peale became so fond of his animals he could not bear to slaughter them, and he hired too many men. "I wanted to make labour easy, and spared no pains to make machines for very many uses." He constructed corn-huskers and butter-churners and straw-cutters, but they all cost money and brought in little, while he was continually employed in fixing them. "Therefore I call them my follies, and great follies they have been, except that while contriving and making them it afforded me amusement, but to complete the climax of my follies I wanted a windmill to pump water." Again and again he erected his structure on the top of a hill, each time with some new safety appliance, but sooner or later a high wind turned the sails so fast that the whole edifice came tumbling down. The children of his second marriage, who thought their father should retire into a decorous old age, were infuriated by his perpetual tinkering: by the way he rushed out in every storm to watch his mill, by the loud crash that soon followed, and by the return of the drenched, discouraged old man, and above all by the renewed cheerfulness of the next morning that set Peale to tinkering again.

Seven times the mill fell, till "the patience of my family and friends was exhausted." Then Peale invented an apparatus that would make the sails shut together like the petals of a flower when a high wind blew. No sooner was it installed than "I saw a dark cloud in the west, and in a short time after I heard the wind whistling, when I ran out and had the pleasure to see that the

violence of the wind did not increase the velocity of the sails. . . . On seeing this, I almost danced with joy. . . . The invention of these sails for mills and that of my wooden bridges I consider the most important of any mechanical works of my invention." Peale promptly urged the City Council to pump all the water for Philadelphia by means of such mills; sourly a committee of the Council replied that "the whole front on the Schuylkill belonging to the corporation at Fairmont would not afford sufficient room for one-half the number that would be necessary."

His children sighed with relief now that the windmill crisis was over, and waited for their father to settle down by the hearth in white-haired calm, but as bad luck would have it Peale saw in Baltimore "a fast-walking machine" that had just been invented in Germany and was called a velocipede; it was similar to an old-fashioned bicycle except that it lacked pedals. The painter hovered round it excitedly, and as soon as he got back to his farm began making contrivances like it, first of iron and then of wood. According to an article that appeared during 1819 in the *American Daily Advertiser*, "This whimsical pedestrian accelerator having excited much curiosity, Mr. Peale has made one which is now deposited in the museum. He rides it around the walks of his garden, gets great pleasure from his expertness in manœuvring it about." To his family's intense mortification, he rode it into Germantown, "disregarding," as he wrote, "the stare of the multitude, and it was pleasing to gratify the children." While his sons and daughters watched in horror, the seventy-eight-year-old painter coasted whooping down the hills, his coat-tails flying. He was very happy.

> " 'You are old, Father William,' the young man said,
> 'And your hair has become very white,
> And yet you incessantly stand on your head—
> Do you think, at your age, it is right?' "

Peale, that amateur farmer, amused Jefferson by writing him advice on how to plough; Jefferson replied that he had been ploughing that way for half a century. The two old men's letters grew increasingly affectionate as the years closed around them. In 1813 the ex-President, who was becoming more and more infirm, wrote to his contemporary: "When I observe that you take an active part in the bodily labour on the farm, your zeal and age give me uneasiness for the result." Four years later he commented wistfully: "I admire you in the variety of vocations to which you can give your attention. I cannot do this. I wish always to be reading and am vexed with everything that takes me from it." Replying in 1818 to a jubilant letter in which Peale announced that he had discovered a new kind of spectacles, Jefferson remarked that he was "at a loss to understand how those of three-foot focus can be made conveniently to direct the operations of the human hand which can with difficulty be extended to that distance. However, the invention answers a useful purpose if it adds to your amusement, and I rejoice to learn that new improvements in your art [painting] increase your attachment to it; for one of the evils of age is the loss of interest in those employments which in earlier life constituted our happiness." In 1820 Jefferson wrote to Peale: "I can never be a day without thinking of you."

Peale busily visited Washington and Baltimore to execute portraits, and in 1819 reported to Jefferson with his perennial optimism: "My late portraits are much better than those I formerly painted—such is the opinion of the public—yet I cannot resist my inclination for mechanical labours as much as I ought." To the extreme horror of his younger children, who felt he was levelling another blow at their social position, Peale had thrown himself enthusiastically into experimenting with the construction of false teeth; the loss of his own teeth had got him started. Searching for a suitable substance from which to make them, he tried ivory and

then the teeth of seacows. When he found that these decayed in the mouth, he experimented with the teeth of all the animals in his museum. The hardest, he discovered, were those of hogs, but "they could very seldom be had sufficiently large." Finally Dr. Planteau, a French dentist practising in Philadelphia, made him a set from porcelain. Delighted with this new substance, Peale determined to perfect its use, and in the plant of a manufacturer named Abraham Miller he made valuable experiments in glazing porcelain teeth and attaching them to the plates.

When his children remonstrated that he disgraced them by following "the profession of a dentist to serve a number of old maids," Peale replied: "I am so sensible of the vast advantage to have these deficiencies overcome, how pleasant it is to be able to masticate any kinds of viands, to assist pronunciation, and to enjoy a sweet breath, and enjoying these comforts myself, it will hurt my feelings to refuse my aid to others."

During 1826 he parried an attack from his son Titian as follows: "Ought I not to do any sort of work that is not dishonourable in order to clear myself of debts? Do you know that I am capable of any employment more likely to relieve myself of debt than that of dentist? Is it discreditable to me to continue a work in which I believe I am serving my fellow-mortals? . . . Have I not done the best according to my judgment and abilities towards all my children? And lastly, am I not entitled to live at my ease and pursue such employment as may please my fancy during the remainder of my life without the censure of my family?"

The sons whom Peale had put in charge of his museum tried vainly to make him retire entirely from the management, insisting they could make more money if he did not interfere; they wanted to add exhibits that lacked scientific interest, but seemed likely to draw crowds. As long as he lived the painter refused to allow them to lower the high standards he had set. After his death, however, his sons reduced his great institution to little more than a dime

peep show. Even at that it failed during the 1840's; many of its exhibits were bought by Barnum.

During Peale's old age, the sons complained that he did not pay them enough for managing the museum, but he could not have been more liberal, for he was very poor. On April 7, 1821, he wrote to Rubens: "I was reluctantly induced to give an order on you for the poor tax of last year. . . . I have only seventy-five cents at present." Although he finally had to sell the farm that gave him so much pleasure, he remained cheerful until his third wife died and he was forced to live with his disgruntled son Titian, whose wife, in the opinion of the other children, paid little attention to his "personal comforts." Then he felt very lonely. "Man," he wrote in his diary, "as is the case with other sociable animals, requires a companion, and although I am eighty-six years of age, [I] feel the loss of a female of my bosom." He expected to live twenty-seven years longer, for he had worked out an infallible system of reaching what he considered on the best scientific grounds the natural age of man, one hundred and twelve years. Under the circumstances, he naturally determined to marry again. It was only a matter of finding a suitable partner.

During December 1826, according to Peale's last diary, a Mr. Morris told him that he "knew a woman that was exactly such as would suit me. She is a most accomplished woman, sensible, amiable, and would delight in the studies I enjoyed." She was fifty-three or fifty-four, and a teacher at the Deaf and Dumb Institution in New York. As Morris sang her praises, Peale became afraid she would not have him. " 'But,' said my friend, 'Miss Stansbury is poor, and with all her accomplishments she is humble.' This gave me the hope that I might succeed in obtaining such a companion." Morris wrote him a letter of introduction, but Mrs. Morris "declined reading it and said she would not have anything to do with it; hence I concluded that she did not much approve of the proceeding."

Full of eagerness and feeling young as a puppy, the octogenarian set off to New York a-courting. When he called at the Deaf and Dumb Institution, Miss Stansbury received him kindly, "took a cloak and put it on a bench for me to set on before the scholars." Peale was much impressed with how well she taught her unfortunate charges, and in talking to her afterwards told her "that I wanted a companion." He gave her a handful of his pamphlets to read.

Peale had been fascinated not only by the lady; he was also fascinated by her technique of teaching the deaf. Paying a call several days later, "I told her that I wished to make a bargain with her, which was to teach her to make porcelain teeth, if she would teach me her art." Afraid of what might follow, Miss Stansbury demurred. Then her impetuous lover proposed. She replied that she was not well and that she would die soon and that she could never bear leaving the school; he must seek elsewhere. But Peale was not discouraged, for he still had a trump card up his sleeve. He mourned over the gaps in her mouth and offered to make her some false teeth. This kindness she could not refuse, and the many fittings required gave Peale further opportunities to press his suit, but all in vain. When the teeth were finished, he had to return alone to Philadelphia, taking a steamboat to Brunswick.

As the rejected lover sat in the cabin, he confided his difficulties to his diary, but the words that poured from his pen were not depressed; after eighty-six years of looking at the bright side of things, Peale was still an optimist. He would get a wife soon, he wrote, and in the meantime the chase was fun. True, his conscience bothered him a little for fear that his investigations had raised hopes in the hearts of several eligible ladies; but he argued that a man could not be expected to marry a woman until he had found out all about her. When an acquaintance, Mrs. Matlow, tapped him on the shoulder and asked him to visit her sometime in Burlington, he replied: "Oh, yes, Madam, it will give me great

pleasure to do so. And very probably you can recommend me to some agreeable companion."

The boat grounded below the landing, but the octogenarian, full of rosy dreams of future married happiness, felt so strong that he slung his trunk over his shoulder and walked. "To add to my difficulties it was dark, and the shore side rough, and to lug my trunk about a half-mile was too severe labour with me, having my cloak and umbrella."

Peale had strained his heart. When he reached Philadelphia, he took to his bed. Some months later, on February 22, 1827, he awoke feeling very weak; dimly he could see his daughter Sybilla sitting beside him. "Sybilla," he whispered, "feel my pulse." She took the emaciated hand, fingered it clumsily for a moment, and said: "Pa, I can't find it."

The aged painter nodded cheerfully. "No," he said, "it is gone. The law makes my will." And he settled back so gently, closed so softly the eyes that had been interested in all God's wonders, that his daughter was confident he slept. But Charles Willson Peale had joined the heroes of the American dream among whom he belonged. We may be sure that Paul Bunyan took him by the hand and Johnny Appleseed called him brother, while George Washington must have smiled as he smiled when he saw the militia captain stuffing his troops with food during the retreat from Princeton. Even Rip van Winkle took off his hat as the old man scorched by on his velocipede.

If the documents were not there, if the paintings did not hang on museum walls, who would believe that Peale had really lived? We would not expect to find him in the sober writings of historians; he seems rather a more intellectual version of some story told around the fire in a lumber camp or on a prairie, when the narrator's mind, heated with rum or applejack, calls again from the heavens the reverberating echoes of American legend. Peale was the early American spirit come to life, the spirit of the simple folk. He was

ingenious, crotchety, sentimental, kind, given to feats of strength and wild soarings of the imagination, superficial perhaps but interested in everything, part genius and part wastrel, a scorner of tradition who solved problems his own way even if it were the worst way, but whose versatility and optimism prepared the ground for a more complex civilization that would drive men like him from the continent. Peale may not have been a great painter, but he was a great man.

Gilbert Stuart

(1755–1828)

ON DESPERATE SEAS
GILBERT STUART

I

LIKE a true believer entering a shrine, John Neal tiptoed reverently into Gilbert Stuart's Boston studio. The more art is banished from the main current of national life by utilitarian pursuits, the more holy it seems to its votaries. In the roaring 1820's, when all the energies of the nation were absorbed in the growing settlements beyond the mountains, John Neal, that sensitive youth who aspired to culture, thought of Gilbert Stuart as a god. Was not Stuart recognized as the greatest painter in America? Had he not preserved the features of Washington for all future ages? Humbly Neal advanced toward the end of his pilgrimage.

He passed the threshold with eyes modestly downcast, but when he looked up, the worship in his expression gave way to surprise. He saw before him a furious-looking old man whose dishevelled clothes were encrusted with snuff, and one of whose feet was bound up because of gout. A huge mouth curved powerfully downward among the sagging muscles of his lower face; bloodshot eyes stared with unpleasant intensity from behind red lids. This terrifying countenance was dominated by a tremendous nose whose purple-red veins proclaimed its owner a perpetual drinker. When Neal asked incredulously if this was Gilbert Stuart, the corners of the mouth lifted suddenly into a sarcastic smile. However, the voice in which the painter admitted his identity was suave and had the well-bred London sound that Americans associated with culture. Neal was reassured by the courtliness with which he was shown to a chair; it was a mistake, he decided, to judge by first appearance.

After a few minutes, the painter excused himself and limped to a closet. Neal expected him to bring out some delicately tinted painting for them to exclaim over together, but Stuart emerged with a half-gallon jug in which red liquid swished sibilantly. Swinging the jug over his shoulder, he poured two brimming glasses, "like cider-switchel at haying time," Neal remembered. When the lad hesitated about drinking his portion, the painter told him not to worry: the Madeira was good; it had been twice around the Cape.

Neal reported years later that he could not believe his eyes and ears; it was impossible that a denizen of the high kingdom of art should descend to such vulgarity. Suddenly he remembered Stuart's reputation for practical jokes. Of course, genius had to have its vagaries; Neal smiled wanly, but his smile faded when Stuart tossed off half a tumbler at one swallow and peremptorily ordered him to drink up. The frightened youngster explained that he had been brought up on "the plainest of wholesome food"; liquor had never touched his lips. At this Stuart laughed raucously and winked, as much as to say: "Can't you trust me?" He tossed off a whole tumblerful this time, and wished for better acquaintance.

The young man remembered the rest of the interview with horror. Stuart, the godlike painter whose work Neal so admired, made a series of the vilest puns, and laughed at them immoderately. He criticized the saintly burghers of Boston, calling the righteous statutes by which they regulated their neighbours "blue laws" which showed "the bigotry and fanaticism of the day." Not a word of art came from between the heavy lips; the old man, who obviously enjoyed shocking his visitor, talked about wine. He boasted that he was the best judge of wines "on this side of the water," and told innumerable stories to demonstrate it. Neal recalled with particular disapproval how Stuart gloated over the gay parties he had attended in Philadelphia, where he had belonged to a club of a dozen or twenty good fellows, "who were a law unto themselves."

LIFE MASK OF STUART AT SEVENTY

TAKEN BY J. H. I. BROWERE

ALEXANDER:
ALEXANDER GRANT

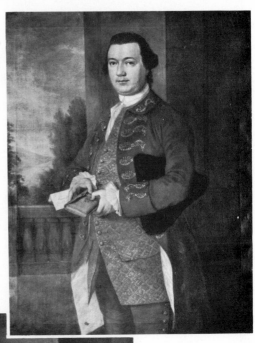

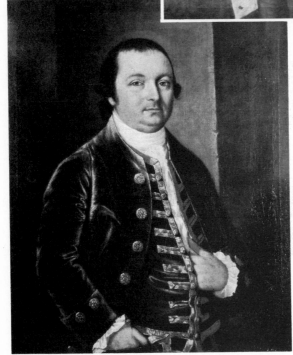

STUART:
JOHN BANNISTER

Once a year they got together, each bringing a bottle for every guest, a dozen or twenty, according to the number who were coming, and it was a point of honour to drink up every drop before dawn.

All the while he talked, Stuart was filling his capacious nostrils from a snuff-box "nearly as large round as the top of a small hat." This snuff-box, one of the biggest ever seen in America, was famous in Stuart's circle; once, after he had mislaid it, a friend hired a porter with a wheelbarrow to bring it back. On another occasion, when Stuart was entertaining two young painters less prudish than Neal, one of them asked him for a pinch. "I will give it to you," Stuart replied, "but I advise you not to take it. Snuff-taking is a pernicious, vile, dirty habit, and like all bad habits to be carefully avoided."

"Your practice," the young painter remembers he replied, "contradicts your precept, Mr. Stuart."

"Sir, *I* can't help it. Shall I tell you a story? You were neither of you ever in England, so I must describe an English stage-coach of my time. It was a large vehicle of the coach kind, with a railing around the top to secure outside passengers, and a basket behind for baggage and such travellers as could not be elsewhere accommodated. In such a carriage, full within, loaded on the top, and an additional unfortunate stowed with the stuff in the basket, I happened to be travelling in a dark night, when coachee contrived to overturn us all—or, as they say in New York, dump us—in a ditch. We scrambled up, felt our legs and arms to be convinced that they were not broken, and finding on examination that inside and outside passengers were tolerably whole (on the whole), someone thought of the poor devil who was shut with the baggage in the basket. He was found apparently senseless, and his neck twisted awry. One of the passengers, who had heard that any dislocation might be remedied if promptly attended to, seized on the corpse with a determination to untwist the man's neck and set his head

straight on his shoulders. Accordingly, with an iron grasp he clutched him by the head, and began pulling and twisting by main force. He appeared to have succeeded miraculously in restoring life, for the dead man no sooner experienced the first wrench than he roared vociferously: 'Let me alone! Let me alone! I'm not hurt; I was born so!' Gentlemen," added Stuart, "I was born so." He took an enormous pinch of snuff. "I was born in a snuff mill."

It had come about as a result of the failure of Bonnie Prince Charlie's rebellion in Scotland, which had forced Dr. Thomas Moffatt, a learned Boerhaavian physician, to flee to Rhode Island. When he found that his aristocratic manners so annoyed the Quakers there that they would not have him in their houses, he decided that his graces were more important to him than his profession; he gave up medicine, and cast round for another means of livelihood. Discovering that all the snuff in the Colonies was imported from Scotland, he determined to set up a snuff mill, and finding that no one in America was capable of building one, he imported a Scottish millwright, Gilbert Stuart the elder, who erected on a tidal river near Narragansett the first "engine for the manufacture of snuff" in New England. In this mill Gilbert Stuart the painter was born on December 3, 1755. He used to amuse himself by telling people he met in England that he first saw the light "six miles from Pottawoone and ten miles from Pappasquash and about four miles from Conanicut and not far from the spot where the famous battle with the warlike Pequots was fought." When they asked him what province of India he came from, he was delighted.

The infant's first memories must have been instinct with rushing waters and the rumble of revolving weights, for the Stuart family lived in the upper story of the mill, their floor level with the top of the dam, while the water ran for ever outside the lower windows. The smell of ground tobacco was always in the nostrils of the spoiled child, whose elder sister doted on him, as did his easygoing and impractical parents. Stuart's father was so absent-minded

that once, when he and his wife were riding to church on the same horse, he dropped the lady off without noticing. And she was so good-humoured that she was not angry as she sat on the road where she had landed, but rather smiled to think how surprised her husband would be when he found her gone. She watched the millwright jog gaily round a bend, there was the silence of heat and birds singing, and then suddenly the clatter of hoofs. Stuart appeared at a gallop, leaning eagerly over his horse's neck. "God's-my-life!" he cried. "Are you hurt?"

The usual stories are told of Gilbert's precocity. When he was five, his daughter relates, he drew on the earth with a stick a perfect likeness of a neighbour. Family tradition also records a holiday excursion to a hanging as an example of his early powers of observation. The shy hangman, who had hidden his identity with a sheet draped from head to ankle, mystified everyone but the babe on Mr. Stuart's shoulder; Gilbert reported who it was. "I know him," the innocent lisped, "by his sues."

Mrs. Stuart decided that so brilliant an infant must be taught Latin before he was well out of swaddling clothes. Since no one in the neighbourhood knew any Latin, she sent to Newport for a primer and, though she had never seen a word of the strange language, essayed to teach little Gilbert herself. Of course he did not learn very much.

Gilbert's father, we are told, "was remarkable for his ingenuity and his quiet, inoffensive life"; he lacked the gift for making money. When Colonial industry proved unable to supply any bottles into which his snuff could be packed, he was in despair, until Moffatt suggested the substitution of beeves' bladders. Then gaiety returned to the clanking mill, but not for long; the bladders were not immediately popular. Heart-broken, Stuart sold his share in the mill when Gilbert was six, and settled in Newport on a scrap of property his wife had inherited. Moffatt then proceeded to make money from the mill. Thus it always was with the well-meaning

mechanic. According to his granddaughter, he later invented a machine for loading ships which made someone else rich and did him no good whatsoever.

Gilbert was to describe his family's Newport house as "a hovel on Bannister's wharf." Like Copley, Stuart spent his boyhood in a tobacco shop on the seafront of a maritime city; but while Copley had trembled behind windowpanes, Stuart was for ever out on the streets leading a gang of urchins in outrageous pranks. The Episcopalian charity school to which he was sent served him only as a reservoir for companions he could lead astray. Schoolbooks were forgotten, while he frolicked with Arthur Browne, later a famous English attorney, and Benjamin Waterhouse, who was to introduce vaccination into the United States. The three bright youngsters prowled on the docks, practising oaths and trying to spit like veterans. Or, curled up on bulkheads over the bright water, they would sail in their imaginations to that almost impossible homeland which their parents described to them. They were all, Waterhouse tells us, "inspired with the same ardent desire to visit Europe."

Once Stuart and a friend named Channing swore revenge on a shoemaker who got them into trouble. They sneaked up to his open window on a dark night, and one boy fired a gun while the other squirted blood they had stolen from a butcher onto the cobbler's bald head. The shoemaker rolled over among his lasts and lap-stones, crying that he was murdered. Hiding in the long grass, swallowing down their mirth, the urchins watched his wife run in and scream for help; they saw the doctor, who had arrived with his hair flying, approach the corpse gravely, wash off the blood, and then stare in amazement. They were so entranced that they did not set off for their homes in time to make a clean get-away; the miraculously revived cadaver rushed out to complain, and as the boys were found in bed with their shoes on they were adjudged guilty and roundly beaten with a birch. When Stuart called on their vic-

tim years later and reminded him of the incident, the old man shook his head. "If you're as good a man as you were a bad boy, you're a devilish clever fellow."

Waterhouse remembered that Gilbert was "a very capable, self-willed boy, who perhaps on that account was indulged in everything, being an only son, handsome and forward and habituated at home to have his own way in everything, with little or no control from the easy, good-natured father." Rebellion was in the Stuart heritage. Although there appears to be no foundation for the story that Gilbert's father fought at Culloden, his sympathies were undoubtedly with Prince Charlie, and most of his American friends were Scottish exiles. He seems to have become a more violent rebel after he had been in Rhode Island for several years; he changed the spelling of his family name from "Stewart" to "Stuart," and added to his son's name, some time after his baptism, the middle name of "Charles," which the lad bore proudly for a while before he discarded it entirely. Certainly the talk around the dinner table did not teach slavish obedience to constituted authority.

Despite his wildness, Gilbert was in his own way preparing himself for his future career. He played duets with his doting sister, and spent hours listening to the fine organ Bishop Berkeley had given Trinity Church. He could not decide which he liked more, music or the fine arts. There were a few indifferent copies of old masters in Newport for him to see, and these inspired the drawings he made before he was well in his teens. A rotting stone or a lump of clay served him as a pencil, and fences, barndoors, or the tailboards of wagons took the place of canvases. His technique was entirely childish, merely the sketching of an outline, but the result was adequately impressive to discourage the emulative efforts of Waterhouse and to impress a distinguished Scottish physician, Dr. William Hunter, who during a professional visit to the Stuart home was amazed to find every flat space scrawled over with drawings. The physician cultivated the acquaintance of the ragged urchin he

found sketching in a corner, and invited the youngster to his house, on whose walls hung several pictures ascribed to Salvator Rosa. Hunter gave the boy brushes and colours, probably the first he had ever possessed, and commissioned him to paint two spaniels lying under a table in his drawing room. The resulting picture still exists.

Stuart soon met Samuel King, a young instrument-maker who had taught himself to manufacture portraits. Although completely uninspired, he worked in the crabbed, unillusionistic style of the American primitive tradition to which Stuart was to show allegiance when he first became a professional portraitist. Crude as King's work was, it passed as art in Newport, and its author had the distinction of being the first instructor of three important American painters: Stuart, Malbone, and Allston.

Stuart, however, forgot about King when Cosmo Alexander turned up in Newport. An elegant Scotsman, Alexander had taken part in Prince Charlie's rebellion but was not an exile; it was rumoured he was a spy sent by the British to keep an eye on the obstreperous Colonials. Be that as it may, he declared he was travelling for his health and to recover some lost lands belonging to his family. He admitted in the parlours of the Scottish colony that he was an expert painter, that he had studied in Italy and was a member of the London Society of Artists, but added that he was too much of a gentleman to follow the low profession of artist; he sketched merely for his own amusement. However, he set up a painting room provided with cameras obscura and "optical glasses for taking perspective views." Although an obscure and inferior craftsman in the English face painting tradition that had preceded the era of Reynolds, he was the most expert portraitist who had practised in Newport for years; the Scottish colony flocked to have their effigies taken, and he was soon making a large income. We can imagine Stuart's delight when Alexander took him on as an apprentice.

The Scottish artist must have reached Newport before 1770, the

date usually given, for his canvases of Mr. and Mrs. Charles Dudley, the Newport collector of customs and his wife, are both inscribed 1769. But even this year may not have been his first in Rhode Island; a hitherto unnoticed letter from William Hunter* states in a passage concerning Stuart that his genius was first discovered by the writer's father, Dr. William Hunter, who in 1768 persuaded Alexander to take him on as an apprentice.

Thus Stuart was thirteen or fourteen when the Scotsman appeared and became his instructor. After several years of study in Newport, probably late in 1770 or early in 1771, he accompanied his master on a painting tour through the South, and then destiny presented him with the ultimate favour, a trip to the almost fabulous land across the ocean whence art came. Alexander took Stuart to Scotland. For a while the young man prospered in Glasgow and Edinburgh, following in the wake of his elegant master, who may even have sent him to school for short periods of time. But on August 25, 1772, Alexander died. As he felt himself failing, he begged one of his friends to take care of Stuart, but this gentleman, who has never been definitely identified, was either too poor or too callous to help the sixteen-year-old apprentice. Stuart found himself destitute in a strange city.

Penniless, many months' sailing from home, he had no means of livelihood except his very inexpert brush. He signed himself "Charles Stuart," appealing to Scottish patriotism, and does seem to have obtained a commission or two, but probably he was paid very little. The gay youngster who had been the darling of his family, the prodigy whom the Scottish colony of Newport had admired and caressed, now walked the streets of a strange and hostile city, his pockets and his belly empty, his feet sore. Never during the hours and hours of autobiographical conversation with which he

* This letter, addressed to Charles C. Bogart and dated Newport, July 22, 1811, may be found among the papers of the American Academy of Fine Arts in the library of the New-York Historical Society.

filled his later years did he refer to those months of abject misery, and his daughter tried to gloss them over by saying that he spent two years at the University of Glasgow, long enough to acquire "a classical taste." But the records of that institution are innocent of his name, and an almost illiterate letter he wrote several years later shows that little education had come his way.

Hungry, footsore days massed into months, the months ran on toward years, and still there seemed no way out for the lonely boy: no money to go home with, nothing to eat if he stayed. Finally he seized a desperate expedient; he enlisted before the mast on a collier bound for Nova Scotia. The sea was a brutal mistress in those days. Men were beaten and starved and worked to the limit of endurance. We can see the young painter clinging to a yardarm over the black sea, a month of terrible sailing behind him, months more ahead, his thoughts tumbling sickishly to the unremitting beat of waves and to the curses of the boatswain coming up from below.

When Stuart reached Newport at last, he could not make himself describe his trip home even to his best friend. "What his treatment was I never could learn," writes Waterhouse. "I only know that it required a few weeks to equip him with suitable clothing to appear on the streets, or to allow any one of his former friends, save the writer, to know of his return home. Suffice it to say that it was such as neither Gilbert Stuart, father or son, ever thought proper to mention."

After a while, Stuart returned to his painting, and he had little difficulty securing portrait commissions; had he not studied abroad? His work reflected some of Alexander's compositional devices and typical shapes—squarish faces, for instance—but it represented fundamentally an altogether different artistic approach. Alexander sought to catch the surface appearance of things, while Stuart was groping for the essence of form, simplifying the surface in a naïve but powerful quest for shape, weight, and the third dimension.

Stuart followed more closely the tradition of American primitive, provincial, artisan-trained painters than the sophisticated transatlantic manner of which Alexander had given him a glimpse. This was a clear act of will: he could have imitated Alexander more closely had he wanted to. And the result pleased the Newport connoisseurs.

"Our aspiring artist," writes Waterhouse, "had as much business as he could turn his hands to, and the buoyancy of his spirits kept pace with his good fortune." The horrible days in Scotland seemed forgotten while Stuart dashed off portraits, flirted with the ladies, taught himself to play various musical instruments, and tried his hand at composing. "Once," his friend continues, "he attempted to enrapture me by a newly studied classical composition. I exerted all the kind attention I could muster up for the occasion, until his sharp eye detected by my physiognomy that I did not much relish it. He coloured, sprang up in a rage, and striding back and forth the floor, vociferated: 'You have no more taste for music than a jackass! And it is all owing to your stupid Quaker education!' "

Although Stuart seemed as outrageous and self-confident as ever, he showed no inclination to try experiments that would take him out of the narrow field of face painting in which he felt himself proficient. When the Redwood Library invited him to execute a full-length of its founder, he refused the commission that might have heightened his reputation, and answered all remonstrances with "sullen silence," although by doing so he turned the popular tide in some degree against him, and cooled the zeal of many of his friends. Probably Stuart, who had never painted a full-length, was not sure he could do a good one. His pride, which had suffered so severely during the past few years, was unwilling to risk a venture that might turn out badly, nor would it let him tell even his most intimate friend that he considered anything beyond his powers. Without a word, he watched his popularity diminish.

The times were not propitious anyway. Revolutionary agitation

was mounting higher daily; before long it become clear there would be war. When his family, whose friends were all Tories, fled to Nova Scotia, Gilbert could not afford to go along, since there would be no demand for painting in that wild region. He stayed behind in Newport, but fewer and fewer commissions came to him as all minds turned to the impending struggle, in whose issues Stuart had little interest. Sadly he watched Waterhouse sail for England to complete his medical education there; the youth who had been stranded in Scotland now found himself well on the way to being stranded in his native city. Perhaps some rich relatives he had in Philadelphia took an interest in his plight, for Peale tells us that during the 1770's he was asked to accept as a pupil a young man who he later inferred must have been Stuart. However, nothing came of it. Stuart regarded himself as a professional, not a student, and in all probability did not find the prospect of going to Maryland or Philadelphia exciting. By nature inclined to desperate expedients, he borrowed enough money to buy passage to London, although he had no friends in that city except Waterhouse. He promised himself that Waterhouse, who was blessed with cash and English connexions, would take care of him. And perhaps he did not realize that he was too inferior a painter to earn his living in the British capital.

Once he had made up his mind, he felt gay. He spent his last night in Newport playing the flute under the window of a young lady and mocking the night-capped burghers who shouted for quiet from the neighbouring windows. Then he went to Boston to wait for his boat. During his short stay there, he seems to have given instruction to a young boy who was himself to have a brilliant career in England as a painter. Mather Brown wrote to his aunts in 1817 that Stuart "was the first person who learnt me to draw at about twelve years of age at Boston. He lived then near Mr. Whiting's, a print seller near Mill Bridge." * In a year or so Brown

* John Hill Morgan argues that, since Brown became twelve in October 1773, this letter demonstrates that Stuart must have stopped off in Boston on his way

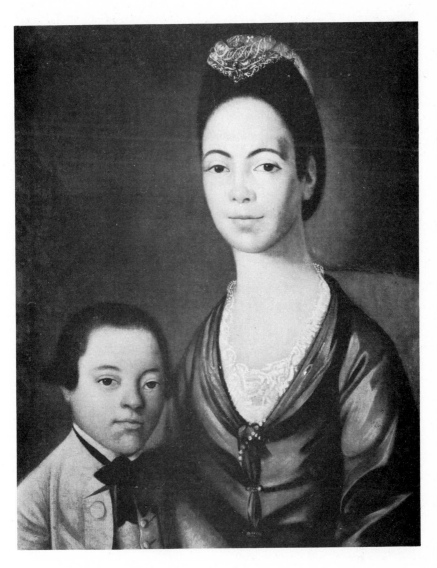

STUART: MRS. AARON LOPEZ AND HER SON JOSHUA

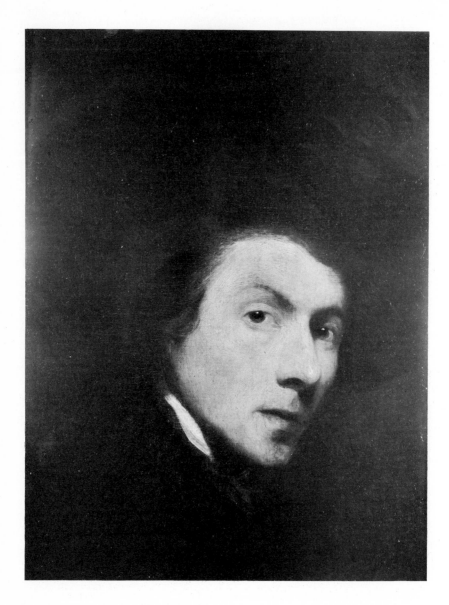

STUART: SELF-PORTRAIT AT TWENTY-THREE

was to run away from his grandfather and wander with a knapsack on his back through the countryside in a successful effort to make enough money as an itinerant painter of miniatures to follow his instructor to London.

Stuart was in Boston during the battle of Lexington, but "the shot heard round the world" did not inspire him to do any shooting. He sailed on June 16, 1775, the day before the battle of Bunker Hill. What thoughts passed through his mind as he saw the beleaguered city disappear behind him? He had set out for the British Isles before, in the company of a distinguished and powerful patron, but the result had been tragedy. Now he was alone, with only enough money in his pocket to keep him a few days in the forbidding British capital. He had but one letter of introduction, to a Scot named Alexander Grant whom he had never seen. Everything depended on the chance that Waterhouse, from whom he had received no word, would be in London.

II

Naturally Stuart hurried to Waterhouse's lodgings the instant he arrived, but he was told that his friend was in Edinburgh attending medical school. Stuart stood dazed in the hallway for a moment and then without a word walked out into the street; his prospects had sunk to nothing. He took a tiny, airless room in the house of a tailor, and ate as little as he could, but the few shillings in his pocket decreased daily, while he saw no prospect of replenishing them, for he had no way of finding possible patrons for portraits. Again he walked the pavements of a strange city with the gait that he remembered, the aimless shuffling of the unpossessed who have

back from Scotland. Such an assumption, however, cannot be made to accord with Waterhouse's account of Stuart's return, and Brown himself, as his letter explicitly states, was not certain that he was exactly twelve when he studied with Stuart. He might have been fourteen.

no place to go and no reason to walk except that they cannot always stand still. He spent a few pence on postage to Edinburgh and wrote Waterhouse a broken-hearted letter. "Your father," he remembered wistfully, "was at our house just before I left home, when he said Gilbert and Ben are so knit together like David and Jonathan, that if you heard from one, you would also hear from the other." In a later letter we find a sentence that seems to epitomize Stuart's lonely state: "I don't know the day of the month or even what month, and I have no one to ask at present, but the day of the week is Tuesday, I believe."

Finally there was no more money to pay the landlord or the baker; Stuart spent almost all his time on the streets now, afraid to return to his lodgings for fear he would be dispossessed. His daughter tells us that years later, when he was famous, "if any young man apparently not in very good circumstances came to him for instruction, it never failed to depress Stuart greatly, as his own early struggles were thus recalled."

Shuffling down Foster Lane one melancholy day, Stuart heard the notes of an organ radiating from a church. As always when he heard music, his heart quickened a little. His footsteps had a sudden purposeful ring when he hurried toward the door, but just as he was about to enter he remembered the pew woman; she would want her fee. He stood listening on the church steps like a hungry waif sniffing the odours outside the door of a pastry shop. Fat people walked by him into the house of worship. The ragged young man, who had been so bold a few months before, watched them in an agony of hesitation for a long time before he dared ask what was going on within. He was told that the vestry were holding a competition for the position of organist.

Stuart trembled with excitement; he could play the organ, and in America men had thought he played it well. If only he could get the position, it would mean meat and wine and other half-forgotten things. But when he looked at his rags, he realized that no vestry

would ever give him a chance. He stood on the steps disconsolate, and the music cheered him no longer.

Then, with a sudden resolution, he hurried into the church, his head held high; a quick manœuvre enabled him to avoid the pew woman and find a seat near the judges. One after another the spotless and sombrely dressed contestants walked up to the organ, and as their notes echoed through the vault Stuart's heart rose, for he knew he could do better. Studying the vestrymen with the knowledge of physiognomy that was later to make him famous, he selected the one with the most tolerant face and asked if a stranger might try his skill. Smiling at the ragged apparition, the man agreed. Thus Stuart found his way to the organ, and his fingers moved on the keys with all the eloquence of hunger and despair. He got the job and a salary of thirty pounds a year.

When Waterhouse returned to London the following summer, he found Stuart still lodging at the tailor's, still poor, and still struggling to get started as a painter. He had one canvas on his easel, a family group for Alexander Grant, the gentleman to whom he had a letter of introduction. Grant, Waterhouse tells us, "had paid him for it in advance. It remained long in his lodgings, and I am not sure that it ever was finished."

With his friend's return, Stuart's prospects took a tremendous leap forward. Waterhouse induced some of his Quaker cousins to put Stuart up in their houses, where he saw clean sheets and decent food for the first time in months. Several of his new acquaintances sat to the young man for their pictures. When Waterhouse's uncle, Dr. John Fothergill, who was one of the most famous physicians in London, agreed to have his portrait made, the opportunity Stuart was waiting for had arrived. But he was not ready.

The young American, Waterhouse tells us, visited the principal English collections to pick up what knowledge he could, but he seems to have been unimpressed by the sophisticated work of men like Reynolds and Gainsborough, for, as Alan Burroughs points

out, he did not struggle to imitate their excellencies. The few improvements he incorporated in his style were borrowed from the canvases of the previous generation, from the face painters in whose methods the teachings of Alexander had already grounded him. Perhaps Stuart would not allow himself to recognize beauties that would make his own work, so praised in Newport, seem hopelessly inferior, and that would throw him back into the humble position of a student. He did not go to the Royal Academy school or appeal to West for the assistance that was never refused to young Americans. Instead, he stubbornly tried despite his inadequate technique to make his reputation as a professional portraitist.

However, he must deep down in his nature have recognized the inferiority of his work, for he developed a total inability to stick to his painting. Instead, he threw himself into dissipation. Whenever he had money in his pocket, he spent it instantly in some wild spree. How grandly he treated his gay companions! As he carelessly tossed pound notes on the bar, he smiled to think that no one could guess he ever had been poor. After his money was gone he borrowed, and when he found he could not pay he threw himself into a depression as extreme as his high spirits had been. "With Stuart," Waterhouse remembers, "it was either high tide or low tide. In London he would sometimes lie abed for weeks, waiting for the tide to lead him on to fortune." But when at last a knocking on the door aroused the slovenly lad from his slovenly bed, it was not opportunity that knocked; it was the bailiff come to hustle him off to debtors' prison. Waterhouse often rescued him from sponging-houses by paying the demands for which he was confined. "Of my allowance of pocket money, he had two-thirds, and more than once the other third." A self-portrait Stuart painted several years later shows him as a brash, dissatisfied, and self-centred young man, a little on the elfin side, with a narrow, pointed face and vaguely shifty eyes. The face is brilliant with an unhealthy brilliance; clever, but for that reason less to be trusted. Perhaps the most

amazing thing about this picture is the deep self-understanding it reveals; as if Stuart were conscious of the cankers in his spirit, and even a little proud of them.

Not discouraged by his friend's aberrations, Waterhouse redoubled his efforts to find him commissions. He persuaded the celebrated Dr. Lettsom to pose for a full-length that could be shown at the Royal Academy, but Stuart was unable to finish the picture. Next Waterhouse organized a subscription to pay for an engraving of a popular medical professor, and engaged Stuart to make the painting. Stuart spent the money in a burst of hope and joy, but when the time came to get to work, he could not even make himself begin. As a result, he alienated the only friends he had in London; Dr. Fothergill, who had to pay back the money, refused to speak to Stuart again, and Waterhouse suffered "inexpressible unhappiness and mortification, which at length brought on me a fever, the only dangerous disease I ever encountered."

Stuart was again an impoverished and futureless waif in the big city. Forced at long last to give up his pretensions to being a professional, he wrote Benjamin West, whom he had never met, a letter so abject that it could have been drawn from his haughty nature only by the most acute misery:

"Sir,
"The benevolence of your disposition encourageth me, while my necessity urgeth me, to write you on so disagreeable a subject. I hope I have not offended by taking this liberty. My poverty and ignorance are my only excuse. Let me beg that I may not forfeit your good will, which to me is so desirable. Pity me, good sir. I've just arrived at the age of twenty-one, an age when most young men have done something worthy of notice, and find myself ignorant, without business or friends, without the necessities of life, so far that for some time I have been reduced to one miserable meal a day, and frequently not even that. Destitute of

the means of acquiring knowledge, my hopes from home blasted, and incapable of returning thither, pitching headlong into misery, I have only this hope: I pray that it may not be too great to live and learn without being a burden. Should Mr. West in his abundant kindness think of aught for me, I shall esteem it an obligation which shall bind me for ever with gratitude. With the greatest humility,

"Sir, at your command,

"G. C. STUART."

When West with his usual benevolence took the young painter under his wing, it was the turning point of Stuart's life. On the surface it would seem that the two were fire and water, the eternal opposites, but West, the methodical, the moral, the temperate, understood his wild apprentice from the first and recognized his worth. He knew that Stuart's hands trembled so violently because of overtaut nerves; he recognized that his outrageousness was caused by a lack of self-confidence; and he treated him, Stuart remembered, like a son. Shortly after the young man had found a safe berth in West's studio, his unstable hand betrayed him into dropping a valuable optical instrument; the camera lucida lay in fragments on the hearth. Stuart stood with his back to his master, waiting for the burst of anger with which he would himself have greeted such an accident. "Well, Stuart," West said mildly, "you may pick up the pieces." Years later, when one of Stuart's intimates compared West to a fool, Stuart gave way to fury: "I should prefer your playing practical jokes on others!" In 1816 his pupil Matthew Harris Jouett jotted down in his notebook that Stuart had said: "West [was] wiser than Reynolds, and was in fact as to goodness what Sir Joshua seemed. . . . By nature West was the wisest man he ever knew, but no Negro boy [was] more awkward in expressing his ideas. This came of want of literature."

Despite his gratitude, Stuart's nerves sometimes forced him to

mock and even depreciate his benefactor. We may get an idea of his disruptive activities in West's studio from several stories he loved to tell, which his friend William Dunlap repeats avowedly in his own words: "I used very often to provoke my good old master, though Heaven knows without intending it. You remember the colour closet at the bottom of his painting room. One day Trumbull and I came into his room and, little suspecting that he was within hearing, I began to lecture on his pictures, and particularly upon one then on his easel. I was a giddy, foolish fellow then. He had begun a portrait of a child, and he had a way of making curly hair by a flourish of his brush: thus, like a figure three.

"'Here, Trumbull,' said I, 'do you want to learn how to paint hair? There it is, my boy! Our master figures out a head of hair like a sum in arithmetic. Let us see, we may tell how many guineas he is to have for this head by simple addition—three and three makes six, and three are nine, and three are twelve——'

"How much the sum would have amounted to, I can't tell, for just then in stalked the master, with palette-knife and palette, and put to flight my calculations. 'Very well, Mr. Stuart,' said he—he always *mistered* me when he was angry, as a man's wife calls him *my dear* when she wishes him at the devil—'very well, Mr. Stuart; very well, indeed!' You may believe that I looked foolish enough, and he gave me a pretty sharp lecture without my making any reply. When the head was finished, there were no *figures of three in the hair.* . . .

"Mr. West treated me very cavalierly on one occasion," Stuart continued, "but I had my revenge. It was the custom whenever a new Governor-General was sent out to India that he should be complimented by a present of His Majesty's portrait, and Mr. West, being the King's painter, was called upon on all such occasions. So, when Lord —— was about to sail for his government, the usual order was received for His Majesty's likeness. My old master, who was busily employed upon one of his ten-acre pictures in company

with prophets and apostles, thought he would turn over the King
to me. He never could paint a portrait.

" 'Stuart,' said he, 'it is a pity to make His Majesty sit again for
his picture; there is the portrait of him that you painted; let me
have it for Lord ——. I will retouch it, and it will do well enough.'

" '*Well enough!* Very pretty!' thought I. 'You might be civil
when you ask a favour.' So I *thought,* but I *said:* 'Very well, sir.'
So the picture was carried down to his room, and at it he went. I
saw he was puzzled. He worked at it all that day. The next morn-
ing, 'Stuart,' said he, 'have you got your palette set?'

" 'Yes, sir.'

" 'Well, you can soon set another. Let me have the one you pre-
pared for yourself. I can't satisfy myself with that head.'

"I gave him my palette and he worked the greater part of that
day. In the afternoon I went up into his room, and he was hard at
it. I saw that he had got up to the knees in mud. 'Stuart,' says he,
'I don't know how it is, but you have a way of managing your tints
unlike everybody else. Here; take the palette, and finish the head.'

" 'I can't, sir.'

" 'You can't?'

" 'I can't indeed, sir, as it is, but let it stand till tomorrow morn-
ing and get dry, and I will go over it with all my heart.'

"The picture was to go away the day after the morrow, so he
made me promise to do it early next morning. You know, he never
came down into the painting room at the bottom of the gallery
until about ten o'clock. I went into his room bright and early, and
by half-past nine I had finished the head. That done, Rafe [West's
son Raphael] and I began to fence; I with my maulstick and he
with his father's. I had just driven Rafe up to the wall, with his
back to one of his father's best pictures, when the old gentleman,
as neat as a lad of wax, with his hair powdered, his white silk stock-
ings, and yellow morocco slippers, popped into the room, looking

as if he had stepped out of a bandbox. We had made so much noise that we did not hear him come down the gallery or open the door. 'There, you dog,' says I to Rafe, 'there I have you! And nothing but your background relieves you.'

"The old gentleman could not help smiling at my technical joke, but soon looking very stern, 'Mr. Stuart,' said he, 'is this the way you use me?'

" 'Why, what's the matter, sir? I have neither hurt the boy nor the background.'

" 'Sir, when you knew I had promised that the picture of His Majesty should be finished today, ready to be sent away tomorrow, thus to be neglecting me and your promise! How can you answer it to me or to yourself?'

" 'Sir,' said I, 'do not condemn me without examining the easel. I have finished the picture; please to look at it.' He did so; complimented me highly; and I had ample revenge for his 'It will do well enough.' "

Although Stuart was West's first assistant for four or five years and often painted on his master's "ten-acre canvases," he himself never attempted any of those historical compositions which everyone who frequented West's studio told him were the only high form of art. "No one," he jocosely replied, "would paint history who could do a portrait," and he stuck to his own specialty, the painting of faces, refusing the instruction that would have enabled him to execute a complicated picture. According to Trumbull, West said one day to a group of his students, Stuart included: "You ought to go to the Academy and study drawing, but as you would not like to go there without being able to draw better than you do, if you will only attend, I will keep a little academy and give you instruction every evening." Stuart came the first night, but soon got his paper black all over. Losing patience, he stamped out, and there is no record that he ever attended the Royal Academy school. The

famous painter Fuseli is reported to have said, on seeing one of Stuart's drawings: "If this is the best you can do, you ought to go and make shoes."

Stuart admitted in his old age that he had never learned to do a line drawing, but insisted that such knowledge was not an asset. Jouett made the following notes on one of his tirades: "Drawing the features distinctly and carefully with chalk a loss of time. All studies to be made with brush in hand. Nonsense to think of perfecting oneself in drawing before one begins to paint . . . one reason why the Italians never painted so well as other schools." He added that when a line sketch is interposed between the creative mind and its vision of a completed picture, "a fastidiousness ensues and, on the heels of that, disappointment and disgust."

West's portrait style did not greatly influence Stuart, for Stuart did not admire West's portraits. Once when Dunlap was sitting to Trumbull, Stuart was asked how he liked the picture. "Pretty well, pretty well, but more like our master's flesh than nature's. When Benny teaches the boys, he says: 'yellow and white there,' and he makes a streak; 'red and white there,' and another streak; 'brown and red there for a warm shadow,' another streak; 'red and yellow there,' another streak. But nature does not colour in streaks. Look at my hand; see how the colours are mottled and mingled, yet all is clear as silver."

"I will follow no master," Stuart asserted. "I wish to find out what nature is for myself, and see her with my own eyes." But, of course, no artist has ever lived who evolved his technique entirely out of his own consciousness. Stuart learned in West's studio to appreciate the great portrait painters who were his contemporaries, and then, with amazing rapidity, he incorporated their merits in his own style. In particular, he was influenced by Gainsborough, whose "dragging method of tinting" he praised as an old man. The two artists certainly met, and some historians believe they collaborated on a picture, for a print exists after a painting by "Gains-

borough and Stuart." But William Whitley argues in his life of
Stuart that the painter referred to was Thomas Stewart, an obscure
portraitist whose name was sometimes thus misspelt, and who might
easily have completed a picture Gainsborough left unfinished when
he died.

Not only did West open up to Stuart the world of modern art;
he had a great influence on his pupil's way of life. The raw, ill-
educated Colonial met the first gentlemen of the realm in the court
painter's studio. Too proud to accept social or cultural inferiority,
he rapidly absorbed the breeding and culture of his associates. Soon
the young man, who a few years before had been unable to write
a literate letter, was discoursing learnedly on Plato. He amended
his rough speech by imitating the elocution of the matinee idol
John Kemble, who had become his friend. As he watched his man-
ners blossom, he became prouder than ever. One day Dr. Johnson,
with the immemorial condescension of Englishmen toward Ameri-
can pronunciation, asked Stuart where a Colonial such as he could
have learned to speak so well. "Sir," replied Stuart, "I can better
tell you where I did not learn it. It was not from your dictionary."

Although he still went on occasional wild sprees, Stuart had
learned from West to paint with regularity and to finish the pic-
tures he began. He exhibited at the Royal Academy in 1777 and
1779; his work, however, was not noticed by the press till 1781,
when the critic of the *Saint James Chronicle* said his portrait of
West was as good as any picture in the room. This was high praise,
for there were twelve canvases by Reynolds and a full-length by
Gainsborough. Enchanted, Stuart spent hours standing before his
picture. When West found him there, he said: "You have done
well, Stuart, very well. Now all you have to do is to go home and
do better."

Concerning the four pictures Stuart showed in 1782, the *Saint
James Chronicle* said: "Mr. Stuart is in partnership with Mr. West,
where it is not uncommon for wits to divert themselves with appli-

cations for things they do not want, because they are told by Mr. West that Mr. Stuart is the only portrait painter in the world; and by Mr. Stuart that no man has any pretensions to historical painting but Mr. West. After such authority, what can we say of Mr. Stuart's paintings? . . . Mr. Stuart seldom fails of a likeness, but wants freedom of pencil and elegance of taste." Although the critic of the London *Courant* thought his portraits "exceedingly fine," he commented on how unflattering were the likenesses, for portrait painting in England was still a social art; the sitter was dressed in the height of fashion, surrounded with expensive-looking accessories, and made as handsome as possible. One of Hoppner's pupils tells us how that master "frequently remarked that in painting ladies' portraits he used to make as beautiful a face as he could, then give it a likeness to his sitter, working down from the beautiful state till a bystander should cry out: 'Oh, I see a likeness coming.' Whereupon he stopped, and never ventured to make it more like." Indeed, it is this flattering artificiality that enrages the critics who disapprove of the British school.

Coming from a country where elegance was rare and men were of necessity realists, Stuart was unsympathetic with the flattery of British portrait painting; he wanted to make a character study of his sitter's face, and he added elaborate costumes and backgrounds only when he had to in order to make his way at all. "You cannot be too particular in what you do to see what animal you are putting down . . ." he told Jouett many years later. "Backgrounds point to dates and circumstances of employment or profession, but the person should be so portrayed as to be read like the Bible without notes, which in books are likened unto backgrounds in painting. Too much parade in the background [is] like notes with a book to it, and as very apt to fatigue by the constant shifting of the attention."

Since Stuart had a prejudice against full-lengths, where the face is necessarily subordinated to the rest of the picture, the connois-

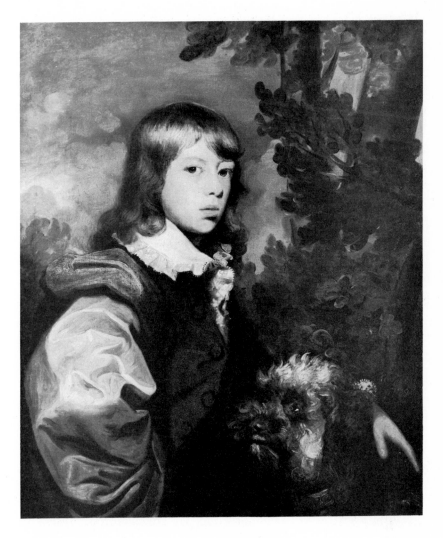

STUART: J.WARD

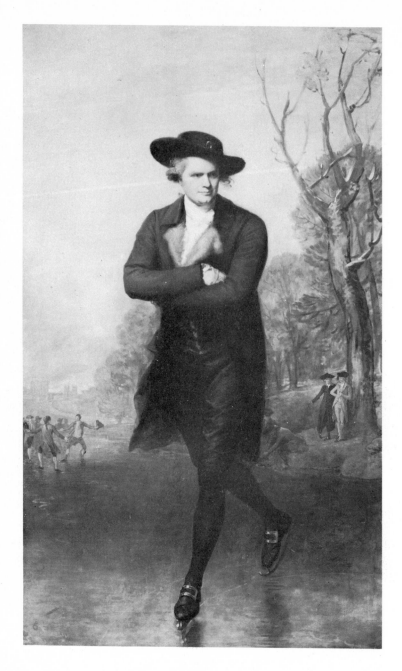

STUART: THE SKATER

(WILLIAM GRANT OF CONGALTON)

seurs whispered that he "made a tolerable likeness of the face, but as to the figure he could not get below the fifth button." Perhaps to overcome such criticism, certainly at West's urging, he grudgingly agreed in 1781 to do a full-length of William Grant of Congalton. However, he was delighted to put off the first sitting when Grant remarked that the day was more suited to ice skating than to standing for one's portrait. Like West, Stuart was an expert skater by English standards; he told a friend that "his celerity and activity accordingly attracted crowds on the Serpentine," but when a crack developed in the ice, he was forced to return with his sitter to the studio. Suddenly Stuart had an inspiration; he decided to paint Grant in the attitude of skating, "with the appendage of a winter scene in the background." After the picture was almost completed, Baretti, the famous Italian lexicographer, called on West and, seeing the canvas in a corner, cried: "Who but the great artist West could have painted such a one!" On a subsequent visit, he found Stuart at work on the portrait. "What, young man, does Mr. West permit you to touch his pictures?" When Stuart replied that the painting was altogether his own, Baretti frowned sagely and remarked: "Why, it is almost as good as Mr. West can paint."

Stuart later told both Jouett and Josiah Quincy that he was suddenly lifted into fame by the exhibition of this one picture; the originality of the pose attracted great attention to the brilliantly painted canvas. When Grant, dressed in the skating costume Stuart had painted, went to the Royal Academy show, "the crowd," Charles Fraser, the miniature painter, tells us, "followed him so closely that he was compelled to make his retreat, for everyone was exclaiming: 'That is he! There is the gentleman!'" Stuart himself was so overwhelmed with praise that he did not dare enter the exhibition room.

After being hidden away in private hands, Stuart's *Gentleman Skating* was exhibited as a probable Gainsborough in 1878 at a

show of British old masters at the Royal Academy. The critics, however, were not satisfied with the attribution; some thought it a Raeburn, others a Hoppner. But all agreed it stood out in the exhibition among the other masterpieces.

After Stuart's first full-length had proved so amazingly successful, West told him he was ready to set up for himself. On June 3, 1782, Mrs. Hoppner wrote: "Today the exhibition closes. . . . Stuart has taken a house, I am told, of £150 a year rent in Berners Street, and he is going to set up as a great man."

III

Within two years after he had set up for himself, Stuart was famous; Dunlap remembers that he "had his full share of the best business in London, and prices equal to any except Sir Joshua Reynolds and Gainsborough." In November 1784 William Temple Franklin wrote to his grandfather, Benjamin Franklin, that Stuart "is esteemed by West and everybody the first portrait painter now living; he is, moreover, an American. I have seen several of his performances which seem to me very great indeed. He is astonishing for likenesses. I hear West says that 'he nails the face to the canvas.' " In 1787 the critic of the *World* called Stuart "the Van Dyck of the time" and insisted that Gainsborough's work "shrinks and fades away" when compared to Stuart's. Knowing art connoisseurs prophesied that he would become the leading portrait painter in England, for Reynolds, Romney, and Gainsborough were coming to the end of their careers, while the new generation of English-born painters—Lawrence, Beechey, and Raeburn—had not yet risen to great prominence.

Here was an amazing metamorphosis. Less than ten years before, Stuart had been a crude Colonial artist who lacked the skill to finish a picture; now he was a leader in one of the most sophisticated schools of portrait painters ever known. And worldly prosper-

ity followed Stuart's fame. He lifted his price for a head from five guineas to thirty, and was soon making fifteen hundred pounds a year, the equivalent in modern money of well over thirty-five thousand dollars. Dukes and lesser peers by the dozens, bishops, admirals, actors, ladies of fashion and ladies of easy virtue, artists, wits, statesmen—all these and many less distinguished people crowded his studio.

The young painter, still under thirty, was beside himself with delight. Sometimes he saw in his mind's eye a ragged vagabond shuffling past closed doors, staring dully at the dandies in their fine carriages; and then he felt this vision must be exorcized at any cost. When he remembered how he had starved on the streets of London, he shook his head angrily and hired the best French cook money could buy. In his dress, Dunlap tells us, "he emulated in style and costliness the leader of English fashion, the Prince of Wales. . . . He lived in splendour and was the gayest of the gay. As he said of himself, he was a great beau." Above all things he loved associating with the rich men-about-town who were born gentlemen and had never felt a touch of hunger. Eager to keep up with this extravagant circle, he spent his huge income faster than it came in. The sponging-houses and the bailiffs' courts that had known him as a ragged boy saw him again as a fine gentleman. "With a hundred guineas in his pocket," one of his early biographers remarks, "he was a lord while it lasted, and when it was gone he was a devil. One day he was dining with earls, dukes, and princes, the star of a brilliant salon. In twenty-four hours he was cracking jokes to his companions in debtors' prison."

The eccentricities of his youth that had been such a trial to his friends were now regarded as signs of genius; W. T. Parke, the famous oboe player, remembers that he "was a little enthusiastical, or pretended to be so. Rising from his chair suddenly, [he] exclaimed to me with great vehemence: 'Sit still! Don't stir for your life!' I stared at him with astonishment, thinking he must be mad,

till in a subdued tone he added: 'I beg your pardon, but your drapery as you now sit is very effective, and I wish to make a sketch of it before you move.' " Puns flowed unendingly from Stuart's lips. When Parke, after a night of carousal, complained of a headache, Stuart cried: "If a man's head comes in contact with a club overnight, it may be expected that it will ache the next day."

No one need be surprised that the young man who had lived on charity for years became with success overbearing and insolent. When his old disciple Mather Brown came to call, Stuart showed himself at the window and then instructed his servant to say he was out. Listening over the stairwell, Stuart was delighted to hear Brown insist that he must be at home, since he had been at the window. "Yes, sir," the servant replied, "and he saw you, and he says he is not at home."

Stuart gleefully repeated this incident to his high-born friends, whom he kept constantly amused by ridiculous anecdotes. Dunlap repeats one that was typical: "In the early period of Stuart's career as an independent portrait painter, he had for his attendant a wild boy, the son of a poor widow, whose time was full as much taken up by play with another of the painter's household, a fine Newfoundland dog, as by attendance upon his master. The boy and dog were inseparable; and when Tom went on an errand, Towser must accompany him. Tom was a terrible truant, and played so many tricks that Stuart again and again threatened to turn him off, but as often Tom found some way to keep his hold on his eccentric master. One day, as story tellers say, Tom stayed when sent on an errand until Stuart, out of patience, posted off to the boy's mother determined to dismiss him; but on his entering, the old woman began first. 'Oh, Mr. Stuart, Tom has been here!'

" 'So I supposed.'

" 'Oh, Mr. Stuart, the dog!'

" 'He has been here too. Well, well, he shall not come again; but Tom must come home to you. I will not keep him.'

" 'Oh, Mr. Stuart, it was the dog did it.'

" 'Did what?'

" 'Look, sir! Look here! The dog overset my mutton pie, broke the dish, greased the floor, and eat the mutton.'

" 'I'm glad of it. You encourage the boy to come here, and here I will send him.'

" 'It was the dog, sir, eat the mutton.'

" 'Well, the boy may come and eat your mutton. I dismiss him; I'll have no more to do with him.'

"The mother entreated; insisted it was the dog's fault; told over and again the story of the pie, until Stuart, no longer hearing her, conceived the plan of a trick upon Tom, with a prospect of a joke founded upon the dog's dinner of mutton pie. 'Well, well, say no more. Here's something for the pie and to buy a dish. I will try Tom again, provided you never let him know that I came here today, or that I learned from you anything of the dog and the pie.' The promise was given, of course, and Stuart hastened home as full of his anticipated trick to try Tom as any child with a new rattle. Tom found his master at his easel where he had left him, and was prepared with a story to account for his delay, in which neither his mother, nor Towser, nor the mutton made parts.

" 'Very well, sir,' said the painter. 'Bring in dinner. I shall know all about it by and by.' Stuart sat down to *his* mutton, and Towser took his place by his side as usual; while Tom, as usual, stood in attendance. 'Well, Towser, your mouth don't water for your share. Where have you been? Whisper.' And he put his ear to Towser's mouth, who wagged his tail in reply. 'I thought so. With Tom to his mother's?'

" 'Bow-wow.'

" 'And have you had your dinner?'

" 'Bow.'

" 'I thought so. What have you been eating? Put your mouth nearer, sir.'

" 'Bow-wow!'

" 'Mutton pie—very pretty—you and Tom have eaten Mrs. Jenkins's mutton pie, ha?'

" 'Bow-wow.'

" 'He lies, sir! [cried Tom]. I didn't touch it. He broke Mother's dish and eat all the mutton.'

"From that moment Tom thought if he wished to deceive his master, he must leave Towser at home, but rather on the whole concluded that what with the dog, the devil, and the painter, he had no chance for successful lying."

When Stuart fell in love with Charlotte Coates, the eighteen-year-old daughter of a Berkshire physician, her father opposed the match, insisting that Stuart was too wild and extravagant. But the painter was determined to have the lady; not only was she extremely pretty, but she had a beautiful contralto voice which her musical lover considered her greatest charm. After much heart-rending negotiation, they were married on May 10, 1786.

If Stuart had promised to reform, the promise came to nothing. Now that he had a beautiful voice in the family, he gave huge musical parties at which the best musicians in London played. It was Stuart's joy to join them on his flute, and to hear his wife sing to their expert notes. He was delighted when the usually over-critical Fuseli made her repeat her songs.

Still the money went out faster than it came in. At one desperate time, Stuart even took advantage of his beloved benefactor; he borrowed back from Mrs. West a portrait of her husband he had given her as a token of gratitude. He wanted, he explained, to touch up some rough place. Instead he sold the picture to Alderman Boydell. Probably he had meant to copy it for Boydell, but, having delayed too long, had at last sent the original in the confident belief that he would paint another for Mrs. West. He never got around to it.

What are we to make of Stuart's irresponsibility? His biograph-

STUART: DOMINIC SERRES

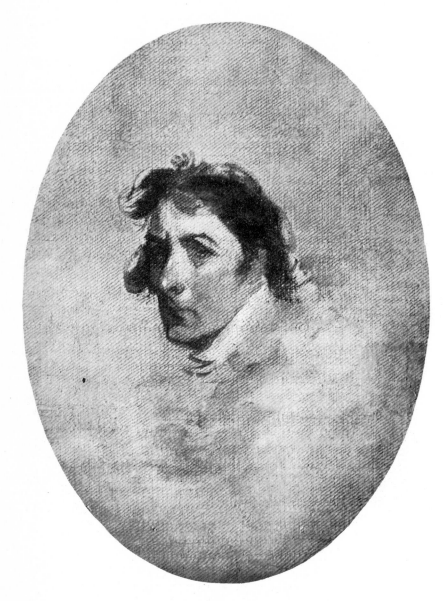

STUART: UNFINISHED SELF-PORTRAIT

ers have liked to paint him as a gay libertine, whose animal spirits were too strong for him. A self-portrait that he started for his bride but could never make himself finish suggests, however, a very different view. The sketched-in canvas is one of the most anguished, tortured pictures this writer has ever seen, a far cry from the suave cynicism with which Stuart painted others. The lean face is twisted, passionately unhappy, with the unhappiness of tortured nerves.

Perhaps Stuart was influenced into spending so much, into being so luridly gay, by lack of confidence in his art. He had limited himself to a very narrow specialty, and thus had acquired skill with sensational speed, but now that he was established he must have realized that he was the least versatile important painter in England. In the painting of faces he was well-nigh incomparable, but the young man who had never learned to draw was uncertain in executing full-lengths, while the representation of several figures on one canvas seems to have been beyond his powers. In 1784 he attempted a conversation piece of the family of William Bingham, which was to include two adults, two children, and a horse. He painted in the heads easily, but he could get no further; the picture was never finished. Again and again during his long life he was to repeat this failure; many scraps of ambitious canvases remain, the heads expertly depicted, but we have hardly any completed pictures that contain more than two figures; even those with two figures can be counted on the fingers of one hand. His full-lengths, too, are neither numerous nor, with a very occasional exception, up to the standard of his other work. Children puzzled him; he painted them rarely and without conspicuous success. The representation of animals seems to have been beyond his powers, and from his entire life we know of only one completed landscape.

However, his painting of faces was so brilliant that with an occasional departure into a full-length it served to maintain his reputation in London; lack of professional success does not explain his sudden disappearance. One day he was the most successful young

artist in the capital; the next day no one knew where he was. Newspapers described him variously as being in America, where he had gone to look after "a large tract of land, the property of his father"; or in Dublin; or in Paris. Even his best friends had no idea what had happened to him. So carefully did Stuart cover his trail that to this day we do not know where he spent the autumn of 1787. Undoubtedly his sudden departure was flight, flight from his debts. "I knew Stuart well," Lawrence said, "and I believe the real cause of his leaving England was his having become tired of the inside of some of our prisons." He owed eighty pounds for snuff alone.

In November 1787 Stuart turned up in Dublin. According to a story he often told, he had gone at the invitation of the Duke of Rutland, then Lord Lieutenant, to paint His Grace's portrait, but as he entered the city he met the Duke's funeral procession leaving it. Rumour has it that his creditors caught up with Stuart at once and lodged him in an Irish prison. The gentry of the distant capital, however, were so pleased to be painted by a famous artist that they flocked behind the bars to sit. It was Stuart's practice to demand half-price at the first sitting; soon he had started enough pictures to pay the debts for which he was imprisoned. Jubilantly he made his way to fine lodgings and finished the pictures there.

Whether or not this story is true, it is probable that he did spend some time in a Dublin prison, and it is certain that from the first his work was immensely popular. He was by far the best artist in Ireland; his arrival drove Robert Home, the leading painter before he came, to the provinces in search of business. All the aristocracy flocked to Stuart's studio, and it became very difficult to get him to finish a picture, "so fond was he of touching the half-price."

Stuart promptly made friends with the wild Irish squires. "The elegant manners, the wit, and the hospitality of the Irish suited his genial temper . . ." his daughter wrote. "I am sorry to say that Stuart entered too much into their conviviality." It was his "mis-

fortune, I might say his curse," to be very popular. "The conse-
quence was that he gave dinner parties, as was the fashion of the
day. . . . My mother used to relate numerous anecdotes of these
gay reunions. . . . I was always fond of hearing these old stories,
but it gave my mother pain to remember anything associated with
reckless extravagance."

Stuart's Irish crony, J. D. Herbert, gives us an admiring account
of his skill in recognizing bailiffs at several hundred yards and of
his address in evading them. "So silly am I," Herbert quotes the
painter as saying, "and so careless of keeping out of debt, it has
cost me more to bailiffs for my liberty than would pay the debts
for which they would arrest me. I confess my folly in feeling proud
of such feats."

Herbert tells us that Stuart "had all the equalizing spirit of the
American, and looked contemptuously on titled rank." He relates
that when Stuart painted the daughter of the Archbishop of Dub-
lin, he did not make the likeness flattering enough to suit her. Her
complaints annoyed Stuart, and he simply stopped painting on the
portrait. While Herbert was lounging in the studio several days
later, a flunkey announced that the Bishop was below in his car-
riage and wanted Stuart to come down and talk with him. Herbert
rose to go.

"No," said Stuart. "You must stay and witness a novel scene."
Then he sent down word that he was not used to attending on car-
riages, but that if the Bishop would come up to his painting room
he would speak to him. The servant returned in a minute to report
that the Bishop's gout kept him from coming up. Stuart sent the
flunkey back with the message that he was extremely sorry for two
reasons: one, for the Bishop's sufferings; and two, that he had the
rheumatism himself. However, he would try to meet His Grace
half-way.

With a wink at Herbert he slipped off his shoe, tied a silk hand-
kerchief round his foot, and limped exactly half-way down the

stairs, where he waited for the Bishop, who came limping painfully up. "Well," Herbert heard the episcopal voice remark, "I have contrived to hobble up, you see, Mr. Stuart. Sorry to see your foot tied up."

"Ha! Oh, dear!"

"Do you suffer very much with your foot?"

"Oh, very much, my lord."

The Bishop remonstrated that the picture of his daughter was "not pleasing." With Stuart leading the way, the two men limped slowly up the stairs to his studio. Placing the picture on the easel, Stuart began to lay a dark colour on the background. The Bishop watched him curiously, but when Stuart, continuing the rhythmical sweep of his brush, laid colour over the face too, he remonstrated. "Now what are you doing? Are you painting it out?"

"Yes, I am putting Your Grace out of pain, as much as I can. I shall return the half-price, and am sorry I cannot please Your Grace."

When the Bishop insisted he only wanted the face altered, not the whole picture rubbed out, Stuart nodded gravely, dipped some tow in turpentine, and removed the colour. Then he said: "A dressmaker may alter a dress, a milliner a cap, a tailor a coat, but a painter may give up his art if he attempts to alter to please. It cannot be done."

The Bishop bowed and hobbled away. Stuart attended him to the middle step of the stairs, bowed low, and returned jubilant with victory. He instructed his servant to take the picture to the Bishop's house but not to leave it until he had collected fifteen guineas.

Obviously Stuart's rapid rise in the world had not made him a snob. The poverty of his young manhood had filled him with the desire to associate with the rich and fashionable, but when he reached this end, he was neither obsequious nor satisfied. Perhaps he realized that the British gentry, although they found his pranks and tall tales amusing, did not regard him as one of them. In any

case, the American, having leaped the hurdle into high society, found it necessary to prove that society was not so high after all. He was like a young boxer who struggles to meet the world's champion, but only that he may knock him out. Herbert found that it was not Stuart's friendship with the rich but his "consciousness of his pre-eminence as a painter" that gave him the air of a coxcomb.

Stuart told Josiah Quincy a story which he may well have made up to show his opinion of ancestors. He said that an Irish merchant, who had got a castle by a fortunate speculation, sent for him to paint the portraits of his forebears. The painter assumed, of course, there would be drawings or miniatures to enlarge; on his arrival at the castle he found none. "How the deuce," he cried, "am I going to paint your ancestors if you have no ancestors?"

"Nothing easier. Go to work and paint such ancestors as I *ought* to have had."

Delighted, Stuart turned out a goodly company of knights with armour, judges with bushy wigs, and ladies depicted in the archaic manner with nosegays and lambs; ancestors which, he implied, did as well as the real article. A painter was the equivalent of a college of heralds.

During his years in Ireland, Stuart did not find his greatest happiness in the wild sprees with which he filled his nights, but rather on the farm where he retired when not driven too hard by his nerves and ambition. Planting in the rich soil, watching the unhurried growth of flowers, he forgot for a little while the dissatisfaction of his spirit. In the silence of the rural landscape the world of fame and fashion seemed unimportant as a dream; he was able to relax a little. Herbert reports that praises of his "very pretty pigs" pleased Stuart more than "anything I could say in praise of his works."

When Stuart's ever-mounting debts made it seem expedient to flee from Ireland, he played one last trick on the gentlemen who

had been his companions and patrons. He began many pictures which he had no intention of completing, demanding half-payment at the first sitting of each. "The artists of Dublin," he told Herbert, "will get employment in finishing them. You may reckon on making something handsome by it, and I shan't regret my default when a friend is benefited by it in the end. The possessors will be well off. The likeness is there, and the finishing may be better than I should have made it."

Stuart had promised to go to London, where several commissions awaited him, but at the last moment he changed his mind; perhaps he discovered his creditors were awaiting him too. He set sail for New York.

<p style="text-align:center">IV</p>

At the moment of his leaving Ireland, Stuart stepped into the realm of American textbook legend, for he had started on the journey that was to end with the most famous picture in American history, his portrait of Washington. Stuart's *Washingtons* haunt us all from the cradle to the grave; they stare at us from primers and posters and postage stamps; indeed it is these canvases, not the hand of God, which determined how the father of their country would look to most future Americans. Should Washington return to earth today, if he did not look like Stuart's portraits many would regard him as an impostor.

Since the figure of Washington—the cherry-tree Washington—which is pounded into every schoolboy's brain is as mythological as Prometheus, it is natural that a full-blown mythology should surround the hero's most famous portrait. It is authoritatively reported, for instance, that Stuart nobly gave up a brilliant European future because of a patriotic desire to preserve the features of the man in the world he most admired. We know, however, that Stuart was driven from the British Isles by debt. Indeed, there is no evidence that he was pleased with the success of the revolution; his

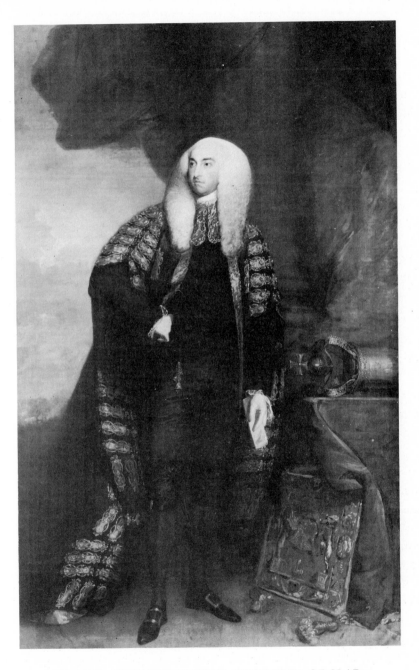

STUART: JOHN FITZGIBBON, FIRST EARL OF CLARE

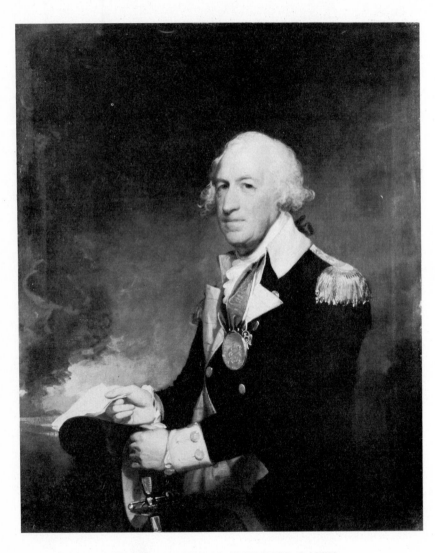

STUART: GENERAL HORATIO GATES

family was Tory and he had fled to the enemy capital on the eve of the battle of Bunker Hill. Innumerable stories he told show that he had no particular respect for Washington; he appears to have been by nature incapable of venerating any man, even, as we have seen, his beloved benefactor West.

It is true, however, that the idea of painting Washington was partly responsible for Stuart's return to America. Harassed by debt, casting around for a new source of income, Stuart remembered that the President was one of the most popular men in the world. "I expect to make a fortune by Washington alone," he told Herbert. "I calculate upon making a plurality of portraits, whole-lengths that will enable me to realize; and if I should be fortunate, I will repay my English and Irish creditors." Upon several other occasions he spoke of the large sums he hoped to make from an engraving after a popular portrait of the father of his country.

However, when Stuart arrived in New York late in 1792 or early in 1793, he was so inundated with commissions that he decided to put off depicting Washington for a leaner year. Stuart was the most skilful painter to practise in America since Copley's departure in 1774; Dunlap, himself an artist, expressed the general opinion concerning his work: "It appeared to the writer as if he had never seen portraits before, so decidedly was form and mind conveyed to the canvas." The rich, the fashionable, the witty, flocked to Stuart's studio.

Stuart's portrait of General Horatio Gates is an excellent example of the work that so impressed his countrymen; it is the best character sketch of Gates in existence. The English-born adventurer who schemed to displace Washington as commander-in-chief and almost succeeded, the general who commanded at the great victory of Saratoga and the great defeat at Camden, had so tangled and unpleasant a character that none of the modern scholars who have begun to write his life has been able to bear with him long enough to complete it. Looking at the mean, facile, and pompous

figure Stuart painted, understand why no biographer has succeeded in capturing with words the character of the second most prominent general in the revolutionary army.

Carrying with him a letter of introduction from John Jay, Stuart moved early in 1795 to Philadelphia, the national capital which was the home of the most self-consciously aristocratic society ever associated with American politics. The war with England had not been regarded by its most conservative leaders as a social revolutionary struggle, but rather as a quarrel between the Brtish aristocracy and the American upper class. The masses, they argued, were embroiled only as common fodder, and once the fighting was over, the Federalists wished to push them back into obscurity. John Adams argued for titles to distinguish quality from persons of no importance. Hamilton organized the country's financial structure to nurture a rich governing class.

The luxurious society of the capital was dominated by rich and elegant women. Philadelphia's tradition of great belles had been nurtured during the winter of 1777–78 when the city had 'been occupied by the British army, and the presence of high-born officers had sparked the grandest social season in all American history. The dancing partners of the aristocrats intermarried with the speculators who flocked to Philadelphia when it became the capital of the United States. "You have never seen anything like the frenzy which seized upon the inhabitants here," an observer wrote. "They have been half mad since the city became the seat of government."

Although Washington refused to be called by any more high-falluting title than "The President of the United States," the social leaders of Philadelphia took advantage of his Virginian love for gracious living to create around him as much of a royal atmosphere as they could get away with. How graciously the belles bowed to the Federalist politicians who bowed as graciously back! If you looked through half-closed eyes, you might imagine you were in London. The Jeffersonians, who were opposed to capital-

ism and agreed with Tom Paine about the rights of man, were rarely
invited to such parties; and when they were, the ladies simpered be-
hind their fans to see they did not know how to behave. The most
brilliant salon of this period, probably the most brilliant ever held
in America, was presided over by Hamilton's ally, Mr. William
Bingham, "the uncrowned queen of the Federalist group," whose
beauty is attested to by Stuart's many portraits of her. Her drawing
room was decorated entirely with furniture imported from abroad,
as was only proper. To the delight of the other provincial belles,
she introduced the foreign custom of having a long line of foot-
men announce arriving guests. When Democrats had to be asked
for political reasons, this sometimes led to misunderstandings.
There was, for instance. the sad experience of James Monroe; had
it been suggested that he might some day be President, every beau-
tiful feminine shoulder, shining bare under Mrs. Bingham's chan-
deliers, would have risen in horror.

"Senator Monroe!" announced a flunkey.

The Senator looked up good-humouredly. "Coming."

"Senator Monroe!" echoed another flunkey down the hall.

"Coming as soon as I can get my greatcoat off."

One was forced to put up with such unfortunate happenings for
the time being, until the Government of the United States was put
on a sound aristocratic basis, but after that you would not even
have to half close your eyes to believe that Philadelphia was Lon-
don.

Stuart became the court painter of the "republican court." It
was during this period that he executed the series of portraits of
lovely ladies that lifts him to a high place among the depicters of
beautiful women. He threw himself with abandon into the gay
parties with which Philadelphia abounded; the man who had
charmed the aristocracy of London and Ireland was immediately
popular, despite the fact that his profession was considered unsuit-
able for a gentleman. Contemporary memoirs dilate on his gay
stories, his wit, his brilliance on the harpsichord. When the beauti-

ful Mrs. Perez Morton, locally known as "the American Sappho," wrote a poem on the portrait of her he had painted, Stuart replied with a poem of his own that put Sappho's in the shade:

> "Who would not glory in the wreath of praise
> Which M—— offers in her polished lays?
> I feel their cheerful influence at my heart,
> And more complacent I review my art.
> Yet, ah, with Poesy, that gift divine,
> Compar'd, how poor, how impotent is mine!
> What though my pencil trace the hero's form,
> Trace the soft female cheek with beauty warm:
> No further goes my power; 'tis thine to spread
> Glory's proud ensign o'er the hero's head;
> 'Tis thine to give the chief a deathless name,
> And tell to ages yet unborn his fame;
> 'Tis thine to future period to convey
> Beauty enshrined in some immortal lay.
> No faithful portrait now Achilles shows,
> With Helen's matchless charms no canvas glows;
> But still in mighty Homer's verse portrayed,
> N'er can her beauty or his glory fade.
> No wonder if in tracing charms like thine,
> Thought and expression blend in rich design;
> 'Twas heaven itself that blended in thy face
> The lines of reason with the lines of grace.
> 'Twas heaven that bade the swift idea rise,
> Paint thy soft cheek and sparkle in thine eyes:
> Invention there could justly claim no part,
> I only boast the copyist's humble art. . . ."

Thus Stuart attested to his brilliance. But before a court painter can be considered really established, he must do a famous picture of the ruler. Shortly after his arrival in Philadelphia, Stuart painted

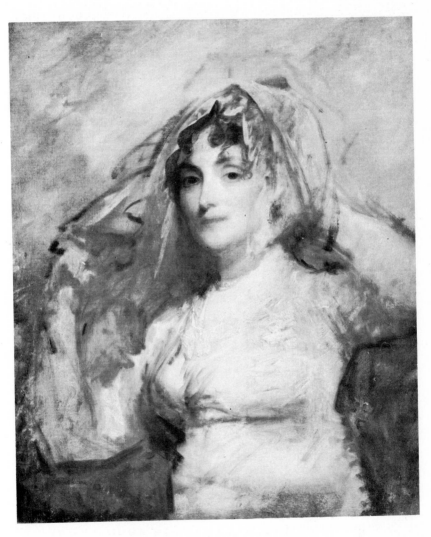

STUART: MRS. PEREZ MORTON

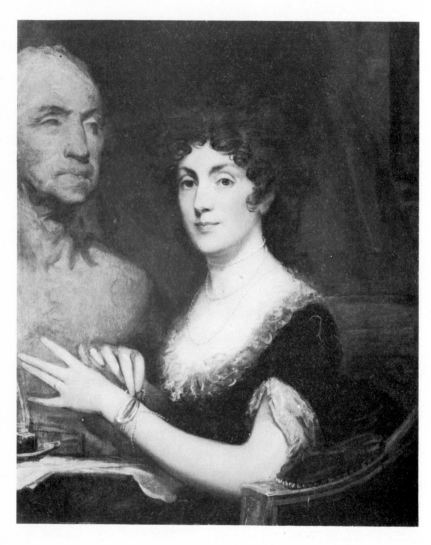

STUART: MRS. PEREZ MORTON WITH AN IMAGINARY
BUST OF WASHINGTON

the President. Since he later destroyed the resulting canvas, insisting it was not up to his standard, a legend has grown up that he was so impressed by the greatness of his sitter that he could not keep his mind on his work.

Actually, as the painter often explained to his friends, Washington proved immune to an important part of his technique. A skilled conversationalist, Stuart kept the faces of his sitters animated by talking to them about their interests. "To military men," Waterhouse tells us, "he spoke of battles by sea and land; with the statesman on Hume's and Gibbon's histories; with the lawyer on jurisprudence or remarkable criminal trials; with the merchant in his way; with the man of leisure in his way; with the ladies in all ways. When putting the rich farmer on the canvas, he would go along with him from seed to harvest time; he would descant on the nice points of horse, ox, cow, sheep, or pig, and surprise him with his just remarks in the progress of making cheese and butter, or astonish him with his profound knowledge of manures. . . . He had wit at will, always ample, sometimes redundant."

As soon as Washington entered his studio, Stuart realized that all his powers would be needed to bring the stern, imperial face alive. Washington had been besieged by painters for years, and even when he first sat for Peale in 1772 he had grumbled about the drudgery. After each of his numerous portraits was completed, he swore he would never sit again. Stuart remembers that "an apathy seemed to seize him, and a vacuity spread over his countenance most appalling to paint." Having ruefully surveyed the iron countenance before him, the painter ventured to remark: "Now, sir, you must let me forget that you are General Washington and that I am Stuart the painter."

"Mr. Stuart," Washington replied politely, "need never feel the need of forgetting who he is, or who General Washington is." His face was stony as ever.

Stuart grasped his brush harder and changed his attack; he re-

solved "to awaken the heroic spirit in him by talking of battles."
The patrician general looked up in surprise for a moment and then
sank back into his boredom, for he had no intention of discussing
military tactics with a mere artist. Rebuffed again, Stuart painted
in silence for a while, but he could hardly bear to look at his can-
vas; the face that was rising before him was dead, though firm and
powerful; he felt he had not got even a glimpse of Washington's
real character. With the energy of despair, he set his facile tongue
moving on the republican days of antiquity; like an angler using
different flies on a wary trout, he dangled Cincinnatus in front of
Washington, and Brutus, and the noble Cato. The fish did not bite.

Thus the sittings passed. We gather that only once did the
painter strike a spark from the general. As Stuart was allowing his
tongue to idle on, no longer in hopes of rousing his sitter but
merely to keep the silence down, he launched on an old and hoary
joke. He told the President how James II, on a journey through
England to gain popularity, arrived in a town where the Mayor,
who was a baker, was so frightened that he forgot his speech of wel-
come and stood there stammering. A friend jogged the Mayor's
elbow and whispered: "Hold up your head and look like a man."
When Stuart told how the flustered baker had repeated this ad-
monition to the King, Washington's stern face unbelievably broke
into a smile. But before Stuart could lift his brush, the smile was
gone.

According to Trumbull, "Mr. Stuart's conversation could not in-
terest Washington; he had no topic fitted for his character; the
President did not relish his manners. When he sat to me, he was
at his ease." This statement, influenced though it was by jealousy,
probably contained some truth, since Stuart's exaggerated talk and
showy erudition may easily have displeased the old and tired states-
man, among whose great virtues were love of truth and dislike for
vain show.

Stuart could not keep from making jokes about the hero, even

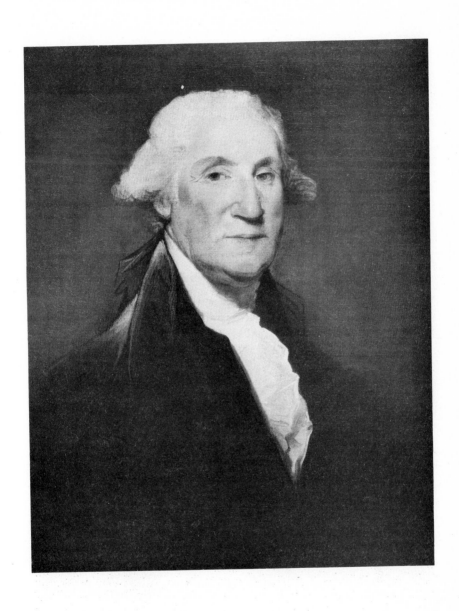

STUART: THE VAUGHAN PORTRAIT OF WASHINGTON

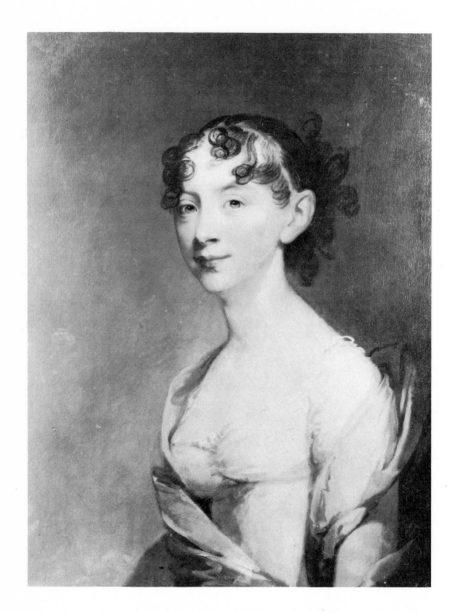

STUART: ISABELLA HENDERSON LENOX

to the hero's own wife. While he was painting Washington, Charles Willson Peale, that doting father of a large family of painters, also secured a promise of sittings. He laid a trap for the President. Once Washington was well seated before his easel, the door opened noiselessly. James, Rembrandt, and Raphaelle Peale tiptoed in one by one and put up their easels. Stuart was highly amused. "I looked in to see how the old gentleman was getting on with the picture," he later told his pupil, John Neagle, "and to my astonishment I found the general surrounded by the whole family. They were peeling him, sir. As I went away, I met Mrs. Washington. 'Madam,' said I, 'the general's in a perilous situation.'

" 'How, sir?'

" 'He is beset, madam. No less than five upon him at once. One aims at his eye; another at his nose; another is busy with his hair; his mouth is attacked by the fourth; and the fifth has him by the button. In short, madam, there are five painters at him, and you who know how much he suffered when only attended by one, can judge of the horrors of his situation.' "

Martha Washington was among the best-natured women alive, but she was often bored by the perpetual adulation poured out before her husband. She may well have been amused.

When Stuart's portrait of Washington was shown in Philadelphia, it was highly praised, although Stuart himself felt it a failure. We can get some idea of the effect he had wished to achieve from the following word picture he gave of the President: "There were features in his face totally different from what I had observed in any other human being. The sockets of the eyes, for instance, were larger than what I ever met with before, and the upper part of the nose broader. All his features were indicative of the strongest passions; yet like Socrates his judgment and self-command made him appear a man of different cast in the eyes of the world."

Despite his dissatisfaction with his picture, Stuart painted some fifteen copies, which he sold for substantial sums; these canvases,

which show the right side of his face, are known by modern scholars as the Vaughan type. All the while he was making them, Stuart agitated for another chance to paint the President. In April 1795 his opportunity came through Mr. and Mrs. William Bingham, who persuaded Washington to stand for a full-length they wished to give the famous British Whig, Lord Lansdowne. "It is notorious," wrote Washington's adopted son, G. W. P. Custis, "that it was only by hard begging that Mr. Bingham obtained the sitting." Stuart, who had not painted a heroic full-length for years, adapted a composition from Rigaud's portrait of Bossuet, and thus armed waited for the President, determined this time to make him talk at all costs. But when the sitter walked sedately into the studio, what was Stuart's horror to see the lower part of his face all pulled out of shape. Washington had just had a new pair of false teeth inserted; they fitted him so badly he wore them only for a short time, but it was the time of the Lansdowne portrait. Not only did the distorted mouth bother Stuart; he was puzzled how to make the general's figure look heroic. He complained that Washington's "shoulders were high and narrow, his hands and feet remarkably large. He had aldermanic proportions, and this defect was increased by the form of the vest of that day."

Under the best of conditions uncertain about doing full-lengths, Stuart got tangled in the complicated composition he had borrowed, and the resulting picture was not, as he himself realized, one of his happiest efforts. However, since his usual pack of creditors was snapping at his heels, he filled orders for four or five copies. It is an amazing tribute to the magic of his name and of Washington's that his Lansdowne type canvases were popular in his own day and have remained so up to the present.

Stuart expected to "rescue myself from pecuniary embarrassment and to provide for a numerous family at the close of an anxious life" through the revenue from an engraving of his full-length of Washington. When William Bingham sent the original

portrait to Lord Lansdowne, Stuart, so he always insisted, asked
him to protect the copyright by stipulating that no print from it
might be made. Bingham agreed, but did not keep his agreement;
the richest man in Philadelphia preferred to endanger the property
of the impoverished artist rather than cheapen his gift by attaching
strings. In all innocence, the British peer gave James Heath permis-
sion to engrave the picture, remarking that Stuart would certainly
be gratified at having his work copied by an artist of such distin-
guished ability. Stuart never received a cent from the print of his
picture, although it had a tremendous sale. When he hurried into
Bingham's office to protest, the banker's face hardened into the
look that the ant in the fable gave the grasshopper; according to
one of Stuart's friends, Bingham asked Stuart whether he had any
proof in writing of a promise to preserve the copyright? The artist,
of course, had nothing in writing, for it had never occurred to him
not to trust Bingham's word. He stamped out of the office, refused
to finish a picture of Mrs. Bingham he was painting, and thus ban-
ished himself for ever from Philadelphia's leading salon.

Probably Stuart did not mind being outlawed, for, long before
this quarrel, he had found the gay society of the republican court
annoying. Well-born loungers seemed to be knocking on his door
all day long, demanding admittance when he wanted to paint, and
they were outraged if he refused to see them. Sometimes the irrita-
tion was so great that he did not put brush to canvas for a whole
day. Nor did he find it easy to get on with his sitters, for the Federal-
ist aristocrats regarded painters as drones, necessary to human van-
ity, perhaps, but hardly admirable. If painters were amusing and
had fine manners as Stuart did, they might even be invited to the
best parties, but no one for a moment considered them on the same
level with merchants and generals and delicately nurtured females.
Stuart so resented the attitude of John Adams that he refused to
finish the Vice-President's picture. Adams's point of view toward
art is shown in a letter he wrote some years later to M. Binon, a

French sculptor who asked his advice on how to sell a bust of Washington.

"Dear Sir," wrote the sage of Braintree, who had been painted by West, Peale, Copley, and Stuart:

"I have received your polite favour of the third of this month. I am afraid you are engaged in speculation that will never be profitable to you. The age of painting and sculpture has not yet arrived in this country, and I hope it will not arrive very soon. Artists have done what they could with my face and eyes, head and shoulders, stature and figure, and they have made them monsters fit for exhibition as harlequin or clown. They may continue to do so as long as they please. I would not give sixpence for a picture of Raphael or a statue of Phidias. I am confident that you will not find purchasers for your bust, and therefore am sorry that you are engaged in so hopeless a speculation, because I believe you are a great artist and an admirable man.

"I am, sir, with sincere esteem,
"Your most obt. humble servant,
"J. ADAMS."

Hundreds of prominent men in America would have said amen to Adams's sentiments. Faced with such an attitude, Stuart carried his artistic arrogance to an extreme. When General Knox, Washington's first Secretary of War, offended him, he used the general's portrait as the door for his pigsty. He refused to continue the picture of anyone who dared criticize the smallest detail; he would ring for his man and send the canvas up to the attic, nor could all the tears of a lady who needed a Stuart to enhance her social position make him change his mind. When an important gentleman, who had improved himself by marrying a rich and homely widow, objected that Stuart's portrait of the lady did not make her beautiful, the painter cried: "What damned business is this of a portrait

painter! You bring him a potato and expect he will paint a peach."

Trott, the miniature painter, found him one day in a great fury. "That picture," he shouted, "has just been returned to me with the grievous complaint that the cravat is too coarse! Now, sir, I am determined to buy a piece of the finest texture, have it glued on the part that offends their exquisite judgment, and send it back." Once he painted a beautiful woman who was a great talker. When the picture was almost done, she looked at it and exclaimed: "Why, Mr. Stuart, you have painted me with my mouth open!"

"Madam, your mouth is always open," the painter replied, and refused to finish the picture.

Stuart's nerves had become dangerously tight; he moved to the suburb, Germantown, and received few visitors. Liquor seems to have become his principal relaxation. "He had the appearance of a man who is attached to drinking," an acquaintance wrote, "as his face is bloated and red." He painted three hundred dollars' worth of portraits for a wine merchant, whose taste for pictures was as strong as his own for Madeira, but found, when they balanced accounts, that he still owed two hundred dollars.

"Mr. Stuart," writes Philadelphia's famous chronicler Watson, "was noted for his eccentricity and his love of good eating and drinking. To the latter he was much addicted, showing therefrom a much inflamed face, and much recklessness in his actions when excited by his drink. In this he dealt in a wholesale way, buying his wine, brandy, and gin by the cask. On one occasion he was seen kicking a large piece of beef across the street from his house to Diehl's, his butcher." The meat, Stuart cried to the startled tradesman as he gave it a final placement through the door, was not fit to handle.

Dunlap notes in his diary the rumour that Stuart frequently fought with his wife; "he was undoubtedly an imprudent man, a bad husband and father." That his children found him difficult is

shown by the great pains Jane takes, in her whitewashing biographical articles, to find excuses for his bad temper. Even Stuart's great admirer Neagle noticed that his family seemed afraid of him.

Eager to find a permanent refuge in the country, Stuart invested the money made from five whole-lengths of Washington and twenty smaller pictures in a farm near Pottsgrove, which he stocked with imported Durham cows. Paying out the money as fast as he earned it, he neglected to take receipts. When the man with whom he had been dealing died, he had no evidence that he had ever paid a dollar, and lost the whole sum, $3442. Undoubtedly such lack of business acumen contributed greatly to the debts with which he was for ever harassed. He could never remember whether pictures had been paid for, and sometimes enraged sitters by demanding payment twice, or amazed them by refusing sums due him. If he had money, he was likely to mislay it; once he found a fifty-dollar bill in a little-used pocket.

Yet Stuart kept his reputation as the greatest painter in America. When Mrs. Washington wanted a picture of the President for herself, she persuaded her unwilling husband to sit to him a third time. The painter must have waited anxiously at the door of the barn he used as a studio for Washington to ride out for the first sitting, and have sighed with relief when he saw that the President's new false teeth did not distort his face so much as the old. Washington entered the barn with cold courtesy, sat down in the chair Stuart had provided, and clamped his face into the rigid expression he saved for portrait painters. Stuart plunged into his fund of anecdote, but the face did not relax.

When Stuart looked up from his canvas after a while, his heart almost stopped beating; Washington's face bore a human expression. It lasted only a few seconds, but by seemingly nonchalant questions Stuart found out what had put it there; the general had seen a noble horse gallop by the window. Instantly Stuart commented on a local horse race; Washington made an animated an-

swer and his face came alive. Then Stuart ransacked his mind for all he knew about horses, and soon the two men were actually talking. Stuart's brush flew merrily in rhythm with his tongue. The conversation moved on to farming, a subject it had never occurred to Stuart to discuss with a commander-in-chief, and again Washington was interested.

Not too interested, however. Before the picture was finished, the President worked out a way to make the sittings bearable; he brought to the studio friends with whom he liked to talk: General Knox, the pretty Harriet Chew. They would keep his face alive, he dryly explained. Stuart at last saw the genial side of the hero, and he happened on an expedient to make the hero look imperial too, as if he were commanding an army. All Stuart had to do was be late for a sitting.

Stuart was delighted with the resulting picture. Although Washington had agreed to sit only so that his wife might have his portrait, Stuart determined to keep the canvas; he felt he could make a fortune from copying it for all comers. He completed the face but did not touch the background, and whenever Mrs. Washington sent for the picture, he apologetically explained that it was not finished. Finally she came in person, bringing the President along. When he fobbed her off with the same transparent excuse, she walked out in a huff. Stuart always insisted that Washington had not followed at once, but had whispered in his ear that he was to keep the portrait as long as he wished, since it was of such great advantage to him. An intimate of Washington's circle, however, reports that the President was very annoyed with Stuart; that he called several times at the studio, demanding the picture, and finally said in a curt manner: "Well, Mr. Stuart, I will not call again for this portrait. When it is finished, send it to me." The picture was never finished. Mrs. Washington had to put up with a copy, which she told her friends was not a good likeness.

Whether Stuart's third picture of Washington, known as the

Athenæum portrait, resembled the President or not, one thing is certain: it was immensely popular in its own day, and is the only representation of the father of their country which most modern Americans know. Stuart himself ceased using his other two portraits; he destroyed the original of the Vaughan type and topped his copies of the Lansdowne full-length with the Athenæum head. He kept the canvas by him all his life and, whenever his creditors became too importunate, dashed off copies to which he gaily referred as his "hundred-dollar bills." He sold more than seventy, and could have sold many more.

To Stuart's intense irritation, many other artists did a rushing business in copying his copies; a large number of forgeries were passed off even during his lifetime. Dunlap tells the following story in what purport to be Stuart's words: "When I lived in Germantown, a little, pert man called on me and addressed me thus: 'You are Mr. Stuart, sir, the great painter?'

" 'My name is Stuart, sir.'

" 'My name is Winstanley, sir; you must have heard of me.'

" 'Not that I recollect, sir.'

" 'No! Well, Mr. Stuart, I have been copying your full-length of Washington; I have made a number of copies; I have now six that I have brought on to Philadelphia; I have got a room in the State House; and I have put them up; but before I show them to the public and offer them for sale, I have a proposal to make to you.'

" 'Go on, sir.'

" 'It would enhance their value, you know, if I could say that you had given them the last touch. Now, sir, all you have to do is to ride to town, and give each of them a tap, you know, with your riding switch—just thus, you know. And we will share the amount of the sale.'

" 'Did you ever hear that I was a swindler?'

" 'Sir! Oh, you mistake. You know——'

" 'You will please to walk downstairs, sir, very quickly, or I shall

throw you out the window.' " When the burly painter laid down his snuff-box and prepared for action, Winstanley decided he preferred the stairs.

Stuart asserted that even the full-length which adorned the White House was a forgery. However, that was not the common opinion, and the mystical importance that was ascribed to Stuart's *Washingtons* even during the artist's lifetime is shown by the care which was taken to save the picture when the English took the capital in 1814. As she fled, Dolly Madison, the President's wife, commanded a servant to save or destroy "the portrait of President Washington, the eagles which ornament the drawing room, and the four cases of papers which you will find in the President's private room. The portrait I am very anxious to save, as it is the only original by Stuart. In all events, don't let them fall into the hands of the enemy, as their capture would enable them to make a great flourish."

Modern critics are by no means unanimous in their praise of Stuart's Athenæum portrait. Many prefer his copies of the portrait he destroyed; they are more forthright, the critics say, more forceful, less flattering. Indeed, there is reason to believe that none of Stuart's *Washingtons* ranks with his best work. At heart completely lacking in reverence, Stuart had for commercial reasons attempted a task for which he was not temperamentally suited: he had tried to make a votive canvas before which a multitude would fall in worship. Probably he succeeded so well in the popular mind because he was by far the most famous and technically proficient artist to paint the father of his country. His canvases are more suave and satisfying than any others.

But are they the best likenesses? The opinion of the general's associates was not unanimous, as was to be expected; some preferred Stuart's pictures, some those of other artists. It is certain, however, that Stuart had worked under a great disadvantage, for by 1790 Washington's splendid physique had begun to break down. The

dashing commander of the revolutionary days was now a tired old man who had been forced, despite himself, to accept a second term as President, and had then, as he labored to preserve true neutrality in the on-going European conflict, been tortured by a controversy between the pro-French Jeffersonians and the pro-English Hamiltonians that was bringing a flood of abuse down on his head. The embittered and puzzled hero complained that every act of his administration had been grossly misrepresented, "and that too in such exaggerated and indecent terms as could scarcely be applied to Nero, a notorious defaulter, or even a common pick-pocket." He was very sad. When Stuart had tried, by talking of battles, to make Washington look as he had looked at Valley Forge, he had tried the impossible; it was a different man who sat before him. Undoubtedly Trumbull and Charles Willson Peale, who had painted Washington many years before, had enjoyed a better opportunity to show him at his best, though they were less expert portraitists.

Stuart himself did not contend that his rendering of Washington was pre-eminent. "Houdon's bust," he told his daughter, "came first, and my head next. When I painted him, he had just had a set of false teeth inserted, which accounts for the constrained expression about his mouth and the lower part of his face. Houdon's bust [done in 1783] did not suffer from this defect."

Although Stuart's *Washingtons* have made his name a national byword, they have probably hurt his artistic reputation. His copies of his Athenæum portrait, which for sentimental reasons occupy prominent positions in so many museums, are for the most part vastly inferior to the original. Impetuous and actuated by inspiration, Stuart was not able to imitate anyone successfully, not even himself. As the years passed he kept altering, perhaps unconsciously, the shape of Washington's head; at first he made it shorter and squatter than in his original painting; when he realized what he was doing, he went too far the other way and turned out a series of heads that were longer and thinner. Finally he became so

bored that his *Washingtons* were merely superficial sketches of the features he had painted *ad nauseam*. "Mr. Stuart," Neagle writes, "told me one day when were before this original portrait that he could never make a copy of it to satisfy himself, and that at last, having made so many, he worked mechanically and with little interest." His daughter tells us that toward the end of his life Stuart dashed off *Washingtons* at the rate of one every two hours.

V

In 1803 Stuart moved from the suburbs of Philadelphia, leaving behind a grocer's bill of two hundred and sixteen dollars, and followed the national Government to the new city of Washington. He was immediately successful. "I can tell you nothing new," a friend wrote to Dolly Madison. "Stuart is all the rage. He is almost worked to death and everyone is afraid they will be the last to be finished. He says: 'The ladies come to me and say: *"Dear* Mr. Stuart, I'm afraid you must be very tired. You really must rest when *my* picture is done." ' "

During a trip to Baltimore, Stuart began portraits of Jerome Bonaparte, Napoleon's favourite brother, and his American bride, but when Jerome condescended to him in the proper princely manner, Stuart slammed down his brushes and refused to finish the pictures. Years later, Sully accidentally stepped on a canvas tossed onto the floor of Stuart's lumber room. "You needn't mind," said Stuart. "It's only a damned French barber." Sully remembers that "Stuart had a beautiful picture of Jerome's beautiful wife, which he refused to give up, threatening that if he was bothered any more about it, he would put rings through the nose and send it to any tavern-keeper who would hang it up. He would have done it too, for he was not a man to flinch from anything of that kind."

Dolly Madison wrote to Mrs. Anna Cutts in June 1804 that Stuart "has now nearly finished all his portraits and says he means

to go directly to Boston, but that is what he has said these two years; being a man of genius, he of course does things differently from other people. I hope he will be here next winter, as he has bought a square to build a 'temple' upon."

When Stuart finally visited Boston a year later, he obviously did not intend to settle, for he left his family behind and stayed at Chapotin's Hotel. "I there saw him both in the paint room and at the dinner table," writes Dunlap. "His mornings were passed in the first, and too much of the remainder of the day in the second."

He soon was borrowing money once more, although he was inundated with business. As Charles Fraser wrote to his sister, Stuart "has all the beauty and talent of Boston under his pencil." The prospects seemed so good that he sent for his family and during the remaining twenty-three years of his life he left the New England city only for a brief pilgrimage to his birthplace.

Stuart found in Boston less disapproval of the arts than he had encountered elsewhere in America, but the prevailing attitude that painters were drones as compared with merchants and mechanics existed there too. Militantly he adopted exactly the opposite attitude. He had, a friend tells us, no respect for the ordinary business of life, and admired only "commanding talents in literature and art." Nor did all kinds of artists meet with his approval. In his reaction against a civilization that distrusted genius and worshipped industry, he despised painters who had become skilful through hard work rather than brilliance. He thought Copley's flesh tints laboured and compared them to "tanned leather."

Stuart saw to it that no one could accuse him of being a business man. For no apparent reason, he ignored lucrative commissions, and his attic was full of canvases he had capriciously refused to finish; he returned to all the irresponsibility of his youth under the justification of revolt. There was, however, a serious æsthetic principle behind his refusal to follow the conventional course for por-

trait painters. The great fault of his European colleagues, he believed, was their business sense. In their desire to please sitters who wished to look noble and prosperous, they had cluttered their canvases with all the accessories of wealth: elaborate backgrounds, fine costumes, grandiloquent postures. On seeing David's portrait of Napoleon, Stuart exclaimed: "How delicately the lace is drawn! Did one ever see richer satin? The ermine is wonderful in its finish. And, by Jove, the thing has a head!"

Stuart made ladies wash off the rouge with which they had armed themselves for their sittings; gentlemen, if they wished to be painted by him, had to disarrange carefully parted hair and elaborately fixed costumes. The artist wanted to show his sitters as they really were, and if they objected he simply refused to go on with their portraits. Although his scorn of social frippery was æsthetically sound, he carried it, as he carried everything else, too far. He often finished his pictures carelessly, filling in the canvas around the face any old way, in a dash of irritation; or he hired a drapery painter to do the work he despised. Disliking elaborate poses, he painted nothing but heads and shoulders against stock backgrounds. Although, when he wanted to, he could depict lace expertly with a few impressionistic strokes of the brush, part of the simplicity of his canvases is undoubtedly due to lack of skill; as we have seen, he had been too impatient in his youth to learn how to draw the human figure or compose a complicated picture.

Perhaps impatience was the personal quality that most influenced Stuart's Boston work. In England, where he had competed with brilliant and finished artists, he had been forced to hold his temperament in check, to paint with exactitude and care. From the moment of his arrival in America, however, his technique became increasingly rapid; he had to fear neither competition nor criticism, since he himself became the artistic dictator of his homeland. "Stuart's word in the art is law," wrote Neal, "and from his decision there is no appeal."

Able to paint exactly as he pleased, Stuart discovered a method of producing the maximum result with the minimum effort. He blocked in the face with opaque colours, which he then covered with a swiftly painted layer of transparent or semi-transparent hues. When he first attempted this method, he was only partly successful; the over-painting did not blend and seemed to be a superimposed drawing. Soon, however, he achieved amazing effects; his finished pictures have all the spontaneity of a sketch, while the transparency of his hues gives a marvellous feeling of flesh, for flesh itself seems transparent. He told a disciple that "it is like no other substance under heaven. It has all the gaiety of a silk-mercer's shop without its gaudiness of gloss, and all the soberness of old mahogany without its sadness." Stuart's flesh tones are his greatest glory; sometimes he seemed to paint in pure colour.

However, Stuart himself did not prefer the pictures of his Boston period to the more laboriously painted works of his younger years. In 1816 Jouett jotted down in his notes that Stuart had said: "I have often, very often, roughened my second or third sitting that I might be thrown back and, having to use more colour, produce a richer effect. The reasons why my paintings were of a richer character thirty years ago: then it was a matter of experiment; now everything comes so handy that I put down everything so much in place that for want of opportunities . . . [I] lose the richness."

Undoubtedly Stuart was forced to adopt his characteristic later style partly by what would seem to have been a physical handicap: the trembling of his hands. His slightly unsteady touch gave atmosphere and added vibrancy to his colouring, while he had to concentrate on the significant masses of the face, since he could not, had he wished, have executed meticulous detail. Neagle tells us: "He deliberated every time before the well-charged brush went down upon the canvas with an action like cutting into it with a knife. He lifted the brush from the surface at a right angle, carefully avoiding a sliding motion. He always seemed to have avoided

vexing or tormenting the paint when once laid on, and this accounts partly for the purity and freshness . . . of his work."

Stuart himself told Jouett: "Never be sparing of colour, load your pictures, but keep your colours as separate as you can. No blending: 'tis destructive to clear and beautiful effect. . . . Short and chopping preferable to whisping, sweeping handling. . . . By chopping, you shorten the flesh and give it a tenderness."

Since Stuart laid his colours side by side, his pictures looked best from a slight distance. When people examined them closely, he would cry in anger: "Well, sir, does it smell good?"

The suaveness of Stuart's technique has blinded some of his critics to the frankness of his vision; it is charged that he was not a realist, but laboured to make his sitters look as aristocratic as possible. He himself would have vigorously resented this accusation, since the ideal that governed his entire career was a passionate desire to imitate nature. "Let nature tell in every part of your painting," he instructed Jouett, "and if you cannot do this, throw by your brush." He preferred Van Dyck to Reynolds because "Van Dyck would copy nature. If a sitter had false eyes they were put down as false. Reynolds would not. He delighted too much in imaginary beauty. Van Dyck [was] so true to nature that you only had to see the hair to know the complexion, and vice versa."

Actually Stuart's work is no more flattering than we should expect from a study of his character. He made the self-confident look smug; the shrewdly intelligent, whom Copley would have idealized, look crafty. Yet his pictures are tempered by a deep sympathy with erring humanity. Himself one of the most tortured and irrational of men, he realized that the basic motivation of angry men is not anger, of frivolous men is not frivolity. His works are rarely satiric and have no similarity to caricature; sometimes they seem at first as unrevealing of personality as the sitter's actual face must have been. Study, however, will bring out the depth of Stuart's insight.

Regarded as the greatest painter in America, Stuart was besieged

by young men who wished instruction. If he thought them pert or lacking in talent, he would demolish them with terrible invective. You had to watch your step in Stuart's studio. Once his nephew, Gilbert Stuart Newton, who was to become well known as a genre painter, rushed into the master's room, flourished his brush, and cried with high animal spirits: "Now, old gentleman, I'll teach you to paint."

"You'll teach me to paint, will you? I'll teach you manners." And not happening to have gout that day, Stuart kicked him out of the room.

However, he was happy to assist aspiring painters who were earnest, civil, and talented. John Hill Morgan in his recently published book *Gilbert Stuart and His Pupils* states that the following painters probably received some help from Stuart: Mather Brown in Boston before Stuart's trip to London; John Trumbull in London; George Place and John Comerford in Ireland; and, after Stuart's final return to America, Benjamin Trott, John Vanderlyn, Rembrandt Peale, John R. Penniman, Thomas Sully, Gilbert Stuart Newton, the painter's children Charles Gilbert and Jane Stuart, James Frothingham, Matthew Harris Jouett, Jacob Eicholtz, Sarah Goodridge, William James Hubard, John Neagle, Fabius Whiting, Henry Sargent, Francis Alexander, and Samuel F. B. Morse. To these may be added on excellent evidence Martin Archer Shee, who succeeded Lawrence as president of the Royal Academy, Nathaniel Jocelyn, and the American backwoods phenomenon Chester Harding.

The list is long, but in most cases Stuart merely gave the young men advice when they called on him; only a few were, like Jouett and Vanderlyn, actually taken into his studio, and these for only several months apiece. Although Jouett and Frothingham learned to paint in Stuart's manner, it is usually extremely difficult to find traces of his style in the work of most of the young men he advised.

Stuart was an impatient teacher, and his technique was so personal that few could imitate it with success.

Indeed Stuart urged his pupils to copy not his work but nature. He believed that young painters should shift for themselves as he had done; the talented would work out a personal style, and it was best that the others fall by the wayside. He opposed art academies because, he insisted, they encouraged the incompetent. "By and by," he shouted, "you will not by any chance kick your foot against a dog kennel but out will start a portrait painter!"

As we have seen, two of Stuart's ten children, his second son Charles Gilbert and his daughter Jane, essayed to follow in his footsteps. Trying to forget the flaws and deficiencies of his own temperament, the unhappiness of his own career, Stuart concentrated his hopes for the future on the boy, who he felt had a great talent as a landscapist. But he was so afraid of destroying the lad's originality that he refused to give him any instruction. Charles Gilbert was forced to appeal to Stuart's other pupils for hints at second hand.

From the first, Stuart had been worried about his son, who seemed to be so like himself; in the tantrums of the infant he had seen his own unstable nerves. Realizing that he had wasted much of his own life, he determined to save his son from the pitfalls into which he himself had fallen. He brought Charles Gilbert up with savage strictness. When the boy did things he saw his father do every day, his father recognized the symptoms he dreaded and flew into a fury. The years passed with much sternness and many beatings, until at last the young man could be controlled no longer. Then he threw himself into dissipation with more abandon than his father had ever known. Stuart sat up many a night till dawn, waiting for the front door to open, and when at last the prodigal returned, pale, feverish, so drunk he could hardly stand, the old man wondered if this could be retribution.

The boy, who was so like Stuart himself, so talented, so uncon-

trolled, wasted away under the influence of liquor and late hours. While his father watched in anguished helplessness, he grew thinner, more drawn, till he could hardly stagger to the haunts of his companions. At last he was too weak to get out of bed; Charles Gilbert died on March 10, 1813, at the age of twenty-six. Although the official record gave the cause of death as consumption, Stuart felt that dissipation had killed his favourite son, and that it was all his own fault. The sad expression of his face grew sadder.

The poverty his own recklessness had caused, forced Stuart to bury Charles Gilbert in the strangers' tomb of Trinity Church; the funeral procession consisted of only one carriage. Unable to bear the house in which his son had died, Stuart moved to Roxbury, a suburb of Boston, where he again tried to forget the world in the calm of a rural landscape. He insisted on having cows and pigs. Friends noticed that the most childish things amused him now. An irascible servant, for instance, got into such a fury with Stuart's cow that Molly clambered somehow up the barn stairs; the next morning everyone was amazed to see her head sticking out of the upper window. "This," comments his daughter Jane, "was just the kind of thing to divert Stuart." He made his friends come out from Boston to see the cow, and was so amused that it took weeks of persuasion from his wife and daughters before he would let Molly be brought down to earth.

He delighted in infantile puns. "Mr. Stuart," a gushing lady would cry, "that is the greatest likeness I ever saw!"

"Draw aside the curtain and you will see a grater."

"There is no picture here."

"But there is a grater." He kept a snuff-grater behind the curtain on purpose.

His dependence on snuff became notorious. David Edwin, the engraver, tells us that once when he was waiting in Stuart's drawing room, his host entered in great agitation, passed Edwin without a greeting, and began to rummage in a closet. Edwin, who had ex-

perienced the painter's terrible temper, thought he must have offended him; he watched uneasily while Stuart found some tobacco, a grater, and a sieve. Although his hands trembled so violently that he could hardly hold his instruments, Stuart managed to grind some powder. After he had inhaled it noisily, his uncommon tremor abated. Then he turned to Edwin with a smile. "What a wonderful effect," he said, "a pinch of snuff has on a man's spirits!"

Stuart had become so irascible that his most intimate friends could no longer get on with him, and his wife and children kept out of his way as much as they could. His daughter Jane complained that he took no interest in her artistic ambitions; he did not encourage her to work on pictures of her own, but kept her busy all day grinding his paints, laying in the backgrounds of his portraits. And woe to her if she made the slightest mistake!

In his later years, Stuart was very lonely; sometimes it seemed that his bottle was his only friend. Indeed, he was out of place in Boston, the self-styled "Christian Sparta" that was preparing for a moral renaissance. The ageing libertine loved to remember the gay evenings he had spent in Philadelphia, where every good fellow had emptied four or five bottles as a matter of course. He irritated the self-consciously cultured Bostonians by referring to Philadelphia as "the Athens of America."

Stuart was not religious enough to please New England. Although his daughter Jane insisted that he did not work on the Sabbath except when pressed, she admitted that he went to church only once in his twenty-three Massachusetts years. He remained standing during the sermon, leaning nonchalantly against the side of the pew and inhaling huge pinches of snuff. "Well," he said on his way home, "I do not think I shall go to church again. . . . I do not like the idea of a man getting up in a box and having all the conversation to himself."

Although he could still summon his courtly manners when he wanted them, Stuart no longer had the patience to dress neatly.

After his return from Roxbury to Boston in 1818, John Quincy Adams described him as follows: "His own figure is highly picturesque, with his dress always disordered, and taking snuff from a large round tin wafer box, holding perhaps half a pound, which he must use up in one day. He considers himself beyond question the first portrait painter of his age, and tells numbers of anecdotes concerning himself to prove it, with the utmost simplicity and unconsciousness of ridicule. His conclusion is not very wide of the truth."

However, Stuart seems never to have become really self-confident. If one of his fellow-artists dared point out the slightest fault in his work, he flew into a fury. We may be certain that he was still worried by his inability to paint anything but heads and shoulders, for in his sixty-sixth year he made one last attempt to branch out; he painted his only landscape and attempted an ambitious composition of a boy chasing butterflies. The pictures were not successful, and he never deviated from heads again.

Yet, despite his realization of his own inadequacies, Stuart lacked the sense of inferiority to European painters that haunted most of his compatriots. When the Academy of Florence asked him to paint them a head of himself—"the greatest compliment," his daughter Anne thought, "ever paid to an American artist"—he did not even answer the letter. He advised his pupils not to study in England, insisting art there "was at a standstill"; they would do better to stay at home. Indeed, American taste was better than that of the sophisticated Londoners, who compared all works of art to the old masters, while Americans compared them to nature. The embittered old man was not, however, sanguine about the future of painting anywhere. "It was his opinion," Henry Sargent writes, "that the art was on the decline. I never argued with him, for he was a vain, proud man, and withal quick-tempered."

Stuart's painting hardly deteriorated during his old age, although, Neagle tells us, "his hand shook at times so violently that

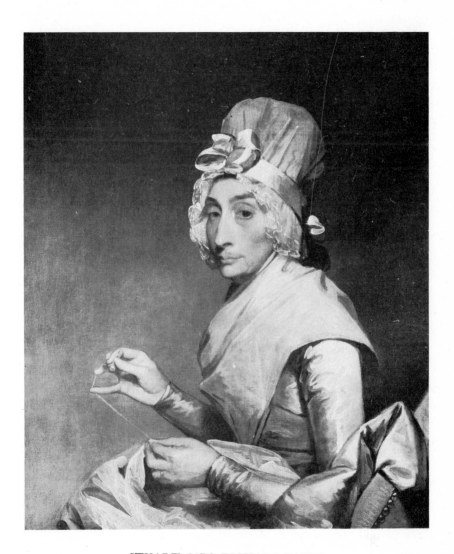

STUART: MRS. RICHARD YATES

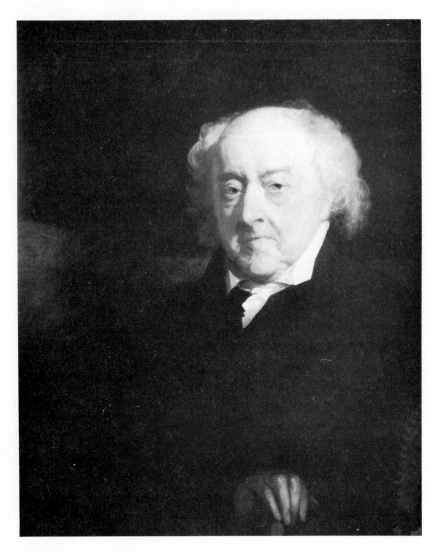

STUART: JOHN ADAMS AT NINETY

I wondered how he could place his brush where his mind directed."
Another eye-witness described how "Stuart stood with his wrist
upon the rest, his hand vibrating, and when it became tolerably
steady, with a sudden dash of the brush he put the colour on the
canvas."

During his seventy-first year, Stuart was induced by a large hon-
orarium to paint John Adams again. He must have been in a rare
good humour, for he charmed the ninety-year-old ex-President into
softening his prejudice against painters. "Speaking generally,"
Adams said, "no penance is like having one's picture done. You
must sit in a constrained and unnatural position, which is a trial to
the temper. But I should like to sit for Stuart from the first of Janu-
ary to the last of December, for he lets me do just what I please,
and keeps me constantly amused by his conversation." When Stuart
showed the finished portrait to one of his friends, he said: "Look at
him. It is very like him, is it not? Do you know what he is going to
do? He is just going to sneeze."

Later that same year, Stuart suffered a stroke that paralysed his
left arm and the left side of his face; this depressed him greatly.
Worried because he had made no provision for his wife and daugh-
ters, he continued to paint, slowly and painfully, yet with amazing
effect. Gout joined with paralysis to make his life an unceasing
round of pain. When in 1828 he became too sick to rise, the doctors
said his gout had settled on his chest and stomach. For three months
he suffered mounting agony. Calling one day, Washington Allston
was horrified to see how emaciated was the body that lay rigid on
the bed. Solicitously he asked Stuart how he was. A ghost of the old
scornful smile appeared on the unparalysed side of Stuart's face.
"Ah," he cried, "you can judge." He drew his pantaloons up to
show his shrunken legs. "You can see how much I am out of draw-
ing." A few weeks later he was dead.

The facts of Stuart's burial are so strange that they are almost
inexplicable. Although he was the most famous painter in America;

although Philadelphia's leading artists agreed to wear mourning for a month in his honour; although the newspapers gave much space to his praises and to expressions of national loss, his family hurried him without ceremony to his grave. They bought the right to place him in a vault owned by some tradesmen, and enclosed his body in the cheapest kind of coffin; the undertaker's bill was only thirty-six dollars, while they spent seventy-five on mourning apparel.

Of course, the meanness of his funeral may have been in accord with the dying man's wish, but how can we explain the fact that his wife and daughters, once they had left Stuart's body in someone else's family tomb, forgot where it was? His daughter Jane explains that a friend wrote down the number of the vault during the interment, but lost the piece of paper; she regretted years later that her father's bones were irrevocably mislaid and could not be moved to the plot his family had acquired in a Newport graveyard. Jane's story obviously does not hold water. When they found that the vault number had been lost, his family must have had several ways of securing it again. Even had their memories failed them, they could have consulted the tradesmen from whom they had bought the right to bury Stuart, or the records of the graveyard, where a modern scholar, John Hill Morgan, found the information they declared was unobtainable. We are led to wonder whether Stuart's family, who had been tortured for so long by his improvidence and ill-temper, were not indifferent to the fate of his body now mercifully dead.

Thus sadly one of the greatest painters America has ever produced passed from the national scene, and with him passed the great days of the first American school of art. True, his pupils and West's pupils lived after him; Trumbull, Allston, Morse, Vanderlyn, Sully, Neagle, Jouett, Harding—these and many others continued to paint with skill in the manner of their teachers, and for another generation they dominated American painting. But

none of them ever equalled the fame of West, the versatility of Peale, or the excellence of Stuart and Copley. America's old masters were dead.

It is often argued that there has never been a truly American art, that all our painters received their techniques from other lands. The men we have discussed, for instance, are supposed to have been provincial offshoots of the British school. True, no major painters on the North American continent have been influenced solely by their own nationals, but we may search the history of modern art in vain to find any major painters anywhere who never looked beyond their national boundaries. Actually those early canvases of America's old masters in which each outstripped his inferior teachers, most of Copley's work, and much of the work of Peale come as close to the phenomenon of local inspiration as any important paintings of modern times. A completely self-sufficient art can exist only in complete isolation. Able minds seeking perfection will welcome assistance from whatever quarter it may come, and only a fool will refuse to consider an idea because it originated in the next county or the next nation. Thus the conception of a purely national art is as much a fallacy as the conception of a pure race; art and blood have mingled since the first ship was launched and the first road built.

Let us consider the English school into which some American critics like to toss America's old masters; according to the same nationalistic standards, would it be English at all? Reynolds, its leader, was an eclectic who argued that great painting could be achieved only by combining the virtues of the great painters of the past; "there is only one door to the school of nature," he said, "and of that the old masters hold the key." He was conspicuously influenced by many Italians: Raphael, Titian, Michelangelo, the Caraccis, Correggio, Guido Reni, and others. Three Dutch and Flemish painters—Rembrandt, Rubens, and Van Dyck—taught him much of his skill. And he followed the theories of the German Winckel-

mann by imitating the statues of the Greeks and Romans. Into what nationalistic pigeonhole shall we place Reynolds?

Suzanne La Follette stated an important truth when she said that no great art is nationalistic, but that all great art is national. Æsthetic influences come from everywhere to make a painter, but any authentic painter automatically stamps his own personality on his work. Whether he wills it or not, this personality is formed by his time and place: by what his parents told him when he was a child, by the economic order in which he struggled, by the attitude of his contemporaries toward his ambitions and his canvases. Only if he is so weak a man that he slavishly copies other painters can his work fail to reveal the civilization in which he lived.

By studying America's old masters against the background of their nation and their times, we have discovered that they reacted very differently to the influences that formed their British contemporaries, and that this divergence was largely due to the cruder and more forthright society from which they came. Even Benjamin West, the expatriate who gives our nationalists their best argument against our painters, never lived down his twenty-two formative years in the Colonies; when he was an old man, his English friends insisted that he was still an American at heart, and, as we have seen, his best canvases resulted when he turned back to the realism of his American origin.

APPENDIX
ACKNOWLEDGMENTS
BIBLIOGRAPHY
CATALOGUE OF ILLUSTRATIONS
INDEX

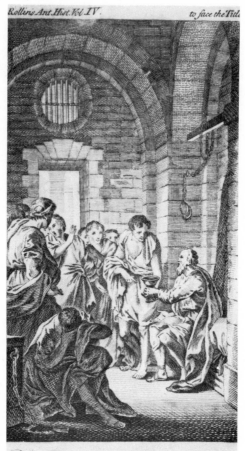

The DEATH *of* SOCRATES.

Published 20 June 1749 by I. & P. Knapton.

FRONTISPIECE FROM ROLLIN'S "ANCIENT HISTORY"

APPENDIX

BENJAMIN WEST'S AMERICAN NEO-CLASSICISM[1]

THE EMPHASIS commonly placed by art historians on lines of direct influence connecting one painter or picture to another has fostered the belief that whenever there is a similarity between the arts of early America and of Europe it must be because the Americans have consulted transatlantic models. Although such an explanation is often valid, there is another basis for resemblance which has not been adequately recognized.

It is an accepted phenomenon in the history of invention that the same idea appears spontaneously in many places when the time is ripe. This also happens in the history of art and for identical reasons. A painter does not live only in his work room, nor is his experience limited to the viewing of pictures. A painter walks the world, and as he walks and observes and gossips, he builds unconsciously into his own personality the conceptions that characterize his environment. In other places where a similar environment exists other personalities are similarly shaped. Thus it is not surprising that the same conceptions appear automatically on the canvases of men separated by space but allied in culture.

The only circumstance under which American artists, working on their own, would fail upon occasion to duplicate European conceptions would be if there were no similarity between the cultures of the two continents. That this was never the situation,

[1]Reprinted in a slightly abridged form from the *New-York Historical Society Quarterly*, XXXVI (1952). Miss E. Marie Becker, then Reference Librarian at the Historical Society, gave invaluable assistance in identifying West's early patrons.

the most cursory reading of history will reveal. Many cases could be cited of the independent appearance in America of artistic forms that were also appearing in Europe. This article will be devoted to presenting and trying to explain the unusually dramatic example supplied by the recent rediscovery, made by this writer after more than ten years' search, of a major Colonial canvas: Benjamin West's *The Death of Socrates*, painted in Lancaster, Pennsylvania, probably in 1756.[2]

Four years after making this picture West crossed the ocean to become the first important American-born painter to study abroad. It is a strange phenomenon that he was, in a few more years, considered in the capitals of Europe one of the greatest artists living. West achieved this distinction by playing a leading role in the development of a new wave of neo-classical painting which swept the western world. It has always been assumed that West acquired his interest in neo-classicism after he reached Rome in 1760, and came in contact with Johann Joachim Winckelmann whose *History of Ancient Art* became the bible of the new movement when published in 1764.[3] Yet before he saw Italy or heard of Winckelmann, West had painted a neo-classical picture in the backwoods metropolis of Lancaster.

West's *The Death of Socrates* cannot be explained in the ordinary terms of artistic genealogy. Classicism has never been considered a characteristic of early American painting. Although some of the forms in this picture seem typical of the eighteenth century, others seem more closely allied to medieval art, a type of painting with which West could not have been familiar. Furthermore, the action is imbued with sentiment that presages the romantic move-

[2]The picture was located through the kind help of my high-school classmate, Philip Jordan.

[3]Jean Locquin, "Le Retour à l'Antique dans l'École Française avant David," in *La Renaissance de l'Art Français et des Industries de Luxe*, V (1922), 473–481. Jean Locquin, *Peinture d'Histoire en France de 1747 à 1785* (Paris: 1912).

ment. The creation of such a canvas by an eighteen-year-old boy in pre-Revolutionary Pennsylvania can only be explained through a study of the cultural environment in which he worked.

The main source of information concerning West's early years is the first volume of John Galt's *Life and Studies of Benjamin West*, which was written with the assistance of the painter and published in 1816. The Scotch novelist, who was an extreme romantic, and the septuagenarian painter, who had come to think of himself as a sort of Protestant saint, attempted to exemplify the theories of Rousseau by demonstrating that West had been an untaught child of nature, who painted spontaneously out of natural genius which society had not spoiled. The picturesque view thus given of his early years has been repeated from book to book until it became an American legend. However, we shall not be able to account for *The Death of Socrates* unless we dig deeper. In this labor, Galt's biography will be useful, despite its bias. Since the author and his subject collaborated to play down sophisticated influences, we may be relatively sure that when such influences are admitted, they actually existed.

There is another contemporary account of West's childhood. In 1805, the artist happened on a manuscript that had been written by his early friend and teacher William Williams, whose dates may be given very roughly as *c.* 1710–*c.* 1790. West was led to reminiscence, and his words were written down by the owner of the manuscript, Thomas Eagles. Years later, when Williams's novel *The Journal of Llewellin Penrose, a Seaman*, was published, Eagles's notes were included in the "advertisement," with a quotation from a letter West wrote about Williams, probably at about the same time.[4] West gave information to Eagles

[4][William Williams], *The Journal of Llewellin Penrose, a Seaman* (London and Edinburgh: 1815), 4 vols. A second edition, slightly expurgated for children, was published in one volume, London, 1825.

a decade or so before he talked to Galt; he was sixty-seven rather than in his late seventies. Since men's memories become inaccurate as they enter extreme old age, when the two accounts disagree Eagles's is more likely to be correct.[5]

Galt insists that since West was raised in a community of Quakers that disapproved of art, he had never seen a picture when he himself began to draw. This is most improbable. Even Quakers had signs before their shops. Avid for culture, they read not only their unadorned Bibles, but also secular books that were likely to have been illustrated with engravings. We must be careful not to underestimate the sources of design available to Colonial Americans: fire boards, needlework, iron stove plates, coach panels, etc., etc. West's early drawings of birds and flowers which Galt mentions may well have been inspired by the folk designs of the German settlers who stayed at the Wests' hotel on the way to the interior. The painter's statement that he had received his first colors from a band of Indians fits so snugly into the Noble Savage legend that perhaps we should doubt it.[6]

According to Galt, in June 1745, when West was almost seven, he spontaneously drew his little sister as she lay in her cradle. About a year later, "Mr. Pennington, a merchant of Philadelphia," who was related to the Wests, stayed at their inn. A complex of evidence indicates that this was Edward Penington (1726–1790), one of the richest and most cultivated young men in Philadelphia. A member of the American Philosophical Society, he was sent to attend the Provincial Convention of 1774 and sat for many years on the Court of Common Pleas. He built one of the most elegant

[5] James Thomas Flexner, "The Amazing William Williams," in *Magazine of Art*, XXXVII (1944), 242–246, 276–278.
[6] John Galt, *The Life and Studies of Benjamin West* (Philadelphia: 1816), 9–32. J. Smith Furthey and Gilbert Cope, *History of Chester County, Pennsylvania* (Philadelphia: 1881), 761.

houses in Philadelphia, and was imprisoned during the Revolution as a Tory.[7]

It was Penington who gave the boy, as Galt states, "six engravings by Grevling." Hubert-François Gravelot (1699–1773) was a French illustrator of Racine and Voltaire, who had spent thirteen years in England. His versatility was so great that it is impossible to imagine what were the subjects of the engravings West now fingered with excitement. They were certainly, however, graceful, elegant, and dignified.

According to Galt, Penington soon invited the young artist to Philadelphia. In his letter to Eagles, West implied that this trip took place in 1747, when he was eight or nine, a date which fits in well enough with Galt's chronology.[8]

While he was in the metropolis with Penington, West, so Galt's account reveals, was encouraged by Samuel Shoemaker (1725–1800), a merchant who was to enjoy a brilliant career. A brother-in-law of Edward Penington, Shoemaker was, like him, a member of the American Philosophical Society; he was attorney for the Pennsylvania Land Company of London, treasurer of Philadelphia and mayor in 1769 and 1771. During the Revolution he was a Loyalist and fled to London where West befriended him.[9]

Either through an introduction from Shoemaker, as Galt states, or, as Eagles states, through a chance encounter on the street, West met his first professional painter, William Williams. In addition to practicing what he advertised as "painting in general," Williams was one of the designers and builders of the first permanent theater

[7]Galt, *West*, 32–33. John W. Jordan, *Colonial Families of Philadelphia* (New York: 1911), 577–579. Lorenzo Sabine, *The American Loyalists* (Boston: 1847), 518.

[8]Williams, *Penrose*, xvi. Galt, *West*, 37–38. William Sawitzky, "The American Work of Benjamin West," in *Penna. Mag. of Hist. and Biog.*, LXII (1928), 446.

[9]Benjamin H. Shoemaker, *Genealogy of the Shoemaker Family* (Philadelphia: 1903), 60–64.

in America; he taught drawing and music; he composed verse. Before or after his return to England—he was surely there by 1780 —Williams wrote the novelized account of his experiences with the Indians which West saw in manuscript and which was published in 1815, after the author's death. Similar in style to *Robinson Crusoe*, *The Journal of Llewellin Penrose* was a great critical success. Admired by Byron, it may have influenced Poe. Even today, it makes exciting reading. The painter at whose feet West first sat was a brilliant man, probably self-taught in painting as in all his other pursuits, yet possessed of wide culture.[10]

The boy became intimate with Williams, but this may have been at a later date. Concerning their early meeting, West told Eagles that Williams's landscapes were "the first, I believe, I had ever seen." Admiring some "cattle-pieces," West inquired "how he could paint them so accurately. He said he would show me the secret, and took a small box, which proved to be a camera; he showed me the construction of it. I went home, and was not at rest till I had made one for myself, and my father gave me the glass out of an old pair of spectacles to complete it. My delight was then to go into the farmyards and by means of my camera, draw the cattle, etc."[11] This seems a more likely story than Galt's tale of West re-inventing the camera for himself as he lay in a darkened room.[12]

West continued to Eagles that Williams had lent him a manuscript *Lives of the Painters* which the artist had himself written, and which "confirmed my inclination for the art." Galt does not mention this manuscript, but makes West borrow "the works of

[10]William Sawitzky was the first to identify paintings by Williams. See his "William Williams, First Instructor of Benjamin West," in the magazine *Antiques*, XXXI (1937), 240–242; and "Further Light on William Williams," in *NYHS Quart. Bull.*, XXV (1941), 101–112. Williams, *Penrose*, ix, xv–xvi. Flexner, *Williams*.

[11]Williams, *Penrose*, ix–xi.

[12]Galt, *West*, 60–65.

Fresnoy and Richardson on painting." It is important for our study that Dufresnoy and to a lesser extent Richardson, placed great emphasis on classical culture. From them West imbibed the neo-classical theories that had inspired earlier painters like Poussin.[13]

On his return home, West was no longer willing to ride on the same horse with a schoolmate who intended to be a tailor. Had he not learned from his books that "a painter is a companion for kings and emperors?" If the prodigy had ever had toward art the humble approach of an artisan, he had it no longer.[14]

According to Galt, West's adventures in Philadelphia and his ambitions so excited the envy of his schoolfellows that "all their accustomed sports were neglected and their play hours devoted to drawing with chalk and oker. The little president [West] was confessedly the most expert among them."[15]

Given two or three poplar boards by a local cabinetmaker, West "drew figures and compositions on them with ink, chalk and charcoal." Galt adds that several of the resulting works were bought for a dollar apiece by "Mr. Wayne, a gentleman of the neighborhood." In 1805, West told a friend, so Dunlap relates, that "General Wayne's father" took a liking to six heads drawn in chalk which were among the infant artist's first works, and gave him six dollars for them; the receipt of "so large a price" impressed the boy with the possibilities of making a living from art. West's patron was Isaac Wayne (1699–1774), one of the principal landowners in the district who, after Braddock's defeat, was chosen captain of a militia company to defend Chester County from the Indians. Wayne had been born in Ireland and

[13]Galt, West, 40–41. Williams, Penrose, xi. Charles-Alphonse Dufresnoy, The Art of Painting (York: 1783). Jonathan Richardson, Works (London: 1792).

[14]Galt, West, 41–43. William Dunlap, History of the Rise and Progress of the Arts of Design in the United States (New York: 1834), I, 39.

[15]Galt, West, 43–44.

had received a conventional British education before coming to America; his great belief in the classics as the basis of all learning is revealed by his somewhat pitiful attempts to force knowledge of the Greeks and Romans on his military-minded son.[16]

Dunlap quotes "Mr. Lewis, the American biographer of West" as saying that the boy made colors by mixing the juice of berries with charcoal and chalk. "When about nine years of age, he drew on a sheet of paper the portraits of a neighboring family" in which the likenesses were immediately recognizable. At about twelve, "he drew a portrait of himself with the hair hanging loosely about his shoulders." Dunlap's diary reveals that he quoted Enoch Lewis (1776–1856), the famous mathematician and Quaker journalist, who did a sketch of West for the *Encyclopedia Americana*, which, however, adds nothing to Galt in its account of the painter's early years.[17]

Galt's statement that "doctor Jonathan Moris, another neighbor," gave West "a few dollars to buy materials with" is corroborated by two letters, recalling happy old days, written by West from England to Dr. Jonathan Morris (1729–1819). Morris must have been an intellectual man since he was much more interested in a good professional education than most local practitioners of the Colonial period: he had studied with Dr. John Bard in Philadelphia and gone on to New York for further training.[18]

About a year after West's visit to Philadelphia—I am still quot-

[16]Galt, *West*, 44. Charles T. Stille, *Major General Anthony Wayne* (Philadelphia: 1893), 5. Ruth Lawrence, editor, *Colonial Families of America*, XX (New York: 1941), 104–105. Dunlap, *Rise*, 38.

[17]Dunlap, *Rise*, 38. William Dunlap, *Diary*, III (New York: 1930), 685. *Encyclopedia Americana*, XIII (Philadelphia: 1833), 125–128.

[18]Galt, *West*, 45. Robert C. Moon, *The Morris Family of Philadelphia*, II (Philadelphia: 1898), 443–446. *Penna, Mag. of Hist. and Biog.*, XVIII (1894), 219–222. Henry Graham Ashmead, *History of Delaware County, Pennsylvania* (Philadelphia: 1884), 225.

ing Galt—he was invited to spend a few weeks at the house of "Mr. Flower, one of the justices of the county of Chester." This was Samuel Flower who was listed as a justice of the peace in 1745, but was much more important as an owner of one of the most prosperous iron furnaces in Pennsylvania. The ore was mined from a rich vein at French Creek, part of which, with the necessary furnaces to make iron and steel, Flower owned in partnership with his father-in-law, William Branson. Flower, who seems to have grown up in England, became connected with West's family when, in 1761, his daughter married Dr. Gerardus Clarkson, a brother of West's brother-in-law, John L. Clarkson.

At the time West visited him, Flower had just imported for the benefit of his own children an English governess who, so Galt continues, read the young painter "the most striking and picturesque passages from translations of the ancient historians and poetry, of which Mr. Flower had a choice and extensive collection." That West thus heard "for the first time of the Greeks and Romans" is contradicted by Galt's own admission that the boy had already read Richardson and Dufresnoy.[19]

Hurrying the boy on from Flower's house to Lancaster and a professional career begun before he was in his teens, Galt ends at this point the account of his hero's childhood. I shall attempt to show that West's Lancaster trip took place almost a decade later, as the visit to Flower may also have done. In the intervening time it is to be assumed that the boy attended the local school, made childish pictures, and did the usual chores about his father's house. To Eagles, West spoke of having visited Philadelphia repeatedly when he was a boy, and of calling often at Williams's

[19]Galt, *West*, 45–47. John Hill Martin, *Chester and Delaware Counties, Pennsylvania* (Philadelphia: 1877), 463. Frank Willing Leach, *Clarkson Family* (Philadelphia: 1932), not paged. Furthey and Cope, *Chester*, 343–346. *Lanc. County, Penna., Hist. Soc. Papers*, XVIII (1914), 62–63.

studio. Thus we gather that he did not lose contact with the circle of brilliant men who were befriending him in the great city.[20]

Writing before 1830, John F. Watson stated that the youthful West, during a visit to Philadelphia, boarded at a house in Strawberry Alley. On large cedar panels over two mantelpieces, he painted pictures. After he had become famous, West asked Samuel R. Wood, so Wood told Watson, to seek out and preserve these early efforts. However, they remained in place until 1825 when Thomas Rogers, the proprietor of the house, took them out and cleaned them. The paintings were then given to the Pennsylvania Hospital, to hang in the same room with West's celebrated *Christ Healing the Sick*.[21]

The pictures in question, *Storm at Sea* and *Landscape with Cow*, are dated by Sawitzky *c.* 1749–1752 because they seem to be the work of a child.[22] Perhaps *c.* 1748–1749 would be a better guess, since after West's sister married a Philadelphian in March 1749, the boy stayed, not at boarding houses, but with her. *Storm at Sea* is relatively dull, seemingly a copy of a print, but the landscape's unconventionality reveals it as an original picture. The cow, realistic despite the stylization resulting from simplification of forms, may well have been traced from one of the drawings of the cattle he tells us he made with the camera obscura; the big square-rigger probably was copied from a print; but the rest of the background is the result of uninhibited childish imagination. West may have imbibed his interest in medieval castles from Williams, but their architectural forms are most enchantingly his own.

[20]Williams, *Penrose*, xiv.
[21]John F. Watson, *Annals of Philadelphia and Pennsylvania*, I (Philadelphia: 1891), 575.
[22]Sawitzky, *West*, 445–446.

Two existing portraits of children seem from a stylistic point of view to precede West's Lancaster period. "According to family tradition," to use Sawitzky's words, they show Jane and Robert Morris, children of West's neighbors, John and Elizabeth (Taylor) Morris. John Morris, who was recorded as a "weaver," bought land in 1747 at Marple Post Office on the line between Marple and Springfield Townships. Guessing from the pictures the probable age of the painter, Sawitzky dates them *c.* 1749–52; an anonymous writer (probably Christian Brinton) in *Yesterday in Chester County Art* says, without citing evidence, that they were painted in 1753. Any of these dates is possible.[23]

Robert Morris is the more conventional in conception. A small boy stands stiffly before a fluted column and semi-circular stone bench, while an irrelevant red curtain is looped across the top of the canvas. However, the dead rabbit he holds in his hand, which seems to testify to his childish pride as a hunter, adds an informal note.

This informality is carried much further in *Jane Morris.* She stands as rigidly as her brother, but her surroundings have little relation to the restrainedly elegant backgrounds we find in most Colonial portraits. Classical culture is paid lip-service in a column which rises to the left, exhibiting one of the strangest capitals ever seen outside an archeologist's nightmare. For the rest, Jane is standing in a naïvely envisioned glade with brown tree trunks and bluish-green vegetation. Red tulips add to the general air of gaiety. The loose and episodic composition lacks not only the logical organization, but also the striving for patrician grace, which even inferior American portraitists imbibed from English prints; the typical gestures and the typical accessories of the Lely-

[23]Sawitzky, *West,* 446–448. Ashmead, *Delaware,* 581. [Christian Brinton (?)], *Yesterday in Chester County Art* (n.p.: 1936), unpaged.

Kneller school are lacking. A comparison of *Jane Morris* with Copley's *Mrs. Joseph Mann* of 1753, painted perhaps in the same year and when the two artists were the same age, shows how much less conventional West's work was.

As his entire biography reveals, the Philadelphia prodigy was more self-confident than Copley; he had also been subjected to less conventional influences. William Williams was not only younger than Copley's English-born mentors, Peter Pelham and John Smibert, but he represented more advanced currents in British painting. Williams's earlier canvases have been lost; yet those that survive, which date between 1766 and 1775, have an amazing resemblance to West's childish work. I have already commented on a common interest in medieval architecture. More significant is the fact that Williams broke with the stereotypes of the Lely-Kneller tradition to paint a gay conversation piece showing a family behaving naturally in their garden, or to reveal a couple strolling with a dog through a romantic landscape full of crotchety and imaginative details. The unconventional sources of Williams's inspiration are shown by his exhibiting, as the trade signs of his various studios, the heads, not of Raphael and Van Dyck, but of Hogarth and Rembrandt.[24] Williams was an early romantic, which may have contributed to his interest in encouraging the natural genius of a small boy.

Galt tells us that during his later trips to Philadelphia West stayed "at the house of Mr. Clarkson, a gentleman who had been educated at Leyden, and was much respected for the intelligence of his conversation and the propriety of his manners." This was John Levenus Clarkson (b. 1725), the son of Matthew and Cor-

[24]Rita Susswein Gottesman, *The Arts and Crafts in New York, 1726–1776* (New York: 1938), 7. Alfred Cox Prime, *The Arts and Crafts in Philadelphia, Maryland, and South Carolina*, I (n.p.: 1929), 13.

nelia De Peyster Clarkson of New York. His uncle, Levenus Clarkson, lived in Holland, which may explain the boy's foreign education. After his father died, his mother married the Rev. Gilbert Tennent (1703–1764), who was one of the most famous Presbyterian divines in the Colonies, and is said to have ranked with Jonathan Edwards and Whitefield as a leader of the Great Awakening. When Tennent had achieved prominence in New Jersey, a church was organized for him in Philadelphia, and he brought his family to that city in 1743. During March 1749, the stepson of this famous man married West's sister, Rachel; West was soon living in their house.

It casts an interesting light on the young painter's artistic education that John Clarkson's brother Matthew (1733–1800) advertised in the *Pennsylvania Journal* of July 25, 1754: "For ready money or short credit: the four seasons painted on glass and in mezzotinto; the six sciences painted on glass and in ditto; the five senses on glass and in ditto; . . . the jolly sailor, the twelve months, several history pieces, and sundry humorous scenes printed on glass; . . . views about London, ditto in Rome, on the river Tiber, in Florence, in Holland, on Greenland whale fisheries." That Matthew Clarkson became a friend of West's a later correspondence reveals. Clarkson had been carefully educated by his stepfather for a professional career, but preferred business; he seems to have published engravings. He became extremely successful as a merchant, held many political offices, was active in the Revolution, was four times mayor of Philadelphia, and, like most of West's patrons, a member of the American Philosophical Society.

West's connection with the important Clarkson family must have been very valuable. Later the relationship turned sour, which may have been one reason why he did not emphasize it to Galt. His sister's marriage to John L. Clarkson proved unhappy; and

a son came to England, so the then-famous painter complained, for the special purpose of plundering him.[25]

The moment has now come for us to accompany West to Lancaster. Galt tells us that the Mr. Flower at whose house West had studied with an English governess, called the prodigy to the attention of George Ross, with whom, so independent records reveal, Flower had business connections. Ross, Galt continues, invited the youth to Lancaster to paint the members of his family. The young artist's new patron (1730–1779), had received an excellent classical education. Son of a leading Episcopal minister, Ross had been graduated from the University of Edinburgh. Although he served as chaplain to several royal governors of Pennsylvania, he became a signer of the Declaration of Independence, and one of the most distinguished jurists in the new nation.[26]

In Lancaster, West met William Henry (1729–1786). An extremely successful gunsmith, Henry played an important part in developing the most accurate firearm then known, the Kentucky rifle, and, during the French and Indian war, became armorer for the Pennsylvania troops attached first to Braddock and then to Forbes. Later, he proved one of the most valuable public leaders in Pennsylvania's Revolutionary effort. An inventor of imagination, he proposed many ingenious devices to the American Philosophical Society, of which he was a leading member.[27]

Galt tells us that, after examining West's likenesses, Henry "observed to him that, if he could paint as well, he would not

[25]Samuel Clarkson, *Memoirs of Matthew Clarkson* (n.p.: 1890), 23–25. *The Clarksons of New York*, I (New York: 1875), 126. *Penna. Mag. of Hist. and Biog.*, XXXII (1908), 3–4, 23, 77. Alfred F. Gegenheimer, *William Smith* (Philadelphia: 1943), 97. Josiah Granville Leach, *History of the Bringhurst Family* (Philadelphia: 1901), 116–119.

[26]Galt, *West*, 47–48. *Dictionary of American Biography*, XIV (New York: 1935), 177–178. Charles S. Boyer, *Early Forges and Furnaces in New Jersey* (Philadelphia: 1931), 57–58.

[27]Francis Jordan, Jr., *The Life of William Henry* (Lancaster: 1910).

waste his time on portraits but would devote himself to historical subjects; and he mentioned the death of Socrates as affording one of the best topics for illustrating the moral effect of the art of painting." When West stated that he had never heard of Socrates, "Mr. Henry went to his library" and read West the story from an English translation of Plutarch. (As a matter of fact, the story is not told in Plutarch.)

West, so Galt continues, made a drawing and, on receiving Henry's approval, determined to translate it into paint. "Having hitherto painted only faces and men clothed," he feared that "he should be unable to do justice to the figure of the slave who presented the poison, and which he thought ought to be naked." Henry thereupon called in one of his workmen, "a very handsome young man. . . . The appearance of the young man, whose arms and breast were naked, instantaneously convinced the artist that he had only to look into nature for the models which would impart grace and energy to his delineation of forms."

The *Death of Socrates*, Galt tells us, attracted much attention and enlisted the interest of "Doctor Smith, the provost of the College at Philadelphia" who was in Lancaster advising the inhabitants on the founding of a public grammar school. "After seeing the picture and conversing with the artist, he offered to undertake to make him to a certain degree acquainted with classical literature; while at the same time he would give him such a sketch of the taste and character of the spirit of antiquity, as would have all the effect of the regular education requisite to a painter. . . . After returning home for a few days, Benjamin went to the capital, and resided at the house of Mr. Clarkson."[28]

In a life of William Henry published during 1910, Francis Jordan, Jr., gives us the story as it had come down in the Henry

[28]Galt, *West*, 48–52.

family. He states: "Colonel Henry invited the boy to his house, assigned a room to his use, and supplied the materials essential to his work. On the walls of this apartment were many little studies that were permitted to remain until the house was demolished. Here West made a number of excellent attempts at portraiture, of which two examples, Colonel Henry and Mrs. Henry, are in the possession of the Historical Society of Pennsylvania." West's model for the central group of *The Death of Socrates*, Jordan continues, was a frontispiece from the first volume [actually the fourth volume] of Rollin's *Ancient History* (London: 1738). The engraving was still in the possession of the Henry family, as was the canvas, which Jordan reproduced in the small and most inadequate cut which has for a generation been our only indication of the appearance of the picture.[29]

Galt gives no date for West's visit to Lancaster, but the sequence of events he describes implies 1748 or 1749. He then gives his hero a period of study in Philadelphia; brings him back to Chester County "when he attained his sixteenth year" (October 1753) so that his choice of profession could be formally determined; and then sends him off for a second stay at Lancaster.[30] Whether West really made two trips is not clear, but it seems certain that the events in which we are interested could not have taken place, as Galt states, during the earlier visit.

Dr. William Smith (1727–1803) did not even reach America until 1751. He was a tutor in New York; visited Philadelphia briefly in 1753 to discuss plans for establishing a new educational institution there, and then returned to England where he remained until May 1754. On August 23, 1754, at a meeting in Philadelphia Smith was appointed secretary of the Society for the Propagation of Christian Knowledge Among the (Pennsylvania)

[29] Jordan, *Henry*, 26–30.
[30] Galt, *West*, 45–88.

Germans, and on the same date a committee was appointed to consider founding a school at Lancaster. On December 28, 1754, a group of Lancasterians petitioned that such a school be actually established, and in 1755 some residents of the city, including George Ross, subscribed a considerable sum of money to help pay "a Latin schoolmaster." This sequence of events lends credence to Galt's story that Smith saw West's painting when he was in Lancaster to help found a school. However, Smith could not have visited the city on such business before his return from England in May 1754, nor is he likely to have done so before the organizational meeting of August 23. Several letters reveal that a trip of inspection he made in September 1756 carried him to Carlisle and thus presumably through Lancaster, but this may not have been his only journey into western Pennsylvania.[31]

Sawitzky and the distinguished historian of Lancaster, Charles I. Landis, point out that it is extremely improbable that the companion portraits of Mr. and Mrs. Henry were painted before the couple were married. Using as his source an indefinite statement in Jordan, Sawitzky gives the date of the marriage as January 1755. Landis, however, reveals that the Henrys were actually married on March 8, 1756, and that they did not occupy the house in which Jordan said West painted *Socrates* until that year. In his *Henry Genealogy*, William Henry Eldridge also gives the date of William Henry's marriage as 1756.[32]

Probably Galt is right in stating that the death of West's mother later in 1756 brought West's Lancaster trip to an end. Both Hart and Myers agree, in their articles on the West family, that Mrs. West died in that year, but neither gives a specific date

[31]Gegenheimer, *Smith*, 64–146. Horace Wemyss Smith, *Life and Correspondence of the Rev. William Smith, D.D.*, I (Philadelphia: 1880), 594.

[32]Charles I. Landis, "Benjamin West and his Visit to Lancaster," in *Lanc. County Hist. Soc. Papers*, XXIX (1925), 57–61. Sawitzky, *West*, 448–449. Jordan, *Henry*, 19. William Henry Eldridge, *Henry Genealogy* (Boston: 1915), 167.

or cites any written record. According to Galt, Mrs. West died practically at the moment the young artist reached his Chester County home. West was detained for "some time" by the funeral and the family distress, "and about the end of August in 1756," so Galt continues, "he took his final departure and went to Philadelphia."[33]

That West began his permanent stay in Philadelphia in 1756 is indicated by an independent source. During 1816, West stated that a miniature of himself had been drawn in that year, when he was eighteen years old. That the miniature was done in Philadelphia is probable because he gave it to a young lady in that city; and because there is a drawing for it in a sketch book that contains drawings similar to portraits certainly created during his Philadelphia years.[34]

The evidence thus indicates that West painted *The Death of Socrates* some time between the Henrys' marriage in March 1756 and his mother's death, which seems to have taken place late in the autumn of that year. The artist was eighteen years old.

The Henry portraits, which were probably painted at the same period, show no stylistic evidence of having been created at a much different time from West's other Lancaster likenesses, including those of Mr. and Mrs. Ross, the commission for which, so Galt tells us, brought West to the city. Since they seem all to have been painted within a year or so of each other, all the Lancaster portraits which Sawitzky discovered may be dated c. 1755–1756.

These comprise, in addition to Mr. and Mrs. Henry and Mr. and Mrs. Ross, a likeness of Mr. Ross' sister Catherine, and companion portraits of Dr. and Mrs. Samuel Boudé. The Boudés

[33]Galt, *West*, 78–79. Hart, *West*, 3. Albert Cook Myers, "Benjamin West's Mother, Sarah Pearson, and her Family," in *Friends' Hist. Assoc. Bull.*, XVIII (1929), 75–76.
[34]Hart, *West*, 5–6. Sawitzky, *West*, 452–453.

were connections of the artist, since Mrs. Boudé's sister was mar-
ried to Matthew Clarkson. Dr. Boudé (*c.* 1723/4–1782) had studied
medicine in Philadelphia before he practiced in Lancaster, where
he became "a very prominent man." He was a pillar of the Epis-
copal Church, and testified to his interest in books by helping
to found the Lancaster Library Association in 1759.[35]

The likenesses West painted in Lancaster show a considerable
technical advance over the earlier Morris canvases. Forms are
more three-dimensional; eyes are no longer holes cut in mask-like
faces; compositions are tighter; and affectations of pose, particu-
larly the gesturing of the hands, show a new familiarity with
prints after the Lely-Kneller school. West's exuberant originality
has receded into the backgrounds, where it tends to take the
form of amazing classical structures. Behind Catherine Ross there
is something that looks like a fountain, and also what Sawitzky
calls "a sort of stone porch, with an urn on the corner of the
roof."[36]

Like West's earlier pictures, these portraits are amalgams of
three different manners. A reliance on engravings makes the
poses of body and hands increasingly traditional. However, the
sitters' faces are drawn with an effort at stark realism which, prob-
ably because of a technical inability actually to fool the eye, takes
the form of emphatic stylization. Into the backgrounds, West
draws the past, sometimes medieval but more often classical. This
introduction of elements that were unknown in America is done
in no scholarly mood: West seems only occasionally to have con-
sulted engravings to see what a castle or a classical fountain looked
like. The past was something for his imagination to play on; a
delightful vision of a world that, as far as his own experience went,
need never have existed outside his own brain.

[35]Clarkson, *Clarkson*, 17. Leach, *Bringhurst*, 131–132.
[36]Sawitzky, *West*, 448–452.

In *The Death of Socrates*, West moved almost completely into this world of fantasy. The picture is so free and spontaneous that we must conclude that he associated with his imaginary Greeks quite naturally—the way one spends an evening with old friends —and without any of the sense of strangeness that makes a man tighten up lest he misbehave. For this freedom, our researches have supplied the reason. Since he was about nine years old, the boy had been the petted favorite of remarkable people. Penington, Williams, Shoemaker, Ross, Henry, and Matthew Clarkson were major cultural or civic leaders in America's most cultured Colony; they all made enduring marks on history. Wayne, Flower, Dr. Morris, Boudé, and John L. Clarkson seem also to have possessed considerable intellectual sophistication. Galt's picture of an untutored farmboy whistling woodland notes has not stood up under scrutiny. Rarely has a youthful prodigy been encouraged by so many brilliant and well-informed men.

How deeply the culture West's patrons shared was grounded in classicism is revealed by Benjamin Franklin's difficulty in establishing at Philadelphia an "English school" that would teach the knowledges and skills of the modern world rather than of ancient times. He could not get his Academy started in 1751 until he agreed to have a Latin as well as an English school, and under the leadership of West's patron, Dr. Smith, the English school was slighted and allowed to shrink. As we have seen, when the residents of Lancaster, that city on the edge of the wilderness, subscribed to start an educational institution, they sought "a Latin schoolmaster."

Carl Bridenbaugh points out that it was the lower classes, the artisans and the rising bourgeoisie, who were interested in an education that would include arithmetic for bookkeepers and facts about geography useful to sea captains. The local aristocracy, from which class most of West's patrons came, were more concerned

with giving the inhabitants of the New World the old-fashioned gentlemanly education of the Old. That classical times seemed even remoter in Philadelphia than in London only made it seem more urgent to import knowledge of them across the ocean.[37]

There is, however, no reason to believe that West received a thorough classical training. After he became president of the Royal Academy, Englishmen who considered him a great artist nonetheless commented on his lack of conventional training. Galt tells us that when Dr. Smith taught West, he ignored the fundamentals of classical pedagogy to give more emphasis to the spirit of antiquity and to happenings that would make edifying pictures; probably West's other patrons followed the same course. Talking to brilliant men not as a schoolboy but as a painting prodigy needing material for his art, the eighteenth-century lad was encouraged, like pupils in the most modern of twentieth-century schools, to skim the cream of knowledge and not bother with the milk.[38]

West might have imbibed a more inhibited view of antiquity had his patrons not been, as a group, young men. When the lad painted *Socrates*, Isaac Wayne was, it is true, fifty-seven, and William Williams about forty-six. None of the rest of his friends whose birth dates have been determined had entered middle-age: Boudé was about thirty-two; Shoemaker and John Clarkson, thirty-one; Penington, thirty; Smith, twenty-nine; Henry and Dr. Morris, twenty-seven; Ross, twenty-six; and Matthew Clarkson, twenty-three.

The contrast between *The Death of Socrates* (1756) and *Mars, Venus, and Vulcan* painted by the youthful Copley at about the same time (1754) demonstrates West's startling departure from the conventional view of antiquity. Copley made a meticulous

[37]Carl and Jessica Bridenbaugh, *Rebels and Gentlemen* (New York: 1942), 40–69.
[38]Galt, *West*, 51.

copy of a print; West used the frontispiece to Rollin's *Ancient History* only as a starting point for personal improvisations. Although taken from the engraving, the architectural background has been enlarged and moved around to fit West's more expansive composition: a stone block with a chain attached to it has sailed far off to the other side of the composition; the round window is in an altogether different place and seen from an altogether different angle. The crouching figure in the foreground of the print is in a similar position in the painting, but his outstretched leg is now on the other side of the composition and attached to a different person. Closest to the original is the figure of Socrates, but even here there are changes, such as in the folds of the falling mantle, and in the arm holding the goblet, which is not so far outstretched.

Galt tells us that West drew his characters from living figures. His statement that West wished the slave bearing the poison to be naked, and depicted the torso from an actual model, is borne out by the fact that in the print the slave is largely covered and in the canvas naked to as far below the waist as modesty permitted. West was already showing the originality that was to make him a pioneer in several European art movements, for it was Copley's reliance on exact imitations of transatlantic sources that was the American norm in figure painting. During 1744, for instance, Robert Feke (active *c.* 1741–*c.* 1750) exhibited to visitors in his Newport studio "a large table of the Judgement of Hercules copied by him from a frontispiece of the Earl of Shaftesbury"; while in Boston the venerable and famous Smibert impressed connoisseurs by showing them copies he had made in Europe, including Poussin's *Continence of Scipio*.[39]

The torso West depicted from life might almost have been out of a European primitive of the thirteenth century. Since paint-

[39]Alexander Hamilton, *Itinerarium* (St. Louis: 1907), 123–124, 139, 164.

ing that predated by many years the age of Raphael was neither admired nor collected in the mid-eighteenth century, no motivation existed for carrying such pictures across the Atlantic, and it is highly improbable that West had ever seen one. The naïve and intense boy seems automatically to have drawn the human figure somewhat as it was drawn by the intense artists of a much earlier time.

This strange resemblance exemplifies an intangible that impedes those who try to define American art in terms of chains of influence. There seems to be a way of seeing and a way of painting that is the dead center to which European and American man returns if not pushed in any direction at all. This style crops up automatically whenever an untutored hand puts brush to canvas, producing if the artist is not very able the quaint results so adored by modern interior decorators, and rising with the genius and sincerity of the artist to a closer and closer parallel with the great primitives of the past.

The canvas is so in need of cleaning that it is difficult accurately to describe the colors. Socrates seems to be wearing light golden-brown robes; the other figures are clothed in dull browns, roses, greens, blues, and greys. The foreground seems to be in shades of brown and the background in dull grey. The canvas, which measures about 34 x 41 inches, belongs to Mrs. Thomas H. A. Stites, of Boulton, Nazareth, Pennsylvania, a direct descendant of William Henry, at whose suggestion it was painted.[40]

In enlarging the composition of the small engraving, West destroyed its unity. However, it is a strange fact that he imagined a frieze-like arrangement of his figures that foreshadows, although very crudely, one of the basic conceptions of the more sophisticated neo-classical painting which, after his association with Winckelmann, he helped popularize in Europe. There are even

[40]Mrs. Thurman Rotan of the Frick Art Reference Library.

rudimentary beginnings of the groups of figures on the two edges of the foreground which, according to neo-classical conceptions, lead the eye to the central group.

Although the composition can only be described as messy, some of the individual figures have amazing vitality. They exemplify not the calm rigors of conventional classicism but rather the ardors of the romantic movement, that natural expression of the bourgeois class to which West and his patrons belonged. The woman weeping behind Socrates' head expresses grief in the very shape of her back. Letting himself go completely, without any fear of being comic, vulgar, or unconventional, the boy has given his characters wild facial expressions that are, to this viewer at least, strong and moving. The head leaning in second from the left is a startling imaginative conception, as is another that stares with superhuman horror over the slave's shoulder. Tears stream unashamedly from the eyes of bearded patriarchs, and even the elongated hands, with their white highlights stroked down the fingers, seem instinct with tragic emotion. The painting of the drapery suggests an archaic mode, but it seems also to have grown from West's emotional reaction to his tragic theme. Those deep clumsy shadows, cutting with a staccato rhythm across the bodies of the disciples, emphasize their sorrow. West has attempted emotional counterpoint by contrasting the anguished faces on the left with Socrates' stoic resignation in the center, and the bored indifference of the soldiers on the right. Unable to conceive how any human being could be unmoved, West has given the soldiers the brutish faces of automatons.

The many virtues that shine through the crudity of *The Death of Socrates* make one wonder whether West might not have produced stronger art if, like Copley, he had stayed in America long enough to permit his naïve, largely self-taught style to mature according to its own nature. However, after a brief period as a

successful portrait painter in Philadelphia and New York, West
sailed for Italy at the age of twenty-one.

In Rome, he became familiar with Winckelmann and Winck-
elmann's disciple, Raphael Mengs. Moving on to England, he
painted during the 1760's such pictures as *Agrippina with the
Ashes of Germanicus*, which won him world-wide renown. A
comparison of this once-famous canvas with *The Death of Socrates*
reveals vastly superior technical resources, yet some of the old
vitality is gone.[41]

West had learned to be on less familiar terms with the ancients.
Once he had regarded them as imaginary neighbors, whose emo-
tions he could fathom by determining how he himself would have
felt. Now he saw them as inhabitants of a long-vanished Golden
Age, who could be approached only through scholarship. Winck-
elmann demanded archeological accuracy, and if West did not
always achieve this ideal, he was inhibited by the obligation.
Furthermore, he had come to realize that the ancients did not
respond to emotion like modern men: they were calmly noble.
Agrippina as she carries her husband's ashes, her mourning attend-
ants, and the bereaved crowd in the fore and middle ground
express no more than a gentle sadness.

But West had not made himself over into a completely new
man. He painted even such complicated canvasas as this with an
awe-inspiring rapidity; it would not be surprising if sometimes,
as he dashed in a background, his will went to sleep and his hand
painted automatically. Perhaps some such lapse was responsible
for the reappearance, back on a parapet overlooking Agrippina's
mournful cortège, of the cast of characters of *The Death of Soc-
rates*. Only a few inches high, figures in heavily shaded drapery
with distorted figures and faces, race and scream and throw their

[41] James Thomas Flexner, "The American School in London," in *Metropolitan
Museum of Art Bulletin*, n.s. VII (1948), 64–67.

arms heavenward in hysterical emotion. The featured players in West's painted drama are as classically restrained as anyone could wish, but there against the hills the supers reveal the ardors and excitements of the romantic movement. We need not be surprised that eventually West painted such altogether romantic pictures as his highly effective *Madness of Lear*.

"The child," as Wordsworth states, "is father of the man"; the Pennsylvania boy did not travel as far as we have been led to believe in order to become president of the Royal Academy. Winckelmann's classicism could not have come to him as a surprise, since he had practiced it in a crude form in his homeland. Indeed, it is possible that, had he stayed on these shores, West, who was the most original of our Colonial painters, and who manifested in Pennsylvania the ability to impress patrons which gave him unusual opportunities in England, might have developed a native version of the neo-classicism he did so much to foster abroad. Certain it is that his *The Death of Socrates* was a spontaneous growth from the culture of mid-eighteenth-century Pennsylvania.

ACKNOWLEDGMENTS

I am grateful to the following authors and publishers who have kindly permitted me to reprint source material from the books and articles named hereunder: the Cambridge University Press and the Macmillan Co. for *Art in England, 1800–1820* by William T. Whitley; Countess Bathurst, Doubleday, Doran & Co., and Hutchinson & Co. for *The Farington Diary*, edited by James Greig; the Harvard University Press for *Gilbert Stuart* by William T. Whitley; the Massachusetts Historical Society for *The Letters and Papers of John Singleton Copley and Henry Pelham;* the Medici Society for *Artists and Their Friends in England, 1700–1799* by William T. Whitley; the Historical Society of Pennsylvania for the *Pennsylvania Magazine of History and Biography;* Charles Coleman Sellers for *The Artist of the Revolution, the Early Life of Charles Willson Peale;* and Harry MacNeill Bland for the diary of Matthew Harris Jouett, published in *Gilbert Stuart and His Pupils* by John Hill Morgan. My debt is also great to the authors of the books and the possessors of the manuscript material listed in the bibliography at the back of this volume.

My especial thanks are due to the Frick Art Reference Library, which placed all its remarkable facilities at my disposal. I regret that the other libraries, historical societies, art galleries, museums, and private collectors who were of assistance to me are too numerous to mention.

BIBLIOGRAPHY

Since a long, unannotated list of books is terrifying to the layman and baffling even to the scholar, I have attempted in this bibliography to classify the sources mentioned under specific headings. A thoroughgoing student of any individual painter will, however, have to use the bibliography as a whole; it will be manifest to him that any book on Stuart must deal with West, or that the Peale papers will contain mention of most of Peale's artistic contemporaries.

At the beginning of each section the most important sources concerning each painter are described and discussed. The casual student will not have to go much beyond these, but in order to aid scholars I have appended further lists of the scattered and often seemingly irrelevant places where I found bits of information.

So the reader may ascertain on exactly what sources the bulk of the text was based, this bibliography has not been augmented or otherwise altered from its original form. In the intervening years, there has been much publication, some of it impressive.

I. General Reference Books

Bolton, Theodore. *Early American Portrait Draughtsmen in Crayons.* N.Y., F. F. Sherman, 1923.
Early American Portrait Painters in Miniature. N.Y., F. F. Sherman, 1921.

Burroughs, Alan. *Limners and Likenesses; Three Centuries of American Painting.* Cambridge, Harvard Univ. Press, 1936.

Dunlap, William. *History of the Rise and Progress of the Arts of Design in the United States.* 2 vols., N.Y., 1834. (New edition, edited by Frank W. Bayley and Charles E. Goodspeed, 3 vols., Boston, C. E. Goodspeed & Co., 1918.)

Fielding, Mantle. *Dictionary of American Painters, Sculptors, and Engravers.* Phila., printed for the subscribers, 1926.

Graves, Algernon. *Royal Academy of Arts; a Complete Dictionary of the Contributors and Their Work from Its Foundation in 1769 to 1904.* 8 vols., London, Henry Graves, 1905–6.
The Society of Artists of Great Britain, 1760–1791; the Free Society of Artists, 1761–1783; a Complete Dictionary of Contributors and Their Works. London, Bell and Graves, 1907.

Isham, Samuel. *The History of American Painting.* N.Y., Macmillan, 1916.

Kelby, William. *Notes on American Artists, 1754–1820, Copied from Advertisements Appearing in the Newspapers of the Day.* N. Y. Hist. Soc., 1922.

La Follette, Suzanne. *Art in America,* N.Y., Harper, 1929.

Lee, Cuthbert. *Early American Portrait Painters.* (With discussions of pictures in public collections.) New Haven, Yale Univ. Press, 1929.

Lester, Charles Edwards. *The Artists of America; a Series of Biographical Sketches.* N.Y., 1846.

Morgan, John Hill. *Early American Painters.* N. Y. Hist. Soc., 1921.

Muther, Richard. *The History of. Modern Painting.* 4 vols., London, Dent, 1907.

Sherman, Frederick Fairchild. *Early American Portraiture.* N.Y., privately printed, 1930.
Early American Painting. N.Y., Century, 1932.

Smith, Ralph Clifton. *A Biographical Index of American Artists.* Baltimore, Williams and Wilkins, 1930.

Trumbull, John. *Autobiography, Reminiscences, and Letters, 1756–1841.* N.Y., 1841. Also manuscript papers at the Yale School of Fine Arts.

Tuckerman, Henry Theodore. *Book of Artists.* N.Y., 1867.

Wehle, H. B. *American Miniatures, 1730–1850* (with a biographical dictionary of the artists by Theodore Bolton). Garden City, Doubleday, Page, 1927.

Whitley, William T. *Artists and Their Friends in England, 1700–1799.* 2 vols., London, Medici Society, 1928.
Art in England, 1800–1820. Cambridge Univ. Press, 1928.
Art in England, 1820–1835. Cambridge Univ. Press, 1930.

II. Benjamin West

The Historical Society of Pennsylvania possesses many West manuscripts. A collection which seems to have come from his own files is bound into an extra-illustrated edition of John Galt's life of the painter, together with a large group of contemporary prints after his canvases. In addition there are a sketch book dating from his youth, an account book dating from his old age, and many miscellaneous letters. Most of his early paintings also belong to the Historical Society of Pennsylvania.

Swarthmore College, on whose campus stands the house where West was born, owns a large collection of his drawings and Mrs. West's household journal from 1785 to 1789. The women's minutes of the Chester Monthly Meeting, which may also be seen there, contain under the date of November 27, 1717, the record of his mother's expulsion from meeting. A similar record may be found in the men's minutes for December 24, 1717.

The H. F. Marks Book Company, 280 Park Avenue, New York City, has for sale another extra-illustrated edition of Galt which contains some original West letters, many prints after his work, and some accounts of his life clipped from contemporary periodicals.

A few West letters may be seen at the British Museum and in the New-York Historical Society.

Amazingly enough, no complete life of West has appeared in the more than a century since the publication of John Galt's *The Life, Studies, and Works of Benjamin West Esq., President of the Royal Academy of London, Composed from Materials Furnished by Himself;* 2 vols., London, 1820. Although West went over the manuscript of the entire book and read the proofs of the first volume before his death, Galt's account can be shown to be full of errors; probably West was so old that his memory had become inaccurate. The work remains, none the less, the most important single source of information concerning West's years in America and Italy. It has sometimes been possible to supplement, confirm, or disprove Galt's stories from more reliable quarters, but much material in the book cannot be checked, since it survived only in West's memory. Such matters have been repeated from Galt for what they are worth, their source being given so that scholars may place on them whatever credence they feel they deserve.

An invaluable source of information concerning the latter half of West's life is *The Farington Diary, edited by James Greig;* 8 vols., N.Y., Doubleday, Page, 1922–9; or London, Hutchinson, 1922–7. Farington, who was an intimate friend of West, recorded from day to day the painter's adventures in the Royal Academy and the court of George III.

No scholar has attempted a systematic catalogue of West's work, although the canvases of his American period are discussed by William Sawitzky in his "The American Work of Benjamin West," *Penn. Mag. of Hist. and Biog.,* LXII, 1938. Galt contains a general list of his pictures that might be helpful in tracing a canvas painted in England. Other sources of information are the files of the Frick Art Reference Library, the contemporary catalogues listed below, and the two invaluable publications by Algernon Graves mentioned under the heading of General Reference Books.

West was so important a figure in his own period that a complete bibliography of works in which he is mentioned would in itself fill a volume. I have merely at-

tempted to list the publications I found especially useful in preparing my sketch. Those dealing primarily with his American career are as follows:

American Magazine. Phila., 1758. (Contains poems to West and Wollaston.)

Ashmead, Henry Graham. *History of Delaware County, Penn.* Phila., 1884.

Balch, Thomas. *Letters and Papers Relating Chiefly to the Provincial History of Pennsylvania.* Phila., 1855.

A Brief Statement of the Rise and Progress of the Testimony of the Religious Society of Friends against Slavery and the Slave Trade. Phila., 1843.

Dufresnoy, Charles-Alphonse. *The Art of Painting; translated into English verse by William Mason.* York, 1783.

Hart, Charles Henry. "Benjamin West's Family; the American President of the Royal Academy of Arts not a Quaker," *Penn. Mag. of Hist. and Biog.,* XXXIII, 1908.

Hastings, George E. *The Life and Works of Francis Hopkinson.* Univ. of Chicago Press, 1926.

Hawthorne, Nathaniel. *Biographical Sketches for Children.* Boston, 1842.

Jones, Rufus Matthew. *The Quakers in the American Colonies.* London, Macmillan, 1911.

Jordan, Francis, Jr. *The Life of William Henry.* Lancaster, Penn., New Era Printing Co., 1910.

Jordan, J. W. *Colonial Families of Philadelphia.* 2 vols., N.Y., Lewis Pub. Co., 1911.

Morgan, John Hill. "Notes on John Wollaston and His Portrait of Sir Charles Hardy," *Bklyn. Mus. Quarterly,* 1933.

Myers, Albert Cook. "Benjamin West's Mother, Sarah Pearson, and Her Family," *Bull. Friends' Hist. Assoc.,* XVIII, 1929.

Richardson, Jonathan. *The Works of Jonathan Richardson, containing: one, the theory of painting, two, essay on the art of criticism . . . three, the science of a connoisseur.* London, 1792.

Sawitzky, William. "William Williams, the First Instructor of West." *Antiques,* XXXI, 1937.

Smith, George. *History of Delaware County, Pennsylvania.* Phila., 1862.

Stern, C. *Our Kindred, the McFarlan and Stern Families.* N.p., 1885.

Stowe, Walter Herbert. *The Life and Letters of Bishop White.* N.Y., Morehouse, 1937.

Walker, Lewis Bund. *Extracts from Chief Justice Allen's Letter Book.* Pottsville, Penn., 1897.

Watson, John Fanning. *Annals of Philadelphia.* Phila., 1830.

Williams, William ("Llewellin Penrose"). *The Journal of Llewellin Penrose.* London, 1825.

Publications dealing with West's career in general are as follows:

The Analectic Magazine and Naval Chronicle. Phila., VII, 1815; VIII, 1816.

The Annual Register. London, 1822.

Bürger, M. W. *Histoire des Peintres de Toutes les Ecoles; Ecole Anglaise.* Paris, 1863.

Burney, Fanny. *Diary and Letters of Mme. d'Arblay; edited by Charlotte Barrett.* Vol. 3. London, 1904.

Carey, William. *A Critical and Analytical Review of "Death on a Pale Horse."* London, 1817.

Catalogue of Pictures . . . Painted by Benjamin West Now Exhibiting in Pall Mall. London, 1816.

Catalogue of Pictures and Drawings by the Late Benjamin West . . . Including a Description of the Great Pictures, "Christ Rejected" and "Death on a Pale Horse." London, 1823.

Cunningham, Allan. *Lives of the Most Eminent British Painters; revised by* Mrs. *Charles Heaton.* 3 vols., London, 1879-80.

Description and Critical Remarks on the Painting of "Christ Healing the Sick in the Temple." N.p., n.d.

Description of Mr. West's Picture of Death on the Pale Horse. London, 1818.

Description of the Picture, "Christ Healing the Sick in the Temple." Phila., 1817.

Dunlap, William. *History of the Rise and Progress of the Arts of Design in the United States.* (See General Reference Books.)

Edwards, Edward. *Anecdotes of Painters Who Have Resided or Been Born in England.* London, 1808.

Einstein, Lewis. *Divided Loyalties; Americans in England during the War of Independence.* Boston, Houghton Mifflin, 1933.

Fletcher, Ernest, editor. *Conversations of James Northcote, R.A., with James Ward*. London, Methuen, 1901.

Hilles, Frederick Whiley, editor. *Letters of Sir Joshua Reynolds*. Cambridge Univ. Press, 1939.

Hodgson, J. E., and Eaton, Frederick A. *The Royal Academy and Its Members, 1768–1830*. London, Murray, 1905.

Hofland, Mrs. T. C. *A Visit to London*. London, 1814.

Hunt, Leigh. *Autobiography*. 2 vols., N.Y., 1850.

Jackson, Henry E. *Benjamin West, His Life and Work*. Phila., Winston, 1900.

Kimball, Fiske. "Benjamin West au Salon de *1802*," *Gazette des Beaux Arts*, VII, 1932.

La Belle Assemblée. London, 1808, 1822.

Lamb, W. R. M. *The Royal Academy*. London, MacLehose, 1935.

Leslie, Charles Robert. *Memoirs of the Life of John Constable; edited and enlarged by Andrew Shirley*. London, Medici Society, 1937.

Leslie, Charles Robert, and Taylor, Tom. *Life and Times of Sir Joshua Reynolds*. London, 1865.

Loquin, Jean. "Le Retour à l'Antique dans l'Ecole Anglaise et dans l'Ecole Française avant David," *La Renaissance de l'Art Français et des Industries de Luxe*, V, 1922.
Peinture d'Histoire en France de 1747 à 1785. Paris, Laurens, 1912.

London *Times*, March 13, 1820.

Massachusetts Historical Society. *The Letters and Papers of John Singleton Copley and Henry Pelham*. (See Copley.)

The Massachusetts Magazine or Monthly Museum. Boston, December 1795.

Morse, Edward Lind. *Samuel F. B. Morse, His Letters and Journals*. 2 vols., Boston, Houghton Mifflin, 1914.

Moses, Henry, engraver. *The Gallery of Pictures Painted by Benjamin West*. N.p., 1811.

M'Quin, A. D. *A Description of the Picture "Christ Rejected by the Jews."* Phila., 1830.

Penn. Mag. of Hist. and Biog. References to West will be found in the following volumes; indices are at the back of every volume: I, 1877; II, 1878; VI, 1882; IX, 1885; XIII, 1889; XVI,

1892; XVIII, 1894; XIX, 1895; XXII, 1898; XXXII, 1908; XXXV, 1911; XXXVII, 1913; XXXVIII, 1914; XLII, 1918; XLV, 1921; L, 1926; LIII, 1929; LVII, 1933; LIX, 1935.

Philadelphia Museum of Art. *Benjamin West, 1738–1820*. Phila., 1938 (Catalogue of an exhibition.)

Philosophical Society of London. *The European Magazine and London Review*. September 1794.

The Portfolio. Phila., 1809, 1810, 1811, 1816, 1823.

Public Advertiser. London, April 1764.

Public Characters of 1805. London, 1805. (Contains a biography of West from material supplied by one of his sons.)

Reynolds, Sir Joshua. *Discourses Delivered to the Students of the Royal Academy; with introduction and notes by Roger Fry*. N.Y., Dutton, n.d.

Robinson, John. *A Description and Critical Remarks on the Picture "Christ Healing the Sick in the Temple."* Phila., 1818.

Rush, Richard. *The Court of London, 1819–1825*. London, 1873.

Smith, J. T. *Nollekens and His Times, edited and annotated by Wilfred Whitten*. 2 vols., London, Lane, 1917.

Thornbury, William. "West, the Monarch of Mediocrity." In his *British Artists from Turner to Hogarth*, vol. 2, London, 1861. (An attack which shows the violence to which some of West's critics descended.)

Universal Magazine of Knowledge and Pleasure. London, 1805.

Walpole, Horace. *Anecdotes of Painting in England, 1760–95. Edited by Frederick W. Hilles and Philip B. Daghlian*. New Haven, Yale Univ. Press, 1937.
Letters; edited by Peter Cunningham. Vols. 5 and 6. Edinburgh, 1906.

Webster, J. Clarence. *Wolfe and the Artists; a Study of His Portraiture*. Toronto, Ryerson, 1930.

West, Benjamin. *A Discourse Delivered to the Students of the Royal Academy, December 10, 1792*. London, 1793.

Whitley, William T. *Artists and Their Friends in England, 1700–1799*. (See General Reference Books.)
Art in England, 1800–1820. (See General Reference Books.)
Art in England, 1820–1835. (See General Reference Books.)

III. John Singleton Copley

There exists voluminous manuscript material dealing with all of Copley's life except his boyhood and youth, and almost all of it has been published. A collection concerning his American career and his trip to Italy is contained in *The Letters and Papers of John Singleton Copley and Henry Pelham, 1739–1776;* Boston, Mass. Hist. Soc., 1904. The originals of these documents, which seem to have come from the private files of both Copley and Pelham, were found among the papers intercepted by the British Government during the revolution. They are in the Public Records Office, London (C.O. 5/38, 39). Although all the letters of importance were printed, in some cases there were two or three drafts of which only the most complete was used, and the editors considered a few documents so insignificant that these were omitted. Photostats of all these papers, published and unpublished, may be seen at the Massachusetts Historical Society, together with some Copley material from other collections.

A group of Copley's letters to his wife while he was in Italy, and of letters written mostly by members of his family during his English years, has been published in an abridged and edited form in Martha Babcock Amory's *The Domestic and Artistic Life of John Singleton Copley, R.A.;* Boston, 1882. Most of these papers were recently burnt by one of Copley's descendants because they contained allusions which she considered undesirable to preserve. A few, which came down in another branch of the family, are in the Library of Congress.

Other letters may be seen in the collections of the Boston Public Library and the Historical Society of Pennsylvania. An important letter from Copley to Samuel Adams is in the New York Public Library.

The Copley papers are so interesting and so voluminous that it is hard to understand why no modern writer has made use of them in a biography of the great artist. Mrs. Amory's life was prepared before the Copley-Pelham papers had been discovered, and in any case it is a "descendant's book," ramblingly written and given to eulogy.

Copley's American paintings have been catalogued and discussed by Barbara Neville Parker and A. B. Wheeler in their *John Singleton Copley, American Portraits in Oil, Pastel, and Miniature,* Boston Museum of Fine Arts, 1938. The last fifty pages of the book consist entirely of photographs.

There is no up-to-date catalogue of Copley's English paintings. The best sources of information concerning them are Augustus Thorndike Perkins's *A Sketch of the Life and a List of the Works of John Singleton Copley,* Boston, 1873; and Frank W. Bayley's *The Life and Work of John Singleton Copley, founded on the work of Augustus Thorndike Perkins,* Boston, Taylor Press, 1915. The biographical sections of both these books are negligible. For more recent discoveries concerning Copley's English paintings see the files of the Frick Art Reference Library.

The most interesting contemporary account of Copley will be found in William Dunlap's *History of the Rise and Progress of the Arts of Design in the United States* (see General Reference Books). Dunlap copied most of his material concerning Copley's English career from Allan Cunningham's *Lives of the Most Eminent British Painters* (see West).

Other published sources of material on Copley are:

Ayer, Mary Farwell. *Boston Common in Colonial and Provincial Days.* Boston, privately printed, 1903.

Bayley, Frank W. *Five Colonial Artists of New England* (Badger, Blackburn, Copley, Feke, Smibert). Boston, privately printed, 1929.

Bolton, Theodore, and Binsse, Harry Lorin. "John Singleton Copley Appraised as an Artist in Relation to His Contemporaries with a Checklist of His Portraits in Oil," *Antiquarian,* XV, 1930.

Boston *Gazette.* December 2, 1773. (An account of Copley's appearance before a town meeting in connexion with the tea.)

Chamberlain, Allen. *Beacon Hill; Its Ancient Pastures and Early Mansions.* Boston, Houghton Mifflin, 1925.

Drake, Francis S. *Tea Leaves; Being a Collection of Letters and Documents Relating to the Shipment of the Tea to the American Colonies in the Year 1773.* Boston, 1884.

Einstein, Lewis. *Divided Loyalties* (see West).

Farington, Joseph. *The Farington Diary,* edited by James Greig (see West).

Healy, G. P. A. "Reminiscences of a Portrait Painter," *North Am. Review,* CLI, 1890.

Hutchinson, Thomas. *The Diary and Letters of His Excellency Thomas Hutchinson, compiled by Peter Orlando Hutchinson.* 2 vols., Boston, 1886.

Masters in Art: Copley. Boston, Bates and Guild, 1904.

Metropolitan Museum of Art. *Catalogue of Copley Exhibition.* N.Y., 1936.

Miller, John Chester. *Sam Adams; Pioneer in Propaganda.* Boston, Little, Brown, 1936.

Morgan, John Hill. "Some Notes on John Singleton Copley," *Antiques,* XXXI, 1937.

Morison, Samuel Eliot. "The Commerce of Boston on the Eve of the Revolution," *Proc. Am. Antiquarian Assoc.,* XXXII, Worcester, 1922.

Monkhouse, William Cosmo. *Masterpieces of English Art.* London, 1869.

Morse, Edward Lind. *Samuel F. B. Morse, His Letters and Journals* (see West).

Rankin, William. "An Impression of the Early Works of John Singleton Copley," *Burlington Magazine,* VIII, 1905.

Sherman, Frederick Fairchild. "Portraits and Miniatures by Copley," *Art in America,* XVI, 1928.

"John Singleton Copley as a Portrait Miniaturist," *Art in America,* XVIII, 1930.

Slade, D. R. "Henry Pelham, the Half-Brother of John Singleton Copley," *Publications of the Colonial Soc. of Mass.,* V, Boston, 1902.

Spielmann, Marion Henry. *British Portrait Painting to the Opening of the Nineteenth Century.* Vol. 2. London, Berlin Photographic Co., 1910.

Stark, James H. *The Loyalists of Massachusetts.* Boston, W. B. Clarke, 1907.

Watson, Elkanah. *Men and Times of the Revolution, or the Memoirs of Watson.* N.Y., 1856.

Whitley, William T. *Artists and Their Friends in England, 1700–1799* (see General Reference Books).

Art in England, 1800–1820 (see General Reference Books).

For the American background of Copley's art see:

Bolton, Theodore, and Binsse, Harry Lorin. "An American Artist of Formula, Joseph Blackburn," *Antiquarian,* XV, 1930.

"Robert Feke, First Painter of Colonial Aristocracy," *Antiquarian,* XV, 1930.

Burroughs, Alan. *Limners and Likenesses* (see General Reference Books).

Dresser, Louisa. *Seventeenth-Century Painting in New England; a catalogue of an exhibition held at the Worcester Art Museum . . . with a laboratory report by Alan Burroughs.* Worcester Art Museum, 1935.

Foote, Henry Wilder. *Robert Feke, Colonial Portrait Painter.* Cambridge, Harvard Univ. Press, 1930.

La Follette, Suzanne. (See General Reference Books.)

Lee, Cuthbert. "John Smibert," *Antiques,* XVIII, 1930.

Morgan, John Hill, and Foote, Henry Wilder. *An Extension of Lawrence Park's Descriptive List of the Works of Joseph Blackburn.* Worcester, Am. Antiquarian Soc., 1923.

Park, Lawrence. *Joseph Badger, and a Descriptive List of His Works.* Boston, University Press, 1918.

"Joseph Badger of Boston and His

Portraits of Children," *Old Time New England*, XIII, 1933.

Joseph Blackburn, a Colonial Portrait Painter, with a Descriptive List of His Works. Worcester, Am. Antiquarian Soc., 1923.

Whitmore, William H. "The Early Painters and Engravers of New England," *Proc. Mass. Hist. Soc.*, IX, 1866–7.

"Notes Concerning Peter Pelham, the Earliest Artist Resident in New England, and His Successors Prior to the Revolution," *Proc. Mass. Hist. Soc.*, IX, 1866–7.

IV. Charles Willson Peale

The biography of Charles Willson Peale in this book is based primarily on the voluminous collection of papers belonging to Charles Coleman Sellers, who most hospitably received the author in his house at Hebron, Conn., and gave him access to the manuscripts. Mr. Sellers possesses Peale's unpublished autobiography, and numerous diaries and letters, not to mention much related material which has been collected by generations of the Peale and Sellers families.

The Pennsylvania Historical Society has many Peale manuscripts, the most interesting being a group of papers concerning his successive art academies, and an unpublished description of his museum entitled *A Walk through the Philadelphia Museum*. Both the New-York Historical Society and the Huntington Library, San Marino, Calif., possess Peale diaries.

The first half of Peale's life is interestingly and authentically described by Charles Coleman Sellers in his *The Artist of the Revolution, the Early Life of Charles Willson Peale*, Feather and Good, Hebron, Conn., 1939.

The *Pennsylvania Magazine of History and Biography* contains three articles by Horace Wells Sellers: "The Engravings of Charles Willson Peale," LVII, 1933; "Letters of Thomas Jefferson to Charles Willson Peale," XXVIII, 1904; and "Charles Willson Peale, Artist Soldier," XXXVIII, 1914. The third of these is a short biographical sketch that carries the painter through the first years of the revolution.

No accurate or full account of the second half of Peale's life has been published, for most scholars other than the members of the Sellers family have ignored the Peale papers. Most accounts of Peale, from Dunlap's down to the present, have been based on the amazingly inaccurate sketches of his father by Rembrandt Peale contained in his *Cabinet of Natural History*, Phila., 1830; in Francis Lieber's *Encyclopædia Americana*, Phila., 1848; and in the *Crayon*, I, N.Y., 1855. Although these articles may not be believed, credence may be given to the two accounts of the exhuming of the mastodon written by Rembrandt Peale many years before: *Account of the Skeleton of the Mammoth*, London, 1802; and *An Historical Disquisition on the Mammoth*, London, 1803.

For Peale's portraits of Washington, see the books on Washington portraits listed under Stuart; also Charles Henry Hart's "Peale's Original Full-Length Portrait of Washington," in the report of the Am. Hist. Soc. for 1896; and Theodore Bolton and H. L. Binsse's "Peale Portraits of Washington," *Antiquarian*, XVI, 1931.

No systematic attempt has ever been made to list the bulk of Peale's pictures, or to distinguish those falsely attributed to him from his genuine works. Here is an important and almost untouched field of research waiting for some American Ph.D. student who has the courage to leave the conventional occupation of writing on those phases of European masters that European scholars have considered too insignificant to bother with.

The following are printed sources of information concerning Peale:

Adams, John. *Familiar Letters of John Adams and His Wife during the Revolution; edited by Charles Francis Adams,* N.Y., 1876.

Burns, Frank. "Charles W. and Titian R. Peale and the Ornithological Section of the Old Philadelphia Museum," *Wilson Bulletin,* Sioux City, Iowa, XLIV, 1932.

Colton, Harold Sellers. "Peale's Museum," *Popular Science,* LXXV, 1909.

Columbianum or American Academy of Fine Arts. *The Constitution of the Columbianum.* Phila., 1795.

Custis, George Washington Parke, *Recollections and Private Memoirs of Washington.* (See Stuart.)

Etting, Frank W. *Independence Hall.* Phila., 1891.

Faxon, Walter. "Relics of Peale's Museum," *Bull. Mus. of Comparative Zoology,* Cambridge, LIX, 1915.

Hart, Charles Henry. "Charles Willson Peale's allegory of William Pitt," *Proc. Mass. Hist. Soc.,* XLVIII, 1915.

Hutchinson, Helen Weston. *The Pennsylvania Academy of Fine Arts, and Other Collections in Philadelphia.* Boston, Page, 1911.

Janson, Charles Wilson. *The Stranger in America.* London, 1807.

Lucas, Frederick A. *The Story of Museum Groups.* N.Y., Am. Mus. of Nat. Hist., 1921.

Maryland Historical Magazine. "Documents concerning Charles Willson Peale," XXXIII, 1938.

Peale, Charles Willson. *An Address to the Corporation and Citizens of Philadelphia.* Phila., 1816.

Discourse Introductory to a Course of

Lectures on Natural History. Phila., 1800.

An Epistle to a Friend on the Means of Preserving Health. Phila., 1803.

An Essay on Building Wooden Bridges. Phila., 1797.

An Essay to Promote Domestic Happiness. Phila., 1812.

Peale, Charles Willson, and Beauvois, A. M. F. J. *A Scientific and Descriptive Catalogue of Peale's Museum.* Phila., 1796.

Pennsylvania Academy of Fine Arts. *Acts of Incorporation.* Phila., 1813.

Catalogue of Exhibition of Portraits by Charles Willson Peale, James Peale, and Rembrandt Peale. Phila., 1923.

Pennsylvania Magazine of History and Biography. References to Peale will be found in the following volumes (each volume is indexed): I, 1877; III, 1879; V, 1881; IX, 1885; XI, 1887; XII, 1888; XIII, 1889; XV, 1891; XVI, 1892; XIX, 1895; XX, 1896; XXI, 1897; XXII, 1898; XXIV, 1900; XXVIII, 1904; XXIX, 1905; XXXVI, 1912; XXXVII, 1913; XXXVIII, 1914; LV, 1931; LVI, 1932; LVII, 1933; LVIII, 1934; LIX, 1935.

Proceedings of the Boston Society of Natural History, XXVI, 1894.

Sartain, John. *The Reminiscences of a Very Old Man, 1808–1897.* N.Y., 1899.

Stone, Witmer. "Some Philadelphia Ornithological Collections and Collectors, 1784–1850," *Awk,* XVI, 1899.

Thomas, M. & Sons, auctioneers. *Peale's Museum Gallery of Oil Paintings . . . to Be Sold without Reserve at Public Sale.* Phila., 1854.

Warren, John C. *Monograph on the Mastodon.* Boston, 1852.

V. Gilbert Stuart

No important collection of Stuart papers has ever been found; probably he was too careless to preserve any documents, too impatient to write any long, revealing letters. A few of his letters may, however, be seen at the Pennsylvania, the Massachusetts, and the New-York Historical Societies, as well as in the collections of Harry MacNeill Bland and Hall Park McCullough, both of New York. Mr. Bland owns the book of notes kept by Matthew Harris Jouett when he was studying in Stuart's studio, the most important single source concerning the painter's ideas on art.

The mill in which Stuart was born still stands near Jamestown, R.I., although the author saw it nearly blown away when he visited it on the afternoon of the famous hurricane of 1938. It contains snuff-grinding machinery of the period.

William Dunlap's *History of the Rise and Progress of the Arts of Design in the*

United States (see General Reference Books) contains, in addition to Dunlap's own recollections of Stuart, accounts of him written by a number of his associates, including the essay by Dr. Waterhouse, which is the most reliable source of information concerning Stuart's youth. Although the picture of Stuart drawn in this book is not flattering and was much resented by Stuart's daughters, it tallies well with independent contemporary accounts, and may be largely taken at face value. That Dunlap himself suppressed some of the more unflattering anecdotes of Stuart he received may be seen by consulting his *Diary, 1766–1823*, 3 vols., N.-Y. Hist. Soc., 1931.

Jane Stuart, the painter's daughter, who had a social position to keep up in Newport, tried to counteract Dunlap's chapter by three articles published in *Scribner's Monthly*, June 1876, March and July, 1877. Many of her statements, such as her assertion that Stuart studied at the University of Glasgow, must be discounted, but her articles contain some new facts and several interesting anecdotes.

Stuart's daughter Anne contributed a short sketch of her father to Wilkins Updike's *History of the Episcopal Church in Narragansett*, 3 vols., Boston, Merrymount Press, 1907. This work also quotes important source material concerning Stuart's childhood copied from church records.

William T. Whitley's *Gilbert Stuart*, Cambridge, Harvard University Press, 1932, contains a large amount of new material, primarily about Stuart's English and Irish periods. Mr. Whitley's investigations in contemporary newspapers are particularly important.

The most complete catalogue of Stuart's paintings is Lawrence Park's *Gilbert Stuart, an Illustrated Descriptive List of His Works*, 4 vols., N.Y., William Edwin Rudge, 1926. An excellent short biographical sketch of Stuart by John Hill Morgan and an appreciation by Royal Cortissoz are included in the first volume. The last two volumes are made up entirely of illustrations.

For subsequent discoveries concerning Stuart's paintings see William Sawitzky's "Lost Portraits Add to Gilbert Stuart's Fame," N. Y. *Times Magazine*, August 12, 1928.

In George C. Mason's *The Life and Works of Gilbert Stuart*, N.Y., 1879, may be found an early catalogue of the painter's work and a lengthy biographical sketch which contains some previously unpublished material obtained from Stuart's daughters, but pays for this privilege by glossing over the unpleasant details of his life and character.

The most important source concerning Stuart's Irish years is J. D. Herbert's *Irish Varieties of the Last Fifty Years*, London, 1836.

For a short account of Stuart by one of his Boston friends who had a deep psychological insight into the painter's tortured character see Samuel L. Knapp's *American Biography*, in his *The Treasury of Knowledge and Library of Reference*, vol. 3, N.Y., 1855.

John Hill Morgan's *Gilbert Stuart and His Pupils*, N.-Y. Hist. Soc., 1939, lists many of the young men who worked in Stuart's studio and contains a complete transcript of the notes Jouett kept concerning Stuart's teachings.

Stuart's portraits of Washington are catalogued and discussed by John Hill Morgan and Mantle Fielding in their *The Life Portraits of Washington and Their Replicas*, Philadelphia, printed for subscribers, 1931. An earlier volume of similar intention, Elizabeth Bryant Johnston's *Original Portraits of Washington*, Boston, 1882, is, of course, less up to date but contains some material not elsewhere published. See also

Charles Henry Hart's *Catalogue of the Engraved Portraits of Washington,* N.Y., Grolier Club, 1904; and Charles Allen Munn's *Three Types of Washington Portraits,* N.Y., privately printed, 1908.

Other published sources of material on Gilbert Stuart are:

Appleton, Thomas Gould. "Portrait Painting and Gilbert Stuart," *International Review,* X, 1881.

Browne, Arthur. *Miscellaneous Sketches,* London, 1798.

Channing, George G. *Early Recollections of Newport, R.I., from the Year 1793 to 1811.* Newport and Boston, 1868.

Clark, Allen C. *Life and Letters of Dolly Madison.* Washington, W. F. Roberts, 1914.

Cortissoz, Royal. *The Painter's Craft.* N.Y., Scribner, 1930.

Custis, George Washington Parke. *Recollections and Private Memoirs of Washington.* Washington, 1859.

Didier, Eugene Lemoine. *The Life and Letters of Mme. Bonaparte.* N.Y., 1879.

Drake, Francis S. *The Town of Roxbury.* Roxbury, Mass., 1878.

Einstein, Lewis. *Divided Loyalties* (see West).

Fearon, Henry Bradshaw. *Sketches of America; a Narrative of a Journey.* London, 1819.

Flagg, Jared B. *Life and Letters of Washington Allston.* London, 1893.

Griswold, Rufus Wilmot. *The Republican Court, or American Society in the Days of Washington.* N.Y., 1855.

H. E. T. "Gilbert Stuart as a Craftsman," *Bull. Rhode Island School of Design,* II, 1914, and III, 1915.

Hall, Mrs. Basil. *The Aristocratic Journey; Being the Outspoken Letters of Mrs. Basil Hall Written during a Fourteen Months' Sojourn in America, 1827–1828.* Prefaced and edited by Una Pope-Hennessy. N.Y., Putnam, 1931.

Hart, Charles Henry. *Browere's Life Masks of Great Americans.* N.Y., 1899.

"Gilbert Stuart's Portraits of Women." Fourteen articles in the *Century Magazine,* 1897–99.

Jonas, E. A. *Matthew Harris Jouett, Kentucky Portrait Painter.* Louisville, J. B. Speed Memorial Museum, 1938.

Leslie, C. R. *Autobiographical Recollections.* 2 vols., London, 1860.

Lester, Charles Edwards. *The Artists of America.* N.Y., 1846.

London, Hannah R. *Portraits of Jews by Gilbert Stuart and Other Early American Artists.* N.Y., Rudge, 1927.

Longacre, James Barton. "Extracts from His Diary," *Penn. Mag. of Hist. and Biog.,* XXIX, 1905.

Madison, Dorothy. *Memoirs and Letters of Dolly Madison, edited by her grandniece.* Boston, 1886.

Mason, George Champlin. *Annals of the Redwood Library and Athenæum.* Newport, 1891.

Reminiscences of Newport, Newport, 1884.

Masters in Art: Stuart. Boston, Bates and Guild, 1906.

Mather, Frank Jewett. *Estimates in Art; series II.* N.Y., Holt, 1931.

"The Origin of Gilbert Stuart's Style," *Art Studies, Medieval, Renaissance, and Modern,* IV. Cambridge, Harvard Univ. Press, 1926.

Morgan, John Hill. "Gilbert Stuart, Miniature Painter," *Antiques,* XVI, 1929.

Neal, John. "Our Painters," *Atlantic Monthly,* XXII, 1868.

Parke, William Thomas. *Musical Memoirs.* London, 1830.

The Portfolio. Phila., June 1803. (Contains Stuart's poem to Mrs. Perez Morton.)

Powell, Mary E. "Miss Jane Stuart," *Bull. Newport Hist. Soc.,* No. 31, January 1920.

Price, Samuel Woodson. *The Old Masters of the Bluegrass.* Louisville, Morton, 1902.

Quincy, Eliza S. M. *Memories of the Life of Eliza S. M. Quincy.* Boston, 1861.

Quincy, Josiah. *Figures of the Past from the Leaves of Old Journals.* Third edition, Boston, 1883.

Sartain, John. *The Reminiscences of a Very Old Man* (see Peale).

Strickland, Walter G. *Dictionary of Irish Artists.* 2 vols. Dublin, Maunsel, 1913.

Sully, Thomas. "Recollections of an Old Painter," vol. X, *Hours at Home,* Phila., 1873.

Swan, Mabel M. "Gilbert Stuart in Boston," *Antiques,* XXIX, 1936.

Trumbull, John. *Autobiography* (see General Reference Books).

Waterhouse, Benjamin. "Sketch of Arthur Browne," *Monthly Anthology,* Boston, 1805.

Watson, John Fanning. *Annals of Philadelphia* (see West).

Wharton, Anne Hollingsworth. *Salons Colonial and Republican.* Phila., Lippincott, 1900.

Social Life in the Early Republic. Phila., Lippincott, 1902.

Bibliographical Note to the 1980 Edition

Since *America's Old Masters* was published more than forty years ago, research in American painting has been taken over by academic institutions. The resulting methodology has discouraged synthesis except within a narrow compass, preferring emphasis on factual details, on the explication of techniques and compositions, on the attribution of individual pictures. Under the editorship of Bernard Karpel, the Smithsonian Institution Press, Washington, D.C., is publishing for the Archives of American Art *Arts in America: A Bibliography*, in four mammoth volumes. No effort will be made to duplicate here what has there been compiled.

To discuss what comprehensive works have in the more than forty years been published concerning the four protagonists of *America's Old Masters* will not occupy much space.

BENJAMIN WEST
No rounded full-length biography of West has been published.

Alberts, Robert C., *Benjamin West, a Biography* (Boston, 1973) , deals effectively with the facts of the protagonist's life. But Alberts did not attempt to respond for himself to matters artistic, inserting, to fill in what gaps he recognized, quotations from previous writers, including this one. Being thus unable to build into his narrative the meaning and significance, the point of the life of so indefatigable and influential an artist, Alberts has ended up with a lengthy genre piece.

Dillenberger, John, *Benjamin West. The context of his life's work with particular attention to painting with religious subject matter, including a correlated version of early eighteenth-century lists of West's paintings, exhibitions, and sales records of his work, and also a current checklist of his major religious works*, San Antonio, 1977. This title well describes a valuable reference work.

Evans, Grace, *Benjamin West and the Taste of his Times*, Carbondale, Illinois, 1959. Of little interest.

Kraemer, Ruth S. *Drawings by Benjamin West and his son Raphael Lamar West*, New York, 1975. This catalogue of an exhibition at the Morgan Library contains fascinating illustrations and, in the notes on the pictures, wide-ranging information. A valuable contribution.

Helmut von Erffa spent several decades amassing material on West's works of art, but achieved little publication. His notes have been handed over to Allen Staley, who, combining that information with the results of his own researches, is preparing the complete checklist so greatly needed. Dr. Staley has kindly consulted with me concerning the color plates included in the volume.

JOHN SINGLETON COPLEY
No effective full-length biography has ever been published.

Flexner, James Thomas. *John Singleton Copley* (Boston, 1948) . This volume publishes in a generous format, with some expansion of text and a great increase in illustration, the account of Copley in *America's Old Masters*.

Prown, Jules, *John Singleton Copley*, 2 vols. (Cambridge, Mass., 1966). A complete checklist, copiously illustrated. The introductory essays to the two volumes present stylistic analyses on a core of bare biographical fact. The conclusions are informed and informative, but lack that profundity of perception in which imaginative insight is a necessary factor. An extremely valuable publication.

CHARLES WILSON PEALE
Charles Coleman Sellers, a direct descendent of the artist, has devoted much of his life to studying Charles Willson Peale and the related Peale painters. He is a writer of skill and charm as well as a scholar of great erudition and accuracy. His basic works are:
Sellers, *Charles Willson Peale*, 2 vols. (Hebron, Conn. 1939 and Philadelphia, 1947). An eloquent biography.
———, *Portraits and Miniatures by Charles Willson Peale* (Philadelphia, 1952). A complete checklist including an illustration of every available work. Indispensable.
———, *Charles Willson Peale* (New York, 1969). A one-volume condensation of his earlier two volumes, written graciously for a broader public and containing new material.

GILBERT STUART
A voluminous biography and an up-to-date checklist are needed.
Flexner, James Thomas, *Gilbert Stuart* (New York, 1955). Published as part of a series entitled "Great Lives in Brief," this separate publication is a version, slightly enlarged, of the biography in *America's Old Masters*.
Mount, Charles Merrill, *Gilbert Stuart a Biography* (New York, 1964). Contains interesting material.

CATALOGUE OF ILLUSTRATIONS

Measurements are given below in inches, height before width. Unless otherwise stated, the medium is oil on canvas. The abbreviation FARL indicates that the photograph reproduced was secured from the Frick Art Reference Library, New York, N.Y.

ALEXANDER, COSMO: *Alexander Grant;* 50 x 40; 1770; Stonington Historical Society, Stonington, Conn.; FARL.

BLACKBURN, JOSEPH: *Mary Sylvester;* 49⅞ x 40; 1954; Metropolitan Museum of Art, New York, N.Y.

BROWERE, J. H. I.: *Life Mask of Gilbert Stuart;* plaster; 1825; Redwood Library and Athenaeum, Newport, R.I.; FARL.

COPLEY, JOHN SINGLETON: *Anatomical Drawing;* red ink and red crayon on paper; 17⅙ x 10¼; 1756; British Museum, London.

——: *Boy with Squirrel;* 30¼ x 25; 1765; owned anonymously.

——: *The Copley Family;* 72½ x 90⅜; 1776–77; National Gallery of Art, Washington, D.C.

——: *Self-portrait at Thirty-eight;* 18⅛ diameter; c. 1776–80; Mrs. Fiske Hammond, Santa Barbara, Calif.

——: *The Death of Chatham;* 90 x 121; 1779–81; Tate Gallery, London.

——: *Brothers and Sisters of Christopher Gore;* 40½ x 56¼; c. 1755; Henry Francis du Pont Winterthur Museum, Winterthur, Del.

——: *Sketch for the Knatchbull Family;* 25½ x 37½; 1800–2; Lord Brabourne, Mergham le Hatch, Ashford, Kent.

——: *Governor and Mrs. Thomas Mifflin;* 60½ x 48; 1773; Historical Society of Pennsylvania, Philadelphia, Pa.

——: *Death of Major Pierson, Study for;* black and white chalk on gray-blue paper; 13⅝ x 22¾; 1782–83; Museum of Fine Arts (M. & M. Karolik Collection), Boston, Mass.

——: *Abigail Rogers;* 50 x 40; c. 1784; Paul Cabot, Needham, Mass.

——: *Epes Sargent;* 49⅞ x 40; c. 1759–61; National Gallery of Art (Gift of Avalon Foundation), Washington, D.C.

——: *Mrs. Charles Startin;* 23¾ x 19¾; c. 1783; William P. Wadsworth, Geneseo, N.Y.; FARL.

——: *Ann Tyng;* 50 x 40¼; 1756; Museum of Fine Arts, Boston, Mass.

——: *Mrs. Samuel Waldo;* 50 x 40; 1764–65; Mrs. Charles E. Cutting, Boston, Mass.

——: *Mary Warner (?);* 48⅛ x 40; 1767; Toledo Museum, Toledo, Ohio; FARL.

——: *Watson and the Shark;* 71¾ x 90½; 1778; National Gallery of Art (Ferdinand Lamont Berlin Fund), Washington, D.C.

HESSELIUS, JOHN: *Anne Tilghman and Her Son William;* 50 x 40; c. 1762; E. J. Rousuck, New York, N.Y.

PEALE, CHARLES WILSON: *Mrs. James Arbuckle and Son Edward;* 48 x 36¼; 1766; Mrs. Walter B. Gay, Washington, D.C.; FARL.

——: *John Cadwalader, Wife, and Child;* 51½ x 41¼; 1772; John Cadwalader, Philadelphia, Pa.

——: *Exhuming the Mastodon;* 50 x 60½; 1806; Peale Museum, Baltimore, Md.

——: *Benjamin Franklin;* 23 x 18¾; 1785; Pennsylvania Academy of the Fine Arts, Philadelphia, Pa.

——: *Self portrait;* 6 x 5½; c. 1777–78; American Philosophical Society, Philadelphia, Pa.

——: *The Artist in His Museum (Self-portrait);* 103½ x 80; 1822; Pennsylvania Academy of the Fine Arts, Philadelphia, Pa.

——: *Elizabeth De Peyster Peale;* oil on paper; 26 x 22; c. 1791–98; New-York Historical Society, New York, N.Y.

——: *The Peale Family;* 56½ x 89½; 1773, completed in 1809; New-York Historical Society, New York, N.Y.

——: *Hanah Moore Peale;* 24 x 20; 1816; Museum of Fine Arts (Gift of Mrs. Reginald Parker in memory of her husband), Boston, Mass.

——: *James Peale;* 30 x 25; 1795; Amherst College, Amherst, Mass.

——: *Rachel Weeping (Rachel Brewer Peale and Dead Child);* 37⅛ x 32¼; 1772; Charles Coleman Sellers, Carlisle, Pa.

——: *David Rittenhouse;* 37 x 27; 1791; American Philosophical Society; Philadelphia, Pa.

——: *Sellers Hall;* 15 x 20¾; 1816–19; Charles Coleman Sellers, Carlisle, Pa.; FARL.

——: *William Smith and Grandson;* 51 x 40; 1788; Mrs. William D. Poultney, Garrison, Md.; FARL.

——: *The Staircase Group (Portraits of Raphaelle and Titian Ramsay Peale);* 89 x 39½; 1795; Philadelphia Museum of Art, Philadelphia, Pa.

——: *Washington at the Battle of Princeton;* 94½ x 57½; 1784; Princeton University, Princeton, N.J.

STUART, GILBERT: *John Adams;* 30 x 25; 1823; Charles Francis Adams, Boston, Mass.; FARL.

——: *John Bannister;* 36 x 30; c 1774; Redwood Library and Athenaeum, Newport, R.I.; FARL.

——: *John Fitzgibbon, First Earl of Clare, Lord Chancellor of Ireland;* 96½ x 60⅝; 1789; Museum of Art, Cleveland, Ohio.

——: *General Horatio Gates;* 44¼ x 37⅝; c. 1794; Mrs. Charles A. Pfeffer, Jr., New York, N.Y.

——: *Isabella Henderson Lenox;* oil on panel; 28 x 23; c. 1810; New York Public Library, New York, N.Y.

——: *Mrs. Aaron Lopez and Her Son Joshua;* 26 x 21½; Newport period; Detroit Institute of Arts, Detroit, Mich.

——: *Mrs. Perez Morton with an Imaginary Bust of Washington;* oil on panel; 29 x 23½; c. 1802; Henry Francis du Pont Winterthur Museum, Winterthur, Del.

——: *Mrs. Perez Morton;* unfinished; 28½ x 24½; c. 1802; Worcester Art Museum, Worcester, Mass.

——: *Dominic Serres (formerly known as Adam Walker);* 36 x 28; c. 1781–82; from the Percy Rockefeller estate, sold at the Parke-Bernet Gallery, Nov. 20, 1947. The sails on the vessel in the background were added by a later hand.

——: *The Skater (William Grant of Congalton);* 95½ x 57⅛; 1781–82; National Gallery of Art (Andrew Mellon Collection), Washington, D.C.

——: *Self-portrait;* 16¾ x 12¾; 1778; Redwood Library and Athenaeum, Newport, R.I.; FARL.

——: *Self-portrait;* unfinished; 10⅝ x 9; late 1780's; Metropolitan Museum of Art, New York, N.Y.

——: *Adam Walker;* see *Dominic Serres.*

——: *J. Ward;* 20½ x 25; 1779; Minneapolis Institute of Arts, Minneapolis, Minn.

——: *George Washington (The Vaughan Portrait);* 29 x 23¾; National Gallery of Art (Andrew Mellon Collection), Washington, D.C.

——: *Mrs. Richard Yates;* 30 x 25; c. 1793; National Gallery of Art (Andrew Mellon Collection), Washington, D.C.

WEST, BENJAMIN: *Agrippina with the Ashes of Germanicus;* 64½ x 94½; 1768; Yale University Art Gallery, New Haven, Conn.

——: *American Peace Commissioners;* 28½ x 36½; 1783; Henry Francis du Pont Winterthur Museum, Winterthur, Del.

——: *Angelica and Medoro;* 35½ x 28; c. 1764; James Graham and Sons, New York, N.Y.

——: *Ascension of Christ;* 20½ x 16½; 1798; Washington County Museum of Fine Arts, Hagerstown, Md.

——: *The Bathing Place at Ramsgate;* engraving after the picture, by William Birch; 1788; FARL.

——: *The Battle of La Hogue;* 60⅛ x 84⅜; 1778; National Gallery of Art (Andrew W. Mellon Fund), Washington, D.C.

——: *Christ Rejected;* 81 x 164; c. 1815; Pennsylvania Academy of the Fine Arts, Philadelphia, Pa.

——: *Death of Socrates;* 34 x 41; c. 1756; Mrs. Thomas Stites, Nazareth, Pa.

——: *The Death of Wolfe;* 60½ x 84; 1770; National Gallery of Canada, Ottawa.

——: *Death on a Pale Horse;* 21 x 36; 1802; Philadelphia Museum of Art, Philadelphia, Pa. See also, *The Triumph of Death.*

——: *Iris Communicating to King Priam Jove's Command that He Should Go in Person to Solicit from Achilles the Dead Body of His Son Hector;* 47 x 59; 1808; French and Company, New York, N.Y.

——: *Ralph Izard and His Friends;* 40 x 50; c. 1763–64; The Brook, New York, N.Y.

——: *Landscape with Cow;* oil on panel; 26¾ x 50¼; c. 1748–49; Pennsylvania Hospital, Philadelphia, Pa.

——: *Thomas Mifflin;* 47½ x 35½; c. 1758–59; Historical Society of Pennsylvania, Philadelphia, Pa.

——: *Mrs. George Ross;* 42½ x 33½; c. 1755–56; Franklin and Marshall College, Lancaster, Pa.

——: *Self-portrait;* 29¼ x 24¾; c 1771; National Gallery of Art (Andrew Mellon Collection), Washington, D.C.

WILLIAMS, WILLIAM: *Conversation Piece;* 30 x 40; 1775; Henry Francis du Pont Winterthur Museum, Winterthur, Del.

INDEX

Adams, John, 193-4, 284, 291, 309
Adams, John Quincy, 308
Adams, Samuel, 118, 127, 130, 137-8, 158
Adolphus, Prince, 79
Ainslie, Thomas, 116
Albani, Alessandro, 20-2, 43, 45
Alexander, Cosmo, 254-7, 262
Alexander, Francis, 304
Allen, John, 40, 48, 53, 184
Allston, Washington, xviii, 56, 74, 113, 254, 309
American Academy of Fine Arts, 255n
American art, beginnings, 110-3
American Daily Advertiser, 238
"American Folk Art," 33, 112
American Magazine, 37
American Museum of Natural History, 227, 229
American Philosophical Society, 224, 227, 318-9, 327-8
American Primitive Art, 33, 112
American Studies Major, xi-xii
Analectic Magazine, 56
Ariosto, Ludovico, 48
Arnold, Benedict, 202, 204-5
Art Students League
Audubon, John James, 229

Badger, Joseph, 115, 171
Baltimore, Municipal Museum, 227
Bard, Dr. John, 322
Baretti, Giuseppe M.A., 271
Barnum, P.T., 227, 241
Bartolommeo, Fra, 96
Bartolozzi, Francesco, 160
Baur, John I.H., xi
Beechey, William, 160, 162
Belknap, Jeremiah, 210
Bembridge, Henry, 189
Berenson, Bernard, v
Berkeley, George, 113, 253
Billingsport, Fort, 199, 201
Bingham, Mrs. William, 285, 290-1
Bingham, William, 290-1
Binon, M., 291-2

Blackburn, Joseph, 115-7
Blake, William, 75
Bogart, Charles C., 255n
Bologna, Academy of, 50
Bolton, Duke of, 157
Bolton, Theodore, x-xi
Bonaparte, C.L., 229
Bonaparte, Jerome, 299
Bonaparte, Napoleon, 83-6, 90, 226
Bossuet, Jacques, 290
Boston, besieged, 149-52; first play, 109-10; massacre, 129-31; tea party, 134-41, 50
Boswell, James, 78-9
Boucher, Francois, 45, 50, 84
Boude, Dr. Samuel, 332-5
Boydell, John, 80, 276
Braddock, Gen. Edward, 321-8
Brewer, Rachel. *See* Peale, Rachel Brewer
Brewer, Thomas, 206
Bridenbaugh, Carl, 334
Brinton, Christian, 325
British Institution, 84, 165
Brooklyn Museum, xi
Brown, Mather, 258-9, 274, 304
Browne, Arthur, 252
Buchan, Lord, 101-2
Buffon, Georges, 216
Burgoyne, John, 201
Burke, Edmund, 72
Burney, Fanny, 76
Burroughs, Alan, 261
Byron, Lord, 94, 320

Caldwell, Susannah, 212
Caraccis, 48, 146, 311
Carroll, Charles of Carrollton, 184
Carter, George, 144-4
Cathcart, Lord, 68
Catskill Mountains, xiii
Ceracchi, Giuseppe, 231
Chambers, William, 155
Channing, Mr., 252
Charlotte, Queen, 60, 62-3, 68-9, 78-80, 85, 89
Chateaubriand, Francois, 84

Supplementary Index

This section of the Index includes references to the Appendix, pp. 315–340 (new in this edition), as well as a few references to revised sections of the main text.